# designers on design

# designers on design

terence conran
and max fraser

COLLINS | DESIGN

*An Imprint of HarperCollinsPublishers*

**Picture Credits**
Front cover photographs clockwise from top left: "Palmhouse" kettle designed by Mario & Claudio Bellini for Cherry Terrace photographed by Leo Torri; "SE15" lampshade designed by el ultimo grito for Mathmos photographed by Nathalie Deleval; "Jack" light designed by Tom Dixon for Eurolounge photographed by Ashley Cameron; Metropolitan chair by Jefferey Bernett for B&B Italia; "Ego Onyx" vases by Karim Rashid for Mglass. **Spine Photograph:** "Goeffel" by Isabel Hamm for WMF.

Our apologies to the excellent designers that we could not include in this small book.
If it sells well, we will do another one!
Max & Terence.

DESIGNERS ON DESIGN

Copyright © 2004
by Conran Octopus Limited

Text copyright © Max Fraser 2004
Design and layout copyright
© Conran Octopus 2004

First Edition

First published in 2004 by:
Conran Octopus Limited,

a part of Octopus Publishing Group,
2–4 Heron Quays, London E14 4JP
www.conran-octopus.co.uk

Distributed throughout North America by:
HarperCollins International
10 East 53rd Street
New York, NY 10022
Fax: (212) 207-7654

Publishing Director: Lorraine Dickey
Senior Editor: Katey Day
Assistant Editor: Sybella Marlow
Art Director: Chi Lam
Designers: johnson banks
Picture Research Manager: Liz Boyd
Picture Research: Anne-Marie Hoines
and Mel Watson
Production Manager: Angela Couchman

Library of Congress Control Number:
2005921868

ISBN 0-06-083410-2

Printed and bound in China

First Printing, 2005

# Contents

| A | austria | | FIN | finland | | I | italy | | CH | switzerland |
| B | belgium | | F | france | | J | japan | | TR | turkey |
| BR | brazil | | D | germany | | N | norway | | GB | uk |
| CZ | czech republic | | NL | netherlands | | E | spain | | USA | usa |
| DK | denmark | | IS | iceland | | S | sweden | | | |

# introduction

Consumer society as we know it today has been growing over the last one hundred years at an exponential rate and shows no sign of waning. Because so many companies produce and sell goods of roughly similar function, their presentation and promotion have become crucial weapons in the clamorous battle to gain our attention. At the same time, concern for the domestic market has now been firmly uprooted in favour of a pursuit of global sales, so that the need for cross-cultural acceptance has heightened the arrival of more universal product solutions. This global transfer of products, however, has contributed to a culture of over-consumption in the developed world that contrasts startlingly with the deprivation of poorer nations. Quite simply, there is too much choice, and most markets are saturated.

This may sound overly pessimistic, but it is such a clear-eyed world-view that designers need if they are not just to add to the sea of what is often –

dare I say it? – substandard product. Some degree of transcendence of contemporary market conditions, indeed, is one of the achievements shared by the designers featured in this book. Sometimes, they have simply and honestly redefined an everyday object so as to refine its functionality, or perhaps they have reinvigorated a concept with an element of humour, symbolism or irony that makes us look again at a previously "invisible" object. At other times, they apply a new material to an object, thereby offering greater ergonomics or adding the alluring emotional quality of greater tactility and comfort. Responsibility lies also, of course, with producers, and some manufacturers have certainly realised the benefit of good design not only in the looks and styling department but also in the advancement of user interface and "new function".

Our – Terence Conran's and my own – motivation in creating Designers on Design has been to unearth some of

the true personal characteristics of a handful of the world's leading design talents who are contributing to the changing face of our three-dimensional environment today. Age was no issue in the selection – the primary criterion being that the designer must still be actively involved in contributing beautiful and innovative creations today. We also wanted to select individuals who collectively represent a cross-section of design practice, from those working in the high-tech, mass-market corporate sphere to those trumpeting a more emotionally driven, singular vision expressed through self-initiated projects or limited and more niche batch production. It is for this reason that we include established names such as Enzo Mari, Michele De Lucchi, Mario Bellini, Norman Foster and Philippe Starck alongside newer talents such as Shin and Tomoko Azumi, Tord Boontje, the Bouroullec brothers, Stephen Burks and Norway Says.

Each chosen designer has been given equal prominence within this book. Accompanying a selection of beautiful images of their existing and past product designs is factual background information on their achievements to date. In addition, each one of the 110 designers included has answered a set of questions that were carefully chosen in order to draw out some of the traits of a designer's character, attitude and approach to his or her profession. The results of this questionnaire have been varied and fascinating. We have unearthed a vast diversity of people, events, cultures and objects that have influenced their design work. We have discovered what it was that successfully launched their career. We have asked them whether it is individual expression or the interaction born of teamwork that primarily motivates their work, and we have quizzed them on the frustrations that line the path of such activities. Are trends, we wondered, at all important to their design approach?

And, in an attempt to avoid the assumption that design is the only profession they have ever considered, we wanted to know which alternative career options they might have opted for or still might pursue. Acknowledging that many of our chosen designers do not speak English as their first language, we have implemented only minor alterations to grammar and spelling so as to enhance the clarity of their replies.

Some of the designers' responses are refreshingly honest and straightforward, whilst others are more mysterious or carefully considered so as not to reveal too much. A common thread linking all of the designers in this book, however, is their desire to introduce their own interpretation of "innovation" into their designs – be it through the concept, the choice of material, or the production process, or, indeed, a combination of all three. Whilst we might take innovation for granted as the primary attribute of

a successful design, we must not forget the personal leap of faith that each designer is championing in their pitch for better, more resolved outcomes. The self-conviction and confidence that are needed to trigger enthusiasm, understanding and belief in the mind of the client should not be underestimated. Indeed, such entrepreneurial qualities are exactly what the truly visionary manufacturers are searching for in their collaborators. They require someone with the ability to recognise the importance of commercial viability and apply that knowledge to the creation of exciting products that will make their brand stand out as a leader in its field. Needless to say, every page of this book bears the fruits of such collaborations.

Placing present designers within the context of design history helps shed some light on the state of our material world as it stands today. The "Timeline of Design" (pp 10–21) highlights the key progressions in

twentieth-century design across each decade, pinpointing the emergence of design movements around the world, political influence, material developments and socio-cultural shifts in mentality and acceptance of changing attitudes and the appearance of our material surroundings. In the "Future Gazing" chapter (pp 22–29), we speculate on the future of how we will live and the impact of technology and consumerism on our evolving cultural identities. We identify concepts already in development as well as those around the corner, whilst even taking a stab at more far-reaching, hard-to-imagine utopian ideals. Most importantly, we ask whether, at the core of such progression, our already fragile environment can sustain the speed of change.

It is important to stress that the designers featured in this book do not make up a definitive list of the very best – such a list could, in any case, never

truly exist owing to the subjective nature of such a proposal. Instead, Terence and I have put forward a suggestive fraction of the exemplary individuals of our time who are making relevant and responsible inroads into the ever-changing face of our material world. What is now left to observe is how the work of today's designers will inform the practice of future generations and the innovations they unveil.

In the interests of preserving our natural world, I would ask that all future product development is handled responsibly and that commercial success does not become the overriding motive in justifying production. Ignorance spells danger, but the following of wisdom, honesty, knowledge and vision, and the search for a common goal, spells long-term prosperity and happiness that will have the effect of ever-challenging and stretching our limits for the better.

**Max Fraser** July 2004

# introduction

This book is, I believe, important because it gives a clear indication of the way design is progressing in the 21st century. It contains the work of many of the world's leading designers, together with their opinions, inspirations and motivations. It is an invaluable reference tool for everybody involved in, or interested in, the design process.

Design, of course, dates back to the moment when men and women started to make things. Decisions had to be made consciously or subconsciously about the shape of a flint arrowhead or an axe. Everybody who signs their name makes some sort of decision about the way they want to express themselves to other people.

When I was a student in the late 1940s, the world of industrial design as we know it today was only just beginning to be formulated. Indeed, at that time we were known as "industrial artists". We were enormously influenced by the Bauhaus and by the work of Raymond Loewy, Henry Dreyfuss and Norman Bel Geddes in pre-war America, and we were, of course, excited by a group of designers working on the West Coast – Charles and Ray Eames, George Nelson, Eero Saarinen and Alexander Giraud. We saw their work and the inspirational Case Study Houses in a cheaply produced magazine called *Arts and Architecture*. It was stirring, invigorating stuff, and it showed us what might be possible.

Nearer home, there was little to see except the work of the architects and designers who had fled Nazi Germany before the war and who had paused in the UK on their way to the richer pastures of the USA – the likes of Marcel Breuer, Walter Gropius and Erich Mendelson. We were also, of course, influenced by Charles Rennie Mackintosh and by some of the opinions of William Morris. Wells Coates was a local hero, as was Gordon Russell, and we were starting to get excited about some of the furniture being made by designer craftsmen in Scandinavia. We even spotted Eileen Grey, Le Corbusier, Charlotte Perriand and Pierre Chareau in France.

It wasn't, however, until my first Trienalle in Milan in 1952 that the whole world of industrial design began to open up for me. When I compare the modest size and attendance of the Triennale in those days with the enormous scale and chutzpah of the contemporary Milan furniture exhibitions, I am impressed by how far design has come in our modern world. It also makes me wonder exactly why design and designers are so important and so popular in the world today.

The simple answer is, I believe, that they have the power to make the world we live in an altogether more pleasant place. Designers have been trained to make sure things are made intelligently – that they are made to work better, without waste and with a concern for the environment, that they are made to last, be pleasurable to use and, last not but not least, be beautiful.

I have always believed that design is 98-per-cent common sense and 2 per cent that magic ingredient sometimes called aesthetics.

But what is intelligent design? To my mind it is a careful assessment of the needs of society and the market you are designing for. It is about trying to improve how something works and how it looks. This can be achieved by a close study of what is currently on offer and realising that there is an opportunity for improvement.

Designers need to have a social conscience; they need to be optimists and to have a vision of the future. They are inspired, as you will read in this book, by a myriad of different things. They need a client who works with them and who shares their enthusiasm. They need to understand the manufacturing processes they work with, both in terms of the skills of the workforce and the capability of the machinery. They also need to be involved in the whole process of

marketing and distribution after the product leaves the factory and is presented to the customer.

The importance of research to a designer is widely recognised. I would say it is essential because you have to know the history of design – what has succeeded and what has failed. It's the knowledge that you need to have before beginning a new project. Many designers do this research automatically – they respond to what the world is producing with a gut feeling that is born of education, experience and the acute sensitivity of their design "antennae". They know what is going on now and what has gone on before – and they know they don't want to repeat it!

Sometimes progress in design is incremental, but occasionally there is a real breakthrough, usually as the result of new materials, technology or manufacturing methods. At other times – if they have relevance to contemporary taste or desires – old products or styles are revisited and revitalised or given a new twist. But there always has to be progress.

One of the dilemmas designers face today is the conflict between their desire to design quality products that do not waste the world's resources and the demand for new products that keep the workforce busy and customers spending. Most designers would like to see the chair they design last several lifetimes, but they know that if they don't design that "new" and "better" chair, their client – the manufacturer – will be out of business, his workforce unemployed and the retailer shutting his doors.

Designers play a major role in keeping entrepreneurial enterprise alive and prosperous. In fact, it is often said that intelligent design is the most economical way to add value to a product, but all the same it has to be done with sensitivity and a well-balanced social conscience. This book, I believe, demonstrates how 21st-century designers are doing just that – with intelligence, optimism and style.

**Q. What type of products do you design?**

A. Practically everything and anything, except products that are connected with aggression.

**Q. What or who has been a significant influence on your work?**

A. There are too many people to list, although I must mention Leonardo da Vinci.

**Q. What was your big break?**

A. Working at the Festival of Britain in 1951.

**Q. What human emotions and necessities drive your designs?**

A. The desire to find practical, simple and beautiful solutions that will improve the quality of people's lives.

**Q. How important is it for your work to reflect a national design characteristic?**

A. Not important but, nevertheless, I believe that most designers do in some way reflect national characteristics, thank goodness.

**Q. How important are trends in your work?**

A. It is impossible not to be influenced by what is happening in the world we live in and I reinterpret this in my way.

**Q. Is your work an individual statement or a team solution?**

A. Both.

**Q. What elements of the design process do you find particularly frustrating?**

A. Indecision by the client.

**Q. What do you still aspire to design?**

A. A school, both inside and outside.

**Q. How would you sum up your design approach?**

A. Plain, simple and useful solutions that anybody who likes them should ideally be able to afford.

**Q. What would be your second career choice?**

A. A cook in a simple restaurant.

**Terence Conran**

**1900s**
from left to right:
Jam dish by Charles
Robert Ashbee for
Guild of Handicraft
(1901); "Hill House
Chair" by Charles
Rennie Mackintosh
(1904); "Sitzmaschine"
armchair by Josef
Hoffmann for Jacob
& Josef Kohn (c.1908)

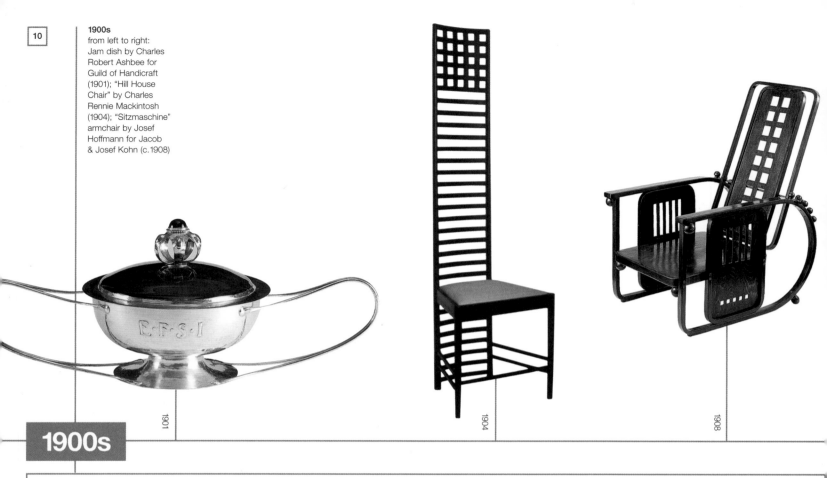

1901

1904

1908

# 1900s

The Industrial Revolution, which in Britain began around 1770 and which subsequently swept across Europe, enabled humans to control and shape their environment on an unprecedented scale. Mechanised industry revolutionised the traditional crafts and gave rise to mass consumer products that met the needs and aspirations of an ever-greater proportion of the population. As technology advanced, the division between the design of products and their making deepened.

A mixture of art and industry was promoted at the Great Exhibition held in London in 1851, where the press and public alike began to adjust their taste in favour of the technical perfection of the machine. For many, the decorative and functional items on display proved that industry was capable of reproducing the ornate precision of craftsmanship. This cultural transition was not universally welcomed, however. Critics such as the essayist and reformer John Ruskin (1819–1900) and the Socialist designer

and artist William Morris (1834–1896) complained that machine production and commerce resulted in goods of compromised aesthetic quality. They argued for the revival of pre-industrial values, targeting the middle classes with the handcrafted products of the Arts and Crafts movement.

By the turn of the century, however, historicism and nostalgia were being pushed out by the desire for a new and original style that would be relevant to the modern world. Here, the pioneers were Continental figures such as the architect Otto Wagner (1841–1918) in Vienna, Henri van de Velde (1863–1957) in Brussels and the Parisian art dealer and critic Siegfried Bing (1838–1905). Bing's gallery in Paris, L'Art Nouveau (opened in 1895), gave its name to an international modern style that embraced everything from architecture and furniture to jewellery and book design and which was most typically characterised by its use of curvilinear natural forms.

Around the same time, the Scottish architect and designer Charles Rennie Mackintosh (1868–1928) led a group of artists in Glasgow towards a related but more abstracted aesthetic that favoured simple geometric shapes and a reduction of colour. In 1897, this more linear approach inspired the foundation of the Vienna Secession by, among others, the architect Josef Hoffman (1870–1956) and the interior designer Josef Maria Olbrich (1867–1908), who pioneered designs of radical rectilinearity and simplicity. This was an approach that was also adopted by architect Frank Lloyd Wright (1867–1959) in the United States.

The new style and approach evident in the work of the Art Nouveau and Secession movements continued to favour hand labour. A more radical departure in production terms was made in Germany – then the world's fastest growing industrial country – where the architect and theorist Hermann Muthesius (1861–1927)

trumpeted machine production as the key to design reform. Among his followers were Peter Behrens (1868–1940) and Richard Riemerschmid (1868–1957), who, in 1904, developed a programme of plain and practical machine-made furniture at a reasonable price. From 1907, Behrens also embraced this approach for the electronics manufacturer AEG, where he applied a unified aesthetic to the company's architecture, graphic and product designs and, in so doing, inadvertently created the early foundations of branding. In the same year, Muthesius, Behrens and Riemerschmid founded the Deutscher Werkbund in Munich to promote industrial design among designers and manufacturers.

By 1911, even the Arts and Crafts stalwart Charles Robert Ashbee (1863–1942), founder of the Guild and School of Handicraft, was coming round to the idea that machine production was an inevitable reality.

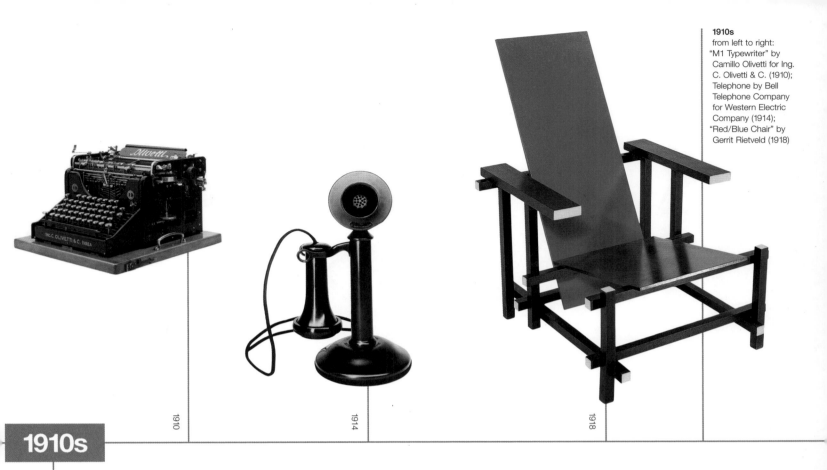

**1910s**

from left to right:
"M1 Typewriter" by
Camillo Olivetti for Ing.
C. Olivetti & C. (1910);
Telephone by Bell
Telephone Company
for Western Electric
Company (1914);
"Red/Blue Chair" by
Gerrit Rietveld (1918)

# 1910s

By 1910, Art Nouveau was suffering from its own over-popularity, as producers jumped on the bandwagon and made poor-quality imitations. Attention was diverted, instead, to the example of the Deutscher Werkbund in Germany, which continued to promote industrial design through its successful programme of exhibitions, lectures and illustrated yearbooks. An 18-room presentation at the Paris Salon d'Automne in 1910, in particular, highlighted the Deutscher Werkbund's commitment to using modern materials for making high-quality, affordable designs.

Similar organisations arose in countries such as Austria, Switzerland and Sweden, while in Britain the "Exhibition of German and Austrian Articles Typifying Successful Design", held in London in 1915, triggered the founding of the Design and Industries Association (DIA). The DIA publicly promoted design in industry via its network of manufacturers, designers,

craftspeople and retailers. Reception of the Werkbund's ideas was much less positive in France, where the geometric, simplified furniture of Francis Jourdain (1876–1958) – released in 1912 – was deemed too rigid and austere; most French designers subsequently reverted back to handcraft traditions as a reaction to foreign influences.

Meanwhile, however, the revolutionary art movements of the opening decades of the 20th century were having a profound impact on wider European culture. The abstract, geometric forms of Cubism – initiated in France by Pablo Picasso (1881–1973) and Georges Braque (1882–1963) – and, to a lesser degree, the Futurist movement in Italy inspired various groups of architects and designers around Europe to apply the same angular aesthetic to buildings, furniture, objects, textiles and graphics, using a Cubist-like dynamic geometry. The influence of Cubism and the Futurists spread to Holland in 1917 with

the founding of the art and design journal *De Stijl* by the painter Theo van Doesburg (1883–1931). The magazine heralded total purist abstraction by reducing forms to simple geometric shapes along horizontal and vertical planes using only primary colours and black, white or grey. The movement not only affected the fine arts but also architecture and interior design, as illustrated by the revolutionary furniture of Gerrit Rietveld (1988–1964; for example, the "Red/Blue Chair" of 1918). The honest, dematerialist, formal purity of *De Stijl* proved hugely influential in the development of the Modern Movement.

Meanwhile, in Russia after the Revolution of 1917, the Constructivist movement of artists, designers and architects cited the activities in the Netherlands as inspiration for their Socialist plans for the democratic production and distribution of goods through industrial processes. However, owing to the political and economic instability that followed the Revolution,

the Constructivists' utilitarian vision for the applied arts and architecture using similar abstract elementary forms and colours was reduced to smaller-scale projects within the realm of graphics, exhibition design and ceramics.

All of these radical movements in Italy, France, the Netherlands and Russia were searching for logic, order and clarity and identified the machine as the ideal route to achieving this. However, the quest for standardisation and universal good taste had the unfortunate effect of dividing the Deutscher Werkbund – with some members such as Bruno Taut (1880–1938), Walter Gropius (1883–1969) and Henri van de Velde seeing it as a threat to their artistic freedom. This divide nearly led to the disbanding of the Werkbund.

The devastation of the First World War (1914–1918) led some commentators to believe that industrial production would provide the path to widespread post-war recovery.

**1920s**

from left to right: Dinner service for the Imperial Hotel in Tokyo by Frank Lloyd Wright, produced by Noritake (c.1922); Ashtray by Marianne Brandt for the metal workshop at the Bauhaus, Weimar (1924); "Sitzgeist" chair by Heinz & Bodo Rasch (1927)

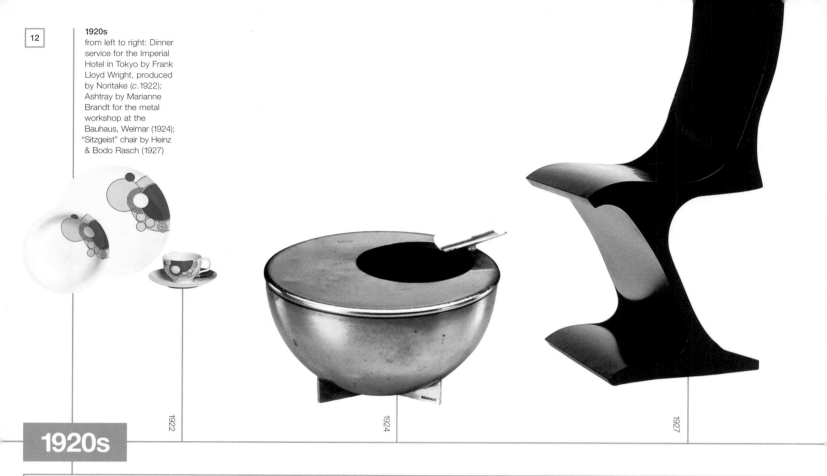

1922

1924

1927

# 1920s

In 1919, Walter Gropius, set up the Staatliches Bauhaus art and design school in Weimar, Germany. Gropius recognised the importance of learning craft, believing that hands-on experimentation and workshop skills provided a secure grounding on which to develop artistic production. Masters such as Gerhard Marcks (1889–1981), Georg Muche (1895–1986), Paul Klee (1879–1940) and Wassily Kandinsky (1866–1944) headed workshops across a diversity of disciplines, including metalwork, pottery, cabinet-making, weaving and painting. The preliminary course in colour, form and line created by the Swiss painter Johannes Itten (1888–1967) invited students to experiment freely without focusing on the importance of a practical outcome. A rift between the authoritarian Gropius and the unconventional Itten led to the latter's departure from the school, which in any case was under pressure from the Weimar authorities to produce more practical results.

In 1923, Gropius appointed the Hungarian Constructivist László Moholy-Nagy (1895–1946) and Josef Albers (1888–1976) as Itten's successors and introduced a revised manifesto for the school. This stressed the importance of teaching design for machine production and sought to forge links between the school's design activities and industry. However, an accompanying exhibition, while critically a success, did not offset the political pressure. After the newly elected National Socialist German Workers' Party in Weimar halved the school's funding, the Bauhaus was forced to move to the more liberal city of Dessau in 1925, where a Gropius-designed school was purpose-built.

In the same year, the "Exposition Internationale des Arts Décoratifs et Industriels Modernes" was staged in Paris. Despite the diversity of works on display, a common thread were Cubist- or *De Stijl*-derived geometric forms and abstract patterns. Critics complained that much of the work simply borrowed the outer trappings of such modernist art movements without understanding the principles that had inspired their original practitioners. Le Corbusier (1887–1965) argued that the market was being swamped by bad imitations and "works of art"; what was needed, he declared, was cost-effective, mass-produced, functional and standardised household equipment that embraced new materials, techniques and forms free from pretentious decoration.

Much the same ethos was already in place at the Dessau Bauhaus and at VKhUTEMAS, the Russian avant-garde art and design school in Moscow. In both institutions, functionality was coupled with a concern for inexpensive production, durability and refined beauty. During the 1920s, for instance, lighting fixtures designed by Bauhaus members Marianne Brandt (1893–1983) and Wilhelm Wagenfeld (1900–1990) and the tubular steel furniture of Marcel Breuer (1902–1981) all reached mass production. At around the same time,

the architects Ludwig Mies van der Rohe (1886–1969) and Mart Stam (1889–1986) were also exploiting the possibilities of metal furniture with cantilevered steel chairs.

In 1927, Le Corbusier's celebrated utilitarian dictum that "the house is a machine for living in" was realised in the Weissenhof Siedlung housing estate built in a suburb of Stuttgart, designed by himself and 15 other leading European architects including Gropius, Mies van der Rohe, Stam, Behrens and Taut. These mass-produced homes were fresh, clean, white, light and uncluttered, fitted with furnishings that resembled efficient industrial equipment. The Weissenhof Siedlung's functionalist steel and glass structures drew sharp criticism for their uncompromising style and radical break with tradition. While a widespread acceptance of the "modern spirit" was some way away, the Bauhaus revolutionaries had succeeded in implementing the principles of the Modern Movement.

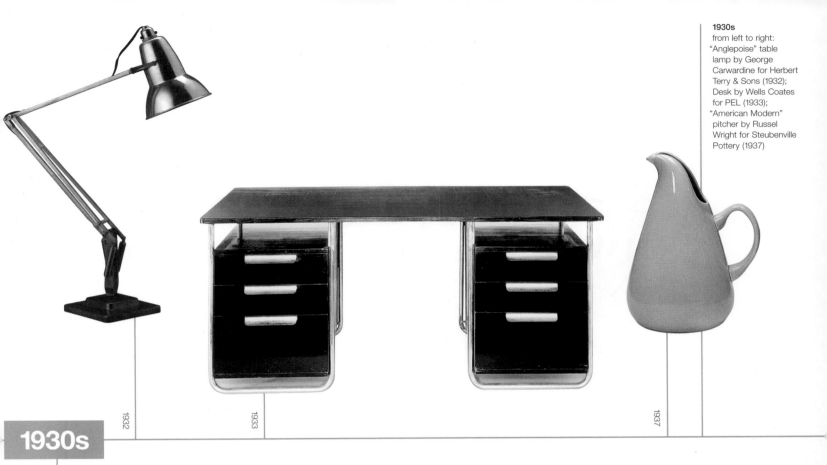

**1930s**
from left to right:
"Anglepoise" table
lamp by George
Carwardine for Herbert
Terry & Sons (1932);
Desk by Wells Coates
for PEL (1933);
"American Modern"
pitcher by Russel
Wright for Steubenville
Pottery (1937)

# 1930s

During the 1920s, the design theories of the European avant-garde had little impact on the design of everyday objects. Towards the end of the decade, however, a new aesthetic emerged in the USA which, while taking the utopian ideals and hard-edged geometric rigidity of the European movements as its initial inspiration, sought to exploit the possibilities of machine production to create commercially appealing goods. The aesthetic took its cue from automobile, liner and aeroplane design, whose aerodynamic, streamlined shaping had come to symbolise speed, prosperity and progress. Adapted by product designers to household appliances, this sleek, sexy aesthetic – called Moderne – introduced modern design to the American public.

The spread of the electricity infrastructure across the United States in the 1920s and 1930s gave rise to an influx of new consumer goods for the domestic environment. The Wall Street Crash of 1929 dealt a hard blow to the economy and sent many companies into decline. In a fiercely competitive marketplace, manufacturers and designers had to keep costs down and desirability high. The streamlined look fulfilled this brief perfectly – an attractive exterior that made products look new, desirable and different from the competition even if the internal mechanics remained the same.

Among the American designers who benefited from this new consumer culture were Raymond Loewy (1893–1986), Henry Dreyfuss (1904–1972), Norman Bel Geddes (1893–1958) and Walter Dorwin Teague (1883–1960), whose multidisciplinary practices breathed new commercial strength into industry. Loewy's restyling of the Sear's "Coldspot" refrigerator in 1934 made sales rocket and was one of the first appliances to be marketed solely for its look. New synthetic materials proved ideal for industrial design. An early form of plastic named Bakelite, for instance, was used to mould streamlined casings for telephones and radios.

In 1933, Hitler's accession to power spelt the end for everything progressive that German designers had stood for – as the Nazis considered the school's teachings to be "decadent" and "Bolshevist". The Bauhaus – now under the directorship of Mies van der Rohe – had already been forced to move to Berlin in 1932, and in April 1933 was raided by the Gestapo and forced to close. Many, including Mies, Moholy-Nagy, Breuer, Gropius and Albers, subsequently emigrated to Britain or the United States to escape persecution. Their presence in the USA was hugely influential, although their Socialist design approach remained far removed from the superficial styling of Moderne.

The Third Reich endorsed a return to a traditional Germanic neo-classicism and arts-and-crafts vernacular. Nevertheless, the rational functionalism practised at the Bauhaus was continued by many German industrial designers.

And while the privately managed Deutscher Werkbund was disbanded in 1934, its members continued to work with private industry along their original ideals. In France, meanwhile, the market for luxury, highly crafted, decorated objects – subsumed under the term "art deco" – was thwarted by the Depression and the looming Second World War (1939–1945).

Distanced from the functionalist austerity of Europe and the populist aesthetic of America was Scandinavia, where individuality, variety and human sensibility were preferred. During the 1930s, the likes of Finnish architect Alvar Aalto (1898–1976) and the Swedish designer Bruno Mathsson (1907–1988) applied organic forms to processed woods and invented new softened forms that were still suitable for low-cost production methods. This palatable affordable modern style sold well and, in the mid-1930s, inspired other European designers, notably Breuer in his work for Isokon in London.

**1940s**

from left to right:
"Lounge Chair", model
no. NV-45 by Finn Juhl
for Niels Vodder (1945);
"LCW" (Lounge Chair
Wood) by Charles & Ray
Eames for Herman
Miller (1945); "Wireless
Receiving Set" by Wells
Coates (1946)

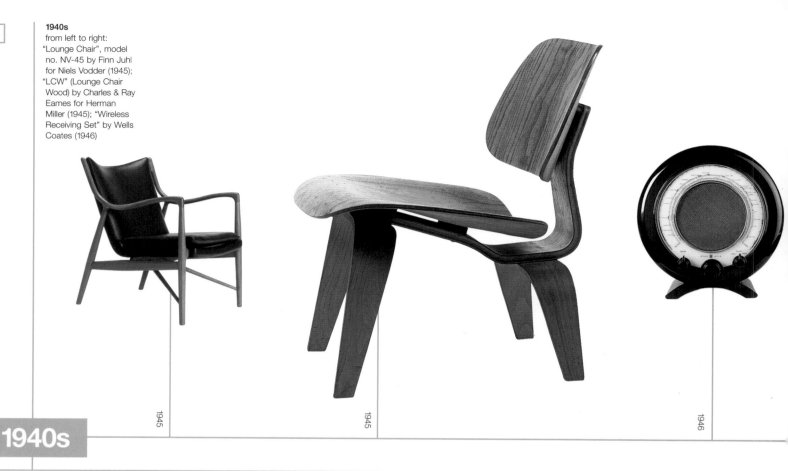

1945

1945

1946

# 1940s

The Second World War brought an end to the growth experienced by the consumer industries in the 1930s. As nations focused their resources on the military struggle, factories shifted their output to war production and governments imposed controls on the manufacture of consumer goods. In Great Britain, strict regulations were imposed on the use of numerous materials, including timber, iron, steel and aluminium, and, in 1941, the British Board of Trade introduced the Utility furniture programme, which restricted the manufacture of furniture to only 20 standardised models – each designed to be strong, serviceable and sparing in its use of raw materials. In 1942, the Utility Furniture Advisory Committee, which included the designer Gordon Russell (1892–1980), was set up to oversee the development of the range, whose simple construction, common-sense forms and functionality seemed to marry the old values of the Arts and Crafts Movement with those of the Modern Movement.

Cutbacks and the rationing of materials also hit industry in the United States, which entered the war in 1941. In 1942, the Office of Price Administration was formed to enforce price limits on consumer products, while the pioneering designers of streamlining from the previous decade were called in to work for the government on military designs. During this period, however, the USA saw considerable innovation in the field of design, despite – or perhaps because of – the limitations placed on certain core materials. The influence of the organic Modernism introduced by the likes of Alvar Aalto in the previous decade gave rise to a softer and more palatable style developed by pioneers such as the Finnish emigré Eero Saarinen (1910–1961) and Charles (1907–1978) and Ray Eames (1912–1988).

In 1940, the US architect and designer Eliot Noyes (1910–1977) organised the "Organic Design in Home Furnishings" exhibition at the Museum

of Modern Art in New York, showcasing the Eameses' and Saarinen's fluid, curvilinear prototype designs. However, it was not until after the war that the moulding techniques Eames had applied to his designs for splints, aircraft parts, stretchers and even glider shells for the US Navy were transferred to ergonomic furniture designs – first in plywood and later in fibreglass and plastic resin – finally giving shape to the Eameses' much-imitated one-piece seat shells. In 1950, working in development with Zenith Plastics and Herman Miller, the Eameses developed the "Plastic Shell" series of chairs that finally fulfilled their ambitions for low-cost, high-quality furniture for mass production.

After the end of the war in 1945, exhibitions were held across the USA and Europe to stimulate post-war sales of consumer goods. Designers and manufacturers were keen to introduce new models for living and, although materials were still limited, experimental prototypes illustrated advanced

possibilities for modern homes. In 1946, the Italian Association for Exhibitions of Furnishings held an exhibition in Milan of imaginative, bold and inexpensive designs that used a plethora of shapes and materials, while in London, in 1946, the "Britain Can Make It" exhibition set out to raise morale with displays of forthcoming consumer goods. The International Competition of Low-cost Furniture Design held at the Museum of Modern Art in New York in 1948 received entries from across the world addressing issues of adaptability, comfort, ease of production, efficiency of shipping, self-assembly and innovative use of materials. And in France, in 1949, the Union des Artistes Modernes (UAM), headed by René Herbst (1891–1982), staged the exhibition "Formes Utiles" (Useful Forms), which finally laid to rest the luxury pre-war market in favour of affordable contemporary products that enhanced everyday life. The message everywhere was one of optimism.

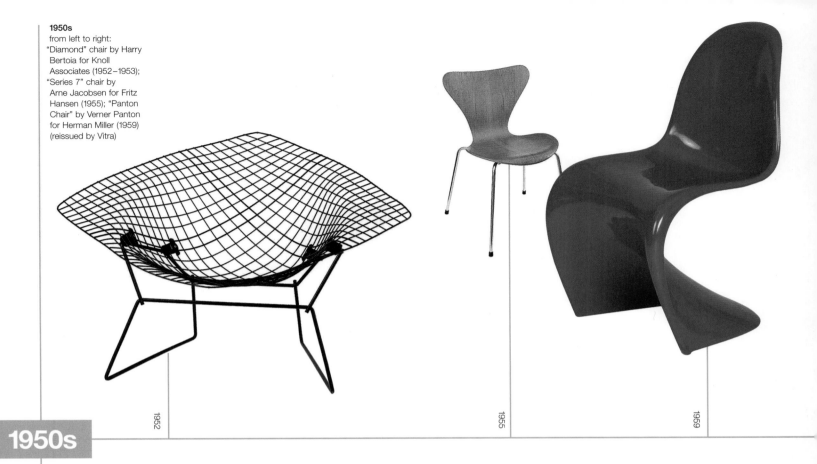

1952

1955

1959

## 1950s

The post-war agenda for recovery continued into the 1950s. In Europe, the industrial community looked enviously towards North America, where a plethora of new seductive consumer products symbolised power, status, happiness and success. Even back in 1944, the British government had recognised that action had to be taken to stimulate the domestic and foreign trade of British goods and set about founding the Council of Industrial Design in order to foster improved standards. The council's work reached a climax in 1951 with the Festival of Britain – exactly a century after the Great Exhibition – providing an opportunity to celebrate the nation's recovery from war while simultaneously showcasing more than ten thousand forward-thinking manufactured products to an attentive public. Other countries also set up national design councils in this period – including the Netherlands (1949), West Germany (1951) and Japan (1953).

"Good Design" was a term widely applied by these organisations to products that had been rationally designed – through simplification of the manufacturing process, consideration of aesthetic beauty and longevity, and with an eye towards commercial success. In 1950, the Museum of Modern Art in New York officially embraced Good Design with an exhibition of the same name. This displayed a selection of approved new products, whose "Good Design" label subsequently added value within retail environments. In London, the Council of Industrial Design opened the Design Centre in 1956 to showcase examples of good design, also accompanied by its own seal of approval, the Kite-mark. The Milanese department store La Rinascente sponsored the first Compasso d'Oro awards in 1954 (which the Italian Industrial Design Association still runs today), with prizes initially awarded for the aesthetic qualities of products.

An emphasis on the partnership between aesthetics and function also characterised the approach of the Hochschule für Gestaltung (Institute of Design), opened by Max Bill (1908–1994), Otl Aicher (1922–1991) and Inge Scholl (1917–1998) in the West German city of Ulm in 1953. The international teaching staff extended the principles of the Bauhaus to focus more closely on the design of objects for everyday use, and, like its predecessor, raised some of its finance from commissions from industry. Its first client was the electronics company Braun, with whose management Aicher and Hans Gugelot (1920–1965) worked closely to develop an austere, clean-lined engineering aesthetic that was later extended under the long-term direction of Dieter Rams (born 1932).

By the 1950s, the industrial functionalist style pioneered since the 1920s had won widespread consumer acceptance under the auspices of Good Design. Meanwhile, however,

the avant-garde design community had inevitably moved on. The likes of the husband-and-wife Eames duo and Saarinen in the United States and Arne Jacobsen (1902–1971) in Denmark overthrew the primacy of aesthetics and the austerity of geometry in favour of a more experimental approach to industrial materials and construction techniques. Some of the boldest innovations from this period took place in Italy. In 1951, Marco Zanuso (1916–2001) designed the organically shaped "Lady" armchair, which utilised Pirelli's new foam rubber – a material that would prove to have a profound effect on furniture design in the forthcoming years. And in 1957, the innovative brothers Achille (1918–2002) and Pier Giacomo (1913–1968) Castiglioni presented their "Readymade" designs, whose rationalism was loosened by an ironic humour that would later manifest itself more widely in the less serious approach of the Pop era of the 1960s.

**1960s**
from left to right:
"Arco" lamp by
Achille & Per Giacomo
Castiglioni for Flos
(1962); "Ribbon"
chair by Pierre Paulin
for Artifort (1965);
"Model No 4966"
storage system by
Anna Castelli Ferrieri
for Kartell (1969)

1962

1965

1969

# 1960s

The 1960s changed the demands and expectations of the design community. By the start of the decade, a new generation of industrial designers had begun to question the notion of "good design" that had been accepted around the world. The rigid, functionalist ideals, and values of permanence and universal appeal that were promoted by International Style were superseded by the increasingly undisciplined tendencies that reverberated through popular culture. As industry had picked up considerably since the war, so too had the rapid transfer of technological developments around the world. The feel good factor that consumerism built up in the United States through the 1950s had reached Europe and the appeal of short-lived mass-produced items was proving contagious. Youth rejection of traditional values gave designers across all disciplines carte blanche to try out new concepts. Designers responded to a liberated society that embraced disposable items

and the affordable versatility of plastic made it the material of choice.

That said, experimentation was the order of the day resulting in a decade that cannot be defined by one particular material or style. An abundance of new production techiniques and materials was introduced to the market, offering designers new opportunities to develop their ideas. They sought a common desire for colour and fresh bold forms.

The burgeoning consumer culture rejected traditional design conventions in favour of a more flexible approach to living. This was embraced by the London-based Archigram group of architects (1963–1975) who reacted against the sterility of postwar building in Britain. Their largely theoretical utopian proposals promoted the use of advanced technologies to create a consumer-oriented cityscape where modular additional units and services could be added to structures when needed. They proposed the idea that everyday consumers should be involved

in development choices, rather than leaving the decisions to architects.

This flexibility was embraced by designers like Verner Panton who invented rather playful modular, multi-purpose furniture that could be configured in a space according to the whims of the particular user. The formal definitions of a room's function were being relaxed and with this came an entirely new attitude to layout and styling, as Panton's "Pantower" of 1968 illustrates. This design was constructed from a curvaceous undulating framework that was entirely upholstered using textile-covered moulded polyurethane foam, a technique also employed by the likes of Pierre Paulin and Olivier Mourgue. Subsequently, internal supporting structures were removed completely and high-density foam blocks were sculpted into the shape of chairs and sofas, then covered in fabric. Designers like Rodney Kinsman, Cini Boeri and Gaetano Pesce developed

this theme to produce throwaway and inexpensive furniture solutions.

The notion of industrially producing furniture using only one material was explored throughout the 1960s. International designers such as Joe Colombo, Helmut Batzner, Eero Aarnio, Robin Day and Verner Panton explored the strength of injection-moulded polypropylene and moulded fibreglass-reinforced polyester inventing forms that upturned the usual appearance of functional objects. The consistent quality of manufacture made plastic ideal for stackable products such as ashtrays, chairs, storage and tableware, and allowed the design of everyday household appliances to be radically rethought. Materials such as PVC, polyurethane foam and polystyrene not only looked radically different but also felt different. This led to the invention of some archetypal 1960s products such as polystyrene-filled beanbags and inflatable PVC armchairs.

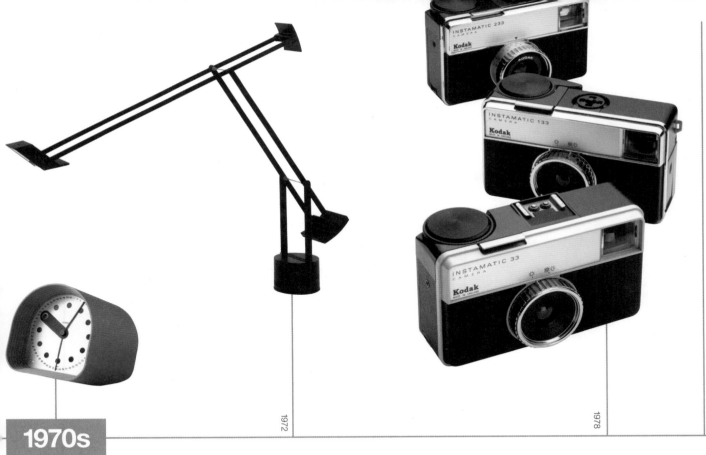

## 1970s

The freedom and feelings of optimism generated in the 1960s had positive effects for the manufacturing industry in several European countries. The Italians, who had traditionally run family-owned craft shops, embraced the mass-market opportunities most successfully. As manufacturers switched over to technology-driven production, so, too, did the skilled craftsmen and artisans whose businesses were dwindling. Developing prototypes and tools closely with the designers, Italian manufacturers were able to realise products faster than their foreign competitors and with more control over research and development costs. The opportunities behind the quick mass-production of synthetic materials saw commercial growth in the domestic and export markets increase rapidly. Coexisting alongside this in the late '60s and early '70s were radical groups such as Superstudio and Archizoom Associati in Florence, who questioned the capitalist values that were widely trumpeted in

industry. They steered the popular culture aesthetic to kitsch new levels, while rather confidently mocking the pretensions of "good design" and the seemingly endless cycle of mass consumerism.

The evolution of oil-based materials had seemed unstoppable. However, the oil crises of 1973 and 1979 brought this heightened optimism down to a level of startling realism. The sustainability of such fast-paced progression was deemed impossible as the oil quantities remaining in the planet's reserves came under questions. The world was forced to rethink its speedy journey into the future. The pop objects of the '60s had generated an attitude towards the values of plastic as a cheap, disposable product. Once a selling point, this perception rapidly turned plastic, which had previously been considered the material of the future, into a symbol of waste. Consequently, industry naturally suffered and investment cutbacks followed – companies relied heavily on

external finance for survival.

The economically strained '70s saw many designers in countries like England, Italy, Scandinavia and Germany turn their backs on industry. The mood was one of disappointment that had been brought about by the failed hype surrounding technology. British design gave way to a climate of retrospection that heralded the Arts & Crafts masters of the 19th century while itself trying to establish new ground in the revival of craft, giving rise to the launch of the Crafts Council in 1972. The Arts and Crafts Movement exhibition that they organised at London's Victoria & Albert Museum the following year supported the production of one-off artefacts over mass-produced objects. The boundaries between art, craft and design became blurred, resulting in innovative cross-disciplinary activities. In addition, design consultancies began to emerge in response to the growth in other sectors such as retail.

Pentagram in London, founded in 1972, worked across the areas of graphics and product design offering a more integrated service to corporate clients such as British Rail and Kenwood.

Meanwhile, an anti-establishment youth movement dubbed "Punk", rooted in '60s pop culture, voiced its anti-taste aesthetic through fashion, graphics and music in pockets across Europe. Radical design took hold again in Italy in the form of the Alchimia design studio in Milan in 1976. Designers such as Alessandro Mendini, Michele de Lucchi (pp 92–93), Andrea Branzi and Ettore Sottsass felt liberated from the industrial stronghold of the previous decade. Rather than inventing new forms, the group applied ironic decorative surface treatments to exisiting classic objects, such as the furniture of the Bauhaus. Once again, the notion of "good design" was challenged. Spontaneous creativity positioned far away from the rigid rationale of Modernism was the flavour of the decade.

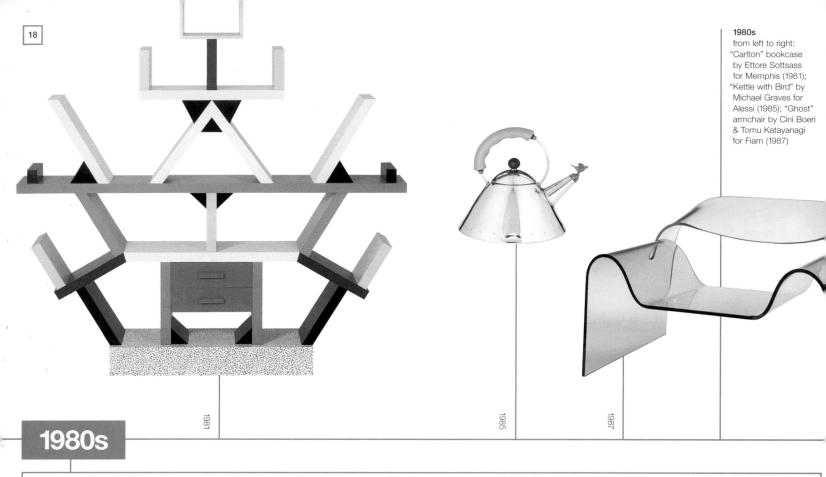

**1980s**
from left to right:
"Carlton" bookcase
by Ettore Sottsass
for Memphis (1981);
"Kettle with Bird" by
Michael Graves for
Alessi (1985); "Ghost"
armchair by Cini Boeri
& Tomu Katayanagi
for Fiam (1987)

1981

1985

1987

# 1980s

At the 1980 Venice Biennale, Alessandro Mendini (born 1931) and his associates in the Alchimia group showcased their collection of experimental furniture and objects under the banner "L'Oggetto Banale" (The Banal Object). The collective's ornate symbolism and ironic references to the past celebrated humour, eclecticism, spontaneity, decoration and colour, as part of a self-conscious mission to shake up the homogeneous principles of Modernism and address the cultural void that it perceived in mass, industrialised design. While Modernism had embraced uniformity as one of its principal characteristics, in the new Postmodernist era variety and pluralism became the key attributes. The mixing of craft with industry, and the combination of new and old techniques and materials, gave rise to a new period in which no one particular style was prevalent.

In 1981, one of Alchimia's members, Ettore Sottsass (born 1917), launched his own radical group, Memphis. This, unlike its predecessor, was a commercial venture, aimed at international markets. The first collection, titled "Memphis: The New International Style", directly referenced the conscious shift away from the regimented pretensions of "Good Design" in favour of a new style that operated on its own terms, adding vitality, humour and emotion through the use of bold colours, irregular forms, ornamented surfaces and diverse materials. Its principal members – Sottsass, Michele de Lucchi (born 1951; pp 92–93) and Andrea Branzi (born 1938) – invited international figures to join the group, including Michael Graves (born 1934) from the USA, Hans Hollein (born 1934) from Austria, Javier Mariscal (born 1950) from Spain, George Sowden (born 1942; pp 222–223) from England, and Shiro Kuramata (1934–1991) from Japan. A recurring feature of much of their work was surface decoration expressed with coloured or patterned laminates (developed with manufacturer Abet Laminati), a material favoured

for its lack of cultural identity. Function and cost were of limited concern to the group. Most pieces were handcrafted in small series, which sidelined the need for large industrial investment in tooling. While the Memphis aesthetic attracted a great deal of attention and was widely imitated, many critics regarded its creations as Postmodernist "conversation pieces" – fashionable and expensive distractions that would have no lasting impact. While Sottsass did indeed disband the group in 1988, during its short lifespan Memphis nevertheless successfully pushed the message of Postmodernism across the world and popularised the notion of "anti-design".

During the mid-1980s, many designers experimented with one-off or limited-edition designs that were markedly removed from the precision and constraints presented by standardised mass-produced goods. Working without the commercial pressures of clients and their markets,

designers such as Ron Arad (born 1951; pp 34–35) and Tom Dixon (born 1959; pp 96–97) produced experimental, expressive, yet functional art objects that often combined low technologies with brutalist forms.

Meanwhile, in contrast to the bold, extroverted exuberance of Memphis, a more restrained and mannered aesthetic style had emerged from the 1970s High-Tech period. This style, which became known as "Matt Black", combined a graphic, even geometric sculptural clarity with materials more closely aligned to production capabilities. Designs such as the "Tonietta" chair (1985) by Enzo Mari (born 1931; pp 162–163) for Zanotta or the "Seconda" chair (1982) by Mario Botta (born 1943) for Alias attempted to return to a more rationalist aesthetic. Technology-driven consumer electronic products, however, shifted towards a more humanised, user-friendly sensibility of softened contours and fluid ergonomics as industry attempted to ease in the introduction of the computerised era.

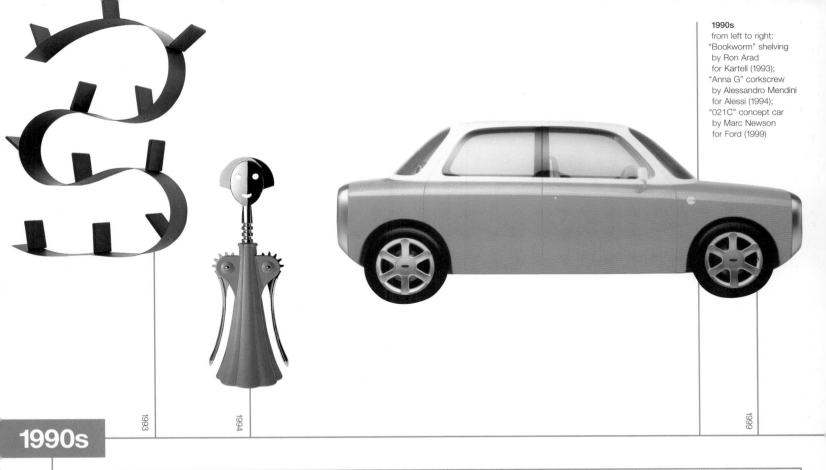

1993

1994

1999

# 1990s

By the late 1980s, visual impact and an obsession with novelty seemed to have overtaken the importance of intellect and content for many designers, who were benefiting from the booming and rather brash culture of conspicuous consumption that had emerged. Corresponding to this development was the growth of "designer" culture in which the reputations of individual designers were artificially hyped via the media. Predictions that this exuberant, credit-fuelled behaviour could not be sustained were confirmed with the outbreak of the Gulf War in the early 1990s. The ensuing global recession saw consumer confidence plummet and many businesses disappear with it.

As the supply to luxury markets dried up, designers had to very quickly reassess their previously privileged position within the market. They had been stung as the bubble of decadence burst, motivating many to rationalise and quieten their previously expressive and rather elite output. The antithesis

was in many cases quite literal – design proposals focused on the simplification of form, materials and their construction, presented with an austerity and practicality that would have seemed unimaginable a few years before.

Manufacturers caught onto this new cost-saving reductionist approach, steering product development towards a more universal, unobtrusive style that sidelined reference to specific cultures and therefore proved more suitable for export to global markets. This rather sombre and reserved style became a reflection of the depressed mood of the economy and consumer caution towards overt spending and ostentatious display. The antidote to the blatant greed and excesses of the 1980s was to focus on community, social awareness and environmental responsibility. Shamed by the antics of their predecessors, emerging designers sought to limit or reject consumption by applying their creative thought, for instance, to more mundane, often recycled, materials.

The proliferation of this idea was also evident in Holland with the founding of Droog Design by Gijs Bakker (born 1942; pp 40–41) and Renny Ramakers. The group applied the idea of reuse to produce ideas of a dry ironic wit, providing a refreshing antidote to the sterility of many of the products emerging from northern Italy's manufacturing community. Redefining the familiar, Tejo Remy (born 1960) turned milk bottles into lamps, and rags into chair upholstery, and, along with other Droog members, proved that simplicity didn't have to be boring. While minimalism became defined and self-conscious, Droog adopted a "non-design, no-style" approach to their collection. The 1980s had supported style without substance, but now ideas and the quality of innovative or quirky design solutions were the designer's prime commodity. The media's vast uptake of interest in contemporary design gave designers the promotional platform they needed to win the attention of the industry's commissioning powers.

Investment in one-off prototypes or batch-production idea-based products became the marketing tool for new designers of the 1990s.

Major top-end European producers survived the slump of the early 1990s by trading within a market segment that still demanded quality. As consumer confidence picked up in the mid-1990s, so, too, did the interiors market, as the buying public supported the "chuck out the chintz" message of reductionism. At the cheaper end of the market, the Swedish homewares giant IKEA saw huge worldwide growth supported by an optimistic yet financially aware youth market, while high-end producers in Italy and Germany fed the growing design retail and contract sectors with expensive desirables. By the late 1990s the mood of designers was one of profound optimism. Independent European designers steamed ahead with their own creations, identifying direct sales through limited self-production as their initial crucial – yet temporary – revenue stream.

**2000s**

from left to right:
"Spring" lounge chair
by Erwan Bouroullec
for Cappellini (2000);
"PET" water bottle
by Ross Lovegrove
for Ty Nant (2001);
"Fjord" armchair by
Patricia Urquiola
for Moroso (2002)

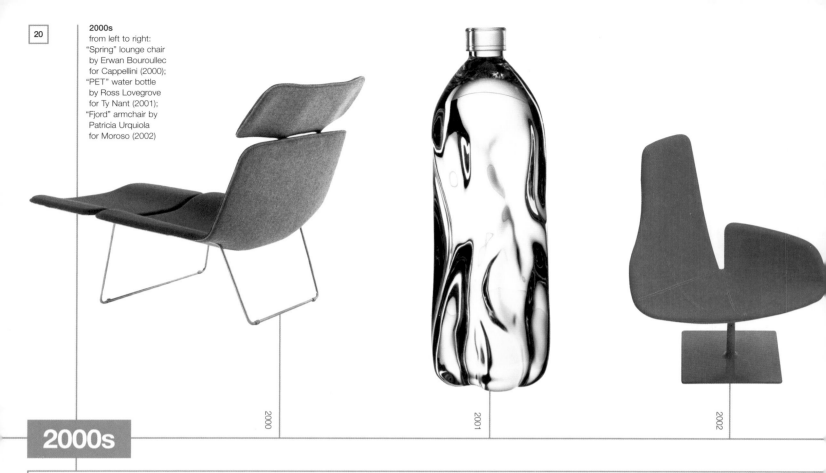

2000

2001

2002

## 2000s

Superstar designers of today such as Philippe Starck (born 1949; pp 224–225), Marc Newson (born 1963; pp 178–179), Jasper Morrison (born 1959; pp 174–175) and Ron Arad (born 1951; pp 34–35) all designed and produced their own works at some point in the 1980s. During this exuberant period, they independently built up international reputations that, by the 1990s, gained them the respect and the design briefs of major global manufacturers. Whilst the newer generation of talents were still nurturing the foundations of their careers, the "big-boy" designers were reaping the opportunities presented by companies prepared to invest in expensive tooling and processes. Thus, the production investment in a mass-market item such as Ron Arad's "Bookworm" shelving for Kartell in 1993 was a world away from the one-off self-production he had practised only a decade before.

With the stabilisation of the economy by the mid-90s, producers of furniture as well as entrepreneurs in charge of hotels, restaurants, bars and shops were back on the scene, commissioning hotshot designers to translate design into profit. The Postmodernist leap of the 1980s had given a green light to personal expression in design, resulting in individual designers attracting considerable attention from the expanding design press. The more stable Italian and German markets opted to introduce international "names" to their collections as a way of adding originality, identity and unique value to their brands amid the ever-encroaching global competition of a free-market economy. Gradually, a more mature and settled market, where practicality, accessibility and affordability were key so as to appeal to the everyday public and not just the avant-garde, came to replace the elitist offerings of the 1980s.

During the 1990s, when many independent new designers were working with low-tech materials and processes, the more established designers from around the world were embracing a shift into plastics. As a material, plastics had been used since the 1930s as a durable casing for items such as telephones and radios, growing in the 1960s to become a fun and disposable medium that embodied the pop culture of the moment. Since then, all sorts of plastics have been applied to all manners of goods, notably the consumer electronics designed in-house by large corporations. For the experimental individualists now facing the mass-impact opportunities of big business in the 1990s, the material presented huge potential for new design – with a little help from the computer.

Indeed, the progress of computer technology had moved significantly forward over the past few decades, as the artificial brain boxes first installed in offices decreased in size and cost and eventually entered ordinary homes. The sophistication of software advanced immeasurably, and designers were presented with the means of inventing previously unimaginable new forms via 3-D simulation and mapping programs. Virtual models could be built and viewed from all angles on the computer screen and their feasibility assessed. Several designers, most notably Ross Lovegrove (born 1958; pp 156–157) and Karim Rashid (born 1966; pp 208–9), came to see Computer Aided Design (CAD) as a powerful tool to build a new futuristic aesthetic style of curvilinear forms and tactile, ergonomic finishes – a modern-day redefinition of the organic design practised over fifty years earlier by the likes of Charles and Ray Eames and Eero Saarinen. Whilst the term "organic" is most commonly associated with nature and its materials, it is in fact plastic, and its application within numerous new industrial production techniques, that lends itself best to the demands of these sensual and comfortable shapes. In 2001, Lovegrove's most affordable and accessible example of his organic style

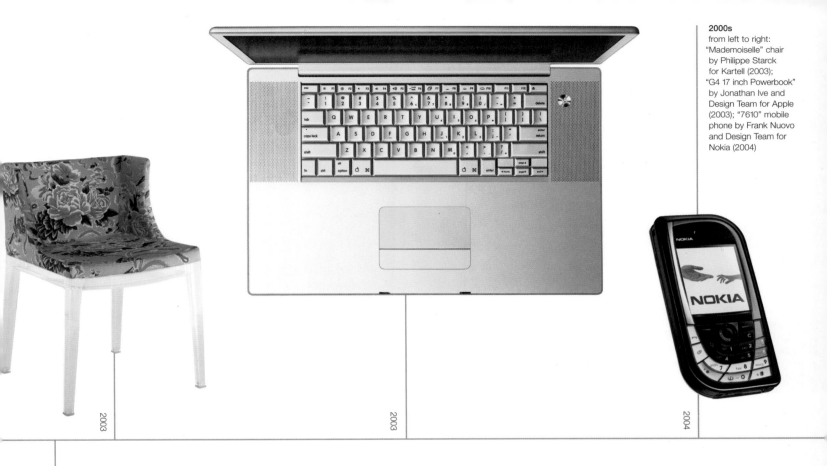

**2000s**
from left to right:
"Mademoiselle" chair
by Philippe Starck
for Kartell (2003);
"G4 17 inch Powerbook"
by Jonathan Ive and
Design Team for Apple
(2003); "7610" mobile
phone by Frank Nuovo
and Design Team for
Nokia (2004)

2003

2003

2004

was released in the form of his fluid-mimicking water bottle design for Ty Nant, with millions of units now sold internationally.

The computer became the new craft to be reckoned with in design. Amazingly, however, the external housing for this digital brain remained for many years rather bulky and unrefined – as if technological developments were so impressive and fast-paced that there was never time to address and resolve the appearance of the computer itself. Nondescript beige boxes dominated the market until the release of the iMac by Apple in 1998, which changed the status of computers, making them curvy, contoured, see-through, must-have plastic accessories available in various eye-catching candy colours. The computer went from being a tool that one would prefer to hide to an attractive object that one was proud to display.

In 1992, the Internet infiltrated computer society allowing businesses and individuals to communicate directly by email. Virtual online information about almost anything such as company services, history, travel times or news could be publicly accessed via individual website addresses on the World Wide Web. Today, this network facilitates the rapid exchange of information around the world between millions of users and has had the profound effect of both speeding up our lives and reducing our patience. Whilst global networking has changed the face of business exchange, it has also contributed to a belief that most international offerings are within easy reach, consequently making the world feel like a smaller place. Within the context of the design industry, this has meant that individuals contributing to a project can now be based in different places around the world.

Running parallel with the growth of the Internet was the mobile phone. The inevitable popularity of this revolution in communications saw mobile sales rocket, triggering fierce competition between phone manufacturers. During the 1990s and continuing today, Frank Nuovo (born 1961; pp 186–87) steered the creative direction of this must-have accessory for the Finnish mobile producer Nokia, turning the mobile into a stylish feature-ridden status symbol whilst always focusing carefully on the product's interface for ease of use.

Indeed, the proliferation of new products over the last ten years has witnessed extraordinary growth as global communication and ease of travel have facilitated more efficient trade between nations. In amongst a sea of badly made, substandard, restyled products are many gems that are packaged, promoted and instantly shipped around the world. Backed up by the profile-building stories of eager journalists, attractive or unusual products and their creators are hyped to iconic status amid a culture desperate to identify with and make celebrities of talented innovators.

In reaction to this, since the turn of the millennium, a design subculture has started to emerge that aims to combine nostalgic elements with the technology-driven realm of industrial production. For example, Dutch designer Marcel Wanders (born 1963; pp 238–239) has combined traditional crochet cotton with epoxy resin to create small stand-alone tables; Philippe Starck (pp 224–225) has upholstered mass-produced acrylic chairs with kitsch fabric designs and adapted Louis XIV style to twenty-first-century materials; and Tord Boontje (born 1968; pp 62–63) has invited images of nature back into the interior with ornate items that are produced by machine but which masquerade as handicraft. Whilst high-tech designers continue to work on simplifying interfaces for emerging and potentially confusing new technologies, more emotion- and concept-driven creatives attempt to pull in the reigns by pushing familiarity, eclecticism, individuality, comfort and customisation to the fore.

If the sizes of homes in urban centres are to shrink, what effect will this have on products as we know them today? Will there be room for large objects like sofas, televisions, and cabinets? Will this emphasise the need for modular furniture that can be configured differently according to the whims of the user? How would one deal with the issue of storing possessions and food?

Might local provisions stores act as sorting and storage centres for individual food orders delivered from out-of-town warehouses? Could integrated artificial intelligence devices in our homes detect, monitor and direct such orders with minimum intervention from the homeowner? Could the stores also act as a recycling centre for discarded packaging and waste?

As the world population continues to rise placing heightened demands on global resources, space, international relations, and our environment, will we act responsibly in the quest for innovation? Will the effects of human intervention on our natural habitat trigger a consumer backlash and a return to traditional values? Or can society achieve a balance between technological progression and established familiarity?

The production of food and products now takes place all over the world, with robust packaging a standard way of protecting merchandise or fresh produce from damage or contamination on long-haul shipping journeys. Once in the consumer's hands, the elaborate packaging is immediately deemed as waste and discarded. Whilst recycling schemes have accrued a rising number of followers and inroads have been made into the development of biodegradable packaging, will we witness the development of more packaging materials that, according to their application, will last for a specific amount of time before eventually disintegrating? Could containers for perishable items such as fruit, vegetables, meat, or milk be designed to break down shortly after the item's predicted life? Will packaging still perform the exterior representation of the product within or will customer purchasing decisions take place via virtual marketing presentations?

# future gazing

In what direction is the global community heading as the twenty-first century starts to unfold? The challenge of predicting what the future may hold is, of course, always a guessing game, though one based on past lessons and the current behavioural patterns of today's society. Merging past experience with an understanding of today's social climate may offer a glimpse of where we are heading, but ultimately people's expectations and desires shift constantly, diverting the predicted path.

That said, the mental journey into the unknown is invigorating territory for the imagination, as make-believe visions of what the world could be like start to unfurl in one's mind. One person's vision, of course, could be another person's nightmare, and when this reality is multiplied by the number of individuals living on this planet, one soon realises that the actual building of the future has to reveal itself as a gradual, gentle and responsible progression that remains sensitive to human beings' varying abilities to accept change. On the whole, progressive, life-enhancing change has always been embraced – in the twentieth century alone, the automobile, the aeroplane, the telephone and the computer are just a few examples of how humans have invited clever innovations into their everyday lives.

However, it is no longer acceptable to just go ahead and produce whatever material items we feel like without giving serious consideration to their purpose and value in society and the impact they will have on our ever-fragile environment. The heightened speed of progress in the twentieth century has exposed the negative changes it has inflicted on the once-healthy environment of our planet. We are beginning to wake up to the reality that even relatively localised and minor pollution brought about by such things as fuel emissions, toxic chemicals and other factors of industrial waste will be inherited by the whole world. Daily activities such as the use of aerosols, commuting in cars and discarding of waste collectively amounts to a myriad of problems, most notably the depletion of the ozone layer.

Often, such issues are swept under the carpet and left for future generations to consider, but this attitude is clearly not sustainable. It is human instinct to believe that one's tiny individual contribution to reform will not make an ounce of difference. The power and influence that governments and large corporations could wield, alongside niche groups and communities, to address concerns and translate these into effective action is yet to be unleashed. However, standing in the wings to implement intelligent solutions are the designers who are responsible for the shaping of our material environment.

Given that the global speed of progression is hard enough to control let alone curb, it is important that the overload of information and product that is already part of the developed world's daily existence is made more manageable and comprehensible. With the onslaught of more advanced technologies, together with their numerous applications and devices, it is crucial that companies should not allow their advancements to alienate the consumer. Too much choice can cause frustration, and subsequent confusion may result in eventual rejection. One way of avoiding such a situation is through the simplification of product interfaces to encourage users to feel familiar with a device and in control of all of its abilities. Designers such as Jonathan Ive (pp 136–137), Naoto Fukasawa (pp 108–109) and Sam Hecht (pp 122–123) have already demonstrated that visual purity and simplified portrayal of technical functions inspire confidence in the user and build emotional associations, consequently extending the lifespan of the product.

Optimising living
space and efficiency
in our ever-growing
densely-populated
urban centres.
**top right:**
"2020 Vision"
concept project
by Jam for Corus.
**bottom right:**
View into Microflats
designed by
London architects
Piercy Conner

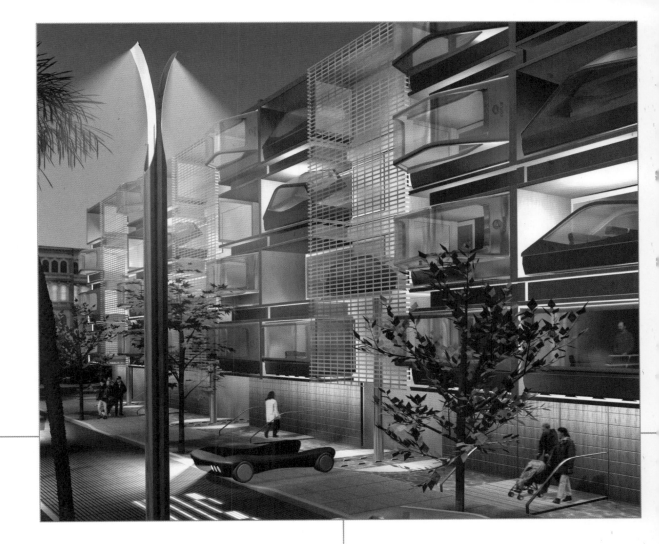

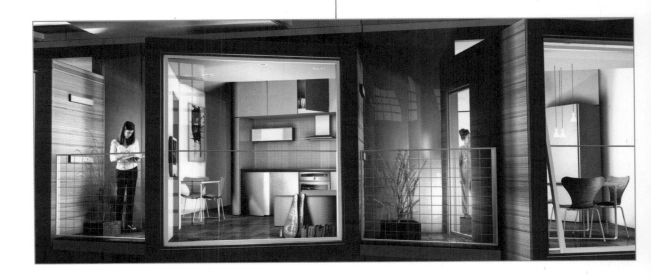

The widespread use of the internet has already considerably altered consumer buying patterns. Whereas previously trading hours dictated when one could shop, now we can shop online around the clock. Avoiding crowded shopping streets one can search for competitive pricing and pinpoint exact item requirements from the comfort of home. Books, music, gadgets, clothes, groceries, flights, and hotels represent just a fraction of the services and commodities available. Despite the convenience of online shopping, tactility, spontaneity, instantaneous satisfaction, and human contact have proved strong enough emotional reasons to keep high street shops alive.

Can we allow our cities to continue to sprawl into our valuable countryside? Is the answer to build more skyscrapers to house more people? If so, how would we achieve visual and social harmony amongst historical landmarks and conservation laws? Is the answer to make use of the quirky, unconventional available spaces left vacant in cities? Could we devise a more democratic distribution of space? Could we suspend tiny home extensions off the side of existing buildings like backpacks? Will prefabricated pods take up residency on available flat rooftops? Will the "Microflat" formula of small single-units catch on? Will this "shrink and stack" mentality constitute an acceptable compromise to the luxury of space? With the maturing of wireless communication technologies, might people abandon cities and move to the countryside where they can continue working remotely whilst retaining the comforts of a spacious home and peaceful surroundings? At a stretch of the imagination, might we one day have cities in the sky or towns below sea level, or will advances in private space travel eventually give rise to the development of new communities living on other planets altogether?

# future gazing

Growing consumer demands in the late twentieth century have contributed to a market in which overproduction and rapid product turnover are commonplace. Within the domain of electronics, for instance, ongoing technological advances make products almost obsolete as soon as they have been released. The fierce competition among brands to stay one step ahead of others has contributed to the emergence of a global throwaway culture, where product developments are about gradual improvements, rather than radical revolutions. The introduction of so much choice has spawned a generation of increasingly savvy consumers who are now looking very closely and critically for innovation, quality and life-enhancing solutions. However, the effects of immediate obsolescence are damaging – not least to the environment that bears the strain of our waste. The attitude of manufacturers constantly needs to be redressed as the world finally wakes up to the fact that the "here today, gone tomorrow" approach is unsustainable.

The day-to-day dealings of life already place enough strain on our precious personal time. Nowadays, people don't seem to have the time or patience to juggle the multitude of options presented to us at every turn, and this aggravation will continue to mount with time. Most people simply want technology to function so that that they are able to focus their energies on their work, social interaction, relaxation or personal space. Nuisances such as the incompatibility between the functions and features of differently branded electronic items such as home entertainment systems will become increasingly intolerable. The twentieth-century American adage that "bigger is better" is slowly being replaced with the opposite maxim, which prefers the miniaturisation of product accessories. Items such as audio systems, televisions, computers and appliances are increasingly being rejected as major features within our homes, their future lying in their subtle and efficient integration into domestic interiors.

As the magnet of opportunity continues to draw a growing population into our urban centres, it is no a surprise that space has emerged as a major premium. With limits set on where and how we can expand properties to accommodate more people, it is the role of architects, designers and town-planners to address the traditional notions of how we manage space in the future. For example, in their "2020 Vision" concept project for Corus, the London-based design consultancy Jam developed the idea that parked vehicles could be removed from our streets by detaching the vehicle body from its wheel base and storing the lightweight chassis on the side of the owner's apartment buildings (pictured, pp 23). While such a solution may seem extreme, it is not beyond the bounds of possibility that such a concept may be accepted as the norm in fifty years time.

Our traditional living values will change and evolve to suit modern lifestyle habits. For example, separate dining rooms have become decreasingly used spaces, as people choose instead a more integrated interaction between various household activities. The idea of cohabiting the functions of various rooms into one unified space is not new – as illustrated by the popular uptake of "loft living" in large open-plan renovated warehouse spaces over the last few decades. What is new, however, is the idea of taking this blueprint and reducing the luxury of physical space down to its essential components – so-called "micro-living". New urban developments that exploit this concept will consist of close-proximity singular living units with fully integrated wireless technology that controls and manages all of the services, appliances and utilities in the home and which can be operated from a central command device, rather like a mobile phone. This will become a crucial way of

**right:**
Artist Stefan Eberstadt's
plywood Rucksuck
Houses propose
the idea of prefabricated
housing extensions
hung from nylon
straps on the side of
an existing building.

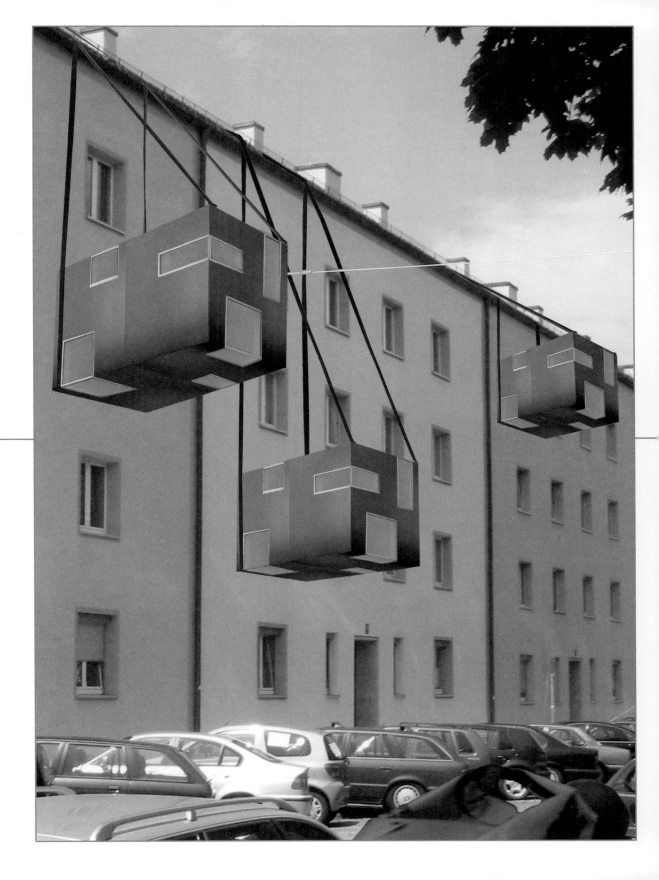

The research into new materials and synthetics evolves everyday and the scope for their application is immense. Already, functional electronics are being merged into clothes through advances in safe-to-touch electronic circuits, microchip memory power, and conductive fibres. Could mini flexible display screens integrated into the lining of a jacket allow us to watch the news or the latest football match whilst waiting to meet a friend? Could subtle embroidered buttons and switches enable us to make and receive phone calls from the sleeve of an overcoat? Will we be able to change the colour of synthetic textile materials to suit a whim? What new applications will advanced composites and artificially intelligent components herald? Such ongoing progressions continue to spell out new opportunities for the future.

How do we prevent the far-reaching assisting capabilities of technological devices from alienating humans from each other? Will easy access to mobile entertainment and information distract us from basic social needs and graces? Might the virtual reproduction of realistic environments replace such activities as field sports, holidays, or outings to the theatre? Or are expectations of such possibilities over-rated and over-hyped? It is the role of designers to identify inherent human emotion so as to implement products that enhance rather than replace the natural world. Homogenisation of society is a dangerous game that must never stagnate the richness of human cultural diversity.

# future gazing

ridding such small spaces, perhaps as tiny as 30 square metres, of the mess and clutter of wires, plugs and light switches. Indeed, this artificial-intelligence software will be able to respond to vocal commands through voice-recognition technology and carry out such requests as dimming the lights, switching on the oven, or running a bath to the desired temperature. The sophistication of such technology is still in its infancy but could evolve into the ultimate personal assistant at home. It could free up one's time by automatically looking after the more mundane tasks in life, such as ordering more food, regulating the room temperature, detecting your mood to alter the intensity of the lighting, or dropping the blinds when it starts to get dark outside. The data of one's personal preferences could be stored on a portable chip that could be plugged into hotel rooms, guest bedrooms or offices to continue its programmed assistance away from one's own home. As long as these new technologies always remain relevant to real humans, then time spent on the daily routines of life should be greatly reduced. Ultimately, artificial sources should effortlessly facilitate human interaction, not dominate our existence.

Needless to say, the installation of such a life-enhancing infrastructure would be a major undertaking in our quest to free up more private time for ourselves. Like space, time has become a premium – juggling the demands of work and play dominates a sizeable chunk of our time. The somewhat self-punishing mission to stay busy seems to have been triggered by the need to keep up with the speed of the progressive, computerised and accelerated world around us. Machines don't need a rest like we do. Human moments of calm, relaxation and privacy are heightened by familiarity, making our homes into a haven for personality, untouched by the outside world. Hiding technological devices will allow more space for more unusual, individual and perhaps traditional objects and possessions, crucially preserving the past and acknowledging heritage and established values.

The challenge will lie in achieving individual expression through universal solutions. Recognising our need to personalise possessions, manufacturers will increasingly offer the option to customise their products. Using several pre-set infrastructure designs, customers will be able to choose various add-on features such as the material, finish, colour and technical specifications. This data would be sent directly to the production facility and manufactured according to demand – a process known as mass-customisation that has been practised by the automotive industry for decades and is increasingly being adopted elsewhere.

The vast potential development of materials and production processes in the future is impossible to predict. The introduction of a totally new and unknown material could prove revolutionary for the production of a whole number of previously inconceivable products and applications. One only has to look at the effect plastics have had over a period of less than one hundred years since their inception. Already, Rapid Prototyping Technology (RPT) is able to produce objects on demand through a process that might best be described as three-dimensional printing. RPT is a term used to describe a range of processes that fabricate physical objects directly from CAD files. The data from the file is sent to the rapid prototyping machine, which then "builds" the object by beaming a laser into a chamber of raw material. The laser solidifies a small layer of material at a time, eventually giving form to an accurate 3-D design.

The memory capacity that tiny silicon and microchips are capable of storing is climbing dramatically year on year. Owing to their ever-shrinking size, these artificial brain banks can be

Advances in materials
and production
techniques continue
to provide designers
with new opportunities.
**right and far right:**
Surface Intelligent
Objects – a clock and
a table designed
by Sam Buxton using
electroluminescent
film to create active
intelligent surfaces
on familiar objects.
**bottom right:**
Detail of a lamp
designed by Dutch
designers Freedom
Of Creation, made
using the prototyping
process of selective
laser sintering (SLS).

What will become of the automobile? As the combustion engine continues to guzzle world oil reserves and pollute our atmosphere, what alternative fuels will power our private transport in the future? Will lightness and aerodynamics become the crucial components to aid fuel efficiency? Or will there be widespread implementation of hydrogen or hybrid power? With rising vehicle numbers contributing to congestion, will private automobiles become smaller or will we turn to more efficient and reliable communal travel options? Individuality, emotional connection, efficiency, and reliability will inevitably place pressure on car manufacturers for survival in a competitive market.

The mobile phone will evolve into much more that just a communication device. The miniaturisation of technology will permit huge memory capacity on tiny devices so that mobile phones will boast the intellect of a personal assistant. Whilst able to undertake the work-related jobs of existing computers, such hand-held devices will be programmable for the personal preferences of the owner. Televisions, printers, lighting and heating systems, ovens, or audio players will be compatible and controllable with one single mobile command device. This wireless technology, also known as Bluetooth, is already commercially available and starting to affect the traditional operation of machinery. Using a personal recognition code, a command device will be able to send a signal to any of your compatible machines to activate one or multiple functions. Imagine that in anticipation of your arrival home from work, you could preheat your oven, put the blinds down, alter the lighting, adjust the room temperature, and start playing your favourite music before you even step through the door. Imagine the next step when such actions are programmed to occur automatically without prompting.

# future gazing

embedded into textiles and linked to conductive fibres, embroidered switches, flexible displays and light-emitting polymers, enabling the performance of various functions within garments, such as the transport and display of data. A new type of illumination using flexible sheets of light made up of electrically charged phosphorescent layers on polymer foil is currently being implemented. The electroluminescent film is safe to touch and can be incorporated into clothing designs or used as back-lighting for displays and control panels. Advanced composites, nature-mimicking materials, and intelligent sensory materials that interact and change under specific circumstances are just a handful of the likely progressions in the future of design production.

All of these potential developments in the future of our material world have been made on the assumption that the planet is capable of providing the seemingly infinite supply of natural resources that are needed to sustain such a vision. The rate of consumption is already unimaginably high, and a wider public is now recognising that we have a responsibility to regulate advancements, prioritise our needs, rationalise our demands and reuse or recycle the waste that we discard each day. Alongside production industries, transportation is one of the biggest polluters, currently spewing out fuel emissions in shocking quantities that significantly damage the ozone layer, contaminating the atmosphere and triggering a long list of loosely identified health problems. Changes in attitude are gradual but not invisible – many of the major manufacturing brands in the automotive industry are investing in the search for greener alternative fuels that reduce or eliminate the drain on natural reserves. In the future, designers and producers must consider not only the birth of a product but also its eventual grave, and predict its potential effects.

Beyond science and fact, one of the hardest factors to predict is humankind itself. Speculation can only accommodate what could happen should global or at least national communities be united along the same line of thinking. The likelihood of achieving such unity of minds is low when one considers the power and conviction of individual emotional preferences and factors such as generation divides, cultural diversity and financial standing. Whilst technological predictions may spell out value through innovation, there are a number of potentially crippling real-world variables that could trip up such progression, such as social needs, commercial viability, international governmental policies and standards, and reliance on other industries and technologies to facilitate its widespread acceptance. Countries need to reveal and share their research results, combining knowledge without exclusivity and deprivation. Such co-operation may help prevent the divide between the developing countries and the developed world growing any wider than it has already become.

Above all, we have to wonder whether the consumer really is prepared to pay for any such new development proposals. Are people ready for the changes such advances may herald? Can manufacturers be confident that their sizeable investments into research, development and production will be recoverable and ultimately bear the fruits of commercial prosperity? How far are governments prepared to guide, encourage or restrict advancements? Will the benefits presented by technology continue to supersede eco-friendliness in importance? And will consumers genuinely support the efforts of well-intentioned companies?

Needless to say, the answers to such questions will be determined by the prevailing attitudes of individuals and societies. After all, it is social acceptability, not technology, which will determine the future.

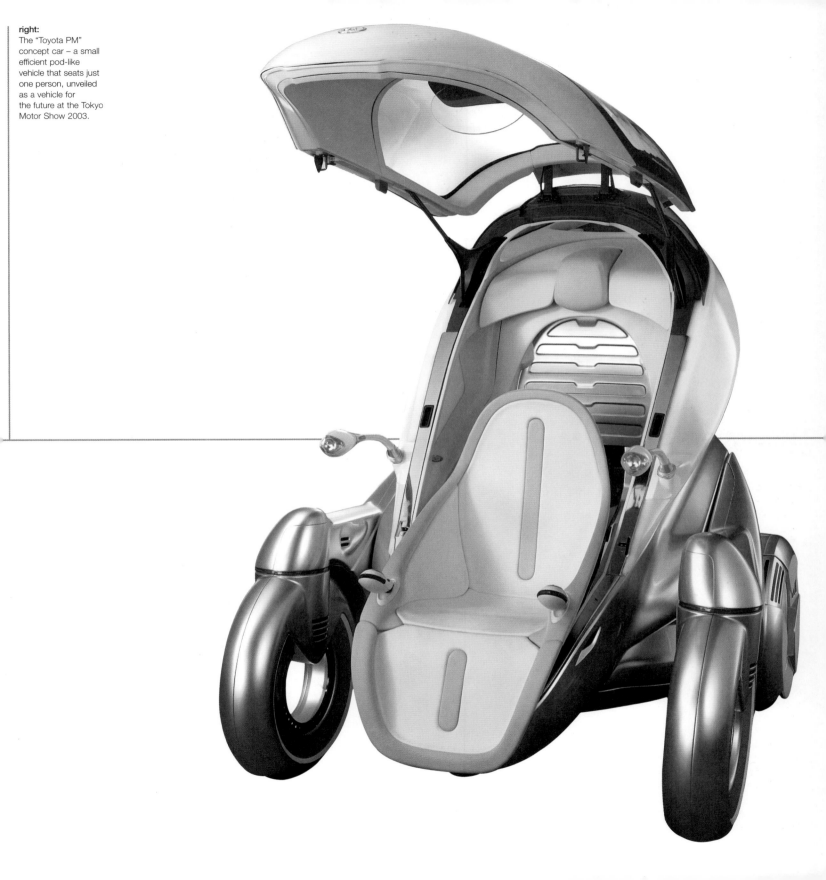

**right:**
The "Toyota PM" concept car – a small efficient pod-like vehicle that seats just one person, unveiled as a vehicle for the future at the Tokyo Motor Show 2003.

**designers**

## Werner Aisslinger
born 1964 in Nördlingen, Germany
**Studio Location**
Berlin, Germany

After graduating in Industrial Design from the Hochschule der Künste in Berlin, Werner Aisslinger gained valuable experience working from 1989 to 1992 as a freelancer in the studios of Jasper Morrison (pp 174–175), Ron Arad (pp 34–35) and Michele de Lucchi.

In 1993, he opened Studio Aisslinger in Berlin, where he has since been developing 3-D projects.

Aisslinger has designed several easily assembled modular storage systems. The first was the instant bestseller and award-winning "Endless Shelf" (1994), made from aluminium joints and wooden and plastic boards.

A desire to exploit technology and material innovations resonates through many of Aisslinger's designs. His "Juli"

chair (1996) for Cappellini employed a new material, polyurethane foam, to form a slightly soft and flexible yet durable structure. A few years later, he applied Technogel – a soft material normally used in the operating room – to furniture. Most recently, he developed a low-cost air-moulded chair for Magis using gas-injection plastic technology.

In 1998, he became Professor of Product Design at the Staatliche Hochschule für Gestaltung, Karlsruhe.

**My inspiration**
Manufacturing visionary Eugenio Perazza of Magis, whose company continually speaks the language of design innovation

## werner aisslinger

**D**

**Q. What types of products do you design?**

A. I have been designing quite a lot of domestic and office furniture in the last few years, some very technology-oriented, combined with research into the application of materials such as Technogel and air-moulding.

I like to work with modular systems, so half of my furniture designs are systematic, "Lego"-type projects. Recently I started becoming involved in smaller products such as tableware and glassware, while also working on a larger scale with architecture and modular housing.

**Q. What or who has been of significant influence in your studio?**

A. Significant for me in my earlier years were my collaborations with some of the most innovative companies in Europe represented by design

pioneers like Giulio Cappellini (Cappellini) or Eugenio Perazza (Magis) and, later on, high-end industrialised producers such as Interlübke in Germany.

Internally, the studio has been, and continues to be, under the permanent influence of the designers working with me. In terms of places, I think my inspiration comes from travelling on the one hand, and the impact of Berlin – a very chaotic and young city – on the other.

**Q. What was your big break?**

A. The "Juli" chair I designed for Cappellini in 1996, which was selected for the permanent collection at the Museum of Modern Art in New York in 1998.

**Q. What elements of the design process do you find particularly frustrating?**

A. First, not spending enough time on really designing because communication absorbs more and more time. Second, I have witnessed a change in industry and company culture. Managers change so fast inside larger corporations that one deals with too many different people during the development process. The ultimate partner for a designer used to be the personality-driven CEO, the ambitious company owner or the enthusiastic and risk-taking entrepreneur, but they are vanishing species. Increasingly, you have to deal with short-term managers who see design as a tool to generate profit without passion.

**Q. To what level will you compromise to satisfy your client?**

A. You can reduce the need to compromise by working with the

right client, by selecting those to whom you really want to commit your energy.

Within the design process, I would never make aesthetic compromises, but in terms of production, you have to accept that technologies or materials sometimes force changes onto a concept.

Basically, I divide projects into two groups – the more market-oriented ones that generate economic profit for the studio and then the more experimental ones that need longer research phases, independent of any client. I try to balance the two groups – both inspire the other.

**Q. What do you still aspire to design?**

A. Products or architecture on any scale and of any complexity that use the latest technologies and materials.

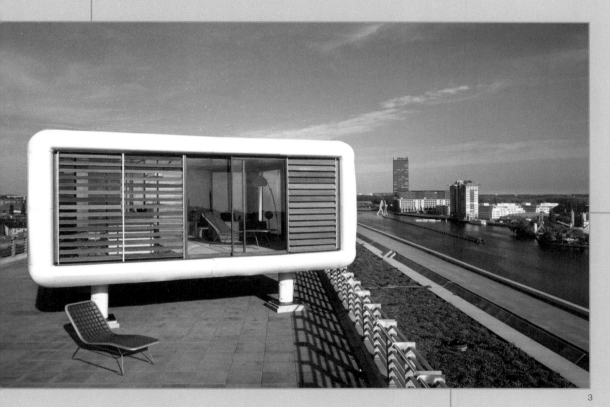

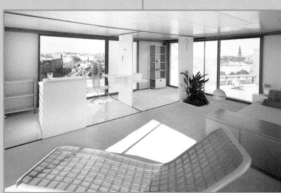

**Ron Arad**
born 1951 in Tel Aviv, Israel
**Studio Location**
London, UK

In the early years of the 1970s, Ron Arad studied at the Academy of Art in Jerusalem before moving to London in 1973 when he took up a place to study architecture under the guidance of Peter Cook at the Architectural Association (AA), graduating in 1979. Two years later, he founded One Off Ltd in London with Caroline Thorman, a design studio, workshop, and showroom in Covent Garden. The proliferation of the High-Tech movement in the mid-80s inspired the use of salvaged industrial materials such as scaffolding poles and car seats, as illustrated with his "Rover" chair of 1981.

Towards the late '80s, he was making a name for himself in the realm of art furniture, manipulating mild steel sheets into organic, sculptural new forms for furniture using rather labour-intensive production techniques. Despite the contrast of his work to that of the mass-produced, he nonetheless began to attract the attention of major industrial manufacturers at the start of the '90s. Subsequently, his fascination with materials and processes has been applied to a wide variety of three-dimensional production pieces that have been included in museum collections and galleries around the world – the "Bookworm" shelving for Kartell and the "Tom Vac" chair for Vitra demonstrating significant commercial success. In 1994, he founded the Ron Arad Studio design and production unit in Como, Italy, where he continues with his limited edition designs, whilst his practice, Ron Arad Associates, takes on interior and architecture commissions. He is Professor of Design Products at the Royal College of Arts in London.

**My inspiration**
Everything that has been done before

GB

ron arad

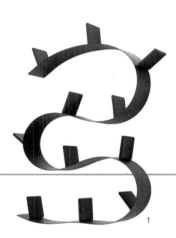

1

**Q. What types of products do you design?**
A. I design very small things like bar equipment for Alessi, and also very big things like a hotel on the roof of Battersea Power Station in London. There are numerous other creations that fit in between the two, like furniture, lighting, sculptures, installations and further interior and architecture projects etc.

**Q. What or who has been of significant influence on your work as a whole?**
A. Everything that was done before now. My favourites change from day to day.

**Q. What was your big break?**
A. Probably the "nouvelles tendances" exhibition in the Pompidou Centre in Paris.

**Q. What human emotions and necessities drive your designs?**
A. All six of them.

**Q. How important are trends in your work?**
A. It is nice to create trends and then run away from them.

**Q. How important is it for your work to reflect the design characteristics of your nation?**
A. Not at all.

**Q. Is your work an individual statement or a team solution?**
A. An idyllic combination of both. I talk as I work, and I talk about design with colleagues, some more intimately than others. Ultimately, the end result has to come from within.

**Q. What elements of the design process do you find particularly frustrating?**
A. It's the time between design and realisation that can be held up by any number of technical errors and human interference.

**Q. To what level will you compromise to satisfy your client?**
A. To the point when a project risks losing its raison d'etre, although I try to prevent it from ever going that far.

**Q. What would be your second career choice after design?**
A. Break dancing.

**Q. What do you still aspire to design?**
A. Everything in the world that still needs designing but excluding weapons. The world is awash with problems that need addressing, opening many opportunities in which to create exciting new solutions.

**Q. How would you sum up your design approach?**
A. There are all sorts of discussions and interests going on at the same time, interests shift from one day to the next. When you look back you can see there is often a single thread.

**Q. What do you try to avoid?**
A. I'm afraid of boredom, fundamentalists and philistines. I'm afraid of the dark and of death. I try to avoid all of these things.

**Q. Can you give an example of one of your greatest architectural experiences?**
A. I designed the foyer of the Tel Aviv Opera House (1988–1994), comprising a series of autonomous structures each performing a different function, creating a new spatial quality amongst themselves and within the main building.

**Client list**
Alessi
**Artemide**
Cappellini
**Cassina**
Draenert
**Driade**
Fiam
**Hidden**
Kartell
**Moroso**
Poltronova
**Vitra**
Also self-production

**My work**
1. "Bookworm" shelving
   for Kartell (1993)
2. "Three Skin Chair"
   for Moroso (2004)
3. "Oh Void" chair
   in collaboration
   with DuPont (2004)
4. "Low-Res-Dolores-
   tabula-rasa" table
   in collaboration
   with DuPont (2004)
5. "Lolita" chandelier
   for Swarovski (2004)

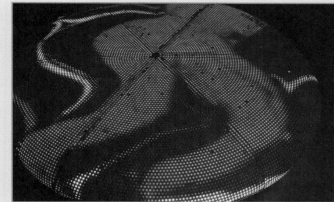

4

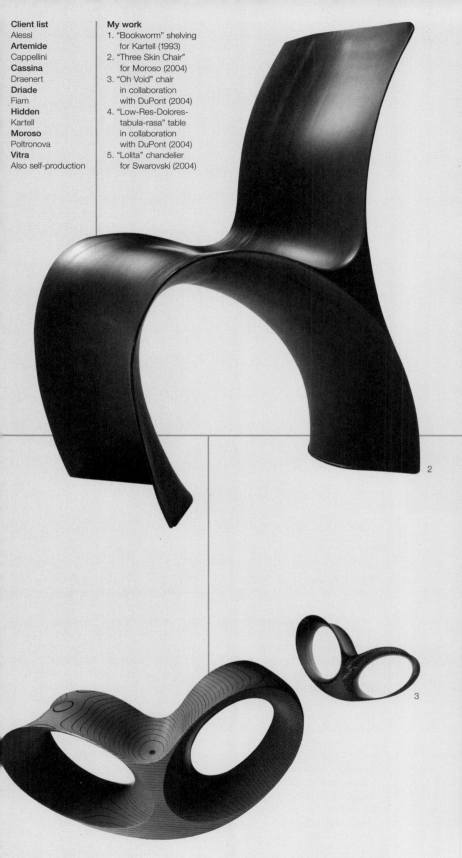

2

3

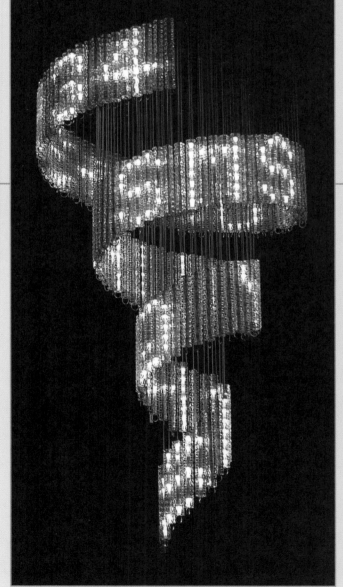

5

**Shin Azumi**
born 1965 in Kobe, Japan
**Tomoko Azumi**
born 1966 in Hiroshima, Japan
**Studio Location**
London, UK

Husband-and-wife partnership Shin and Tomoko Azumi met each other in 1985 during their first year of design studies at Kyoto City University of Art in Japan. On completing the course in 1989, they both gained professional experience in Tokyo – Shin in the personal-computers department of NEC, and Tomoko at various architectural practices. In 1992, they moved to London to commence postgraduate studies – in Industrial Design and Furniture Design respectively – at the Royal College of Art. The couple founded their London-based design studio, AZUMI, in 1995.

Since then, they have produced a number of projects that have quietly caught the attention of the design industry through their combination of formal simplicity, wit and multi-functionality. The reduced sculptural shapes of the "Snowman" salt and pepper shakers (1999) for Authentics – given a playful, figurative twist by the positioning of the small holes in the shakers – is a good example.

The Azumis strive to combine functionality with elegant, tactile materiality, with designs emerging from the observation of daily life. The result is designs that surprise and enchant, as well as enhancing life with touches of theatrical or figurative individuality.

From their London base, this award-winning couple continue to expand their product portfolio and are currently broadening their activities into exhibition and interior design, and architecture.

**Our inspiration**
The sculptural simplicity of ancient Japanese figures, such as this 4th-century ceramic Haniwa horse

**shin + tomoko azumi**

**GB**

1

**Q. What types of products do you design?**
A. We design all kinds of products including furniture, household goods, interior accessories and electric objects, but we also do spatial design.

**Q. What do you think have been the key influences on your work?**
A. First, animation films – especially those of the Canadian animator Norman McLaren, a real master of the art. What we appreciate was the way he combined meticulous planning with wild improvisation, entertainment with experimentation – we know how difficult it is to keep a good balance between these elements.

Second, ethnology – an area we have always been interested in. We've been deeply influenced by Barnard Rudofski's Architecture without Architect. Rudofski encouraged us to look at ordinary objects from fresh angles, as well as to travel the world to see the variety of ways in which people live.

A third influence has been archaeology and especially haniwa – ceramic figures made in ancient Japan. We like their simplicity and spontaneity. And last, we are influenced by the theatre and stage work, in particular that of the Canadian director Robert Lepage. What we like about Lepage is his mastery of visual illusionism; his use of a limited space in a maximised way; the way he introduces the unusual and unexpected.

**Q. What was your big break?**
A. When we decided to collaborate.

**Q. Which human emotions do you think underpin your designs?**
A. Smile: we feel very happy when people smile when they see our designs. Instinct: we try to be faithful to our instincts. Frustration: thinking about how to release people from their frustrations is often a key to developing new ideas.

**Q. What role do trends play in your work?**
A. We always try to design a product that will survive through decades, whatever the trends.

**Q. Do you think your work has been influenced by a specifically Japanese tradition of design?**
A. In a way we belong to two nations – Japan and Britain – but what's important to us is what we can share with people from other cultural backgrounds, rather than somehow representing a nation.

**Q. Are there any aspects of the design process which you find particularly frustrating?**
A. The whole thing is frustrating, but we enjoy those frustrations!

**Q. To what degree are you willing to compromise to satisfy your client?**
A. Instead of compromising, we try to find out a better solution for both parties.

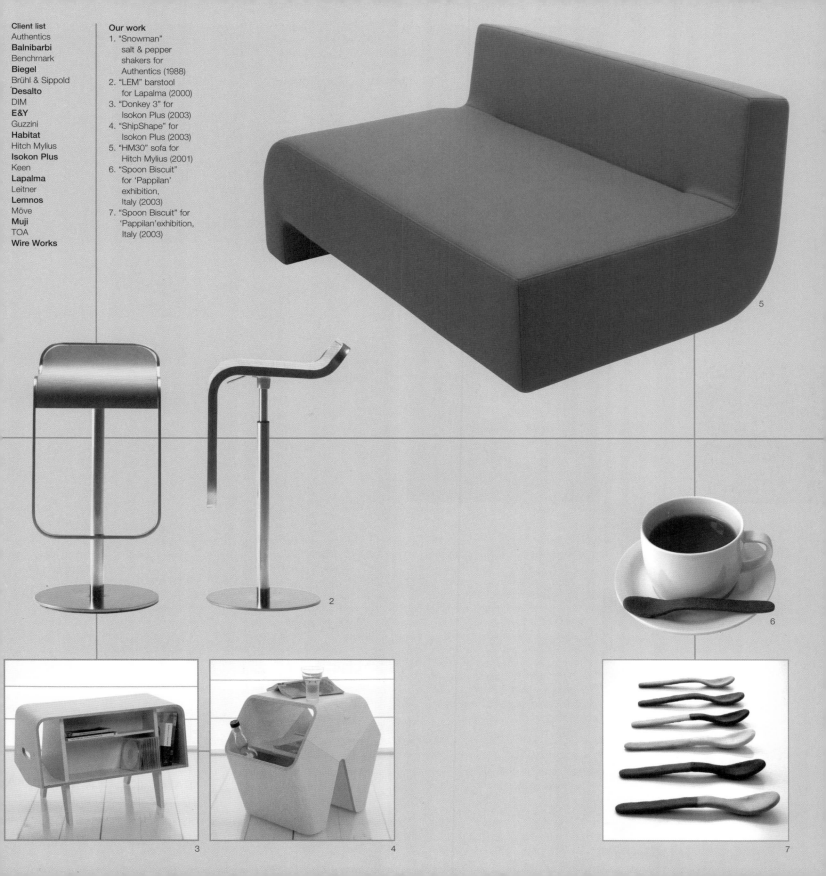

**Client list**
Authentics
**Balnibarbi**
Benchmark
**Biegel**
Brühl & Sippold
**Desalto**
DIM
**E&Y**
Guzzini
**Habitat**
Hitch Mylius
**Isokon Plus**
Keen
**Lapalma**
Leitner
**Lemnos**
Möve
**Muji**
TOA
**Wire Works**

**Our work**
1. "Snowman"
   salt & pepper
   shakers for
   Authentics (1988)
2. "LEM" barstool
   for Lapalma (2000)
3. "Donkey 3" for
   Isokon Plus (2003)
4. "ShipShape" for
   Isokon Plus (2003)
5. "HM30" sofa for
   Hitch Mylius (2001)
6. "Spoon Biscuit"
   for 'Pappilan'
   exhibition,
   Italy (2003)
7. "Spoon Biscuit" for
   'Pappilan'exhibition,
   Italy (2003)

**Emmanuel Babled**
born 1967 in France
**Studio Location**
Milan, Italy

Emmanuel Babled graduated in Industrial Design from the Instituto Europeo di Design in Milan in 1989, and he has, by and large, made the city his home ever since.

After a few initial jobs in art direction, Babled turned his attention to glass design, producing pieces for celebrated producers such as Venini, Wedgwood and Waterford Crystal.

In 1995, he designed a collection for the Japanese design company Idée, which bought him international attention. Subsequently he has also developed partnerships with other respected producers, including Rosenthal, Baccarat and Covo.

Often featuring bulbous forms, bright colours or bold patterning, Babled's fluid glass pieces show the designer's rapturous delight in the medium and his continued commitment to experimentation. Among the most spectacular of his recent creations has been the "Hypnos" collection (2002) of vases, bowls and clocks for Baccarat, in which he set exquisite cut crystal into coloured Corian to create highly contemporary yet timeless pieces.

Babled maintains his creative freedom by producing independent limited series of glass and ceramic pieces alongside his consultancy work for private clients and companies, which encompasses not only glass but interior and product design.

In addition, he has curated many exhibitions and events, notably the successful "SMASH" travelling glass exhibition for Covo in 2001.

**My inspiration**
Amongst other great masters, the harmony, grace, and elegant clarity of Oscar Niemeyer's architectural repertoire

**emmanuel babled**

---

**Q. What types of products do you design?**

A. I design objects connected to the decorative arts, from the functional to the emotional, using high-quality craft techniques as well as mass-production processes based on high technology.

**Q. What or who has been a significant influence on your work?**

A. I grew up in the 1970s, and I was deeply impressed by some of the design feel of that decade – the powerful graphic impact of things like wallpaper and moquette carpets and fabrics vis-à-vis the use of optical effects and strong colours like orange, purple and green. Then, of course, I've been influenced by great artists, architects and designers, like Verner Panton, Andy Warhol, Arne Jacobsen, Oscar Niemeyer, Alvar Aalto, to give just a few examples…

**Q. What was your big break?**

A. My first contact with Venini in Venice in 1992, and my first glass exhibition for Idée in Tokyo in 1995.

**Q. What human emotions and necessities drive your designs?**

A. Happiness, modernity and freedom.

**Q. How important are trends in your work?**

A. Trends are by definition an already "recognised sign of our time" and I'm more excited by discovering new things.

**Q. How important is it for your work to reflect a national design characteristic?**

A. I was born French; I have been living in Italy for almost 20 years; my wife is Dutch and my children have different cultural backgrounds. They really don't know where they come from or where they belong, and they really don't care either… I don't think nationality is an important question.

**Q. Is your work an individual statement or a team solution?**

A. I'm used to working with a lot of different people according to the kind of job I'm doing… In the end, though, I'm the one who's responsible, so, in that sense, it's a personal statement. Of course, on other occasions… I need to work with a well-organised and specialised team.

**Q. What elements of the design process do you find particularly frustrating?**

A. My work is about playing and using all the relevant elements of the design process in order to avoid any frustration that might damage the final result.

**Q. To what level will you compromise to satisfy your client?**

A. I don't really see it as a question of "compromising". If you work with a client, it is because both parties have chosen to work with one another, which indirectly means that you agree with the rules of the game.

**Q. What do you still aspire to design?**

A. The list of my aspirations would be much longer than the list of what I've done so far…

**Q. How would you sum up your design approach?**

A. Listening and watching; analysing and trying; solving and enjoying.

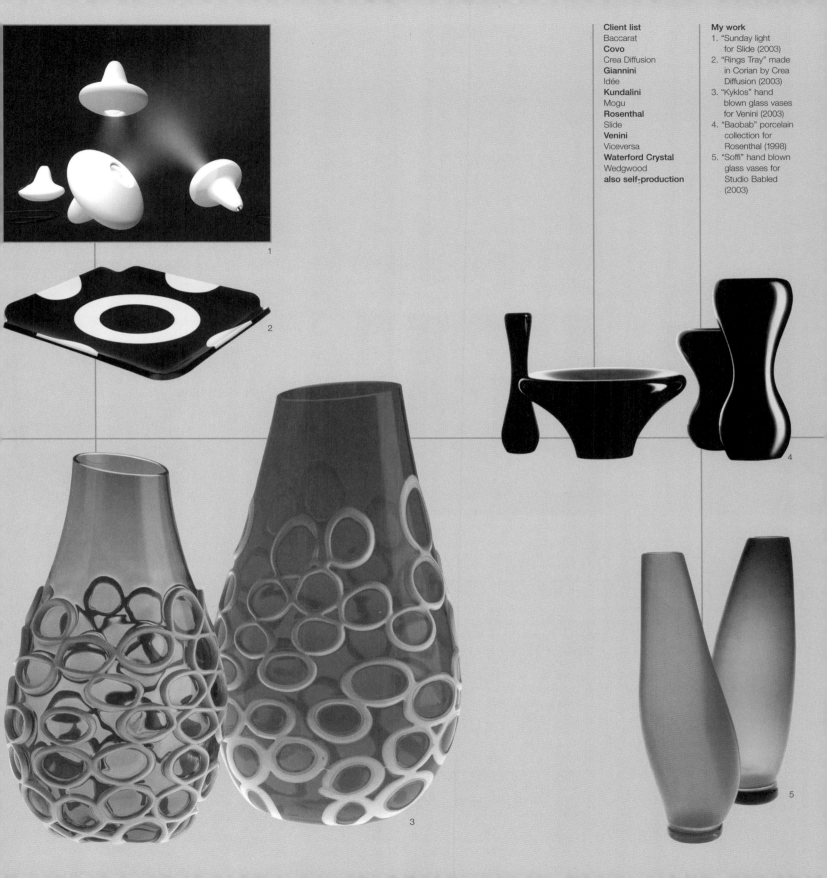

1

2

3

4

5

**Gijs Bakker**
born 1942 in Amersfoort, Netherlands
**Studio Location**
Amsterdam, Netherlands

Gijs Bakker studied Jewellery and Industrial Design in Amsterdam and Stockholm between 1958 and 1963, after which he spent a few years as a designer for Van Kempen & Begeer. In 1966, he married Emmy van Leersum (1930–84) and opened a jewellery workshop with her in Utrecht.

Since then, Bakker has undertaken commissions as a freelance designer for the likes of Polaroid, Castelijn, Artifort and Artimeta, as well as lecturing at various institutions such the Technishe Universiteit Delft and the Design Academy, Eindhoven, both in the Netherlands.

Bakker is probably best known as the co-founder, together with the design historian Renny Ramakers, of leading Dutch group Droog Design, which was launched to great acclaim during the Milan Furniture Fair in 1993. Droog, which means "dry", challenges the design industry's subservience to the demand for constant novelty, and instead explores the potential presented by the redefinition of existing objects and ideas. Bakker and Ramakers select creations not only by their Dutch contemporaries but also from around the world, basing their choice on intuition rather than any preset criteria. The duo also coordinates the Droog "family" of designers to take part in projects with leading manufacturers such as Rosenthal, Mandarina Duck and Levi's.

In 1996, Bakker revived his roots in jewellery when he co-founded, with Marijke Vallanzasca, the Chi ha paura...? foundation, which commissions jewellery from international designers.

Bakker continues to channel his energies into Droog, while staging exhibitions, lectures and workshops all over the world.

**My inspiration**
The structural honesty and simplicity of these bowls by Bruno Munari, which I discovered by chance early in my career

gijs bakker

NL

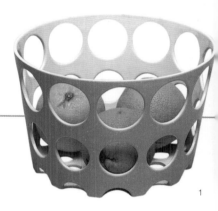

1

**Q. What types of products do you design?**
A. Furniture, hollow ware, jewellery, street furniture, lighting.

**Q. What or who has been of significant influence in your studio?**
A. In 1964, I was hitchhiking through the south of Italy when I saw Bruno Munari's bowl, consisting of a single square sheet of alpaca, in a shop window. By cutting into the square, folding it and fixing it at the edges by point-welding, Munari had created a three-dimensional form. The simplicity and effectiveness of this principle made an indelible impression on me. I sold my camera to be able to afford this beautiful little miracle.

**Q. What was your big break?**
A. In 1967, when I showed my "objects to wear" at the Stedelijk Museum in Amsterdam; in 1974, when I designed the "Strip Chair" for the Dutch manufacturer Castelijn; and in 1993, when I founded Droog Design together with Renny Ramakers.

**Q. What human emotions and necessities drive your designs?**
A. I think through my work (design). Everything I do, see and read contributes to my work.

**Q. How important are trends in your work?**
A. I make my own trends!

**Q. How important is it for your work to reflect Dutch design characteristics?**
A. Although we think and live globally, I am very aware of my background and the way I have grown up... Our long democratic history helped make me an independent thinker. This small country gave me a sense of irony and a desire not to show off, things that are reflected in my work.

**Q. What elements of the design process do you find particularly frustrating?**
A. Working for an industry without any culture.

**Q. To what level will you compromise to satisfy your client?**
A. I don't use the word "compromise". It's a question of investigating alongside technicians and coming up with intelligent solutions.

**Q. What would be your second career choice after design?**
A. The only thing I could do was drawing; that's what my parents told me when I was young.

**Q. What do you still aspire to design?**
A. Together with Droog Design I want to design a car. It will be a car designed to suit our mentality, in which every feature will be turned on its head – speed, for instance, becoming slow, and hard becoming soft, and so on.

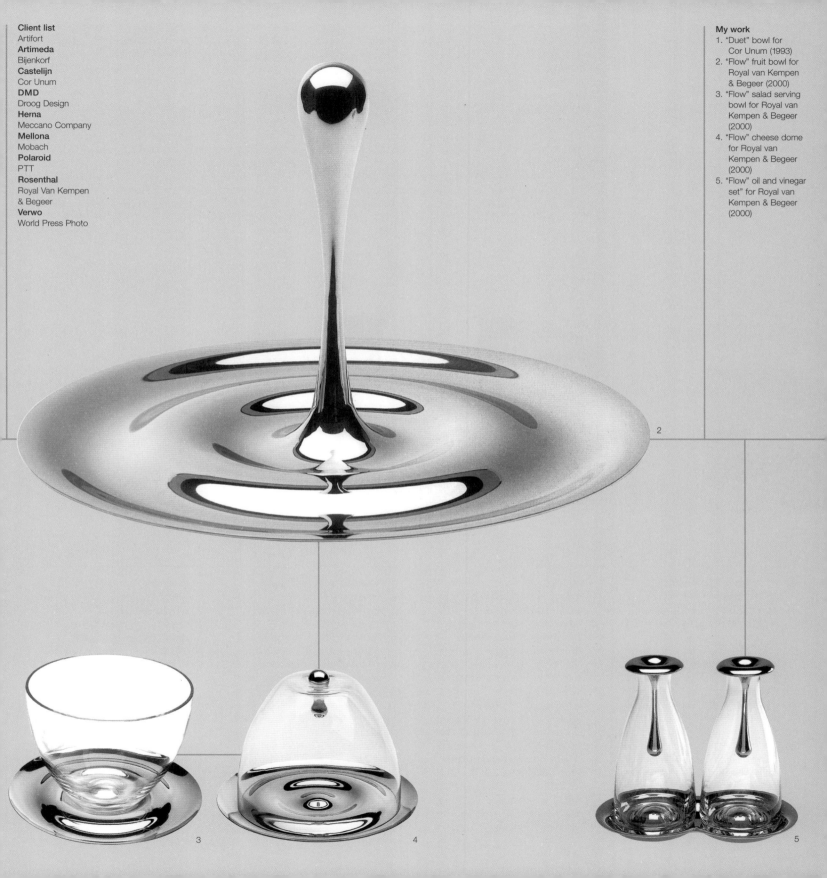

**Edward Barber**
born 1969 in Shrewsbury, UK
**Jay Osgerby**
born 1969 in Oxford, UK
**Studio Location**
London, England

Edward Barber and Jay Osgerby met while at London's Royal College of Art. They formed Barber Osgerby in 1996 and in the same year designed the "Loop" table, which was widely showcased and brought them to the attention of the Italian producer Guilio Cappellini, beginning a long working relationship. This iconic design is now in the permanent collections of the Victoria and Albert Museum, London, and the Metropolitan Museum of Art, New York.

Since then, Barber Osgerby has been developing a variety of interior products for leading manufacturers and clients. They have exhibited products and installation projects internationally and can boast a number of prestigious design awards. They have also been involved in conceptual projects for companies such as Dornbracht (bathrooms) and Abet Laminati (flooring), and in the LOSA project, sharing expertise, skills and ideas with community craftspeople in South Africa.

In July 2001, Edward and Jay formed Universal Design Studio, a multi-disciplinary company specialising in architectural, industrial design and interior projects for clients including Damien Hirst, Stella McCartney, Paul Smith and Selfridges.

**Our inspiration**
The "non-aesthetic" and meticulously calculated precision of nautical and aeronautical details such as this aircraft wing

**barber osgerby**

**GB**

**Q. What types of products do you design?**

A. We work on a broad spectrum of projects – from industrial design, such as bathroom products, coat hangers and drinks bottles, through to furniture, conceptual projects and interiors.

**Q. What was your big turning point?**

A. The "Loop" table was the first piece of furniture that we designed and put into production. Originally produced in the UK by Isokon Plus, it was spotted by Giulio Cappellini in 1997 and included in Cappellini's showcase in Milan the following April. That established a regular working relationship with Cappellini, leading to us to design several more pieces for him, and indirectly leading to subsequent projects for other manufacturers.

**Q. What have been the biggest influences in your studio?**

A. The rigorous designs of strictly functional objects in nautical and aeronautical design are truly inspiring, for example the hull of a boat or the details of an aeroplane wing. Often the elements of design that are not meant to be aesthetically judged are the most interesting.

**Q. What kind of emotions drive your designs?**

A. As a designer there is something in-built that makes you need to create things and explore new ideas, concepts and forms. You have to be passionate about your work and experiment a lot.

**Q. How important are trends in your work?**

A. The word "trend" implies a transiency that we try to avoid.

**Q. Is your work an individual statement or a team solution?**

A. One of us will put forward an idea, and the other one will react to the idea and possibly change the direction completely. The idea goes back and forth between us, and so the process begins. This is how we work – using a process of tacking through which the design evolves. The definitive sketches that result from this become models and then prototypes. This dialogue continues even after a product has left the production line. A project is never mentally left alone.

**Q. Are you frustrated by any aspects of the design process?**

A. The balance of timing. You need to spend a lot of time with a project after it has been conceived to reflect on it, allowing yourself time to tweak and perfect it. But when it has reached the point when you want it to go ahead, it may take years before it reaches production.

**Q. Are you willing to compromise to satisfy your client?**

A. We are fortunate that most of our clients have a strong understanding of our work, approach and philosophy, so compromises are not necessary.

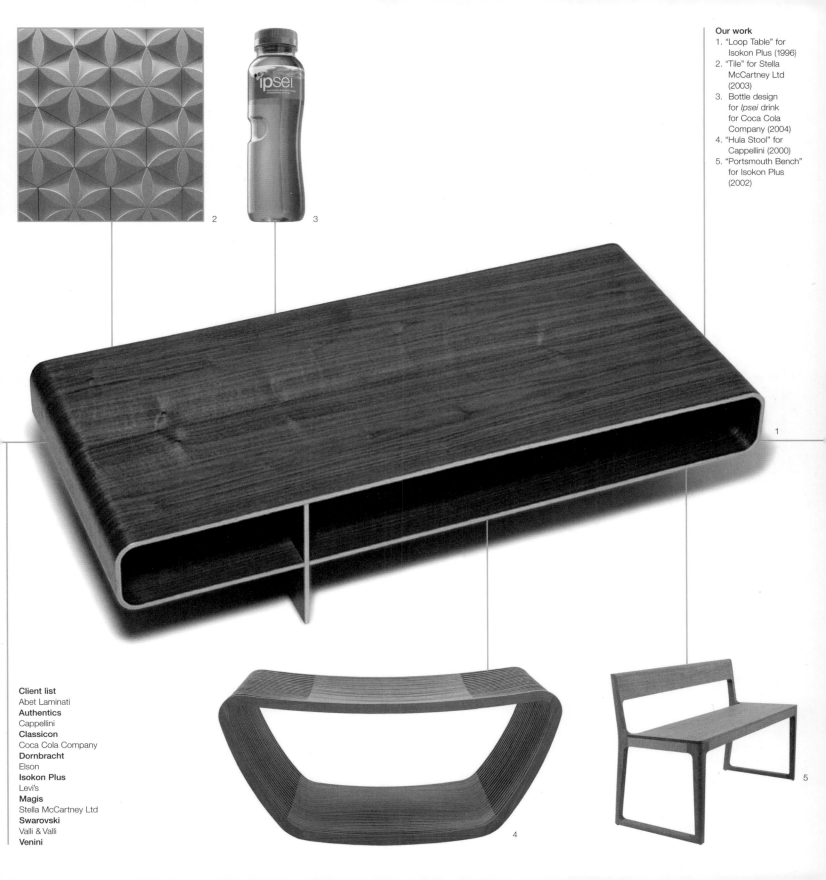

2

3

1

4

5

**Yves Béhar**
born 1967 in Lausanne, Switzerland
**Studio Location**
San Francisco, USA

Yves Béhar graduated from the Art Center College of Design in Pasadena, California, in 1992, after which he worked as a design leader at Lunar Design and frog design. Having amassed considerable professional know-how across the disciplines of industrial, product, graphic, packaging and environmental design, as well as brand strategy, he founded his own company – fuseproject – in 1999.

The open-minded approach of the company has attracted well-known clients from areas such as technology, sports, lifestyle and fashion who are keen to work with the team on the expansion and diversification of their brand values.

Béhar develops ideas that will ultimately extend the emotionally interactive relationship that brands try to instigate between themselves and new or existing customers. One such project was a product range for MINI, branded MINI_Motion, which sought to design objects perfectly attuned to the "urban nomad" lifestyle, including watches, two-part driving shoes and even a tent extension for the car. Other projects that explore technologies and ergonomics include a lipstick-red laptop for Toshiba (2004), a new line of shoes for Birkenstock (2003) and a scent bottle for haasprojekt (2003).

Having been involved in a variety of international exhibitions, fuseproject had its first solo show at the San Francisco Museum of Modern Art in 2004 as part of the museum's Design Series, which identifies and showcases artists and designers at the forefront of their disciplines.

**My inspiration**
Imaginative stories, such as the dreamy world of *The Little Prince* by Antoine de Saint-Exupéry

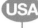

USA

**yves béhar**

---

**Q. What types of products do you design?**

A. I design all product types, from tech to beauty, furniture to shoes, packaging to interiors. I call this approach "multi-specialist", believing that by being guided by ideas and not style, design can connect emotionally and create an experience.

**Q. What or who has been of significant influence on your work as a whole?**

A. Often it is dream-like storytelling like *Le Petit Prince* by Antoine de Saint-Exupéry.

**Q. What was your big break?**

A. A small company [haasprojekt] with vision with whom I made the spacescent and Perfume09 perfume bottles. And then a big company with vision – Birkenstock – with whom we have designed new product lines like Footprints and Birki's.

**Q. What human emotions and necessities drive your designs?**

A. What I try to give through my work is twofold: through function and ergonomics, a sense of intelligence, choice and wit; and through expressive form, ideas and emotion.

**Q. How important are trends in your work?**

A. The only trend for me at the moment is eclecticism, where people are following their personal taste rather than a dictated trend, and integrating different points of view in design into their lives.

**Q. How important is it for your work to reflect the design characteristics of your nation?**

A. As a designer who grew up in Switzerland, with Turkish and German parents, and now living and working in San Francisco, with clients from Asia, Europe and the USA, and surrounded by designers from nine different countries out of a staff of 12, I don't think that "my" nation is a direct stylistic influence. Rather, I am influenced by conditions inherent in the client's personality and origin.

**Q. Is your work an individual statement or a team solution?**

A. It is a team's solution with a strong point of view… and a point of view that comes from individuals and not companies.

**Q. What elements of the design process do you find particularly frustrating?**

A. It is all frustrating and incredibly rewarding at the same time. As long as I am given the space and opportunity to experiment and create new experiences, it is the best job possible.

**Q. To what level will you compromise to satisfy your client?**

A. Good design work is always a partnership, and there is no successful partnership without personal expression from both the designer and client. It just simply makes the work better.

**Q. What would be your second career choice after design?**

A. More storytelling, I guess – writing or filmmaking.

**Q. In one sentence, please describe your design approach.**

A. "Design brings stories to life." Meaning is at the centre of my work, with form being subservient to communicating ideas and stories through design.

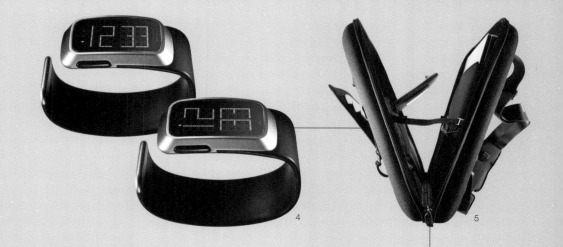

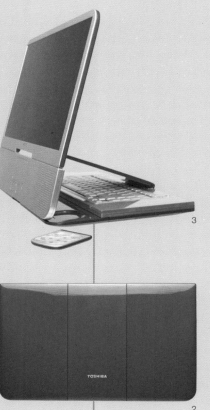

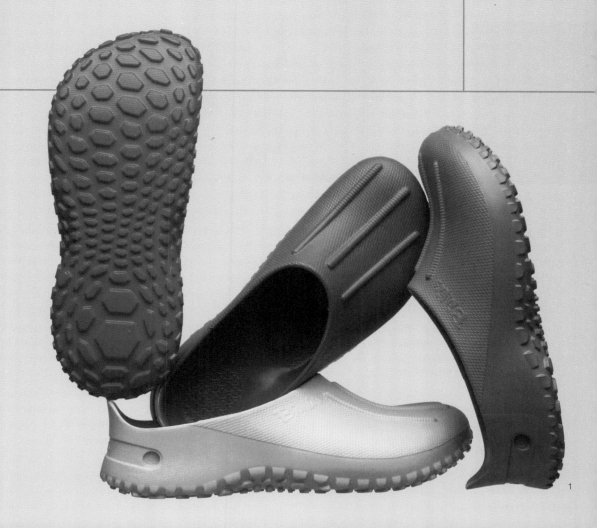

**Client list**
Birkenstock
**haasprojekt**
Herman Miller
**Hewlett Packard**
HIP holistic beauty
**Hussein Chalayan**
Microsoft
**MINI (BMW)**
Nike
**Philou**
PUIG beauty group
**Samsung**
Toshiba

**My work**
1. "Birki" for
   Birkenstock (2003)
2. "Transformer" laptop
   for Toshiba (2004)
3. "Transformer" laptop
   for Toshiba (2004)
4. "MINI_Motion" watch
   for Mini/Festina-
   Candino Watch Ltd
   (2003)
5. "MINI_Motion"
   carpack for
   Mini/Samsonite
   (2003)

**Mario Bellini**
born 1935 in Milan, Italy
**Studio Location**
Milan, Italy

Since completing his training as an architect at the Politecnico di Milano in 1959, Mario Bellini has amassed a staggering body of work, ranging from urban and architectural design to furniture and industrial design. He started his working life in the design offices of La Rinascente, the influential Italian department store, working there until 1961, when he founded his own architecture and design studio. Early success followed when he joined Olivetti as a consultant in 1963, the start of a long-term collaboration that gave shape to several iconic calculator models, typewriters and machines.

Commissions have since come thick and fast: Bellini and his Milan team have developed furniture for B&B Italia, Vitra and Cassina; lighting for Fios, Erco and Artemide; car concepts for Renault and Fiat; and many architectural projects across Europe, Australia, Japan, the USA and the United Arab Emirates. Such a body of work has attracted a long list of awards, including eight Compasso d'Oro awards. In 1987, his contribution to design was given due recognition in a one-man retrospective exhibition at the Museum of Modern Art, New York, where 25 of his works are now included in the permanent collection, including the "Cab" chair of 1977 for Cassina.

Bellini has held workshops and courses internationally and had the role of professor at various institutions, including the Domus Academy in Milan. From 1986 to 1991, he was chief editor of *Domus* magazine. He has designed several art exhibitions, including "Italian Art of the 20th Century" at the Royal Academy of Arts in London in 1989.

In 1997, he opened Atelier Bellini with his son Claudio to handle industrial design projects; architectural projects are handled by Mario Bellini Associati.

**My inspiration**
A small detail from Antonello da Messina's painting, The Anunciation (1474–1475) triggered the design inspiration for my "Logos" series of calculators for Olivetti in the seventies

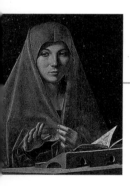

mario bellini

**Q. What types of products do you design?**

A. Almost anything – domestic and contract furniture; objects and vases; tools, kitchenware and furniture; tableware, jewellery, office machines, systems and chairs; domestic and contract light fixtures; consumer electronic goods, concept cars…

**Q. What or who has been a significant influence on your work?**

A. Anthropo- and zoomorphic instinctive understanding. A deep interest in our material culture since its origins. A natural curiosity for old and new technologies.

**Q. What was your big break?**

A. At the age of 27 – when my first furniture design was awarded the Italian Compasso d'Oro. At the age of 29 – when my first machine design was also awarded a Compasso d'Oro.

**Q. What human emotions and necessities drive your designs?**

A. The search for beauty and for a strong expressive energy with a minimum of means.

**Q. How important are trends in your work?**

A. Not much. They are indicators of our times, but quite often they end up being self-referential, mirroring what we have fed into them.

**Q. How important is it for your work to reflect Italian design characteristics?**

A. Not at all, from an ideological point of view. But being used to working for an international range of clients and markets, I believe that my own cultural background is a significant component of my design value.

**Q. Is your work an individual statement or a team solution?**

A. An individual statement supported by an efficient team and various multidisciplinary contributions made by the client's skills and know-how, and even by the many constraints.

**Q. What elements of the design process do you find particularly frustrating?**

A. The interference of marketing people when not supported by a flexible, open-minded and creative attitude…

**Q. To what degree will you compromise to satisfy your client?**

A. Not beyond the point where I cease to be fully satisfied.

**Q. What would be your second career choice after design?**

A. Architecture – the parallel one that I have been enjoying for more than 20 years. Or I think I could have been a poet.

**Q. What do you still aspire to design?**

A. The most innovative car one could possibly want, developing further my radical intuition of a concept vehicle – the Kar-a-Sutra – presented at the MoMA exhibition "Italy: The New Domestic Landscape" in 1974 in New York.

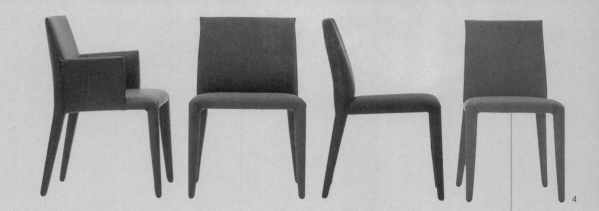

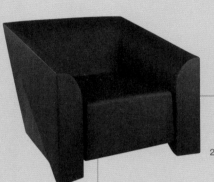

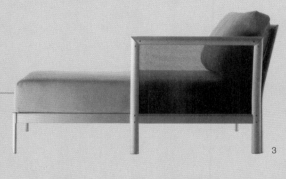

**My work**
1. "Palmhouse" kettle designed with Claudio Bellini for Cherry Terrace (2001)
2. "MB1" rotation moulded armchair for Heller (2003)
3. "Faust" part of a sofa collection for Driade (2001)
4. "Vol Au Vent" fully upholstered chairs for B&B Italia (2001)

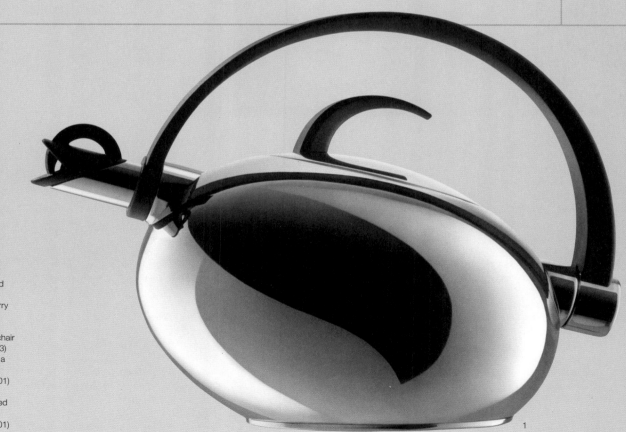

**Sebastian Bergne**
born 1966 in Tehran, Iran
**Studio Location**
Bologna, Italy and London, UK

Born in Iran to a British father and a German mother, Sebastian Bergne spent much of his childhood and teens living in different countries and absorbing a diversity of cultures. He kick-started his career in industrial design in 1984 with studies at London's Central School of Art and Design and the Royal College of Art. After graduating from the latter in 1990, he set up his own London studio. One of his first products was a lampshade made from a thin sheet of stainless steel that clipped directly onto a bare hanging light bulb. It caught the attention of the design industry, and was praised as a simple and confident as well as practical design solution.

The body of work that makes up Bergne's collection of products today, for clients including Authentics, Oluce, Vitra and Luceplan, all share a striking clarity of form coupled with a refreshing honesty of construction that immediately communicates the object's designated function to any user. Although fascinated by materials and manufacturing technologies, Bergne does not draw attention to these elements in his designs, but aims instead to capture the user's or viewer's imagination with a blend of subtle cultural references, twists of humour, and comforting familiarity.

Some of Bergne's award-winning work is included in permanent collections at the Museum of Modern Art, New York, and the Design Museum, London.

**My inspiration**
One of many inspirational individuals, artist Marcel Duchamp's body of work, including this "Bicycle Wheel" (3rd version, 1951) from his ready-mades collection taught me the integrity of ideas

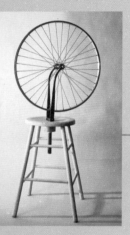

I
GB

**sebastian bergne**

**Q. What types of products do you design?**

A. I design more or less any type of mass-produced 3-D object. Past projects range from a bar of soap to a vacuum cleaner and a bed to the packaging for a diamond ring.

**Q. What or who has been a significant influence on your work as a whole?**

A. Everything that already exists is the starting point to what should or could exist. So, walking down the street or looking in a junk shop can be as much an influence as visiting a museum. Equally, the work of various creative people has influenced my work in different ways. The artist Robert Raushenberg – because, through his work, I was introduced to the idea of collage. The artist Marcel Duchamp – because his work introduced me to the idea of the Idea… Achille Castiglioni because of his charm and consistency. Konstantin Grcic as an old friend, colleague and discussion partner.

**Q. What was your big break?**

A. The first project I designed that had some success was a lampshade made from a thin sheet of stainless steel that clipped directly onto a hanging light bulb. Fifteen years later it is still being produced.

**Q. What emotions underpin your designs?**

A. Ideally, my projects should stimulate a calm smile. This can be achieved in many ways – familiarity, surprise, beauty, satisfaction, pride, simplicity, humour or wonder. If an object can provoke a smile while or even because it is performing its function, it's well designed.

**Q. How important are trends in your work?**

A. Trend analysis is a tool for the marketing world to communicate to those outside the design process. It is something that I come across quite often. It certainly shouldn't be ignored, but it's not something that has a direct impact on how I design. After all, by definition, trends come and go within a year or so, and a product is normally around longer than that.

**Q. Do you think your work is an individual statement or is it the result of teamwork?**

A. Design is always teamwork; even if it's only between a single designer and a client, the context of the project and the client change the approach to the project. That said, my own work is best described as a personal solution that has gone through a team process to solve a specific client need.

**Q. What elements of the design process do you find frustrating?**

A. Where I have no opportunity for input. This could be product photography, communication, packaging or something as simple as reading a press release before it is dispatched.

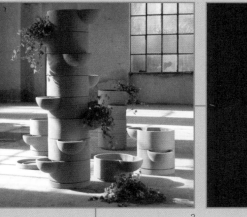

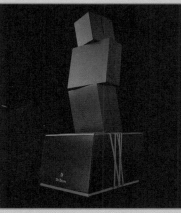

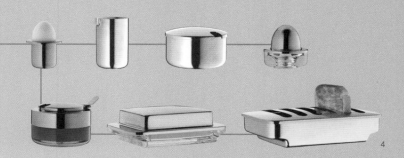

2

3

4

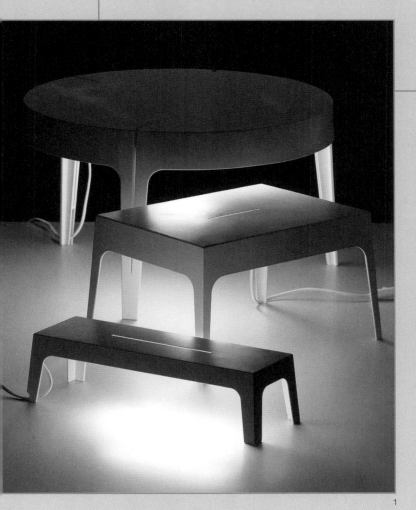

5

**Client list**
Authentics
**Cassina**
DeBeers
**Driade**
Dornbracht
**Filofax**
Habitat
**Lexon**
Luceplan
**Magis**
Moulinex
**Oluce**
Oreka Kids
**Teracrea**
View
**Vitra**
WMF
**Wireworks**

**My work**
1. "Tavolini" lamps for Luceplan (2003)
2. "Balconcino" terracotta planters for Teracrea (2003)
3. "Rhombus" jewellery packaging (corporate identity by DewGibbons, London) for DeBeers (2002)
4. "Kult" breakfast range for WMF (2000)
5. "Bop" dinner service for Driade (2003)

1

**Lena Bergström**
born 1961 in Umeå, Sweden
**Studio Location**
Stockholm, Sweden

Lena Bergström has become renowned for her extraordinary work in glass that is designed for, and produced by, the Swedish glass company Orrefors, so it may come as a surprise to discover that she trained as a textile designer at Stockholm's Konstfack – the University of Arts, Crafts and Design – expanding her knowledge further during educational stints in England, Belgium, Finland and Japan until 1991. She went on to work as a freelance textile designer and undertook several art projects with interior designers in Sweden. Almost by luck, she participated in a design project at Orrefors in 1993. It was then that she first encountered working with glass. The material and its possibilities immediately captivated her, and she joined the company in 1994.

Bergström is the first to admit that her relative newness to the medium has given her the creative freedom to push the boundaries of its production capabilities, and in doing so has developed her own distinct language – combining glossy black glass with sharp graphic shapes or acidic primary colours with thick-walled sensuous curves. For Bergström, "the greatest beauty must balance on the brink of failure" – a testament to the challenges that this award-winning designer presents to the expert glass blowers at Orrefors.

Bergström continues to work with textiles in a freelance capacity for, among others, Designer's Eye, Sweden.

**My inspiration**
The internal and external play of light in architecture, such as the Institute of the Arad World by Jean Nouvel in Paris, or Peter Zumthor's Art Museum in Bregenz, Austria (below)

## lena bergström

1

**Q. What sort of objects do you design?**
A. Functional and decorative interior objects, mainly in glass and textiles – vases, bowls, candleholders, stemware, limited pieces, fabrics, carpets, cushions, blankets, room dividers, bags and so on. I also work on public commissions in both glass and textile.

**Q. What or who have been significant influences on your work?**
A. What: I grew up in Västerbotten (a province in the north of Sweden), where there's plenty of fresh air, sunlight in the summer, and snow and ice in the winter; it's a landscape of strong contrasts between light and shadow.

What: I love living in the present, so contemporary architecture, fashion, art, and so on that are functional, innovative, experimental, humorous are big inspirations for me.
What: Whether the material is glass, wool or whatever, the characteristics and beauty of the raw material in itself inspire me to make the design as simple as possible.
Who: I also believe that people who believed in me as a designer early on have influenced my work in a very positive way – for example the English textile artist and designer Ann Sutton, who was a guest teacher at the Konstfack in Stockholm in 1986. As a young designer, it's important to take a risk and trust your own instincts, and she helped me to do just that.

**Q. What would you say gave you your big break?**
A. The launch of a colourful fabric collection called "X-tra, O-lik and I-hop", presented in spring 1992 at the Ambiente Fair in Frankfurt and at the Stockholm Furniture Fair.

**Q. What human emotions and necessities drive your designs?**
A. Passion, lust, light, the sun, food, wine, human contact and laughter.

**Q. Is your Swedish nationality important in your work?**
A. I don't think about it when I design. I design emotionally, with my heart and instincts. But looking back on my work, I can see that I'm Swedish.

**Q. Is your work an individual statement or a team solution?**
A. The working process can often be a team solution, but the final design is an individual statement. It's me.

**Q. What are the frustrating parts of a project?**
A. When I'm really happy with a design and for some reason the production of it doesn't work out… and when the process of getting designs out into the shops takes too much time!

**Q. Is there something you'd really like to design?**
A. Furniture and work in new materials. I hope I'll get the chance to do that soon. And if you're really talking about dreams – to design an apartment building!

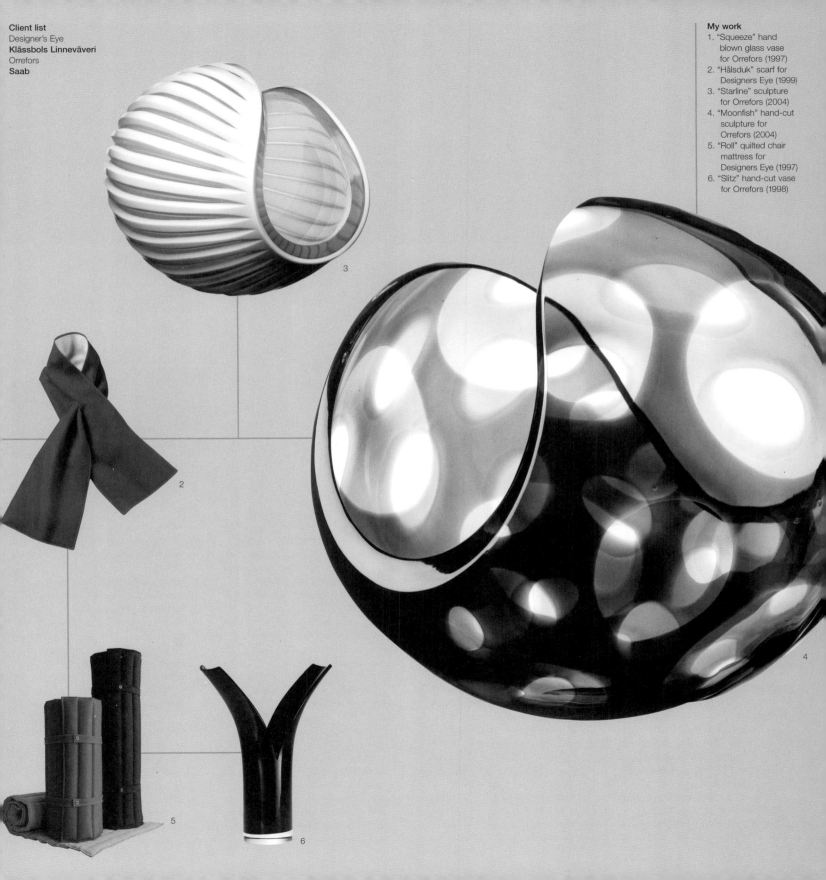

**My work**
1. "Squeeze" hand blown glass vase for Orrefors (1997)
2. "Hålsduk" scarf for Designers Eye (1999)
3. "Starline" sculpture for Orrefors (2004)
4. "Moonfish" hand-cut sculpture for Orrefors (2004)
5. "Roll" quilted chair mattress for Designers Eye (1997)
6. "Slitz" hand-cut vase for Orrefors (1998)

**Jeffrey Bernett**
born 1964 in Champaign, Illinois, USA
**Studio Location**
New York, USA

Jeffrey Bernett is one of only a handful of American designers who have successfully penetrated the European design scene; today he works on furniture and products for some of the continent's top manufacturing brands, such as B&B Italia, Cappellini, Ligne Roset and Magis.

Before setting up his own design practice, Studio B, in New York

in 1995, Bernett studied business at Northeastern University, Boston, and at the University of Minnesota, Minneapolis, before pursuing his passion for furniture design at Parnham College in Dorset, UK.

In May 1996, Bernett presented his first collection at the International Contemporary Furniture Fair (ICFF) in New York, winning the Editor's Award for "Best of Show". This had tremendous repercussions for the new designer, whose work caught the attention of the influential Italian manufacturer Cappellini. In 1998, Cappellini presented Bernett's

designs in Milan, and subsequent years have seen increasing numbers of clients releasing pieces from this US designer.

Bernett's graphic clarity of form, visual simplicity and ergonomic design holds true to the principles of the early twentieth-century Bauhaus movement that is a powerful influence on his work. He avoids unnecessary decoration and considers every detail carefully – a style that indeed seems better suited to his growing European client base.

In addition, Bernett frequently lectures at schools and design events around the world.

**My inspiration**
The little details of everyday life, be it human expression, the insatiable beauty of nature, or the pure function of manmade tools such as these pliers

**jeffrey bernett**

**USA**

**Q. What types of products do you design?**

A. Product designs comprise furniture, household products, lighting, transportation design, fashion accessories, bottle and packaging design, and 3-D branding.
In addition, I have worked on design direction and strategic planning, graphic and communication design, and interior architecture.

**Q. What or who has been of significant influence on your work as a whole?**

A. Among the architects and designers are the Bauhaus, Mies van der Rohe, Le Corbusier, Achille Castiglioni, the Eameses, Vico Magistretti, Enzo Mari, George Nelson, Dieter Rams and Richard Sapper. Among the artists – Gerhard Richter, Donald Judd, Richard Serra, Cy Twombly, Marcel

Duchamp and Alberto Giacometti. In the broader sense – culture! Going to see things such as the Architecture Biennial in Venice, Documenta and the Basel art fairs. It's also the things one sees in everyday life – the shape of a light bulb, the functionality and movement in a tool (such as a pair of pliers), the colours in the sky, the shape of a flower, the notes in a line of music, the smile on someone's face or the look in their eyes… And above all – an insatiable curiosity for how people live and work.

**Q. What was your big break?**

A. First, the courage to follow my heart and my dreams. Second, my presentation at the International Contemporary Furniture Fair (ICFF) in New York in 1996, where I was awarded "Best of Show" and gained my first client, Cappellini.

**Q. What human emotions and necessities drive your designs?**

A. Passion, the pursuit of excellence, functionality and usefulness.

**Q. How important are trends in your work?**

A. Our clients tend to be the market leaders in their particular market segments and as such usually define and set new standards for the market.

**Q. How important is it for your work to reflect the design characteristics of your nation?**

A. Our clients participate in global markets, and I would say that "good design" is universal.

**Q. Is your work the result of an individual statement or a team solution?**

A. Generally speaking our work is client-specific and client-appropriate. I think all good projects are a

collaboration, with everyone involved from inside our firm and inside the client's firm.

**Q. What elements of the design process do you find particularly frustrating?**

A. Excellence is found by pushing hard for the last five per cent of a project. Working with clients who share that desire for excellence is very important in achieving successful projects.

**Q. To what degree are you willing to compromise to satisfy your client?**

A. I think it's important to listen to all comments, both positive and negative, before arriving at the final design solution. Additionally, manufacturing and/or engineering constraints will have a major impact on projects.

**Q. What do you still aspire to design?**

A. Anything in an area we have not yet participated in.

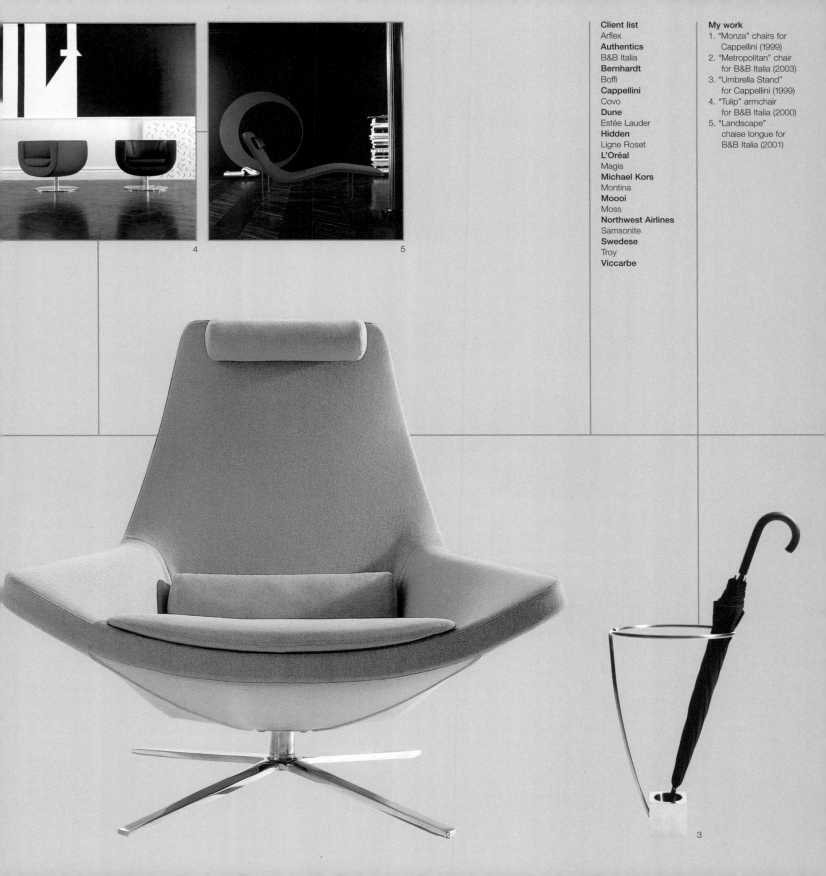

**Jurgen Bey**
born 1965 in Soest, The Netherlands
**Studio Location**
The Netherlands

Jurgen Bey began his design education within the Department of the Environment at the renowned Design Academy in Eindhoven. After graduating in 1989, he formed a partnership with fellow graduate Jan Konings (born 1966), with whom he worked on exhibition design projects and began his long-term relationship with Dutch design collective Droog Design. The duo collaborated until 1998, when Bey set up his own independent studio in Rotterdam and simultaneously took up a teaching position at the Design Academy.

Bey's installations for public spaces, exhibitions and interiors are the result of bespoke commissions, and to a large degree his work is closer to that of an applied artist rather than a commercial designer. Freed from specific market pressures, his designs are honest and conceptually pure, often subverting old, traditional or natural objects by transforming them into magical, quirky and clever design solutions, as, for example, in "Treetrunk Bench" (1999), where the initial inspiration of a fallen tree in a forest is endowed with a new-found function simply by merging backrests into the wooden mass. Similarly mixing old with new, the "Light Shade Shade" (1999) masks a vintage chandelier within a tubular shade made of semi-transparent mirror film. Only when turned on does the ghostly form of the ornate chandelier glow through the shade.

Many designs by Bey are included in the collection of Droog Design with whom he continues to collaborate today.

**NL**

**jurgen bey**

Q. **What types of products do you design?**
A. I don't design specific sorts of products. I design that which has been asked for and falls in my lap.

Q. **What or who has been of significant influence on your work as a whole?**
A. The mind that can spin the world as you can find in art and science.

Q. **What was your big break?**
A. I think that my break came in 1999 when I presented the "Oranienbaum" project for Droog Design comprising such objects as the "Gardening Bench + Container" and the "Treetruck Bench". My self-initiated projects of Collection 01 which contained objects such as the "Kokon" furniture, "Light Shade Shade" and "Broken Family".

Q. **What human emotions and necessities drive your designs?**
A. Not understanding the world and hoping never to design something that can compete with the honest beauty of real life.

Q. **How important are trends?**
A. For me, this is not an issue but of course my world is surrounded with trends and "zeitgeisten", and because I move in it and witness trends all the time, you are also probably able to identify them back in my work.

Q. **How important is it for your work to reflect the design characteristics of your nation?**
A. It is not important in the sense that I want to be a Dutch designer with Dutch products. But because I was brought up in Holland with Dutch parents, brothers, friends, and teachers in a Dutch landscape, it is inevitably a big part of my identity and subconscious, therefore it is a big part of my work too. But if you ask what that definition is, I do not know. That is up to others to define.

Q. **Is your work an individual statement or a team solution?**
A. My work starts by collecting existing objects or 'things' around me. It is then developed organically by a small team and myself, who give form to these 'things'.

Q. **What elements of the design process do you find frustrating?**
A. Economics

Q. **To what level will you compromise to satisfy your client?**
A. There is rarely a situation of real compromise. I want a client to choose to work with me because they want the addition of my mind. At the end of a project, I find it very important that the client is fully satisfied and that is only possible if he gives me a good brief in the first place and then involves himself in the process of the design.

Q. **Is there anything you particularly aspire to design?**
A. I would like my work to become more socially relevant. In that sense, I would like to design a specific public house – anything from a hotel to a hospital; from a kindergarten to a home for the elderly or mental.

Q. **In one sentence, please describe your design approach.**
A. To find and accept what is already there and introduce only a minor change to its perspective.

**Client list**
Auping Foundation
**Centraal Museum,
Utrecht**
Droog Design
**Dutch Tax Office**
Interpolis
**Jean-Paul Gaultier**
Koninklijke Tichellar
**Moooi**
Planet
**Sacred River**
Technical University
Eindhoven
**also self-production**

**My work**
1. "Gardening Bench
   + Container"
   for Studio Jurgen
   Bey/Droog Design
   (1999)
2. "Dutch Pieces" for
   Interpolis (2002)
3. "Light Shade Shade"
   for Droog
   Design/Moooi (1999)
4. "Treetrunk Bench"
   for Studio
   Jurgen Bey/Droog
   Design (1999)

3

4

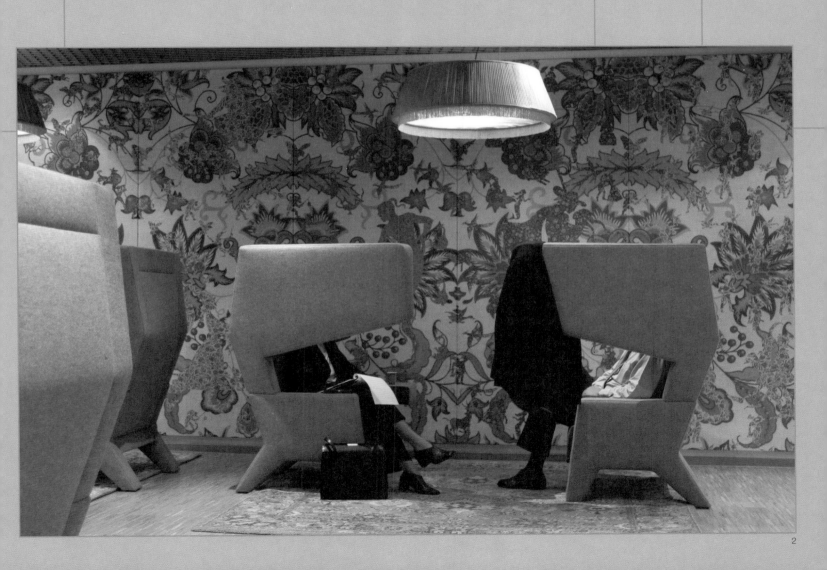

2

**Christian Biecher**
born 1963 in Sélestat, France
**Studio Location**
Paris, France

Christian Biecher received his diploma in Architecture from the Ecole d'Architecture de Paris-Belleville in 1989, while simultaneously working as a designer for Bernard Tschumi Architects in Paris and New York. He continued to work in the practice until 1992, when he established his own freelance practice in the French capital. One of his notable early architectural projects was the design of the Bibliothèque Départementale de l'Aude, Carcassonne, in 1994.

As commissions picked up in 1997, he established the Christian Biecher & Associés (CBA) studio to handle not only his architectural work but also the interior, furniture and graphic design that were increasingly becoming a part of his more holistic approach. Architectural and interiors work has mainly been spread between France and Japan, with such impressive designs as a hospital in Hénin-Beaumont (1999), the Korova restaurant in Paris (2000), Issey Miyake offices in Tokyo (2000), Madeleine coffee shops in Tokyo (2000), Joseph fashion store and bar in Paris (2000) and the Mitsui offices in Tokyo (2001).

In such projects, Biecher typically blends geometry with more fluid, supple forms, applying colour with graphic clarity and heightening tactility with sensual surfaces. Of his work, the designer has commented: "The desire to be discreet, timeless, is filled out by the desire to give places a human appearance…" Biecher was named "Designer of the Year" at the Paris design trade fair Maison & Objet in 2002.

**My inspiration**
Artist Felix Gonzalez-Torres' expression of the rich emotions of life through anonymous objects – the unity of lovers depicted through synchronised clocks in "Untitled" (Perfect Lovers, 1987–90)

## christian biecher

F

1

**Q. What types of products do you design?**

A. I design three-dimensional things, whatever their scale.

**Q. What or who has been of significant influence on your work as a whole?**

A. Definitely the artist Felix Gonzalez-Torres. His vision of the world addresses love, death and politics, but is expressed with a simple medium extracted from everyday life: paper, curtain, sweets, clocks… The simplicity and the beauty of his work touches me like no other.

**Q. What was your big break?**

A. The soft plastic bookcase I designed for the Neotu Gallery [2001], a sort of bookshelf in lacquered wood protected by an envelope of polypropylene sheets. It had to be simplified at the last minute for cost reasons, and I realised how much it had gained in the process…

**Q. What human emotions and necessities drive your designs?**

A. Pleasure, honesty… Pleasure, because it's nice if design can bring something to everyday life, something good to touch or see – a feedback made up of good vibrations. I think of my red Hermès diary or my black Sony Ericsson mobile phone. When I design a small object, like the bottles and containers for Lancôme's *Attraction*, for example, I try to imagine what a woman grabbing the object from her handbag would feel. Honesty has something to do with the truth about design, a sort of social responsibility, a way of respecting people, and not treating them as idiots… as consumers and nothing but.

**Q. How important are trends in your work?**

A. I don't like the idea of trends. I think that a generation comes up with a common style that people think is a trend, but it's not. It's just the shared influences from childhood coming back. My generation's shapes were described as colourful, round and 70s-like: this doesn't have anything to do with trends; it's just the influences we got from our environment when we first started to open our eyes.

**Q Is your work an individual statement or a team solution?**

A. Definitely an individual statement. My team is an intelligent group of people who finalise concepts I've initiated with autonomy and sensitivity.

**Q. What elements of the design process do you find particularly frustrating?**

A. The elements I cannot control. I design products for companies for whom I don't do the art direction! So I can be frustrated by the packaging, advertising, showrooms and so on.

**Q. To what level will you compromise to satisfy your client?**

A. I know the many aspects of a design project that can change. I also know the few components that cannot be changed without altering the design. Those are the components I will never compromise.

**Client list**
Addform
**Aridi**
Baccarat
**Bernhardt Design**
Contents
**De Majo**
H.A. Deux
**Harvey Nichols**
Issey Miyake
**Joseph**
Kappa
**Lancôme**
Mouvements
Modernes
**Neotu Gallerie**
Pantone Universe
**Picard**
Poltrona Frau
**Radian**
Sazaby
**Soca**
VIA

**My work**
1. "Strip" lounger for
   Poltrona Frau (2001)
2. "Mono" chair
   for VIA (2002)
3. "Slot" chair
   for Soca (2002)
4. "Yvon" chair for
   Sazaby Inc. (1996)
5. "Trois-roses"
   crystal vase for
   Baccarat (1998)
6. "Diabolo" ceiling light
   for Radian (1998)

**Maurice Blanks**
born 1965 in Midland, Texas, USA
**John Christakos**
born 1964 in Oneida, New York, USA
**Charlie Lazor**
born 1964 in Morristown,
New Jersey, USA
**Studio Location**
Minneapolis, Minnesota, USA

John Christakos, Maurice Blanks
and Charlie Lazor initially met during
degree studies at Williams College
in Massachusetts in the mid-1980s
and independently pursued further
education and the avenues of art,
architecture and marketing before

coming together again in 1997
to found Blu Dot in Minneapolis.
    The company designs and
manufactures its own collection
of furniture "for everyday people
with everyday needs". The Blu Dot
team believes that interior products
should translate pragmatic functional
issues into contemporary forms
that can be manufactured at a price
that will make the final item accessible
to most budgets. This is achieved
by identifying alternative materials and
fabrication and assembly methods
as well as other cost-saving devices,
such as flat packing for shipping.
Despite this, their unique advantage lies

in their ability to release products that
avoid communicating a cheap
aesthetic or poor quality but which
instead exude confidence, modernity
and timeless clarity.
    Blu Dot has won several awards
over the years, with their "2D:3D"
collection of accessories raising their
profile considerably in their early
years of business. Made from sheets
of power-coated stamped steel,
the product is delivered to the customer
in flat-pack form and he or she bends
the product into shape along the
perforated cuts – fun for the user and
easy for Blu Dot to manufacture,
package and ship.

**Our inspiration**
The matching of new
technologies with
affordable mass-production
techniques fits with our
design ethos, as executed
by the Eameses in the
1940s and 50s

USA

blu dot

**Q. What types of products
do you design?**
A. Home furnishings: case goods,
tables, seating, home office and
bedroom accessories.

**Q. What or who has been of
significant influence on your work?**
A. Who? – Ray and Charles Eames,
Donald Judd, Richard Serra.
What? – New mass-manufacturing
machinery that allows us to design
pieces that real people can afford.

**Q. What was your big break?**
A. The 1997 UPS [United Parcel
Service] strike. It happened
just weeks after we introduced
our first collection and allowed
us extra time to complete
our first-ever production runs.

**Q. What drives your designs?**
A. A light, balanced look is key to
our work. We strive to create
simple straightforward objects in

a complicated world – clarity is
very important to us.

**Q. How important are trends
in your work?**
A. We notice trends and are aware of
them – usually to make sure that we
don't fall victim to them. Trends aren't
bad per se – they can be exhilarating
and sometimes they are downright
practical – but we like to think our
designs still make sense a decade or
two down the road, after the current
trends have run their course.

**Q. How important is it for your
work to reflect national design
characteristics?**
A. Not really at all. Today, the flow
of design, materials, manufacturing
and information is so global that
any sort of regionalism is a bit
artificial. We identify with the simple
pragmatism and basic good sense
of early American industry and

entrepreneurship, but realise those
characteristics now exist, and thrive,
in every corner around the world.

**Q. Is your work an individual
statement or a team solution?**
A. It's a team solution – from the
handful of in-house designers that
generate the initial ideas and
develop the designs, to the various
vendors and fabricators that lend
their insights and expertise, to the
end-users who offer suggestions
and make recommendations and
who ultimately live with the designs.

**Q. To what level will you compromise
to satisfy your client?**
A. Since we design products for "the
marketplace", we don't have clients
in the traditional sense. But it seems
to us that any collaborative process,
any creative activity that is in any
way social, involves compromise.
And if that compromise isn't

productive, if it isn't an improvement
on the individual's effort, then the
wrong people are working together
on the wrong project.

**Q. What would be your second
career choice after design?**
A. Author of a directory of
important designers.

**Q. What do you still aspire
to design?**
A. Just about everything we haven't
had the chance to design.
Each new field is a great learning
experience – new materials, new
manufacturing technology, different
market expectations…

**Q. In one sentence, describe your
design approach.**
A. Solve all the aspects of the design
problem – from manufacturing, to
packaging, to assembly, to function,
to beauty – with the least apparent
effort… and a little bit of fun!

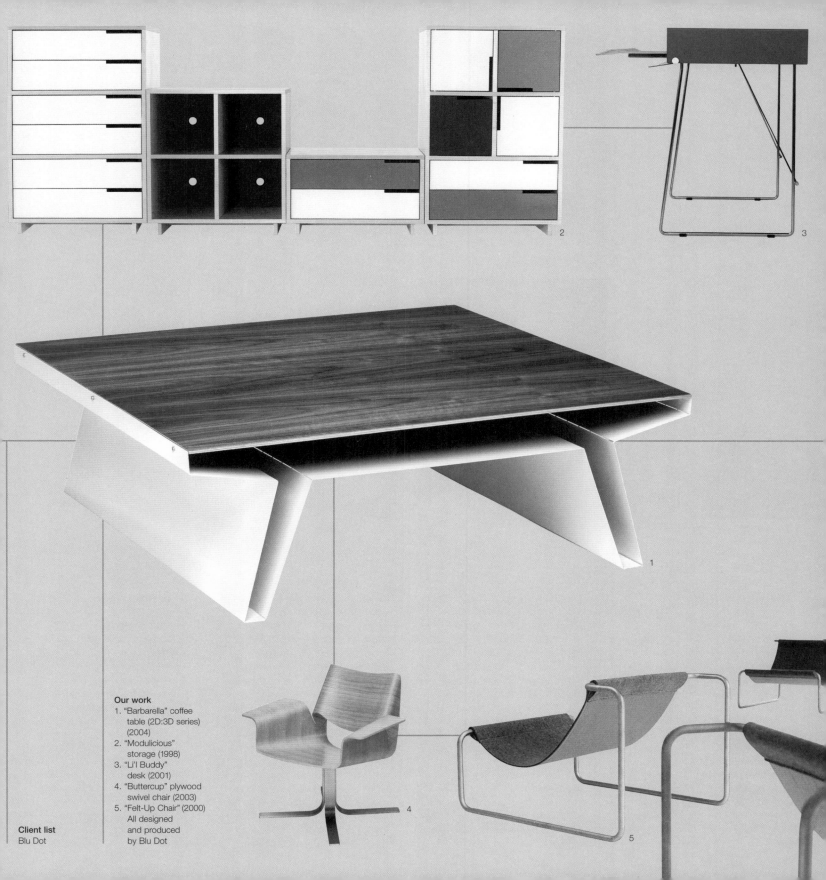

**Our work**

1. "Barbarella" coffee
   table (2D:3D series)
   (2004)
2. "Modulicious"
   storage (1998)
3. "Li'l Buddy"
   desk (2001)
4. "Buttercup" plywood
   swivel chair (2003)
5. "Felt-Up Chair" (2000)
   All designed
   and produced
   by Blu Dot

**Client list**
Blu Dot

**Riccardo Blumer**
born 1959 in Bergamo, Italy
**Studio Location**
Casciago, Varese, Italy

Having trained as an architect at the Politecnico di Milano in 1982, Riccardo Blumer joined the practice of the Swiss architect Mario Botta in Lugano, Switzerland, working on housing projects, competitions, urban masterplans and exhibitions until 1989. Then he set up his own architectural practice dealing with commercial and residential schemes as well as interior and industrial design projects.

While Blumer thinks of himself primarily as an architect, his studio also houses chairs, lights and various prototypes that confirm his other role as a 3-D designer on a smaller scale. His research in this field has focused on the production of lightweight furniture and, in particular, the application of balsawood, a naturally light material. His best-known project is the "Laleggera" stacking chair (1996), which weighs just 1.3 kilograms. The chair's internal wooden frame is covered in a sheet veneer, then polyurethane resin is injected into the hollow structure for rigidity, a concept based on a glider's wing. A thin layer of transparent plastic, reinforced by coats of fibreglass, protects the surface. The chair won a prestigious Compasso d'Oro award in 1998. It has since been joined by stools, benches and tables.

Blumer continues to undertake architectural commissions, mainly in Italy, and is professor at the Accademia di Architettura della Svizzera Italiana.

**My inspiration**
The beauty of Filippo Brunelleschi's dome for the Florence Cathedral of the 15th century is inextricably linked to the engineering brilliance of its structure

riccardo blumer

I

Q. **What types of products do you design?**
A. I design any sort of product that I believe will be of interest in my research, such as furniture and lighting.

Q. **What or who has been of significance on your work?**
A. The best reference would be Brunelleschi's dome in Florence – it's impossible to separate the technique from the beauty.

Q. **What was the turning point in your career?**
A. The years in Mario Botta's studio were a very crucial period because I got to understand the perseverance that's needed in all creative work. In my design career, I believe the undertaking and introduction of the "Laleggera" was an important turning point. However, I think that one's "turning point" is in perpetual and unforeseeable motion.

Q. **What human emotions and necessities drive your designs?**
A. The most important influence on my work has been the capacity to get over aesthetic and technical barriers, always searching for inner truth and beauty.

Q. **How important are trends in your work?**
A. For me, trends are a handicap for our society. Trends are a weakness because they are an amalgamation that opposes the richness of individuality. Trends are the children of marketing.

Q. **How important is it for your work to reflect the design characteristics of your nation?**
A. I am Swiss, but live in Italy. I've never really asked myself this question.

Q. **Is your work an individual statement or a team solution?**
A. Up to this day, it has always been an individual statement.

Q. **What elements of the design process do you find frustrating?**
A. The desire to sell more and more. Generally speaking, companies have only this one purpose in mind. I also desire to sell a lot, but this isn't the primary motivation or purpose for my designs.

Q. **To what degree will you compromise to satisfy your client?**
A. It's a hard fight. However, sometimes some compromise is necessary.

Q. **What would be your second career choice after design?**
A. That's a beautiful question! My answer would be a racing-car driver. It's a way of understanding whether you're a winner or a loser, and I could enjoy myself too

Q. **What do you still aspire to design?**
A. The most difficult and interesting thing is to surpass an already developed design, such as my balsawood chair.

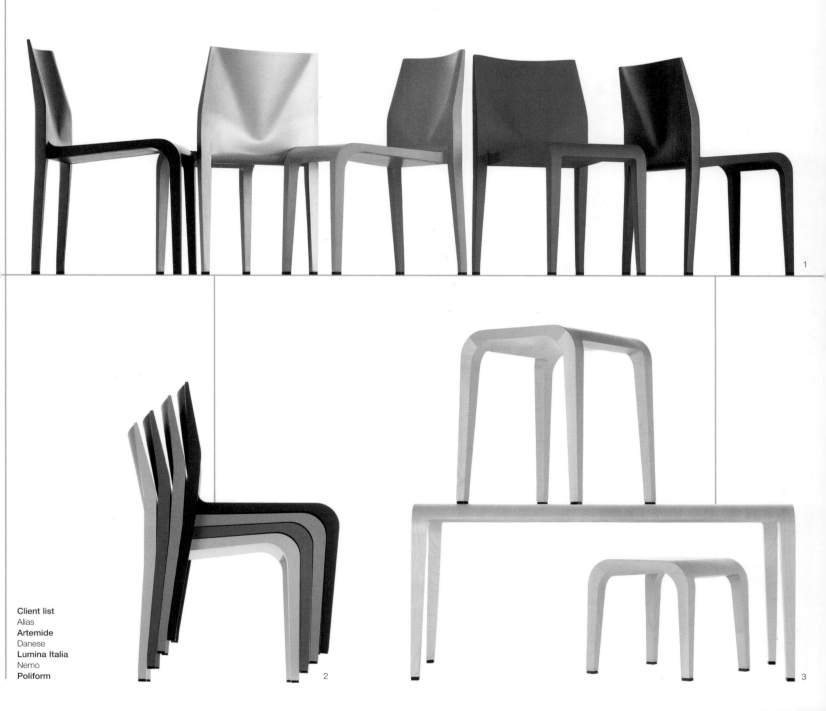

**My work**
1. "Laleggera" chairs
   for Alias (1996)
2. "Laleggera" chairs
   for Alias (1996)
3. "Laleggera" bench
   and stools for Alias
   (1999–2000)

1

2

3

**Tord Boontje**
born 1968 in Enshede, The Netherlands
**Studio Location**
London, UK

Tord Boontje studied Industrial Design at the Design Academy, Eindhoven, briefly also working for the Studio Alchimia design group in Milan. In 1994 he gained a Master's degree from the Royal College of Art, London. In 1996 he set up a studio in Peckham, London,

with Emma Woffenden and collaborated on "tranSglass", a collection of glassware made from recycled bottles.

In 1998, Boontje created the "Rough-and-Ready" chair that, as the name suggests, had an unfinished, imperfect and even impermanent appearance. The chair kit comes in the form of an instructional leaflet, allowing the user to create his or her own chair from available materials – for example, from reclaimed wood and blankets,

tape and string. Recently, Boontje has worked on the ongoing "Wednesday" series of products. Chairs, tables, lights, glass and other objects in the series blend "the hand and machine-made, the historical and the digital".

His work has been widely exhibited – for instance, at the 1999 "Stealing Beauty: British Design Now" exhibition at the Institute of Contemporary Arts, London – and since 2002, he has taught Industrial Design at the RCA.

## tord boontje

**GB**

1

---

**Q. What products do you design?**
A. At the moment I am working on lighting, ceramics, bags, perfume bottles, cutlery, furniture and interiors.

**Q. What or who has been an influence on your work?**
A. I constantly look at contemporary art and craft. Historical sources are important to me too. When I started embroidering, I spent a lot of time in the Victoria & Albert Museum going through the samples of 17th-century English embroidery. On holiday in Sweden, I saw rural embroidery. For the last four years I have worked with Alexander McQueen as a product designer. Fashion is a great inspiration for me – I love the experimentation and the speed with which ideas are tested. I am always drawn to things that are conceptually and visually exciting, like the work of

Martin Margiela, David Lynch, Christian Boltanski and Graphic Thought Facility. I teach at the Royal College of Art in Design Products and a big pleasure is to work there with Ron Arad and the other tutors.

**Q. What was your big break?**
A. In 2003 many things came together and built up momentum. In that year, the "Garland" light was launched by Habitat, Swarovski displayed my crystal "Blossom Chandelier" in Milan, and I was nominated for Designer of the Year by the Design Museum in London. Suddenly there was a fantastic platform to present my work to many people.

**Q. What was your motivation for using recycled or found objects in your earlier work?**
A. Both "tranSglass" and "Rough-and-Ready" furniture use very simple

materials: vessels made from old wine and beer bottles; and chairs made from simple wood and old blankets and packaging strapping. The work stemmed partly from the reality that these were materials that I could afford to work with, but also from a recognition of the beauty of abandoned objects. At a time when design seems to be dominated by the glossy, the slick and the perfect, I automatically become attracted to the real, the raw and the unfinished.

**Q. Can you explain your subsequent shift towards a more decorative, technology-embracing approach?**
A. After my low-tech, austere period, I became very interested in decoration and homeliness. Probably a big motivation was the birth of my daughter in 2000. Technology for me is a means of creating new methods

to make new expressions. Also I am interested in 17th-, 18th- and 19th-century objects because I like the richness of the materials and surfaces. Many of the techniques used to create them are very labour-intensive. New industrial processes enable us to explore these sensual qualities again. I am very disappointed by the global blandness that surrounds us and try to find ways out.

**Q. Is your work an individual statement or a team solution?**
A. I work in my studio with a team of six other individuals. My work is of course quite personal but it is always created with much help from them. Outside the studio, I work a lot with clients and manufacturers whilst occasionally I collaborate with other designers. I see my work as being the creative part of a larger team.

3

4

**My work**
1. "Jug and Glasses" designed in collaboration with Emma Woffenden for tranSglass (1997)
2. "Wednesday Light" in stainless steel (2001), now produced by Habitat as the Garland light (2003)
3. Detail of "Blossom Table" (prototype, 2001)
4. "Horse Vase" for Salviati (2001)
5. "Rock-a-Bye" chair (2003)

5

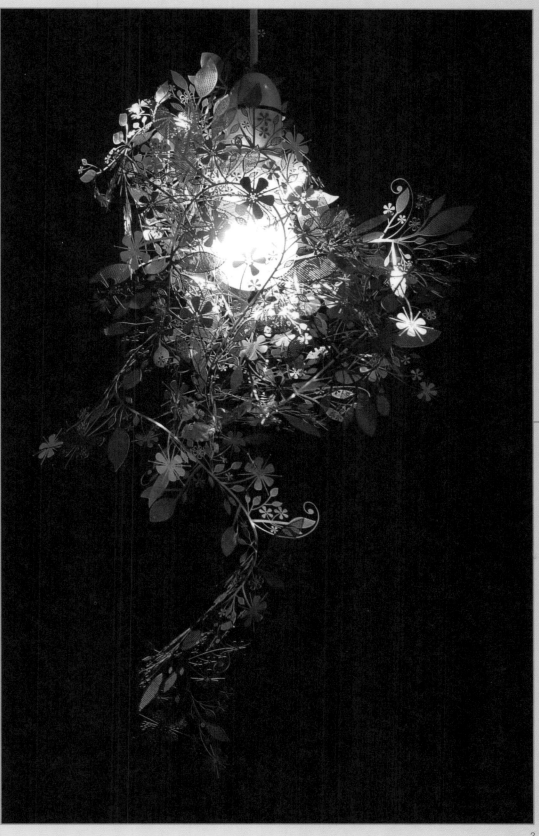

2

Erwan Bouroullec
born 1976 in Quimper, France
Ronan Bouroullec
born 1971 in Quimper, France
Studio Location
Paris, France

After graduating from the Ecole Nationale des Arts Décoratifs in Paris, Ronan Bouroullec started out working alone. His younger brother, Erwan, assisted him while still a student at the Ecole des Beaux-Arts in Cergy-Pontoise, before joining forces with him in 1999.

In 1997, Ronan met Giulio Cappellini while showing the "Disintegrated Kitchen" concept at the Salon du Meuble trade fair in Paris, and this spawned regular collaborations with the Italian manufacturer. With their reputations firmly on the rise, the duo have since embraced commissions from the likes of Issey Miyake, Habitat, Ligne Roset, Magis and Vitra.

In their work, the brothers often refer to the functional simplicity and pleasures of yesteryear, which they reinterpret in a relevant and contemporary way. They are interested in producing designs that grow out of core human behaviours and which help us to manage daily life. Whether they opt to work using artisanal skills or industrial processes, the brothers' designs remain clever without pomposity, stylish without ostentation.

**Our inspiration**
Rolf Fehlbaum, Head of furniture brand Vitra – one of a handful of truely visionary leaders with extraordinary faith, understanding, and passion for the industry

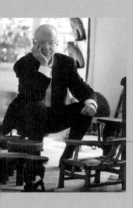

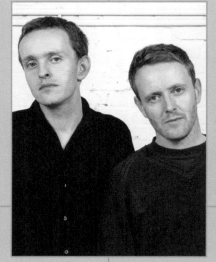

**bouroullec brothers**

F

Q. **Could you try to describe the type and range of products you design?**

A. The biggest piece we've designed is a floating house, and the smallest is a ring. The most "Swiss" project was an office system collection designed for Vitra ["Joyn", 2003]; the most "Italian" was furniture for Cappellini ["Glide" sofa, 2001; "Samourai" chair, 2002; "Spring", 2003].

We are lucky to have had the opportunity to work on a great diversity of designs, moving from industry to craft, from high quantity to limited-edition research pieces, from plastic to leather… We have made a lot of different products, under the guiding principle that all design depends on context.

Q. **Who or what has been influential on your work?**

A. On one hand, there is the world – what you can see, learn and adopt. On the other, there are personalities, people that you meet and with whom you share an unknown path… Life – often so familiar and predictable – should hopefully offer surprises, even disappointments, so that you get to see what's real – the facts. The most important thing perhaps is to listen, to be receptive, to understand and then use what you have learnt to transform or adapt it, or to forget… We like to be attentive to things, whether it's to the detail of a screw that keeps a tap in place, or a Japanese novel.

The people who've inspired us are Giulio Cappellini, Rolf Fehlbaum of Vitra and Issey Miyake. Then there are the people whose names wouldn't probably mean much to you but who share with us this common, unknown path… We never know where it's going, but sometimes we can understand where it comes from.

Q. **What was your big break?**

A. Giulio Cappellini met Ronan when he didn't even have a business card. His advice to him was the day he got one, he would stop coming up with new ideas. We still don't have one.

Q. **What do you think drives your designs?**

A. Dialogue: design isn't something you can come up with on your own. In the first place, this is because most of our work is geared towards answering the needs of a company, and in turn that company is trying to meet the needs of a customer. And the customer is a human being. So who starts out asking the question? And what is the question? Dialogue is a way of limiting misunderstandings. Suggestion: our designs are suggestions, not statements. We like to keep our distance and our sense of humour so that our solutions don't end up becoming hard-and-fast rules.

Q. **Is your work the result of teamwork or is it something more personal?**

A. We're always looking for precision. Precision means that you don't end up with some kind of hazy hotchpotch made up of everbody else's advice. But, as we said above, design emerges from dialogue – from an understanding of the context. In the end, it can sometimes be like conducting an orchestra. So, yes, of course it's teamwork, but it also has to be very individual – when the violin plays that incredible melody, the orchestra has to be wise enough to let it play alone.

**Our work**
1. "Untitled" single flower vase for Cappellini (1998)
2. "Striped Collection" for Magis (2004)
3. "Outdoor" chair for Ligne Roset (2001)
4. "Torique" jug for Gilles Peyroulet Gallery (1999)
5. "Aio" porcelain tableware for Habitat (2000)
6. "Cloud" modular shelving for Cappellini (2002)

2

3

4

5

6

**Client list**
Authentics
**Backstage**
Biegel
**Cappellini**
Coromandel
**De Vecchi**
Domeau & Pérès
**Euro RSCG BETC**
Gallery Kréo
**Gilles Peyroulet Gallery**
Habitat
**Issey Miyake**
Ligne Roset
**Magis**
Néotu Gallery
**SMAK Iceland**
Sommer
**Teracrea**
Vitra

**Constantin Boym**
born 1955 in Moscow, Russia
**Laurene Leon Boym**
born 1964 in New York, USA
**Studio Location**
New York, USA

Constantin Boym was brought up in Russia where he trained as an architect at the Moscow Architectural Institute. At the start of the 1980s, he emigrated to Boston, USA. His move into product design came when he undertook a Masters degree at the Domus Academy, Milan, in 1984, after which he returned to the USA, settling in New York City, where he founded the Boym Design Studio in 1986. Meanwhile, Laurene Leon was studying at the School of Visual Arts, New York City, where she remained until 1984. The duo met in 1988 and collaborated on a project before Laurene started a Masters degree at the Pratt Institute, New York City. She joined Constantin as a partner of Boym Partners in 1995.

The Boyms' work is characterised by an acute observation of familiar and unfamiliar aspects of American life and culture, which they transfer to new contexts with dry, ironic humour. Although the Boyms collaborate with reputable international manufacturers, many of their ideas are without obvious commercial application and often warrant batch-production, which the Boyms undertake themselves. Such projects include the "Souvenirs for the End of the Century" – a limited edition mail-order collection of miniature models – of non-existent "Missing Monuments", rather tacky busts of cultural masters and, controversially, buildings that have experienced tragic events, such as the Twin Towers.

USA

**boym partners**

1

**Q. What types of products do you design?**

A. When I was in Italy as a student at the Domus Academy, I picked up an expression about designers' field of competence – it was "from the spoon to the city". Twenty years later, it still pretty accurately describes our own range of work at the studio. In addition to client-commissioned work, we do self-generated experimental projects, which we exhibit and sometimes market as our own design production.

**Q. What or who has been your biggest inspiration?**

A. The life and work of the late Tibor Kalman has been a great inspiration for both of us. Tibor taught us to "find the cracks in the wall"; to challenge and provoke big companies into doing more experimental and provocative work. He urged us to take matters into our own hands when no such clients were in sight. Many of our better-known, self-generated projects have started that way.

**Q. What was your big break?**

A. The Searstyle project of 1992–1994, which commented on that American cultural icon the Sears Catalogue in an irreverent way, established our reputation as a critical and "funny" design group. The exhibition of this project in Cologne brought us a relationship with Hans Maier-Aichen of Authentics, for whom we did an important body of work in the 1990s.

**Q. What human emotions and necessities drive your designs?**

A. We aspire for the products we design to become "objects of desire". The idea of collectibles is very important to us. People collect things for reasons not very clearly defined, but the act of collecting is essential to many people's lives. For us, this "fuzzy function" is as necessary to address as any other functional area of design, and is perhaps even more crucial because it is so often overlooked. We also like to look at familiar everyday objects and reinterpret them in a different strange way. This generates a sense of wonder, intellectual curiosity and fun in the final user.

**Q. How important are trends in your work?**

A. We would like to create trends, not to follow them. Our design has been often described as "without style". I used to be upset about it, but now we are proud to have it this way.

**Q. Is your work an individual statement or a team solution?**

A. We try to make it as individual as possible. Sometimes we collaborate on a single project, but more often we work side by side. This way we have our freedom combined with the benefit of additional input and review from each other.

**Q. What do you still aspire to design?**

A. Anything we have not worked on before.

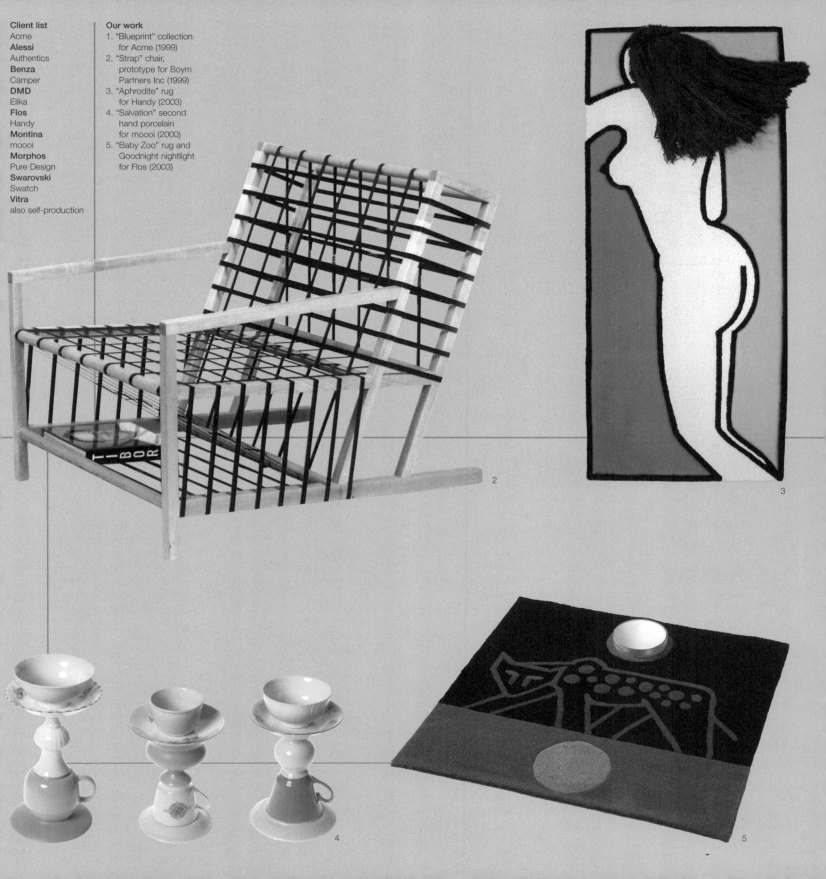

**Our work**
1. "Blueprint" collection
   for Acme (1999)
2. "Strap" chair,
   prototype for Boym
   Partners Inc (1999)
3. "Aphrodite" rug
   for Handy (2003)
4. "Salvation" second
   hand porcelain
   for moooi (2000)
5. "Baby Zoo" rug and
   Goodnight nightlight
   for Flos (2003)

2

3

4

5

**Julian Brown**
born 1955 in Northampton, UK
**Studio Location**
Bath, UK

Julian Brown has carved a consistent and steadily progressive career path for himself that began with the completion of his studies in Industrial Design at Leicester Polytechnic in 1978. After working with the design team David Carter Associates for two years, Brown went on to study 3-D Design at the Royal College of Art in 1980, after which he worked for three years at the Porsche Design Studio in Austria (pp 204–205) until 1986.

Returning to the UK, he co-founded the London-based Lovegrove and Brown Design Studio with Ross Lovegrove (pp 156–157), where the duo developed, among other things, a strong working relationship with the German manufacturer alfi Zitzmann. In 1990, Brown went solo with the launch of Studio Brown in Bath, going on to produce a sizeable body of successful work for a diverse client list – from pens (Berol), office accessories (Rexite) and stationery (ACCO) to toothbrushes (Johnson & Johnson), tennis rackets (Puma) and laptops (NEC).

Because he has been involved in such a wide range of projects, it is hard to affiliate Brown's work with any one style. What can be said, however, is that he always assigns primary importance to functionality in his designs, balancing an innovatory approach to materials with a firm grasp of ergonomics. There is always, too, a subtle sense of humour.

Julian Brown was elected Royal Designer for Industry (RDI) in 1998, one of only eight industrial designers who currently hold this honour.

**My inspiration**
History and the ongoing stories it paints, marking a moment of timely human invention, still relevant today as with these Ancient Etruscan pots

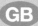

**GB**

**julian brown**

**Q. What types of products do you design?**

A All my products are serially manufactured industrially produced items, including residential, garden and office furniture; tableware, kitchenware and kitchen appliances; consumer electronics (TVs and so on); IT products; sports equipment; vacuum flasks; lighting; pocket knives; desk accessories (clocks, staplers etc.); eyewear; stationery products…

**Q. What or who has been the overriding influence on your work?**

A. History – the knowledge that we enjoy a brief moment within our cultural evolution on this planet. To ignore history would be to sever any connection with the future. The form and purpose of an Etruscan pot is as relevant today as it was 2,500 years ago. It is so deeply rooted within our subconscious that to ignore it would be to miss a beautiful continuity in our use of objects and artefacts.

**Q. What was your big break?**

A. Meeting Jörg Dümmig-Zitzmann of alfi (Germany) and Rino Pirovano of Rexite (Italy), in 1988 and 1990 respectively. With the "BASIC" vacuum flask (1991) for alfi (co-designed with Ross Lovegrove) and the "Vercintorige" alarm clock (1993) for Rexite, two adventurous products were nurtured from design idea to exquisite manufactured object. Each has been very influential and resulted in ongoing design collaborations.

**Q. What makes a good design?**

A. Product design lives beyond the two-dimensional world of advertising and magazines. First, you need to fall in love with a product to buy it; after that, it needs to prove itself day in, day out, time and time again. If it begins to irritate you, or you begin to ignore it because it lets you down, the relationship will collapse and you will move on. Never forget charm – and, yes, design is a long-term thing.

**Q. How important are trends in your work?**

A. "Trend" is such a futile word – it's anathema to the concept of longevity and classicism, and it means death to individuality… Shutting your eyes, however, is not the answer… well, maybe you should keep just one of them open… keep the other strictly for yourself and you will be OK.

**Q. Is your work an individual statement or a team solution?**

A. If I personally am not 100 per cent convinced that a work should exit the studio, then it doesn't go out. As such, yes, the work is the result of a judgement made by an individual mind. At the same time it may – and does – involve the contributions of other valued collaborators.

**Q. To what degree are you able to compromise to satisfy a client?**

A. Compromise implies losing ground, weakness, stubbornness and so on. These are words that have no meaning when you work "together" with your client, as I am fortunate – in most cases – to do so. I therefore never compromise; collectively "we" reach the best possible solution.

**Q. What do you still aspire to design?**

A. The perfect "work" or office chair. One that transcends the notion of the body as a mechanical problem and responds intelligently to our combined physical, mental and emotional patterns.

**Client list**
ACCO
**Alfi Zitzmann**
Berol
**Boker**
British Airways
**Carrera**
Frighetto
**FX Nachtmann**
Haworth
**IBM**
Johnson & Johnson
**Knoll International**
Louis Vuitton
**Magis**
NEC
**Parker Pens**
Piz Buin
**Puma**
Rexite
**Sony**
Studio Brown
Products
**Wedgwood**
WMF
**Zanotta**

**My work**
1. "Standard" A4 letter tray, part of desk accessory range for Rexite (2004)
2. "Toscana" vacuum jug for Alfi Zitzmann (2004)
3. "Stowaway" pocket watch for Studio Brown Products (2002)

**Stephen Burks**
Born 1969 in Chicago, USA
**Studio Location**
New York, USA

Following his studies in product design at the Illinois Institute of Design, Stephen Burks went on to study architecture at the Illinois Institute of Technology. Then in 1997, after attending Columbia University's Graduate School of Architecture, he formed his New York based studio called Readymade Projects. Stephen and his team work across a variety of disciplines ranging from furniture, lighting, and industrial design to interior and exhibition design, events, creative direction and brand strategies.

Alongside his commercial work for international clients such as Cappellini, Covo, David Design, and E&Y, Stephen Burks also shares ideas with like-minded artists, designers and brands. This often results in collaborative projects that involve individuals from other nations, such as the 'Alone Together' collection for E&Y, working with graphic illustrator Masanao Hirayama from Tokyo.

Burks' projects have been exhibited around the world, launching at annual design events in Milan, New York, and Tokyo, where he continues to nurture new business relationships. In 2003, he designed and co-ordinated the Mogu-fied Fun House exhibition in Milan for Mogu (pictured). He was later appointed as art director of this Japanese brand.

**My inspiration**
My wife, Claudette, helps me see things in a new light. This photograph shows her as a child and she is refreshingly honest about my work

**stephen burks**

USA

1

**Q. What types of products do you design?**

A. Here in the studio we're interested in developing new product types. We try to find opportunities to interact with everyday behavior and develop new products around it. There's always a balance between what your client is looking for and what you as a designer would like to pursue, but overall we want to create products that hopefully make a contribution to both our clients needs and our own.

**Q. What or who has been of significant influence in your studio?**

A. My wife Claudette helps us all see things in a different light. In a way, it's very refreshing to have a constant critic who doesn't think like a designer. Although she doesn't work directly with the studio, her contribution is invaluable.

**Q. What was your big break?**

A. A great opportunity came my way, when Giulio Cappellini put my Display shelving system into production back in 2000. It's definitely helped open doors in the international design community. And here in the US, the design market somehow validates designers who have worked in Europe first.

**Q. Do emotions drive your designs?**

A. There is a joy in making things to which others can relate. Maintaining creative curiosity as a designer has always been important to me. I try to translate that creative emotion to the end user through how they relate to the product.

**Q. Are trends important?**

A. Trends in the design market are constantly changing and it's counter-productive for us to try to keep up.

Ultimately, the best clients are more interested in the trajectory of their own product development and not everyone else's.

**Q. How important is it for your work to reflect the design characteristics of your nation?**

A. In this age of globalization, individuality is increasingly important. But I'm not sure how much of America's characteristics I would really want to consciously portray in my work. New York is not America.

**Q. Is your work an individual statement or team solution?**

A. I've never believed that design is an individual statement. To bring an industrial project to market is more often than not a team effort. The team effort begins in my studio and extends to the client, manufacturer and distributor.

**Q. What elements of the design process do you find particularly frustrating?**

A. Typically, meeting low development budgets is challenging, but they are necessary constraints.

**Q. To what level will you compromise to satisfy your client?**

A. Compromise is just one part of the process of design. Everyone compromises, if they are at all interested in the dialogue of design. Sometimes the most interesting developments can be the result of compromise.

**Q. What would be your second career choice after design?**

A. I'm constantly inspired by contemporary developments in architecture and the technology of building. If I had the patience, I'd be an architect.

2

**Client list**
Cappellini
**Covo**
David Design
**E&Y**
Herman Miller
**Idée**
Missoni
**Mogu**
Moroso
**Pure Design**
Vitra

**My work**
1. "Display" shelving
   system for
   Cappellini (2000)
2. "Missoni Patchwork"
   vases for
   Readymade
   Projects & Missoni
   (2004)
3. "Not So Soft" chair
   for Mogu (2003)
4. "Plank of Wood" coat
   rack for Readymade
   Projects (2002)
5. "Alone Together"
   transitional
   accessory for E&Y
   (2003)

3

4

5

**Benjamin Hopf**
born 1971 in Hamburg, Germany
**Constantin Wortmann**
born 1970 in Munich, Germany
**Studio Location**
Munich, Germany

The Büro für Form design studio was founded in 1998, shortly after its directors, Benjamin Hopf and Constantin Wortmann, graduated with Masters degrees in Industrial Design from the University of Design in Munich, Germany. While building essential client relationships, they have also developed several of their own prototypes, which have been presented at key design events such as Salone Satellite in Milan and Passagen in Cologne. Exposure of this sort has caught the attention of the design industry and the related media, propelling this relatively new partnership into the arms of such reputable manufacturers as Habitat and Ycami.

The duo's products are often characterised by a combination of organic, fluid and ergonomic moulded forms, which are sometimes tinged with a touch or two of humour.
In addition to their work on interiors, furniture, lighting, tableware and accessories, Büro für Form also cross over into the realm of graphics and corporate identity, involving freelance designers from a diversity of creative fields such as art, film and media.
In 2001, Alexander Aczél (born 1974 in Munich, Germany) joined the studio as Head of Graphics.

**Our inspiration**
The never-ending portfolio of organic forms invented by nature trigger emotional associations that influence the shapes we apply to the design of objects

**D**

**büro für form**

1

**Q. What types of products do you design?**
A. Our main focus is on furniture, lighting, consumer products and interior design, but we also work on interdisciplinary projects, collaborating with people from various fields, such as graphics, fashion, arts and media.

**Q. What or who has been of significant influence in your studio?**
A. The fascinating variety of organic shapes found in nature – the formal as well as the emotional, significative and associative qualities they combine. For example, the variety of shapes and emotional qualities of water and liquidity inspired our "Liquid_Light" series (for Next, 2001). The combination of two elements that usually don't go together – water and light – created a surprising product that lives through the viewer's associations and emotions.

**Q. What was your big break?**
A. We don't feel like we have had a big break. It is more like an ongoing, steady development – a continuous process.

**Q. What human emotions and necessities drive your designs?**
A. Actually, the necessity of emotion is the driving part. A product needs emotion to be able to correspond with its user.

**Q. How important are trends in your work?**
A. The importance of trends lies rather in setting them than following them.

**Q. How important is it for your work to reflect a specifically German character in design?**
A. We sometimes find it more important not to reflect the design characteristics of our nation…

**Q. Is your work an individual statement or a team solution?**
A. Most of the designs start as an individual statement or idea and are… developed and improved by intense dialogue and exchange as a team.

**Q. What do you find most frustrating about the design process ?**
A. The length of time the whole process takes. It takes too long for an idea to materialise into an actual product that hits the stores. Or perhaps it's our own impatience that we find rather frustrating!

**Q. To what point do you compromise to keep a client happy?**
A. To the point of insomnia – whether we compromise or not.

**Q. What would be your second career choice after design?**
A. Producer.

**Q. What would you most like to design?**
A. The Ferrari F2005!

**Client list**
Acme
**Elmar Flötotto**
Fingermax
**Habitat**
Koziol
**Kundalini**
Mu Meubles
**Next**
Osram
**Serien Lighting**
Siemens
**Vibia**
Ycami

**Our work**
1. "Liquid_Light" lamp
   series for Next (2001)
2. "Leni" headrest
   for Next (2000)
3. "Rocker" chair for
   Mu Meubles (2001)
4. "Diva" barstool for
   Elmar Flötotto (2004)
5. "Flapflap" lamp
   for Next (1999)
6. "Dicke Trude" mobile
   lamp for Next (2000)
7. "Valeria" chair
   for Ycami (2004)

2

3

4

5

6

7

**Humberto Campana**
born 1953 in São Paulo, Brazil
**Fernando Campana**
born 1961 in São Paulo, Brazil
**Studio Location**
São Paulo, Brazil

Humberto Campana trained as a lawyer and his younger brother, Fernando, as an architect before they began working together in the field of design in 1983. The duo launched their first exhibition, entitled "The Inconsolable", at the Museu de Arte de São Paulo (MASP) in 1989, which consisted of a provocative political manifesto rather than a display of functioning objects. Their work was mainly concentrated in Brazil until they were noticed in Europe in the mid-1990s. Since then, they have taken part in exhibitions across the world and produced furniture, lighting and accessory designs for various manufacturers, most notably Edra.

The Campanas' designs are recognised for their use of cheap and readily available materials such as rope, cardboard, recycled textiles, scrap wood or PVC tubing. The result is radically new and unpredictable furniture designs whose form and function are dictated by the material in question. The brothers are fascinated by the way pre-existing components can be assembled into objects with new functions, and will scour industrial suppliers to find suitable materials for their work. Their skill lies in being able to combine high technology and "poor" materials with a handmade appearance of intriguing tactility.

The Campanas inject fun and a refreshing air of confidence into the design industry, and their work has helped draw attention to Brazil's unique contribution to contemporary design.

**Our inspiration**
Brazil is our font of inspiration. Its diversity, its chaos… From the baroque of the forest to the poverty of the city, everything teaches us how to transform scarcity into beauty

campana brothers

BR

**Q. What types of products do you design?**

A. Whenever we start a project, we believe we are creating a "bridge" that connects emotion and function. We never start with a brief.

**Q. What or who has influenced your work most deeply?**

A. The link between the huge urban chaos of São Paulo and the roots of our home town in the countryside.

**Q. What was your big break?**

A. Our exhibition "Project 66" at the Museum of Modern Art in New York in 1998, curated by Paola Antonelli.

**Q. How important are trends in your work?**

A. We have never been concerned with that. Trends are ephemeral. We always try to follow our own path. Many of our projects were shaped in the early 1990s when "neo-minimalism" was the big trend. By that time, our work had gone in completely the opposite direction. We used to make objects that could be called "maximalist", but we didn't change our minds because of criticisms or tendencies – we believed in the power and truth of our roots, our identity.

**Q. How important is it for your work to reflect the design traditions of your nation?**

A. This is the most important challenge for us – to make a portrait of our poor yet beautiful and culturally rich country. Brazil is our main fountain of inspiration. We make our "treasures" out of scarcity, and we are driven to find solutions that bestow nobility on ordinary materials.

**Q. Is your work an individual statement or a team solution?**

A. We are involved in a continuous process of creation – Humberto is more intuitive about forms and materials, while Fernando is the rational side of the team. Besides that, we have a small crew who provide us with fresh air as well as a fresh eye.

**Q. What elements of the design process do you find particularly frustrating?**

A. When it takes us five or more attempts to finish an object. But we always say that to create is to learn how to deal with frustration. Sometimes being frustrated can move us on to better solutions. To be obsessed is very important at such moments.

**Q. To what degree will you compromise to satisfy your client?**

A. As far as we can. But we never think of a project as complete or totally satisfying. In the depth of our souls, there will always be something missing.

**Q. What would be your second career choice after design?**

A. Fernando: Astronaut. Humberto: Gardener.

**Q. What do you still aspire to design?**

A. Fernando: An aeroplane. Humberto: A garden.

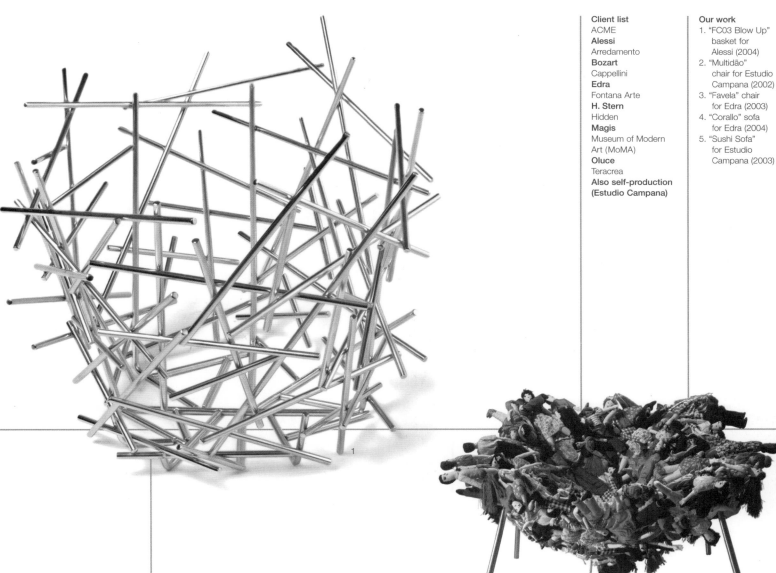

1

2

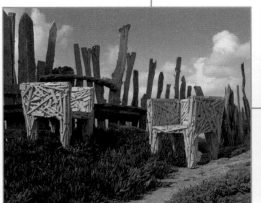

3

4

5

**David Chipperfield**
born 1953 in London, UK
**Studio Locations**
London, UK, and Berlin, Germany

David Chipperfield is first and foremost associated with architectural work. His practice – David Chipperfield Architects (DCA) – has worked on numerous projects, spanning showrooms, hotels, offices, museums, studios and private homes. These have included Dolce & Gabbana stores across the world, the Vitra showroom in London, Bryant Park Hotel in New York City, the River & Rowing Museum in Henley-on-Thames and Antony Gormley's London studio. Current large-scale projects include BBC Scotland's new headquarters in Glasgow, the British Film Institute Film Centre in London, the City of Justice Law Courts in Barcelona, the Anchorage Museum of History and Art in Alaska, and the Neues Museum in Berlin.

Despite this workload, Chipperfield still finds time to design items on a smaller scale, perhaps because his furniture, lighting and bathroom products have often been developed by extending the architectural programme inwards, focusing on interiors and the objects contained within them. He enjoys working with the varying properties of materials, employing, for example, aluminium panels as both structure and surface for furniture, or silver and rubber for a fluid asymmetric tea and coffee service.

Chipperfield qualified from the Architectural Association (AA) in London in 1977, before going on to work for Douglas Stephen, Richard Rogers and Norman Foster. In 1984, he established DCA, which now employs over a hundred staff in two studios in London and Berlin.

## david chipperfield

**GB**

1

**Q. What types of products do you design?**

A. As an architect, I have always considered and enjoyed the detail and the small scale of any space, and designing elements of furniture was an integral part of my projects for clients such as Issey Miyake, Joseph and Dolce & Gabbana. I feel privileged that today I am able to work at an industrial scale for clients such as Cassina IXC. and Ideal Standard, and enjoy the challenges that come with the change of scale of production.

**Q. What or who has been of significant influence in your studio?**

A. I am lucky to work in locations all over the world, mainly in Germany, Italy and Spain, but also in places further a field such as Alaska and China. Working abroad exposes us to a variety of influences and their material and artistic cultures. In particular, in the way they have influenced our product design, I have always admired the work of Gio Ponti, Sol Lewitt and Giorgio Morandi.

**Q. What was your big break?**

A. Designing a shop for Issey Miyake in London enabled me to travel to Japan and be introduced to the clients for my first buildings – in Japan. This was fortunate timing – London at this time was afraid of modern architecture and young architects.

**Q. What human emotions and necessities drive your designs?**

A. I relish the enjoyment of daily rituals, whether this is taking a bath in a beautiful bathroom, eating breakfast from a simple oak table or reading by a perfect lamp. In my designs, I try to make simple, beautiful and functional objects.

**Q. Is your work an individual statement or a team solution?**

A. I run two studios with architects and designers, one in London and one in Berlin. The studios are structured around a series of teams. Teamwork is essential in architecture – the complexity of projects requires enormous teams of architects, engineers and other specialists. Because of the number of projects and deadlines for all the architectural projects, I have less time than I would like for product design.

**Q. What elements of the design process do you find particularly frustrating?**

A. Manufacturers unwilling to try something they've never done before. This is rare, however, and with encouragement we can sometimes be persuasive. This is something that's never happened to us in Italy.

**Q. What do you still aspire to design?**

A. I believe that we are starting to produce our most interesting work. The experience of the studio allows us to develop our ideas with more authority and conviction.

**My work**
1. "Air Frame" furniture collection for Cassina IXC (1992–2002)
2. "Tea & Coffee Service" for Alessi (2002)
3. "White & Silver" bathroom collection for Ideal Standard (2002)
4. "White & Silver" bathroom collection for Ideal Standard (2002)

2

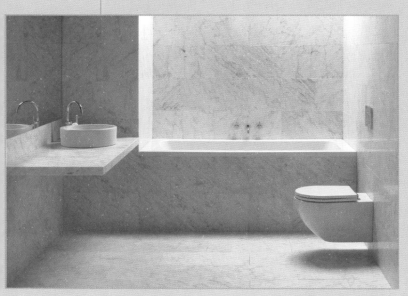

3

4

**Antonio Citterio**
born 1950 in Meda, Italy
**Studio Location**
Milan, Italy, and Hamburg, Germany

Antonio Citterio graduated in Architecture from the Politecnico di Milano in 1972, after which he began working as an industrial designer for established Italian and international manufacturers, often in collaboration with fellow Italian designer Paolo Nava. In 1981, he opened an architectural and interior design practice, joining forces with his wife, the American architect Terry Dwan, from 1987 to 1996.

The duo worked on impressive joint projects including the Esprit headquarters in Milan, Amsterdam and Antwerp, and the Vitra furniture factory in Neuenburg, Germany. During this time, Citterio developed products for a wide variety of companies, either independently or together with another designer.

In 1999, Citterio and his long-time collaborator Patricia Viel founded Antonio Citterio & Partners in Milan as a multidisciplinary practice, operating within the fields of product design, private and public architectural design, space planning, retail and showroom design, corporate identity and location design. The following year, he set up a new office in Hamburg with partner Jan Hinrichs. Recent projects include the renovation of Line 1 of the Milan subway, concepts and interiors for Bulgari's luxury hotels and resorts in Bali and Milan, and concept and interiors for De Beers' offices in New York and Los Angeles.

Despite his many large-scale projects, Citterio also manages a considerable output of award-winning interior products, making him one of Italy's most successful designers.

**My inspiration**
Over the years, I have developed ongoing relationships with my clients. Here I am with B&B Italia's chairman, Piero Ambrogio Bushelli, sitting on my "Sity" sofa which won a Compasso d'Oro award in 1987

# antonio citterio

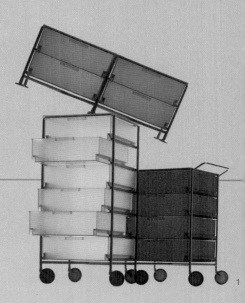

1

**Q. What types of products do you design?**
A. Furniture for domestic and office use, lighting, kitchens, bathroom fittings, as well as doors, handles, cutlery and display systems.

**Q. What or who has most influenced you as a designer?**
A. To answer that, I have to go back to my childhood in Meda, in the Brianza area north of Milan. I became familiar with design at a very early age, and when I was 13, I went to the local art school and started designing furniture four hours a day. Growing up in this very special environment has been an extremely significant influence on my studio…

**Q. Are you ready to compromise with your clients?**
A. "Compromise" refers to something negative, pointless in a working partnership. I strongly believe in the client's role, regarding them in some way as the father of the design and myself as the mother.

**Q. What emotions or needs drive your design?**
A. It is difficult to generalise as it depends on the project. On every project you have to work hard in terms of the many different problems for which you have to find solutions. The ongoing drive is to learn something new and improve every time. Emotions are part of creativity.

**Q. How important are trends in your work?**
A. I tend to keep myself distanced from what's trendy. My approach to the design has always been product-oriented instead of market-oriented.

**Q. What is the relationship between your architectural and industrial designs?**
A. In the Italian architectural tradition, the architecture and the interior design go together. As a result, the way in which my career has evolved is based on the mixture between the architect's conceptual approach and the creativity of the industrial designer. When I start working on a new product… I always visualise its surroundings along with the user's needs and lifestyle.

**Q. Is your work an individual statement or a team solution?**
A. A team solution.

**Q. What elements of the design process do you find particularly frustrating?**
A. What I find frustrating and challenging at the same time is working hard on a technical problem without succeeding in finding a solution that fulfils my expectations.

**Q. What do you still aspire to design?**
A. I would be interested in designing electronic products that everybody can use at home, such as a TV.

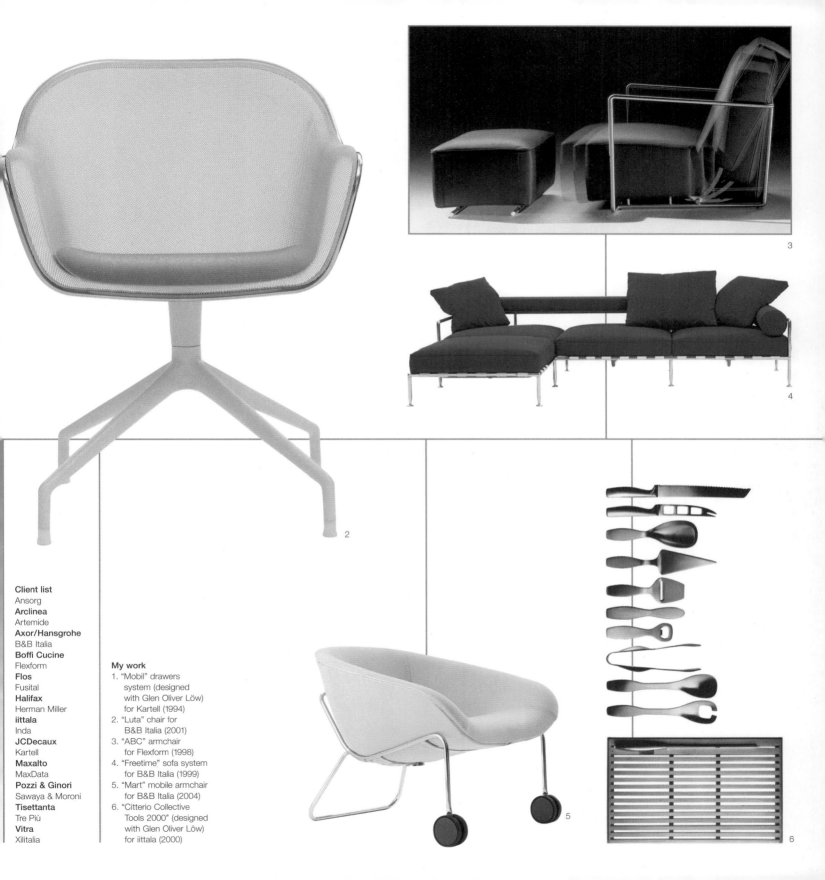

**Client list**
Ansorg
**Arclinea**
Artemide
**Axor/Hansgrohe**
B&B Italia
**Boffi Cucine**
Flexform
**Flos**
Fusital
**Halifax**
Herman Miller
**iittala**
Inda
**JCDecaux**
Kartell
**Maxalto**
MaxData
**Pozzi & Ginori**
Sawaya & Moroni
**Tisettanta**
Tre Più
**Vitra**
Xilitalia

**My work**
1. "Mobil" drawers
   system (designed
   with Glen Oliver Löw)
   for Kartell (1994)
2. "Luta" chair for
   B&B Italia (2001)
3. "ABC" armchair
   for Flexform (1998)
4. "Freetime" sofa system
   for B&B Italia (1999)
5. "Mart" mobile armchair
   for B&B Italia (2004)
6. "Citterio Collective
   Tools 2000" (designed
   with Glen Oliver Löw)
   for iittala (2000)

2

3

4

5

6

**Mårten Claesson**
born 1970 in Lidingo, Sweden
**Eero Koivisto**
born 1958 in Karlstad, Sweden
**Ola Rune**
born 1963 in Lycksele, Sweden
**Studio Location**
Stockholm, Sweden

The dynamic design trio of Mårten Claesson, Eero Koivisto and Ola Rune met while studying at Stockholm's Konstfack (University of Arts, Crafts and Design). Before graduating together in 1994, they had already decided to start a business, and the following year founded their architecture and industrial-design practice Claesson Koivisto Rune (CKR) in the Swedish capital. The practice has designed numerous private residences, as well as restaurants, stores and offices, such as Gucci's Stockholm store, Sony Music's Stockholm offices, the Swedish ambassador's residence in Berlin, and the four-storey Sfera Building in Kyoto.

In addition to their architectural projects, CKR has a prolific industrial-design output whose visual clarity, material honesty and considered functionality are comparable to that of some of the great masters of 20th-century Scandinavian design. Working across such a diversity of scale, the trio have evolved a distinct and acute awareness of the way humans relate to their environments. Each of their seemingly minimalist and functionalist designs has an element of emotion that distinguishes their work from the mainstream of Modernism. Commissions are tackled collectively or individually, leaving each partner free to pursue additional activities such as writing, teaching and lecturing.

**Our inspiration**
A variety of artists influence our designs, including Donald Judd for his confident execution of geometric sculptural clarity, demonstrated here in "Untitled" (1990)

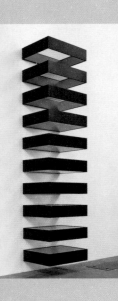

## claesson koivisto rune   s

**Q. What types of products do you design?**
A. Urban buildings, private houses, interiors, furniture… we have designed everything from a multi-storey building to a toothbrush.

**Q. What influences your work?**
A. Travel, people, food, fashion… life in general, especially the things that add quality to experience. Art, of course, is influential, particularly the work of Richard Serra, James Turell, Anish Kapoor and Donald Judd.

**Q. What was your big break?**
A. Our very first piece that gained world recognition was the 1997 "Bowie" chair for David Design. A later important piece is the 2001 "Pebbles" seating module for Cappellini.

**Q. What emotions and necessities drive your designs?**
A. First, the irrational emotions – passion, love, joy. Second, the rational necessities – function, ergonomics, economics and so on.

**Q. How important are trends in your work?**
A. We do try not to be trendy in our work. Does that mean that time doesn't leave its mark on our designs? Probably not.

**Q. Is your Swedish nationality important in your work?**
A. Nationality is absolutely not important. Does that mean our nationality doesn't show at all? Probably not.

**Q. Is your work an individual statement or a team solution?**
A. Shared joy is joy tripled.

**Q. What elements of the design process do you find particularly frustrating?**
A. When someone along the way who does not understand the essence of the design tries to change it.

**Q. To what level will you compromise to satisfy your client?**
A. Everything can be negotiable except the core, the idea, the essence. This is a very fragile thing. If this is threatened, it's sometimes better to start over again or even cancel the project.

**Q. What would be your second career choice after design?**
A. There is no second choice. Really!

**Q. What do you still aspire to design?**
A. There is no end to the challenges. Things we haven't done before like a high-rise building, a subway station or a car. But also things we have done before – you always want to improve!

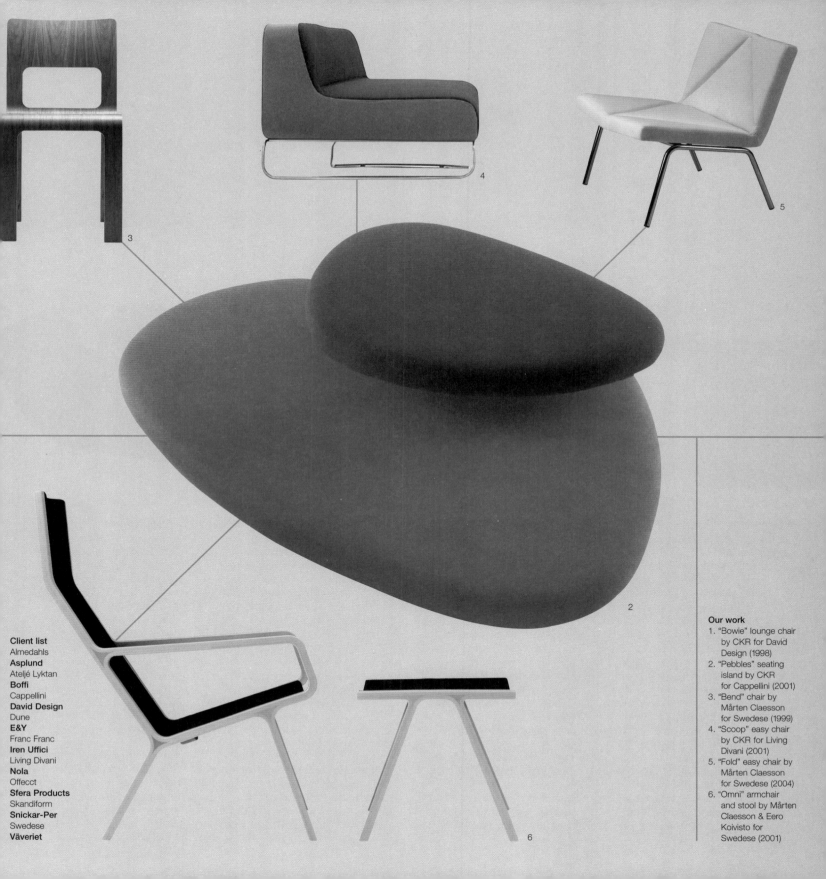

**Client list**
Almedahls
**Asplund**
Ateljé Lyktan
**Boffi**
Cappellini
**David Design**
Dune
**E&Y**
Franc Franc
**Iren Uffici**
Living Divani
**Nola**
Offecct
**Sfera Products**
Skandiform
**Snickar-Per**
Swedese
**Väveriet**

**Our work**
1. "Bowie" lounge chair
   by CKR for David
   Design (1998)
2. "Pebbles" seating
   island by CKR
   for Cappellini (2001)
3. "Bend" chair by
   Mårten Claesson
   for Swedese (1999)
4. "Scoop" easy chair
   by CKR for Living
   Divani (2001)
5. "Fold" easy chair by
   Mårten Claesson
   for Swedese (2004)
6. "Omni" armchair
   and stool by Mårten
   Claesson & Eero
   Koivisto for
   Swedese (2001)

**Claudio Colucci**
born 1965 in Locarno, Switzerland
**Studio Locations**
Paris, France, and Tokyo, Japan

Claudio Colucci has lived and worked in many countries, which has shaped his distinctive approach to design – at once multicultural and transcultural. He initially studied in Geneva before heading to the Ecole Nationale Supérieure de Création Industrielle (ENSCI) in Paris, where he stayed from 1988 to 1992, during which time he also undertook a scholarship exchange at Kingston University in London. Gaining work experience in the studios of Ron Arad (pp 34–35) and Nigel Coates, he returned to Paris in 1993, working as a designer for Pascal Mourgue (pp 176–177).

In 1994, Colucci co-founded RADI Designers. That year, he worked on a variety of industrially produced electrical items for Thomson Multimedia under the art direction of Philippe Starck (pp 224–225). He then began an enduring love affair with Japan, setting up a Tokyo office for RADI Designers. In 2000, Colucci went independent, opening Claudio Colucci Design in Tokyo, though he still retained an office in Paris. The cultural cross-pollination flowers in such works as the "Dolce Vita" lounger (2000), which transfers the function of the traditional Japanese mat, the tatami, to a chair. Starck-esque wit is evident in the "Fisholino" toilet brush (2000), while multifunctionalism reminiscent of much contemporary Japanese design is evident in the "Solo/Duo" (2000) chair/bed for Habitat.

**My inspiration**
The buzz of Tokyo constantly feeds creative ambition – the cultural discoveries adding a refreshing contrast from those of Europe

## claudio colucci

1

**Q. What types of products do you design?**

A. I design any kind of product, from the very small scale – an electrical switch, for example – to a 14-storey building, but the project has to have a challenge or something new about it. I like my designs to tell a story, to have a twist of humour, a magic touch… something hidden.

**Q. What or who has been the most significant influence on your work?**

A. I think travelling – and probably living and working between Paris and Tokyo. Absolutely everything inspires me in Japan – the city, the speed, the nightlife, the girls, the food, the ephemerality, the lifestyle, the onsen (hot springs), the kimono, the happiness, the contradictions, the language, the design, the fashion, the silly things… the travelling, too, between Paris and Tokyo, having a double life, being in a plane, in the airport, coming back, leaving again… I could talk about Japan for hours.

What I'm always influenced by is an environment and culture in which I feel good. Paris was a very good influence for many years… today it's Japan… and recently both cities have fed a new creativity in me.

**Q. How important is it for your work to reflect the design characteristics of your nation?**

A. My own sense of nationality is very complicated. I have always travelled a lot, and I'm a child of immigrants, so my nationality is a mixture of many things. So, yes, it is important to show this mixed identity in my work. In my designs, I create a new boundless nation that is very much a reflection of my personality.

**Q. Is your work an individual statement or a team solution?**

A. It used to be a team "solution" – I created RADI Designers in 1992, and I spent eight years with the group. It was very interesting work and our vision was unique – it was a great laboratory where everything had to be approved by each of the five members. Since 2000, when I created my own offices in Tokyo and Paris, my design has been an individual statement. I have 14 people working for me, and, of course, we do collaborate, but the concept, the direction, the first draught sketch, always comes from me.

**Q. What elements of the design process do you find particularly frustrating?**

A. Basically nothing; even the frustration is a creative part of the design process. It is just like a game. Frustration can bring about a new solution, a new vision of something. Design is about discovering things and finding innovative solutions.

**Q. To what degree will you compromise with a client?**

A. Until he persuades me that he is right and backs it up with a very solid argument. It's about right or wrong; it's not about a colour preference.

My clients choose me for what I do, so most of the time they are quite happy to follow my judgement. But, of course, clients have needs that we have to listen to and follow. If I listen carefully to my client, then I have done most of my work and I don't have to compromise on anything.

**Q. What do you still aspire to design?**

A. A space station or something similar under the sea. Any new challenge!

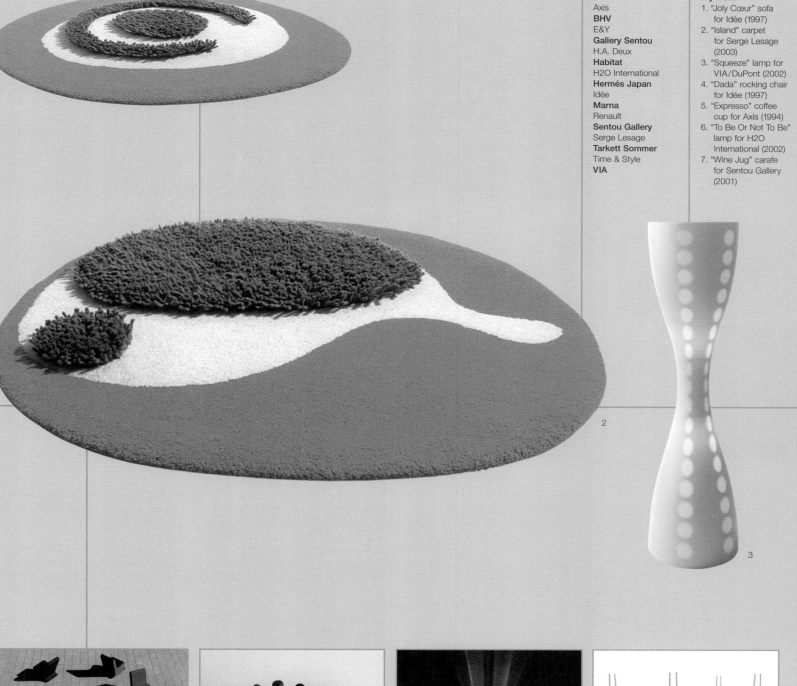

2

3

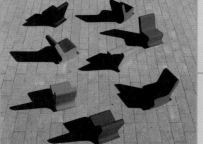

4

5

6

7

**Sebastian Conran**
born 1956 in London, UK
**Studio Location**
London, UK

Sebastian Conran's career in design began in 1974 when he went to London's Central College to study Industrial Design Engineering. In 1976, he became involved with the band The Clash, designing their record sleeves, promotional posters, advertising, literature and branded merchandise. A year as a product designer at Conran Associates preceded his time as Design Director at Woolf Olins, one of Britain's leading corporate/brand identity consultancies, where he took the creative lead for key accounts such as British Rail, Pilkington and Shell Petroleum from 1979 to 1985. During this time, he was also directly responsible for reinventing the look of the high-street chain Mothercare.

In 1986, he founded Sebastian Conran Associates, to work across the practices of corporate graphics, product design, merchandise development, and retail, environmental and exhibition design. In 1999, the consultancy merged with Conran Design Partnership to become Conran & Partners to work across the disciplines of interiors, architecture, products and graphics.

Conran is the creative director responsible for products and graphics. He has been instrumental in developing award-winning products, ranging from ceramics and luxury leather goods to concept cars. Among the many products he has designed are the "Equilibrium" kitchen range, the "Via" pushchair (1986) for Mothercare and the MicroMap.

**My inspiration**
The considerable professional undertakings of my father have had a marked effect on my life, he gave me invaluable mentoring advice

GB

sebastian conran

1

**Q. What types of products do you design?**

A. Hopefully ones that are functionally innovative and display a certain amount of mechanical ingenuity and inventiveness. My approach to form could be described as soft tech or organic, though it is really a question of delivering appropriate design solutions that meet requirements and the challenges set.

**Q. What or who has infuenced your work?**

A. Everything influences me. My primary influences have been my father, Terence, and Professor Brainstawm (really!), though sculptors such as Anish Kapoor, Henry Moore, Brancusi, Eduardo Paollozzi and the Russian Constructivists have also helped shape my approach. Designers would include Dieter Rams, Seymour Powell, Ross Lovegrove, Michael Woolf, Georgina Godley, Achille Castiglioni and Jonathan Ive.

**Q. What was your big break?**

A. Apart from being born to two very interesting – if a little difficult – parents, I would say getting a job at Woolf Olins with Michael Woolf, then working with Terence on repositioning Mothercare.

**Q. What human emotions and necessities drive your designs?**

A. Logic, charm and wit.

**Q. How important are trends in your work?**

A. I like to think that my work will be timeless, although it is affected by what is going on around me at the time. Also being a commercial activity, it has to reflect consumers' desires at that time – if it doesn't sell, we don't eat and all else is irrelevant. Profit surfs the wave of fashion but sadly doesn't precede it.

**Q. Is your work an individual statement or a team solution?**

A. All successful teams have leaders and chaired committees produce [Millennium] Domes. As I see it, all the work is that of the team, but it wouldn't have been the same (or as good?) if I had not been leading it; we all need to share the fruits of success.

**Q. Are you annoyed or frustrated by any elements of the design process?**

A. Poor or misinformed research – the natural enemy of innovation – like when people ask the opinion of others rather than make a decision themselves. To be told by a client that the receptionist didn't like the colour makes me weep. I cannot think of one true innovation that was ever spawned by research. If you are going to take the trouble and expense of going to a decent designer, at least take notice of what they have to say – especially if it is of a subjective nature.

**Q. To what level will you compromise to satisfy your client?**

A. All good design is by nature a compromise of requirements, whether function, quality, aesthetics or price.

**Q. What would be your second career choice after design?**

A. Perhaps being a physicist or an engineer, otherwise photography or illustration.

**Q. What do you still aspire to design?**

A. A compact, energy-efficient city car that emphasises space ahead of pace – a TARDIS would be about right.

**My work**

1. "Anywayup" cup
   for Haberman (1998)
2. "Equilibrium"
   kitchen scales
   for Bliss (1999)
3. "Automotive tool
   case" for Connolly
   Leather (1997)
4. "Compact disk
   case" for Connolly
   Leather (1997)
5. "Cube" show-car
   for Nissan (2003)

**Client list**
Bliss
**Boots**
British Airways
**Connolly Leather**
Economist
**Guzzini**
Haberman
**Imperial War Museum**
Legrand
**Michelin**
Moët & Chandon
**Monoprix**
Mothercare
**Nigella Lawson**
Nissan
**Rolls Royce
Aerospace**
Sainsbury's
**Science Museum,
London**
Umbro
**Villeroy & Boch**
Wedgwood

**Matali Crasset**
born 1965 in Châlons-en-Champagne, France
**Studio Location**
Paris, France

Matali Crasset started out by studying marketing. During an advertising course, however, she tried her hand at packaging design and was inspired to change direction and enrol on a course in Industrial Design at Les Ateliers, Ecole Nationale Supérieure de Création Industrielle (ENSCI) in Paris. After graduation in 1991, Crasset participated in the 1992 Milan Triennale, where she presented "The Domestic Trilogy" project – the first of many projects that re-examine domestic environments. In the same year, she worked for the Italian designer and architect Denis Santachiara on product, exhibition and architectural designs. She returned to Paris in 1993 to join the agency of Philippe Starck (pp 224–225) and the Thomson Multimedia electronics group.

In 1998, she set up her own studio within her home in Paris. Her first significant project was "When Jim Comes to Paris", a bed–lamp–clock installation presented (to somewhat mixed reactions) at the Salone Satellite exhibition in Milan in 1998. Subsequent projects have continued to explore new possibilities, such as the "Phytolab" bathroom concept for Dornbracht (2001) – an acrylic bathing cube whose lack of mirrors diverts our attention from how we look to the comparatively neglected senses of touch and smell – and the playful interiors of the much-fêted Hi Hotel (2003) in Nice.

**My inspiration**
This Blashka glass model of a greatly enlarged single-celled protozoan by Haeckel shows the geometric perfection achievable in nature

## matali crasset

**F**

1

---

**Q. What types of products do you design?**

A. I will design anything except weapons and objects associated with the tobacco industry. Best of all, I like working on projects that I have never done before.

**Q. What or who has been influential in your studio?**

A. An image of a radiolarian [a marine unicellular animal whose glassy skeleton often displays near-perfect geometric forms] was an important influence. I think that we can learn a lot from nature. I am fascinated by how nature uses very basic forms to create a multifaceted richness.

**Q. What was your big break?**

A. The birth of my first child, Popline, when we decided to set up a studio in our home. I am 100 per cent workaholic, but for me, there is no separation between life and work. I work with my husband, who manages the studio, and we work together at home – we want to see our children growing up.

**Q. What human emotions and necessities drive your designs?**

A. Generosity, hospitality, optimism … Let's take the example of "When Jim Comes to Paris."

Form is not my first concern. My furniture does not rely on double functionality but rather on new approaches to use, typology, organisation and the behaviours linked to furniture. For the most part, furniture has remained just the same as in our grandparents' times. The questions that inspire my work are: How can we rethink domestic space? How do we infuse hospitality and generosity into our living environment? How can we reconceive small spaces?

I decided to design a set of objects using the specifics of real or imagined friends as founding elements. I wanted, moreover, to offer an alternative solution to the sofa bed. For me, the convertible couch relies on an idea that is cruel and ungenerous.

"When Jim Comes to Paris" is an answer to the cramped space of Parisian apartments, a way to accommodate a friend in the best possible conditions when there is no spare bedroom.

**Q. How important is it for your work to reflect French characteristics?**

A. I am French, my grandfather was Belgian; we don't choose our nationality. It's a concept that means very little to me. My connections are more European, with designers like Vogt + Weizenegger in Germany or Denis Santachiara in Italy.

**Q. Is your work an individual statement or a team solution?**

A. My proposals are individual, but the process is a team solution. We cannot design a project in our world without being in contact with engineers, marketing, etc.

**Q. What elements of the design process do you find frustrating?**

A. When a project is cancelled because there's been an adverse movement on the stock exchange … design and creativity are very fragile.

**Q. To what level will you compromise to satisfy your client?**

A. I never compromise, but there is always some kind of evolution in a project. There's a point, though, beyond which I will not go.

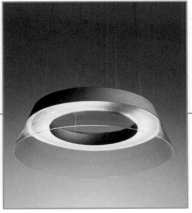

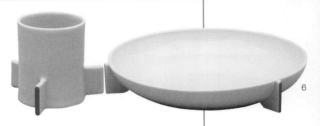

2

3

4

**Client list:**
Aquamass
**Artemide**
Authentics
**Comité Colbert**
Cristal Saint Louis
**Danese**
De Vecchi
**DIM**
Dolomite
**Domeau & Pérès**
Dornbracht
**Edra**
Felice Rossi
**Gandy Gallery**
Hermès
**Hi Hotel**
Lexon
**Orangina**
S.M.A.K
**Tefal**
Thomson Multimedia

**My work**
1. "Don O" portable mono radio-cassette player for Thomson Multimédia (1995)
2. "Energizer" bathroom concept for Dornbracht (2002)
3. "Lerace" fluorescent suspension lamp for Artemide (2000)
4. Wireless electric kettle, part of the "Home Wear" collection for Tefal (2000)
5. "Phytolab" bathroom concept for Dornbracht (2002)
6. "Hi.Link" porcelain table service for Hi Hotel, Nice (2002)
7. "Happy Bar" for Hi Hotel, Nice (2003)

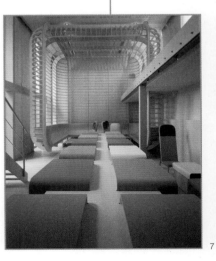

6

5

7

**Nick Crosbie**
born 1971 in London, UK
**Studio Location**
Inflate studio, London, UK

Nick Crosbie trained in Industrial Design first at London's Central St Martins College of Art and Design followed by postgraduate studies at the Royal College of Art. On completing the course in 1995 – with the help of his first investment, a high-frequency welding machine – he had begun to explore the notion of creating inflatable products. That year, along with his partners, Mark and Michael Sodeau (pp 220–221), he set up the Inflate studio. By cutting and welding PVC sheets, this innovative trio formed a collection of inflatable products such as a fruit bowl, light and egg cup.

The designs captured the imagination of the international design scene and, before Crosbie and his partners knew it, they had a brand. Michael Sodeau left to set up independently in 1997, the same year that Inflate began to add dip-moulded products to its range. In 1999, Inflate developed the "Memo" beanbag in conjunction with Ron Arad (pp 34–35), and a year later it produced the "Snoozy" bed, the company's first rotational-moulded product.

In 2001, Inflate opened a shop in London's Clerkenwell. From here, Inflate have expanded their offerings to include large-scale inflatable structures such an "Office in a Bucket" (OIAB) – a portable office and meeting room.

**My inspiration**
The manufacturing experimentation of the Eameses gave rise to some truly revolutionary plywood mouldings. Here is one such design undergoing early testing

1

## nick crosbie — GB

**Q. What types of products do you design?**
A. I design anything from small packaging items all the way to architectural outdoor structures.

**Q. What or who has influenced your studio?**
A. Manufacturing processes: without manufacturing I would be nowhere. Come to think of it everyone would! The Eames partnership's work: especially the early prototypes and experimental plywood moulding. They embraced a new manufacturing process in such a way that they allowed the process to inform the products.
PVC: because it is the most versatile man-made material. It can be used in almost any manufacturing process and is very economical. However, the last years have seen concern over its effects on the environment, so unfortunately my loyalties are moving towards nylon.

**Q. What was your big break?**
A. In 1994, when I bought my first welding machine.

**Q. How important are trends in your work?**
A. For me, it's important to try and position yourself outside trends. When I started out initially, what I did became very trendy. Then when that was all over, it took a lot of work to continue to grow without being trendy. I prefer just doing it my way, and even if we are never "the trend" again but continue to grow all the same, that's fine with me.

**Q. How important is it for your work to reflect the design characteristics of your nation?**
A. When I began I was totally into the "Made in Britain" stuff. Unfortunately our government had, and continues to have, policies that are completely killing off our ability to compete competitively in manufacturing. Britain is a creative place. We breed vision and creativity. It is one of our best exports, and it shouldn't be. It should be at the heart of the future Britain.

**Q. Is your work an individual statement or a team solution?**
A. It's a mixture. I drive a lot of projects from a personal starting point, but one can benefit from many heads during the process.

**Q. What elements of the design process do you find frustrating?**
I find it frustrating when clients do not appreciate that there is a process to creating physical objects and that this is when all the problems are resolved.
The ease with which computer renderings can be presented has devalued the role of good designers.

**Q. To what level will you compromise to satisfy your client?**
A. I don't like to compromise, as I believe every project should be held back only by your own imagination.

**Q. What would be your second career choice after design?**
A. A builder. I used to enjoy experimenting with building materials. The first thing I designed was a concrete ashtray.

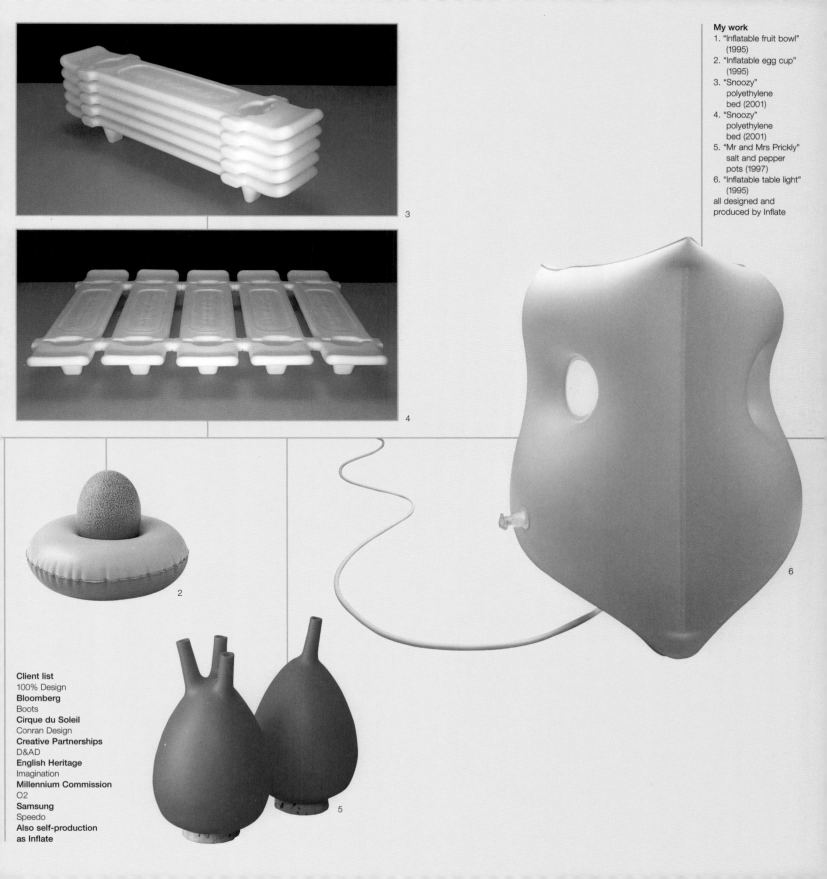

3

4

2

6

**Client list**
100% Design
**Bloomberg**
Boots
**Cirque du Soleil**
Conran Design
**Creative Partnerships**
D&AD
**English Heritage**
Imagination
**Millennium Commission**
O2
**Samsung**
Speedo
**Also self-production as Inflate**

5

**Björn Dahlström**
born 1957 in Stockholm, Sweden
**Studio Location**
Stockholm, Sweden

Industrial and furniture design, as well as graphic design, accounts for most of Björn Dahlström's work, but this wasn't always the case. This self-taught Swede began his career working on animation and graphics for film and TV productions in the mid-1970s. In 1978, he worked as an art director and graphic designer in an advertising agency, focusing mainly on printed design.

In 1982, he started his own company, concentrating on graphic design for clients such as Ericsson, Scania and Atlas Copco. Later that decade, he turned his attention to the third dimension, beginning with children's toys, to which he applied a graphic clarity reminiscent of that of his two-dimensional work. He has even tackled designing tools for heavy industry, creating, for example, a pneumatic drill that produces less vibration and noise but is elegant to look at and easy to use.

Dahlström's work for clients such as cbi and iittala has earned him an international reputation and several design awards. From 1999 to 2001, he was professor at the Konstfack (University of Arts, Crafts and Design) in Stockholm. He now teaches at the city's Beckmans School of Design, and is a member of the Society of Swedish Industrial Designers (SID).

**My inspiration**
Coming from a background in graphics, I have a fond appreciation of timeless typefaces, such as Gill that was designed in the early 20th Century

ABCDEFGHI
JKLMNOPQR
STUVWXYZ
abcdefghijklmn
opqrstuvwxyz

## björn dahlström

s

1

**Q. What types of products do you design?**
A. I have a relatively broad spectrum of work. It goes from graphic design to toys, furniture, cookware, bicycles, glass and heavy industrial equipment.

**Q. What or who has inspired your work?**
A. One of my greatest inspirations is typography… Some of the best typefaces never seem to become dated. They just appear in different settings, communicating information and adopting, and adding to, the message. And it is not all about the design of the typeface itself; it is also how it combines with what surrounds it – and the important space in between. It reminds us that every object has to relate to an environment. Take the font Gill as an example, which dates back to the early 20th century and which is still going strong. It's complex yet simple – use it well and it will look as if someone made it yesterday. It is exciting trying to imagine other design objects travelling through time and remaining just as unaffected.

**Q. What was your big break?**
A. The "Rocking Rabbit", a rocking toy I designed for the Swedish toy company Playsam in 1989, was my first product design that made an impact and received an Excellent Swedish Design award. In 1998, iittala launched the Hackman Tools cookware collection, called "Dahlström 98". This was a chance for me to combine my idea of designing with both graphic simplicity and functionality in mind. The result was a success and gave me international contacts.

**Q. What motivates your designs?**
A. I think that when working with toys, for example, the big reward is to see children actually use the object. If they like it, it is directly communicated by the fun they have. Adults are not as direct as children, but we are definitely positively affected by using objects that are simpatico. So, for me, it is obvious that we need a certain amount of well-designed everyday objects that help us with the everyday things we do, so why not start by trying to make them a little bit better – more easy and fun to use?

**Q. Do you think your work is influenced by your nationality?**
A. I don't think about this a lot. On the other hand, I'm sure that culture and heritage does come through in some way in all the things one does.

**Q. To what level will you compromise to satisfy your client?**
A. I find it important to be able to look at the finished result and still feel proud of my work. When drawing the line of compromise it's helpful to ask yourself questions like, "Are we actually improving or degrading the project through the proposed changes?" On the other hand it's sometimes through compromise that you find a new direction.

**Q. What would be your second career choice after design?**
A. Engineer.

**Q. What do you still aspire to design?**
A. I would like to go into more specialised fields of furniture. Working with school furniture, for example, would be exciting. Sometimes the more restraints there are, the better the project, I think.

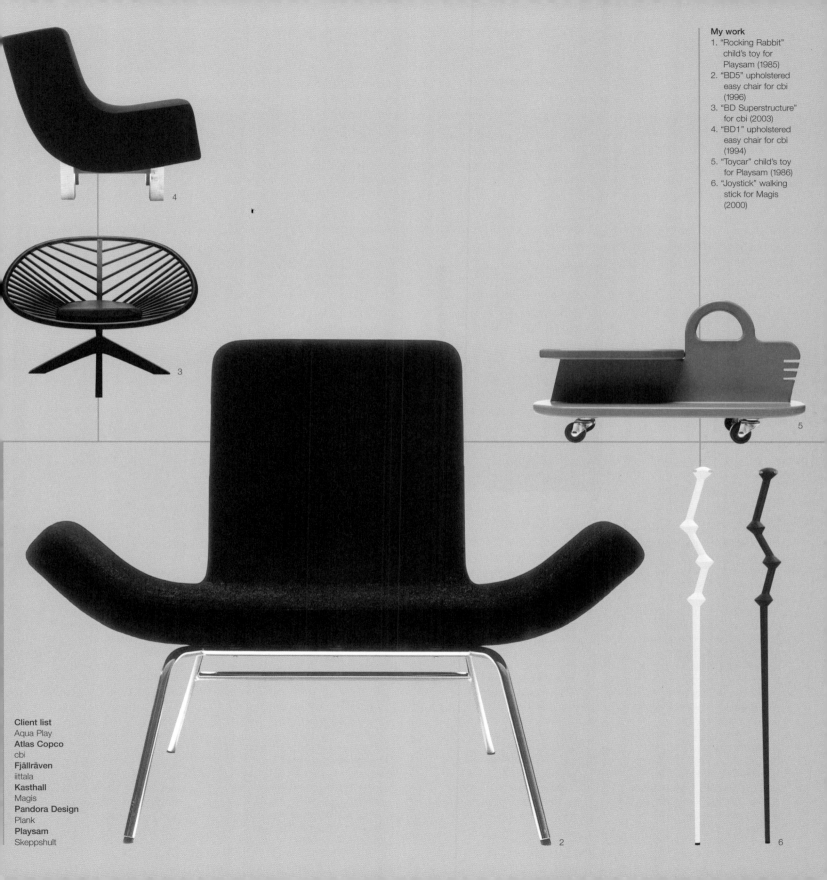

4

3

5

2

6

**Client list**
Aqua Play
**Atlas Copco**
cbi
**Fjällräven**
iittala
**Kasthall**
Magis
**Pandora Design**
Plank
**Playsam**
Skeppshult

**Michele De Lucchi**
born 1951 in Ferrara, Italy
**Studio Location**
Milan and Rome, Italy

The architect, designer and design theorist Michele De Lucchi studied Architecture first in Padua, and then at the university in Florence, from which he graduated in 1975. Even before finishing his studies, De Lucchi had set up the radical design group Cavart and subsequently worked on projects for the Alchymia group. In 1981, he became a founder member of Memphis, the Milan-based collective of furniture and product designers whose irreverent Postmodern style came to dominate early-80s design. During this period, De Lucchi produced some of his most famous, iconic designs, including the "Kristall" table (1981), the "First" chair (1983) and the "Tolemeo" articulated desk-top lamp (1984) for Artemide.

Since the 1990s, De Lucchi has undertaken a vast array of projects – encompassing industrial and product design, visual communication, museum and exhibition stands, interiors, and public and private architecture. In 1992, he took on the direction of product design at Olivetti, and has also been responsible for redesigning the look of Telecom Italia. In parallel with such large-scale projects, De Lucchi also runs Produzione Privata (established 1990) to develop and produce more experimental, craft-based pieces.

De Lucchi has received numerous awards for his work, including the Compasso d'Oro and Good Design (Japan), and lectures widely.

## michele de lucchi

1

**Q. What types of products do you design?**
A. I design products for the home and for the office; for public environments and retail environments; services, furniture, lamps, electronic goods, technical components, architectural components … I don't design fashion accessories or vehicles.

**Q. What or who has been of significant influence on your work as a whole?**
A. My influences are my mentors, Ettore Sottsass and Achille Castiglioni, and Italian design in general. It is very important to realise that everything we touch today has been manufactured. We do not have alternatives to industrial production, though artisanal production still creatively feeds the experimentation that industry does not have.

**Q. What was your big break?**
A. The moment that I understood that design is developed and produced within large industries, but created in the world of the everyday.

**Q. What human emotions and necessities drive your designs?**
A. All of them, save those that come from market and commercial competition.

**Q. How important are trends in your work?**
A. They're important in so far as they are a testimony of the age and able to withstand the test of time.

**Q. Is your work an individual statement or a team solution?**
A. I will say my work is an individual statement with a team solution, as long as the outcome is consistent and meaningful.

**Q. What elements of the design process do you find particularly frustrating?**
A. None […]. Frustration often becomes an opportunity to go beyond the prejudices of a project. What I normally won't accept is when market research diminishes the content of a project.

**Q. To what level will you compromise to satisfy your client?**
A. On every level. I am willing to directly make compromises as long as it makes sense.

**Q. What would be your second career choice after design?**
A. I would have to think about it!

**Q. What do you still aspire to design?**
A. Something that in some small way contributes to the survival of the universe.

**Q. In one sentence, please describe your design approach.**
A. To give meaning to industrial production.

**Q. What should be the role of a designer in society today?**
A. A designer should try to improve the quality and importance of the industrial culture with subjects that refer to intellectual honesty, simplicity, and beauty. Design helps to increase the importance of the culture in which we live.

**Client list**
Artemide
**Banca Populare
de Lodi**
Compaq
Computers
**Dada Cucine**
Deutsche Bank
**Deutscher
Bundesbahn**
ENEL (Italian
electricity board)
**Kartell**
Mandarina Duck
**Matsushita**
Mauser
**Olivetti**
Philips
**Poltrona Frau**
Poste Italiane
**Siemens**
Telecom Italia
**Vitra**
Also self-
production for
Produzione Privata

**My work**
1. "Tolomeo" lamp
   for Artemide (1987)
2. "Viso" limited edition
   lamp for Produzione
   Privata (1994/2001)
3. "First" chair for
   Memphis (1983)
4. "Logico" light
   designed in
   collaboration with
   Gerhard Reichert
   for Artemide (2001)
5. "Castore" lamp
   designed in
   collaboration with
   Huub Ubbens for
   Artemide (2003)
6. "Treforchette" lamp
   for Produzione
   Privata (1997)

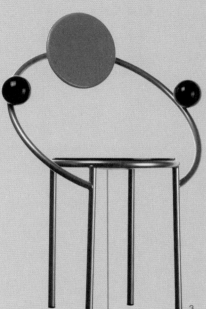

3

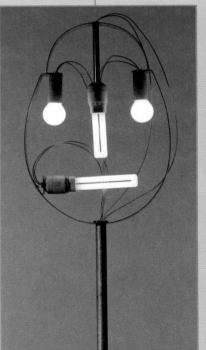

2

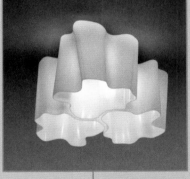

4

5

6

**Nick Dine**
born 1965 in New York City, USA
**Studio Location**
New York City, USA

Nick Dine was educated at the Rhode Island School of Design (RISD), where he majored in Sculpture, and then pursued a Masters degree in Furniture Design at London's Royal College of Art (RCA). Returning to New York, Dine began working as a furniture and interior designer in the 1990s, while acting as a design consultant for the Sunshine Group – a PR and marketing firm.

In 1995, he founded his own company, Nick Dine Design – later rechristened Dinersan – spanning both interior and product design. The company has been responsible for a wide range of retail environments in New York, including the Stüssy flagship store and the Kirna Zabete fashion boutique, as well as restaurants – such as the Embassy Bar and Take – and private residences. Most of Dine's furniture designs have been produced by Dune, a young New York–based manufacturer, of which Dine has been Design Director since 2000. His furniture often features a strong use of colour, which is used to accent graphic forms. Modular configurable options are also available, such as the "Electrode" shelving for Dune (2003) and the "Gomer Pile" storage system for Idée (1996).

A multidisciplinary approach is crucial to Dinersan, with team members encouraged to embrace various elements of the creative process during any one project. Such challenges, Dine argues, breed lateral thinking and broaden imaginations, better equipping the team for multiple scenarios.

Dine is a guest lecturer at Parsons School of Design and RISD. He was named Best Designer at New York's International Contemporary Furniture Fair (ICFF) in 2000. In 2004, he set up Dine Murphy Wood LLC to undertake a wider scope of design.

**My inspiration**
Early influences were comic books such as Hergé's *The Adventures of Tintin*

**USA**

**nick dine**

---

**Q. What types of products do you design?**
A. Furniture, ceramics, interiors and structures.

**Q. What or who has been of significant influence on your work as a whole?**
A. Influences change with time. My first big influence was a compendium of Buck Rogers comics from the 1930s and 1940s. They were in a large bound book and reproduced in colour. The intense graphic quality was monumental to me. The Hergé books about Tintin are also paramount. Among designers: Mies van der Rohe, George Nelson and Jasper Morrison.

**Q. What was your big break?**
A. It hasn't happened yet.

**Q. What human emotions and necessities drive your designs?**
A. Historically, I have worked at other things while maintaining a design office. Construction, teaching, freelancing for others… Designing is a huge thrill and honour. I regard it now as a privilege. Humility is important. Lots of designers' egos are way out of proportion; it's not healthy for them or the community.

**Q. How important are trends in your work?**
A. Not at all. I love watching my peers' careers and enjoying their success. I also try to stay far away from the action, fairs and so on; it distracts the hell out of me.

**Q. How important is it for your work to reflect a US design aesthetic?**
A. The USA only has a fledgling design culture, yet we invented industrial design. I think I have always looked at Italy and Scandinavia for inspiration as opposed to the USA.

**Q. Is your work an individual statement or a team solution?**
A. I have been fortunate to have great people working with me. I regard the essence of the idea as owned by an individual. The end product is usually a collaborative process.

**Q. What elements of the design process do you find particularly frustrating?**
A. The business component is so understudied and underestimated.

**Q. To what level will you compromise to satisfy your client?**
A. I compromise all the time and to varying degrees. I provide a service. That service can be utilised in many different ways. Some clients want Nick Dine. Some… just want a good designer to collaborate with. If it's a retail shop I will try and compromise as little as possible. With a private residence I'm more amenable.

**Q. What would be your second career choice after design?**
A. Teacher or a custom car builder.

**Q. What do you still aspire to design?**
A. A free-standing structure/dwelling. A motorcycle.

**Q. Describe your design approach**
A. Fast, cheap and out of control… actually: slow, very expensive and totally rational.

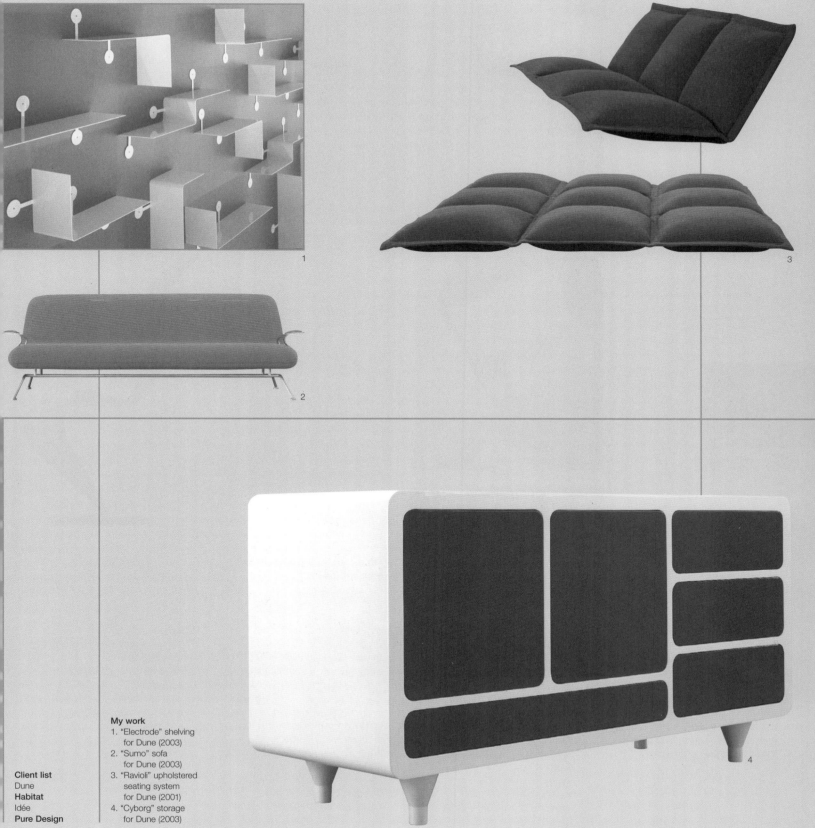

1

3

2

**My work**
1. "Electrode" shelving
   for Dune (2003)
2. "Sumo" sofa
   for Dune (2003)
3. "Ravioli" upholstered
   seating system
   for Dune (2001)
4. "Cyborg" storage
   for Dune (2003)

4

**Client list**
Dune
**Habitat**
Idée
**Pure Design**

**Tom Dixon**
born 1959 in Sfax, Tunisia
**Studio Location**
London, UK

Tom Dixon's route into the design world was not conventional. Born in Tunisia, he moved to England at the age of four and spent his school years in London. Studies at Chelsea Art School were cut short when a motorbike accident put him in hospital for three months. After his recovery, Dixon pursued his passion for music and played bass guitar in a band. Playing in London's nightclubs left him free during the day to experiment with his friend's welding machine, turning scrap metal into desirable sculptural objects. Commissions and exhibitions followed.

In 1985, he founded his workshop, Creative Salvage, which, in 1994, turned into Space, a retail outlet for emerging designers in London's Notting Hill. His work caught the attention of the Italian manufacturing guru Giulio Cappellini, who put Dixon's iconic "S" chair into production in 1989. It has since been added to the permanent collection at the Museum of Modern Art, New York. After 1994, Dixon became interested in plastics and founded Eurolounge to produce his designs, the first of which was the rotation-moulded "Jack light" – a "sitting, stacking, lighting thing".

In 1998, Dixon moved from batch production to global mass production, when he was appointed to head the UK design studio of Habitat; in 2001 he was promoted to Creative Director. During these years, he also undertook designs for numerous European manufacturers and set up a studio bearing his own name in 2001. He received an OBE for service to design and innovation in June 2000.

**My inspiration**
20th-century sculpture, such as "Figure no. 6" (1954), by Henry Moore always inspires me

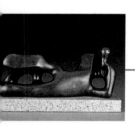

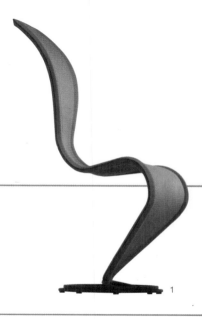

1

## tom dixon — GB

**Q. What kind of products do you design?**
A. Chairs and tables; lights, lamps and chandeliers; screens and coffee machines; a vibrator and a restaurant interior; packaging and carpets; exhibitions, retail environments and marques.

**Q. What has been the greatest influence on your work?**
A. The spot welder, which gets people away from the computer screen and allows them to make full-size outlines and frames of furniture quickly.

**Q. What was your big break?**
A. My first big break was a broken leg, which finished my short career at art school. My second big break was a broken wrist, which finished my career as a musician. Both were motorcycle accidents, and both pushed me into new careers and gave me time to reflect on where I was heading.

**Q. What drives your designs?**
A. Boredom and restlessness; irritation with what I have done before; and inquisitiveness about things I haven't.

**Q. How important are trends in your work?**
A. Trends are things that are useful for business but should be resisted or opposed by designers. They are important in as much as they can give you something to challenge, and can often be used to justify a personal preference in a client meeting.

**Q. How does your work reflect your nationality?**
A. Having Latvian, French and British grandparents, and being born in Tunisia, means that it's difficult to be too nationalistic… but "Britishness" is often an asset in Japan.

**Q. Is your work an individual statement or a team solution?**
A. It depends completely on the project – it can be either – and different projects call for different skill sets. I find it's good to approach different problems with different modi operandi.

**Q. What do you find most frustrating about the design process?**
A. Meetings meetings meetings…

**Q. To what degree will you compromise to satisfy a client?**
A. Everything is ultimately a compromise – budgets, timescales, materials, technology… Sometimes the toughest clients are the ones that set no limits.

**Q. What would be your second career choice after design?**
A. Civil engineer.

**Q. What do you still aspire to design?**
A. So many things: buildings and bridges, motorcycles and aeroplanes, watches and mobile phones, tidal power stations and underwater cities, textiles and pasta shapes, fashion and luggage… Come to think of it, anything I haven't had a go at before.

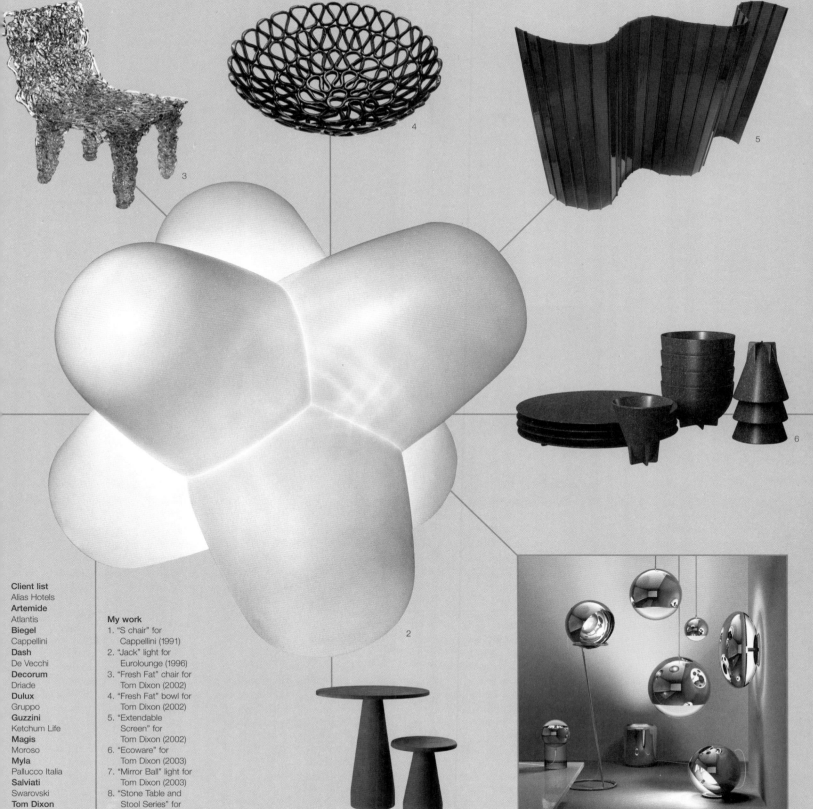

**My work**
1. "S chair" for Cappellini (1991)
2. "Jack" light for Eurolounge (1996)
3. "Fresh Fat" chair for Tom Dixon (2002)
4. "Fresh Fat" bowl for Tom Dixon (2002)
5. "Extendable Screen" for Tom Dixon (2002)
6. "Ecoware" for Tom Dixon (2003)
7. "Mirror Ball" light for Tom Dixon (2003)
8. "Stone Table and Stool Series" for Tom Dixon (2003)

**James Dyson**
born 1947 in Norfolk, UK
**Studio Location**
Malmesbury, Wiltshire, UK

Perseverance, passionate ambition, personal belief and entrepreneurial flair are some of the characteristics that have steered James Dyson to the success he commands today. His achievements stem from the release of his first Dual Cyclone vacuum cleaner (the "DC01") in 1993, a cleaning device that sidelines the use of a bag for increased suction power – a seemingly simple innovation that has revolutionised the vacuum market.

There has been nothing simple or straightforward, however, about Dyson's career. After his studies in Furniture and Interior Design at the Royal College of Art in 1970, he joined the leading actuator manufacturer Rotork to manage its marine division, later becoming a director. In 1974, he independently developed the "Barrowball", a wheelbarrow with a ball instead of a wheel. He identified the problem with existing vacuum cleaners in 1978 and used money from sales of the award-winning "Barrowball" to fund his research. He spent five years making prototypes, encountering endless rejections from

potential manufacturers, who viewed the idea as a threat to their existing market. In 1986, a Japanese company released his "G-Force" vacuum cleaner, which became an instant status symbol, selling for $2000 each.

By 1992, royalties enabled him to open his own R&D centre and factory in the UK and within two years the "DC01" was a bestseller. The next ten years saw Dyson develop several new models and pick up numerous awards and accolades. He has also launched the "Contrarotator" – the world's first washing machine with two drums rotating in opposite directions.

**My inspiration**
My time spent working with Jeremy Fry at Rotork in the '70s triggered a get-up-and-go mentality with no boundaries that I apply to all idea development today

# james dyson — GB

1

**Q. What types of products do you design?**
A. We design, engineer and manufacture better and different machines for the household.

**Q. What or who has been of significant influence in your studio?**
A. Jeremy Fry... I worked with Jeremy's firm Rotork while at college and went on to join him when I graduated. The responsibility Jeremy gave me allowed me freedom to explore new ideas with no boundaries. When he had an idea, it was his style to go off and do it rather than sit down and make laborious calculations. This rubbed off on me, and today I employ young graduates (who have no restrictive preconceptions) and give them open-ended challenges.

**Q. What was your big break?**
A. My big break came while sitting on my kitchen floor having dismantled my brand-new but totally ineffective bag vacuum cleaner. I ripped open the bag to find that, although it wasn't anywhere near full, its pores were clogged with dust. Understanding the problem wasn't enough – I wanted to find a solution.

**Q. What human emotions and necessities drive your designs?**
A. Frustration. Obsession. Love. Stubbornness. Hope. You really have to believe in your idea and, despite the setbacks you may face, you have to carry on.

**Q. How important is it for your work to reflect the design characteristics of your nation?**

A. National characteristics don't have a physical or technical influence on our machines, but I like to think Dyson is playing a part in a renaissance of Britain's great engineering and innovative heritage.

**Q. Is your work an individual statement or a team solution?**
A. We don't have think tanks or brainstorms at Dyson, I don't believe in them. I believe innovation comes from individual actions rather than discussion. But it's teamwork that takes that initial innovation and turns it into a working machine.

**Q. What elements of the design process do you find particularly frustrating?**
A. Tooling. It takes an age but it's so critical and is the point at which you

have to have true faith in your design. It's very expensive, time-consuming and potentially catastrophic.

**Q. To what level will you compromise to satisfy your client?**
A. People often comment on a Dyson's looks, but every nozzle, groove and curve has a point. It's a case of function over form. To focus on aesthetics first and foremost would be an unsatisfactory compromise.

**Q. What do you still aspire to design?**
A. A truly autonomous vacuum cleaner... Robotics combine navigation systems, artificial intelligence and sophisticated mechanical operations; all three have to work together if a robotic vacuum cleaner is to be viable. It needs to do the job better than you or I. We're close to it, very nearly there...

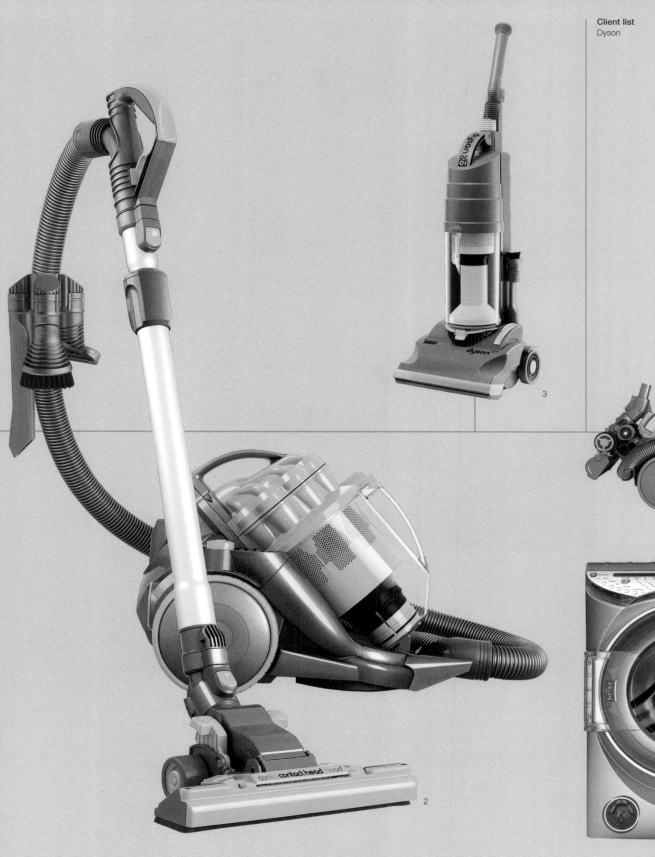

3

4

2

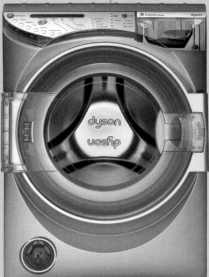

5

**Roberto Feo**
born 1964 in London, UK
**Rosario Hurtado**
born 1966 in Madrid, Spain
**Studio Location**
London, UK

In 1997, Roberto Feo and Rosario Hurtado established El Ultimo Grito ("The Last Shout") following their postgraduate design training at the Royal College of Art and Kingston University respectively. (A third founding member, Francisco Santos, left in 2001.) Unlike many college-leavers, they did not immediately set out to find manufacturers for their work but instead pursued the avenue of self-production, which freed them from the need to meet any preconceived commercial expectations. Their ventures caught on, and, before they knew it, interest was growing from both the trade and design commentators. They won the Blueprint/100% Design Award three years in a row (1997–1999) and the OXO Peugeot Design Award twice (1999 and 2000).

El Ultimo Grito's playful and rather quirky observation of everyday life, and the various shortfalls of domestic routine, provides the basis from which they invent their furniture, lighting and accessory solutions. Their research and experimentation with existing materials and mechanisms can absolutely inform the function to which they apply it. For example, in the "Mind the Gap" coffee table, the synthetic rubber tabletop drops through a crevasse in the middle of the table to form an integrated pouch for magazines and newspapers. Similarly, in the "La Lu" lamp, the electrical cable that supplies the power to the light bulb is woven using traditional basketweaving techniques and also forms the integrated shade.

In the space of a few years, the group's projects have been exhibited internationally and published widely, inevitably attracting propositions for commissions from manufacturers. The financial propositions must be tempting, but the duo refuse to compromise on their integrity – preferring to nurture their unique approach and to produce projects that have a long-lasting character.

**el ultimo grito**

**GB**

**Q. What types of products do you design?**
A. "Domesticated" ones.

**Q. What or who has been of significant influence in your studio?**
A. London (inevitably) and Ron Arad – "maestro" and our friend.

**Q. What was your big break?**
A. We've had many little breaks… but we're still waiting for the big one.

**Q. What human emotions and necessities drive your designs?**
A. Our own, which keep changing.

**Q. How important are trends in your work?**
A. We "design against trends".

**Q. Is your work an individual statement or a team solution?**
A. A team statement through individual solutions.

**Q. What elements of the design process do you find particularly frustrating?**
A. When everything goes too smoothly. You always need a bit of a challenge.

**Q. To what level will you compromise to satisfy your client?**
A. "Don't ask what you can do for your client, but what your client can do for you." (In short: collaboration works!)

**Q. What would be your second career choice after design?**
A. Is there a choice?

**Q. What do you still aspire to design?**
A. The unknown.

**Q. Describe your design approach.**
A. Observant.

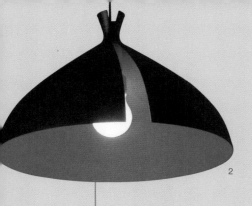

1

**Our work**
1. "SE15" lampshade
   for Mathmos
   (2002)
2. "Of Black Holes
   and Pink
   Elephants"
   project "Pet
   Shirts" (2002)
3. "Showroom"
   at Carnaby
   Street December–
   January 2004
   for Griffin (2004)

**Client list**
Abet Laminati
**Bloomberg**
Griffin
**Joinedupdesignforschools**
Lavazza
**Magis**
Marks & Spencer
**Mathmos**
Metalarte
**Nola**
Orden en Casa
**Present Time**
Punt Mobles
**Selfridges**
Style
**Trico**
Victoria & Albert Museum
**Wireworks**
also self-production

**Martin Bergmann**
born 1963 in Lienz, Austria
**Gernot Bohmann**
born 1968 in Krieglach, Austria
**Harald Gründl**
born 1967 in Vienna, Austria
**Studio Location**
Vienna, Austria

The three founding members of EOOS – Martin Bergmann, Gernot Bohmann and Harald Gründl – met while studying Design at the Akademie für Angewandte Kunst in Vienna from 1988 to 1994. In 1995, they formed their own consultancy, EOOS, to work across the disciplines of furniture and products, as well as flagship store and brand zone design.

The research department forms the heart of the company's operations, analysing human behaviour, instincts, origins and cultures while investigating clients' histories and brand values. Merging seemingly unrelated words, sentences or images with a project, the team give new form to products or interiors stemming from rituals borrowed from the past or contrasting cultures. The incorporation of such research elements is not made obvious – the final designs possess an unobtrusive and often quiet visual language.

Recent projects include a store design for Armani Cosmetics in Hong Kong and a shop concept for Adidas Originals. Among recent furniture designs are the "DERBY" armchair and "KUBE" seating system for Matteograssi, and the "Conlight" conference table for MABEG.

**Our inspiration**
The traditional Japanese Kyudo art of archery requires a certain concentration technique that we apply to our work and ourselves

A

eoos

**Q. What types of products do you design?**
A. We work in the fields of flagship store/brand zone design and furniture/product design.

**Q. What or who has been influential on your work as a whole?**
A. In our in-house research laboratory – which is our creative powerhouse – we are continually searching for things we do not recognise as what they are. We are interested in how ancient rituals and instincts can collide with new technologies and a dramatically transformed environment – as, for example, the missing row 13 in the modern passenger aeroplane.

**Q. What was your big break?**
A. Three years ago, we invited a Japanese archer to Vienna. He demonstrated the art of kyudo, the traditional Japanese art of archery, on the roof of our studio. His explanation of kyudo's concentration technique and dynamic breathing was a big breakthrough in our consciousness and work.

**Q. What human emotions and necessities drive your designs?**
A. To us, design means the articulation of peoples' desires and fears, drawing its strength from the collective unconscious of mankind. We search for deeply engraved rituals and images.

**Q. How important are trends in your work?**
A. Trends in the field of design are not important to us, but trends in other fields – science, for example – fascinate us.

**Q. How important is it for your work to reflect national design characteristics?**
A. We do not believe in national design characteristics. Today, for example, designers from Ireland work in Italy and Australians work in Germany.

**Q. Is your work an individual statement or a team solution?**
A. We work on the same principle as a rock band. We are very interested in the kind of work that is capable of surprising even us. The result of the design process is like a sound. It is the product of our identities (our identities multiplied) and not just the sum of them.

**Q. What elements of the design process do you find particularly frustrating?**
A. Briefings that describe the desired product like criminals on the "Wanted" posters in Westerns.

**Q. To what level will you compromise to satisfy your client?**
A. We think we are able to integrate factors that are diametrically opposed to one another, and we always try to make a product that is 100 per cent EOOS and 100 per cent the customer. Defining the quintessence of brands and products is what we do best.

**Q. What would be your second career choice after design?**
A. Design is related to culture. Our second choice would be something related to nature.

**Q. What do you still aspire to design?**
A. An object in which we would have to forget all that we know about design; to disregard classic, functional and formal aspects to create something unknown…

**Q. In one sentence, describe your design approach.**
A. To us design is a poetic discipline and ritual – culture and poetry are at the centre of our work.

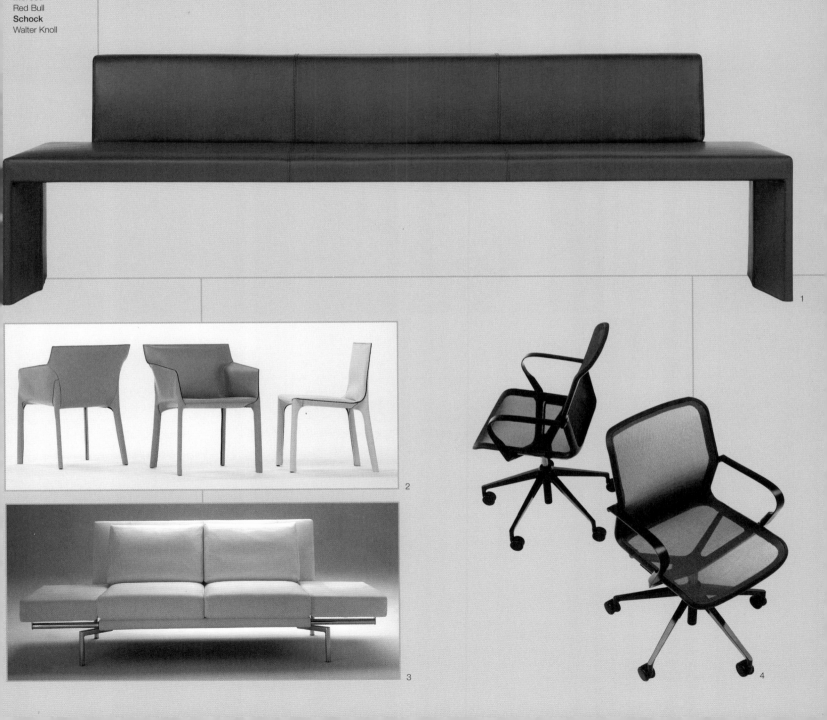

**Sven Jonke**
born 1973 in Bremen, Germany
**Christoph Katzler**
born 1968 in Vienna, Austria
**Nikola Radeljkovic**
born 1971 in Sarajevo,
Bosnia and Herzegovina
**Studio Location**
Vienna, Austria

For Use is a relatively new design group made up of three individuals who came together through initial contact when they were design students. Christoph Katzler and Sven Jonke lived together while studying at the Universität für Angewandte Kunst in Vienna. Jonke also trained at the architecture faculty of the University of Zagreb, where he met Nikola Radeljkovic. Each went on to undertake separate art and design-related activities, but eventually they collaborated on a project for a chair design, which attracted interest from the Italian producer Giulio Cappellini. Unfortunately, the design proved too expensive for production but it gave the trio the boost they needed to found For Use in 1998.

Katzler lives in Vienna, and Jonke and Radeljkovic in Zagreb – which allows them all to undertake independent projects in addition to their group work. Most of the time, however, the group co-creates for international and local clients, working not only on furniture but also interior, exhibition and stage design, sometimes in close collaboration with the graphic and multimedia designers Jelenko Hercog and Toni Uroda (under the label NUMEN). In its work, For Use strives to attain the functional perfection and industrial honesty that are the hallmarks of 20th-century Modernism.

**Our inspiration**
Numerous individuals within architecture, design, art, and music such as Piet Mondrian, creator of this *Composition No1 with Red* in 1931

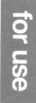

for use

A

---

**Q. What types of products do you design?**

A. Up to now, just furniture – mainly chairs – and systems.

**Q. What has or continues to inspire your work?**

A. In terms of design and architecture, Mies van der Rohe and the Eameses; lots of stuff from Bauhaus to Archigram. In terms of art, Malevich has been extremely important – Mondrian, too, but also Judd, LeWitt and Rothko. In terms of music, a wide range of things from J. S. Bach to Coltrane, as well as electronic music, too – the likes of Pole and Herbert. The work of carpenters and metalworkers – we are often attracted by anonymous objects we find around us, and try to be as open-minded as possible.

**Q. What was your big break?**

A. A meeting with Giulio Cappellini at the Milan Furniture Fair in April 1998. We brought a huge prototype into their main showroom in Via Statuto. He liked our oversized, overdesigned, crazy mutant-chair, and we thought we were on top of the world. The project was never realised though, but we gained the necessary self-confidence.

**Q. Are there any previous design movements that inspire your designs?**

A. We feel an obligation to proceed from the ideals of Modernism – in the sense that there is still room for improvement in terms of the formal, functional and conceptual aspects of industrial design. The plethora of poor designs in our culture proves that a sense of responsibility and ethical values are still crucial qualities in design.

**Q. How important are trends in your work?**

A. We don't think about trends while we work, though inevitably we are affected by the media. In any case, owing to the limitations we impose on ourselves (for example, the rational use of material, function and so on), we usually end up with rather timeless pieces. As a matter of fact, a 75-year-old client told us recently that we were conservative!

**Q. Does your work reflect a particular nationality or culture?**

A. Since we are a multinational team, it's difficult for our work to reflect any particular national characteristics, and, anyway, design is generally speaking a global discipline. Think about it – we are from Austria and Croatia, and we work for Italian and German producers. It's a meeting of Mediterranean and Central European cultures mixed up with a jumble of our own, more personal influences.

**Q. Are you ready to compromise your designs?**

A. We do compromise as long as a client's requests make sense.

**Q. What do you still aspire to design?**

A. An interior for a serious, sensible client.

**Q. Could you sum up your approach to design in a single sentence.**

A. We search for subtle solutions that merge technical, functional and formal aspects of the project in an intelligent way yet which still leave room for power and idiosyncrasy.

**Client list**
Cappellini
**Interlübke**
Magis
**MDF Italia**
Zanotta

3

4

1

2

**Our work**
1. "L-bed" for
   Interlübke (2003)
2. "FU-09" chair for
   MDF Italia (2003)
3. "FU-09" chair for
   MDF Italia (2003)
4. "S,M,L" folding
   outdoor furniture
   for Zanotta (2003)

**Norman Foster**
born 1935 in Manchester, UK
**Studio Location**
London, UK

Norman Foster is one of the most celebrated architects working today, responsible for such major building projects as the German Parliament (1993–9) at the Reichstag, Berlin, the Great Court (1994–2000) at the British Museum and Canary Wharf Underground Station (1991–99), both in London. The scope of his studio's work has encompassed not only large-scale architectural projects but also furniture, product and graphic design.

One of Foster's earliest furniture designs came about in 1981 when his practice moved to new offices and designed its own custom-made flexible desking system. This was later successfully developed as the "Nomus" range of office furniture (1987) for the Italian manufacturer Tecno and is still evolving today. Other designs since then have included the "Kite!" chair (1997), also for Tecno, a tray for Alessi (1998), a range of taps (1999) for Stella and desk-top accessories (2001) for Helit. The studio's has produced eco-friendly design solutions in the fields of transport and energy – including wind-turbines (1995) for the German power company Enercon, and a solar-electric vehicle (1994) for Kew Gardens, London.

Foster graduated from the Manchester University School of Architecture and City Planning in 1961, and subsequently gained a Master's degree in Architecture at Yale University. He established his practice in 1967.

# norman foster — GB

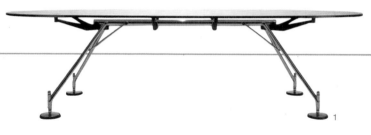

1

**Q. What types of products do you design?**

A. As an architect I started with buildings. The more involved I became with the pieces that make a building, the more I saw the need to design them – the floors, escalators, ceilings, partitions, etc. This led to us being product designers. But I had always been interested in the way that cities work – the infrastructure of public spaces, routes and connections that bind the individual buildings together. This led to us working as urbanists and city planners. Our "products" therefore reflect this vast differential of scale – with the architecture of buildings in between. Current projects range from the largest in the world – Beijing Airport at over 10 million sq m (11 million sq ft), the widest arch at Wembley Stadium. At the other end of the scale there are small pieces like the Nomos Table, down to the domestic scale of lighting, door handles and switches.

**Q. What was your big break?**

A. I would highlight a series of breaks rather than one fateful moment. The decision to study in the USA at Yale is significant in that it broadened my horizons and opened up a whole new world of possibilities. In retrospect some early commissions – the projects for Olsen, the Sainsbury Centre for Visual Arts and the Hong Kong and Shanghai Bank, for example – were clearly important in shaping the future direction of the practice.

**Q. What drives your designs?**

A. I have always been guided by a belief that architecture is about people and their needs – both material and spiritual. I also believe that the quality of our environment – the buildings in which we live and work and the spaces that surround them – has a direct impact on the quality of our lives. To quote Winston Churchill – "we shape our buildings, thereafter they shape us".

**Q. How important are trends in your work?**

A. I would resist the notion of "trends" if by that one means stylistic "isms" or passing currents. However, trends in the sense of themes and directions are clearly important; for example, a concern for the environment and ecology, the social agenda, the poetry of light and space – these are some of the themes that run throughout our work.

**Q. Is your work an individual statement or a team solution?**

A. Undoubtedly both. Every designer has a distinctive "personality", but architecture is also by nature a team activity. It involves countless numbers of people from the architects and technical experts who collaborate with the client and the vast team of people who come together to build it. The "imprint" is also made through the leadership of the process.

**Q. What would be your second career choice after design?**

A. I am passionate about flying and so it would probably relate to flying machines – certainly piloting them, but also perhaps their design, production and utilisation.

**Q. How would you sum up your design approach in one sentence?**

A. Curiosity, research, passion, combining diverse skills and hard work.

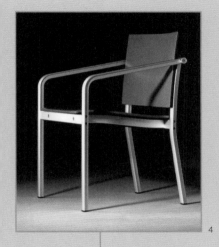

4

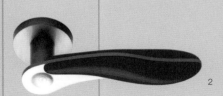

3

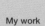

2

5

**My work**
1. "Nomos" table
   for Tecno (1989)
2. "Series NF
   Novantacinque" door
   handle for Fusital
   (1994–95)
3. "Foster 500"
   upholstered chair
   for Walter Knoll
   (2001–02)
4. "A900" chair for
   Thonet (1997–99)
5. "Air Line" public
   seating system
   for Vitra 1997–99)
6. "Helit Foster series"
   of desk accessories
   for Helit (1997–2000)

6

**Naoto Fukasawa**
born 1956 in Kofu, Yamanashi, Japan
**Studio Location**
Tokyo, Japan

Naoto Fukasawa graduated in Product Design from Tama Art University in 1980. He subsequently worked for eight years at Seiko Epson designing microelectronic goods. In 1989, he travelled to the USA, where he joined ID Two, the predecessor to IDEO, now one of the leading product design consultancies in the world. There Fukasawa designed, among other things, electrical goods, watches, computers, furniture, sporting goods and medical equipment.

In 1996, Fukasawa returned to Japan and set up the IDEO Tokyo office. During this period, he also co-operated with DMN (Diamond Design Management Network) to organise a workshop for in-house designers from various companies, culminating in the "Without Thought" exhibition in Tokyo.

In 2003, while maintaining his ties with IDEO, Fukasawa founded his own design consultancy in Tokyo. Working with Takara and DMN, he launched the Plus Minus Zero brand with a collection of products that includes a cordless phone, torch, lamp and LCD TV.

Fukasawa's most acclaimed design is the wall-hung CD player for Muji (2002) – a radically simple design hardly bigger than the CD at its centre. The CD player, which neatly hides the speaker within its case, is activated by a pull-cord.

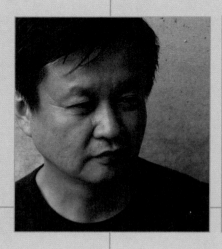

**naoto fukasawa**

**J**

**Q. What products do you design?**

A. Small-scale electronics such as household appliances, audiovisual equipment and mobile phones, lighting equipment, computer monitors, projectors, furniture, miscellaneous goods, cooking utensils and cutlery, stationery, sporting equipment, medical equipment, shop designs, exhibitions, shop displays, bicycles, motorcycles...

**Q. What or who has been of significant influence on your work as a whole?**

A. Kyoshi [Takahama Kyoshi, 1874–1959], a master of haiku poetry. He believed in the accord that exists between human beings and nature.

**Q. What was your big break?**

A. I don't really know whether I've made my big break or not, but it seems that the Muji CD player I designed has garnered a great deal of interest not only in Japan but on the world stage also. While only limited numbers are available in London and Paris, more and more people are telling me that they have one. The other thing would be the mobile phone I designed for au/KDDI – the Infobar. Since it went on sale in Japan in October 2003, stocks have constantly been sold out. While it can't be used overseas, there have been a lot of enquiries from people wanting to know whether it can be used outside Japan or not.

**Q. How important are trends in your work?**

A. I don't actively try to work trends into my designs; trends change just like the seasons, and since they are around us daily, like the air we breathe, they do permeate my designs a little.

**Q. How important is it for your work to reflect Japanese design characteristics?**

A. I try as much as possible not to bring my own character, or the culture or historical background I carry with me, into my designs. But even in trying to do so, it is inevitable that these things do make themselves known in my designs, and I think that this is natural.

**Q. Is your work an individual statement or a team solution?**

A. It's an individual statement, but it's obvious that team support is indispensable in bringing an idea to fruition.

**Q. What elements of the design process do you find frustrating?**

A. I would say that what is frustrating is when a lot of choices are demanded and then nothing is decided on.

**Q. To what level will you compromise to satisfy your client?**

A. Compromise might come as part of a project's constraints. Sometimes though it might grow negatively and threaten the project. That is when one has to say "no" to save the project and the design. There is a necessary notion of ethics.

**Q. What do you still aspire to design?**

A. To create good things that fit in with and improve on our present lives, and logical things that may become icons for the times.

**Q. Describe your design approach?**

A. To design and give concrete form to the mutual senses that people unconsciously feel.

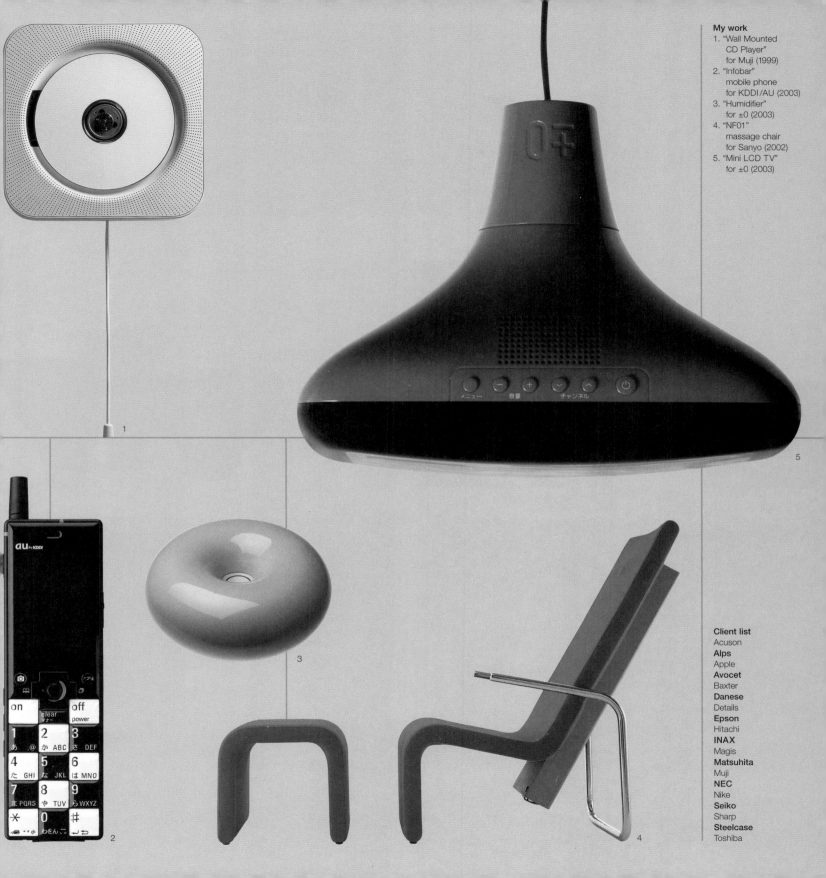

1

5

2

3

4

**Christian Ghion**
born 1958 in Montmorency, France
**Studio Location**
Paris, France

After completing his baccalauréat exams at the age of 18, Christian Ghion went on to study law for five years before finally deciding to embrace design. From 1982, he studied Furniture Design at the Ecole d'Architecture in Charenton, where he was also briefly a teacher, and then at the Ecole Nationale Supérieure de Création Industrielle (ENSCI) in Paris, from which he graduated in 1987.

In the same year, Ghion set up a studio in partnership with the architect Patrick Nadeau, working on projects such as private houses, bars, shops, a hairdressing salon and a hotel. In 1995, during a trip to Japan, he met Idée president Teruo Kurosaki, who put some of his designs into production. In 1998, Ghion started working independently, setting up his own studio a year later to handle an increasing number of commissions from predominantly Paris-based companies, spanning furniture, lighting and objects as well as interior architecture and exhibition design.

The body of work that Ghion can boast today manages to sidestep any one definable signature style, but can perhaps be united by its sculptural use of form, as seen, for example, in his sensual "Inside Out" vases (1999) for XO and "Easy Pieces" (2004) for Driade – plastic storage stools that stack to form totem-like columns.

**My inspiration**
The work of artists such as Bill Viola, his *Hall of Whispers* (1995) shown here

christian ghion

F

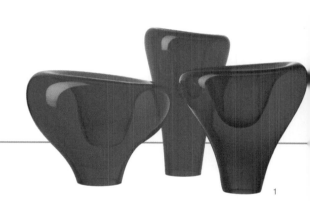

1

**Q. What types of products do you design?**

A. I design an increasingly diverse repertoire of interior goods which range from furniture, household accessories, lamps, tableware, to vases and perfume bottles. Exhibition design is another feature of my design practice.

**Q. What or who has been of significant influence in your studio?**

A. Mostly contemporary artists like Tony Cragg or Bill Viola.

**Q. What was your big break?**

A. The "Inside Out" vase collection that was exhibited at the Galerie Néotu in Paris in 1999. The collection caught the attention of French manufacturer XO who subsequently put it into production.

**Q. What human emotions and necessities drive your designs?**

A. There needs to be a feeling of complicity and "mutual tenderness" for me to work efficiently with my clients as well as with my collaborators.

**Q. How important are trends in your work?**

A. Trends are important for me in the sense that they "feed" me, and become the source of inspiration. New ideas can often stem from creative industries beyond the design arena, such as cinema, photography or dance. But in the "fashion" sense of the word, trends don't mean much to me.

**Q. How important is it for your work to reflect the design characteristics of your nation?**

A. I'm quite proud to belong to what we call today, "La French Touch".

It's the reflection of one generation and a whole attitude towards our profession.

**Q. Is your work an individual statement or a team solution?**

A. Working with a diverse team is very important for me. I strongly encourage brainstorming with the client as well as my own studio group to stimulate the imagination and flow of ideas. The more minds you have contributing, the richer the proposition will be.

**Q. What elements of the design process do you find particularly frustrating?**

A. The drafting process before production. Should a prototype not work, the small detailed but necessary changes that I have to make to my original full size

drawings can be frustrating but I acknowledge that this is a necessary reality of design and a critical part of the process.

**Q. To what level will you usually compromise in order to satisfy your client?**

A. I am willing to compromise as much as my client is willing to compromise with me, just so long as the intention and soul isn't erased.

**Q. What would be your second career choice after design?**

A. Magician.

**Q. What do you still aspire to design?**

A. Once and for all, my dream is to design a restaurant for a great chef, or a small boutique hotel, but there is still plenty of time to achieve this!

**Client list**

Arc International
**Cappellini**
Christian Dior
**Cinna/Roset**
Créa Diffusion
**Daum**
Driade
**Gallerie Néotu**
Idée
**Industrielle**
Lafuma
**Octant**
Poltrona Frau
**Salviati**
Sawaya & Moroni
**Silvera**
Tai Ping Carpets
**Tarkett Sommer**
Tendo
**Ventura**
XO

**My work**

1. "Inside Out"
   vase collection
   for xO (1999)
2. "Butterfly Kiss"
   armchair for Sawaya
   & Moroni (2003)
3. "Shadow"
   chaise longue for
   Cappellini (2002)
4. "Groove" sideboard
   for Driade (2004)
5. "Ystas" vase for
   Driade (2004)

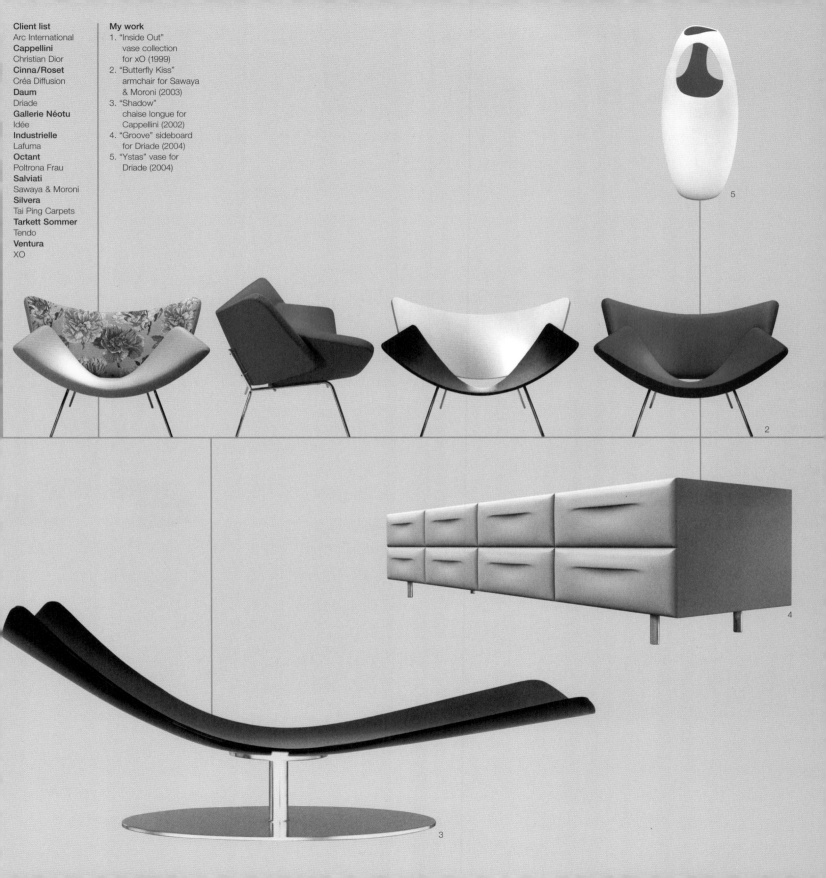

**Stefano Giovannoni**
born 1954 in La Spezia, Italy
**Studio Location**
Milan, Italy

Stefano Giovannoni graduated in Architecture from the Università degli Studi di Firenze in 1978. Since 1979, he has been teaching and conducting research at the Florence faculty of architecture, the Domus Academy in Milan and the Università del Progetto in Reggio Emilia. From 1985 to 1989, he collaborated with Guido Venturini in the King-Kong studio, during which time they designed the hugely successful "Girotondo" range of household goods for Alessi, which has gone on to sell more than a million pieces.

Having set up his own design studio in Milan, Giovannoni has enjoyed considerable success, inventing a colourful and humorous style that has become widely influential.

Believing the world to be more than well provided with Modernist products of the "form follows function" kind, Giovannoni sets out to create practical objects in which fun and playfulness are allowed to take the front seat, translating the magic of comic books into the third dimension.

Typically specialising in plastic products, he often works with bulbous forms in bright colours and using comic-style characters that mimic the object's designated function – as in the dragon-shaped "Bruce" table lighter (1998) or the "Magic Bunny" toothpick holder (1998), both for Alessi. Above all, Giovannoni aims to design objects that are free from pretentiousness and which he believes everyone will understand and enjoy.

**My inspiration**
Eminent French social theorist Jean Baudrillard with his analysis on the culture of consumerism

**stefano giovannoni**

— 

1

**Q. What types of products do you design?**
A. Everything from kitchenware to watches, from telephones to televisions, from cutlery to interiors. We have just restyled a car for Fiat.

**Q. What or who has been of significant influence on your work as a whole?**
A. Jean Baudrillard, with his theories about the consumer society, and Remo Buti, my maestro, a real conceptual and minimalist architect practising in a period [around 30 years ago] when there weren't so many people working in that way.

**Q. What was your big break?**
A. The first product I designed for a company was the "Girotondo" tray for Alessi. They expected to sell 5,000 pieces per year, but they sold 50,000 in the first year. It later became a family of 80 different objects, and millions of "Girotondo" products have now been sold worldwide.

**Q. What human emotions and needs drive your designs?**
A. I am used to thinking of my work as part of an emotional and sensorial supermarket.

**Q. How important are trends in your work?**
A. I believe a product has to represent the specific time of its creation.

**Q. How important is it for your work to reflect a national culture or design tradition?**
A. I think a product has to speak an international language.

**Q. Is your work an individual statement or a team solution?**
A. I have a studio and work with eight collaborators.

**Q. What elements of the design process do you find particularly frustrating?**
A. The problems relating to the communication of the product are usually out of the designer's control, and the producer mostly underestimates them.

**Q. To what level will you compromise to satisfy your client?**
A. It depends on the specific case as each one is different. I've never really had a problem with technicians and marketing people.

**Q. What would be your second career choice after design?**
A. I would like to be a cook or a fisherman.

**Q. What do you still aspire to design?**
A. A complete car.

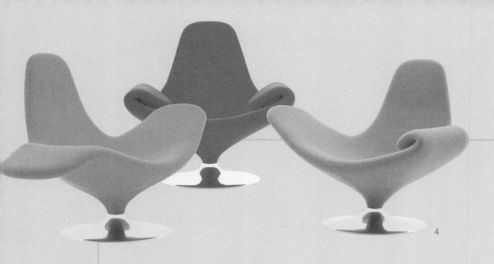

4

5

2

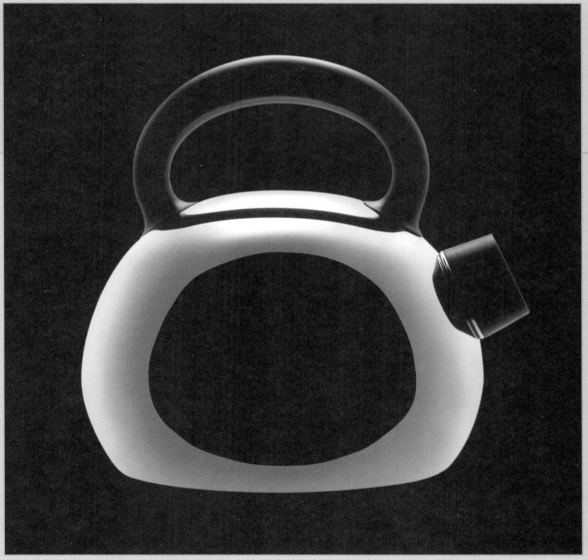

**Client list**
Alessi
**Ardes**
Cedderoth
**Deborah**
Domodinamica
**Fiat**
Flos
**Inda**
Kankyo
**Laufen**
Lavazza
**Magis**
Oras
**Segno**
Seiko
**Siemens**
3M

**My work**
1. "Fruit Mama" fruit
   bowl for Alessi (1993)
2. "Mami" oil cruet
   for Alessi (2003)
3. "Mami" kettle
   for Alessi (2003)
4. "Calla" armchair
   for Domodinamica
   (2004)
5. "Cico" egg cup
   with salt castor
   and spoon for
   Alessi (2000)

3

**Konstantin Grcic**
born 1965 in Munich, Germany
**Studio Location**
Munich, Germany

While today Grcic works for an international clientele from his Munich-based studio, his initial influences and grounding were thoroughly English. Trained as a cabinetmaker at the prestigious John Makepeace School for Craftsmen in Wood in Dorset, he then studied at the Royal College of Art in London. After graduating in 1990, he briefly worked in Jasper Morrison's studio in London, before returning to his native city to set up his own practice. Since then, he has produced furniture, lighting and product designs for a large number of manufacturers, including Flos, Magis, Cappellini and SCP.

Grcic's work is often labelled minimalist, but the spareness of his designs is always enriched by quiet humour, lucidity and inventiveness. Nothing could be simpler than his "Clothes-hanger-brush" (1992) for Progetto Oggetto (Cappellini), but its ingenious transformation of an everyday object has great charm and wit. More recently, Grcic's aesthetic has become harder, more angular and even expressionist – as signalled by his technically and visually demanding concrete and aluminium "Chair One" (2003) for Magis.

Grcic's work has been exhibited internationally. The portable "Mayday" lamp (1998) produced by Flos is part of the permanent collection of the Museum of Modern Art in New York and won Grcic a Compasso d'Oro in 2001.

## konstantin grcic

D

**Q. What types of products do you design?**

A. An expanding variety of products – chairs, tables, shelving, stools, lighting, tableware, accessories, stationery, electrical household appliances such as espresso machine, blenders, mixers etc. I also undertake exhibition design projects.

**Q. Of these varying objects, which do you find the hardest to design?**

A. I find everything difficult, but with lamps I really struggle – they have such a strong kind of typology, especially in a domestic environment.

**Q. Can you name some individuals in design who have been of inspiration?**

A. From books, the likes of Ettore Sottsass, George Nelson, or Marcel Breuer. Of those that I have actually met, Vico Magistretti, Achille Castiglioni, Jasper Morrison, the Bouroullec brothers, and Sebastian Bergne…

**Q. What is the typical starting point on a project?**

A. The project always starts with a personal contact. I think that work really happens between people – we never work for a company, which is just a brand name. An inspiring client is the reason to do or not to do a project.

**Q. What do you think gives a product lasting appeal?**

A. I think a product lasts when it has a balance of being very evident and natural, yet something has changed – it has a twist. You just add one more thought to something very straightforward and common. But I never want to be strategic or formulaic about design. I'd rather not understand how it works, or it would screw things up.

**Q. How important is it for your work to reflect the design characteristics of your nation?**

A. You grow up with a certain culture around you as an immediate influence. Of course, everybody is connected to global media but I think that the local culture is what you can't ignore. There are big differences in education, which also plays a part in creating a national identity… I have worked in a very international scene during the last 10 years, and therefore I don't think I am particularly German. But there is always a bit of German in the end.

**Q. How has your design approach changed over time?**

A. When I started in the beginning of the 90s, it seemed important for me and for other designers to do very simple things. Now I don't want to do simple things, I'm interested in the complexity. I see that inside complex projects the job is about trying to make them simple, but it's another level, more demanding and exciting.

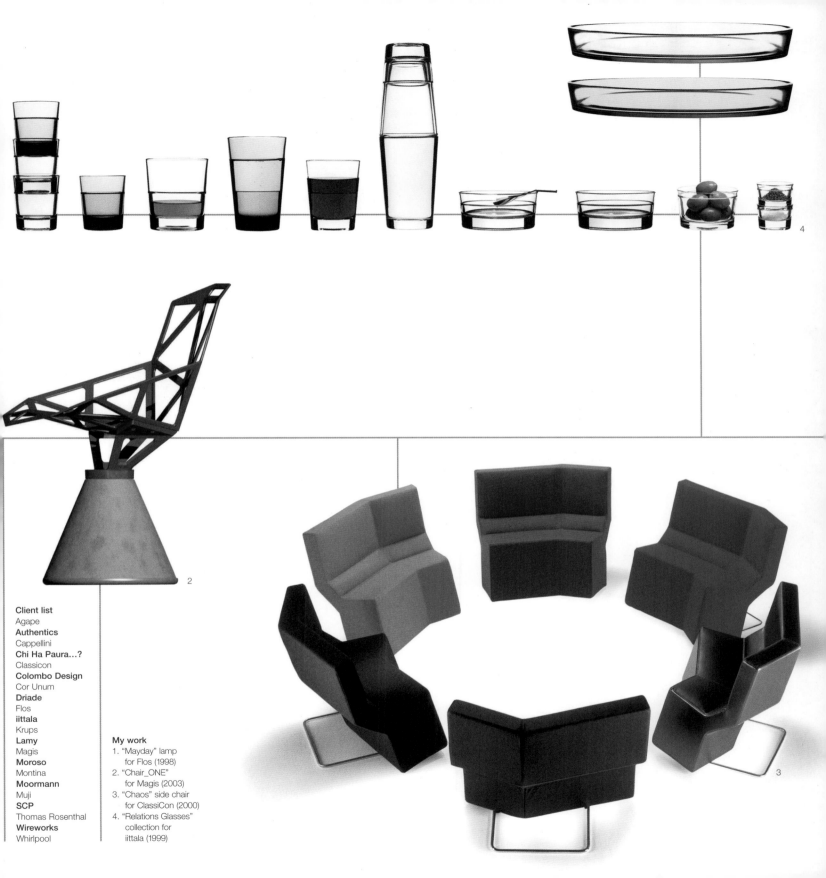

**Client list**
Agape
**Authentics**
Cappellini
**Chi Ha Paura…?**
Classicon
**Colombo Design**
Cor Unum
**Driade**
Flos
**iittala**
Krups
**Lamy**
Magis
**Moroso**
Montina
**Moormann**
Muji
**SCP**
Thomas Rosenthal
**Wireworks**
Whirlpool

**My work**
1. "Mayday" lamp
   for Flos (1998)
2. "Chair_ONE"
   for Magis (2003)
3. "Chaos" side chair
   for ClassiCon (2000)
4. "Relations Glasses"
   collection for
   iittala (1999)

**Alfredo Häberli**
born 1964 in Buenos Aires, Argentina
**Studio Location**
Zürich, Switzerland

Born in Argentina, Alfredo Häberli moved to Switzerland in 1977. After working a few years as an apprentice draughtsman in the construction industry, he went on to study industrial design at the Hochschule für Gestaltung und Kunst in Zürich from 1986 to 1991.

In 1993, he founded the Design Development Studio with Christophe Marchand (pp 160–161), tackling commissions from the likes of Thonet, Danese, Alias and Zanotta. At the turn of the millennium, he opened his own studio, working on mass-production furniture, lighting and accessories.

Häberli's design approach is characterised by his close observation of human behaviour and his ability to find solutions suitable for the commercial market. His products often present a multifunctional element, as seen in "Solitaire" (2001), which combines an upholstered chair with an integrated table surface on a swivel base. The stool (2001) he originally designed for the Zürich sushi bar Ginger incorporates a shelf for the customer's belongings.

Häberli's work has been shown at many exhibitions throughout Europe and has received several awards over the years.

**My inspiration**
My wife Stefanie who has wholeheartedly supported what I do from the early days of my career

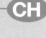

# alfredo häberli — CH

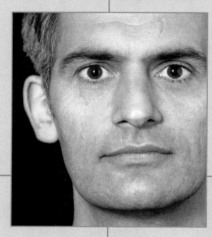

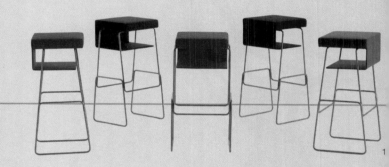

**Q. What types of products do you design?**

A. Everything from lamps to shoes, from chairs to children's toys, from the very small (jewellery) to the very complicated (shelf systems). Over the last few years, I have worked in the field of industrial design, but before that I used to work – as architect, editor and curator – on exhibitions at Zürich's Museum für Gestaltung.

**Q. What or who has been the most significant influence in your work?**

A. My parents, who gave me the confidence and security to believe in the impossible. My wife, Stefanie, who supported me financially at the start of my design career. Also significant were my encounters with Enzo Mari, Bruno Munari and Achille Castiglioni and my study of their oeuvres.

**Q. What was your big break?**

A. The "SEC" shelving system for Alias, which was released at the Milan Furniture Fair in 1997.

**Q. What drives your designs?**

A. I always need a person for whom I can create something. Sometimes it's the client, sometimes friends or a person I imagine. But often it's my own needs and observations, my instinct for a situation…

**Q. How important are trends in your work?**

A. I don't work with trends. I work more on niches. I buy fashion magazines only when I am travelling, but I don't use the trends I see in them. It's just visual inspiration that I take from them.

**Q. How important is your nationality in your work?**

A. I was born in Argentina and grew up there until I was 14. Since then, I have studied and lived in Zürich. I do feel that I have a bit of both nationalities in me – the Latin side is evident more in my character and the Swiss side in how I approach design. I'm very impressed by the innovations present in Swiss products. I always try to make a small step forward in areas like typology or material – something beyond that which we already know.

**Q. Is your work an individual statement or a team solution?**

A. As a designer, one always works in a team with engineers, the client and sometimes marketing. In my approach, I try to make a statement in my work about what I believe. I work more and more like an artist, even if the product doesn't look artistic. I do what I really want to do!

**Q. What elements of the design process do you find particularly frustrating?**

A. When some of the people involved in the process (the prototyper, engineer, builder and so on) just want to take the easy way out and don't understand the core ideas. I get angry when the reason for this is just laziness!

**Q. Will you compromise to satisfy your client?**

A. I am lucky not to have to compromise.

**Q. What would be your second career choice after design?**

A. An artist – a sculptor or a painter.

**Q. Could you try to sum up what you do in one sentence?**

A. I try to make designs with a soul.

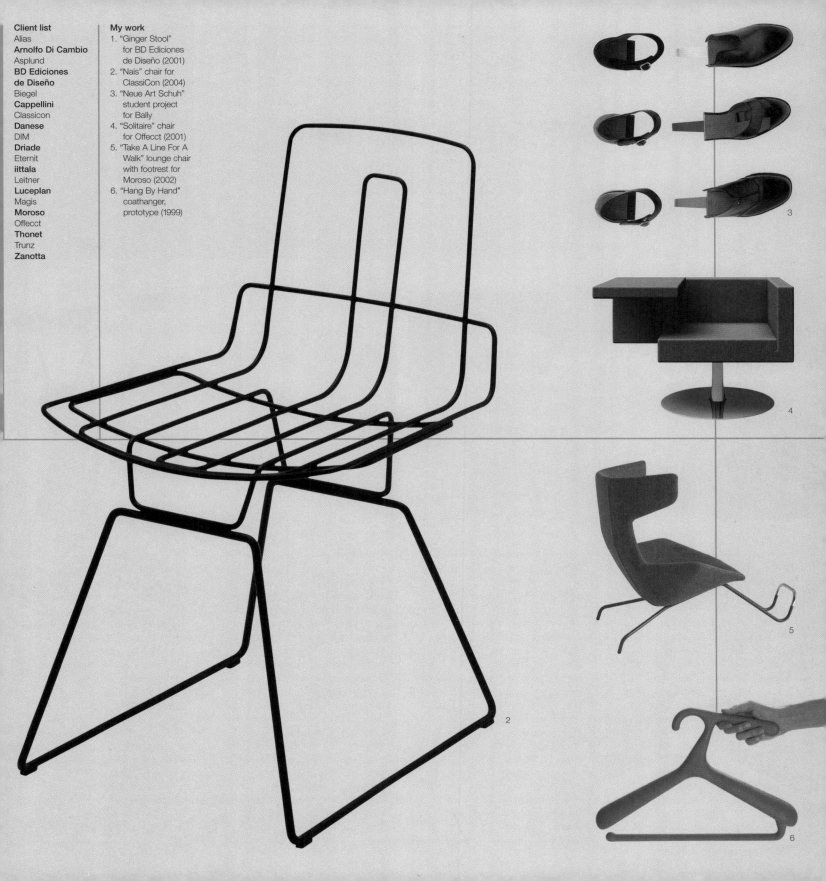

**My work**
1. "Ginger Stool"
   for BD Ediciones
   de Diseño (2001)
2. "Nais" chair for
   ClassiCon (2004)
3. "Neue Art Schuh"
   student project
   for Bally
4. "Solitaire" chair
   for Offecct (2001)
5. "Take A Line For A
   Walk" lounge chair
   with footrest for
   Moroso (2002)
6. "Hang By Hand"
   coathanger,
   prototype (1999)

**Isabel Hamm**
born 1964 in Limburg, Germany
**Studio Location**
Cologne, Germany

Isabel Hamm began her career as a ceramicist at the age of 17, undertaking her apprenticeship as a potter in her native town of Limburg from 1981 to 1984.

Until 1988, Hamm studied at the Fachschule für Keramik in Höhr-Grenzhausen, and, in 1987, she received her Crafts Master Diploma in Ceramics in Marburg. That same year, she became a member of the design group X99 in Cologne, where she settled in 1989 to open her own ceramics workshop, working on the design and production of stoneware pieces.

After many years working professionally in ceramics, Hamm chose to return to education in 1996 when she started her Masters degree in Ceramics and Glass at the Royal College of Art, London. It was here that she expanded her skills to embrace glass design and won the prestigious RSA Student Design Award in Glassware on completion of her studies in 1998.

In the same year, she set up a new design studio in Cologne – the base for various activities such as projects with Salviati, the famous glassmakers of Murano, Italy, and tableware for the German brands WMF and Waechtersbach.

Further activities include commissions for glass chandeliers, teaching in Saarbrücken and Krefeld, the design and organisation of the successful "Spin Off" prototype exhibition at the annual Cologne Furniture Fair, and a period at the European Ceramic Work Centre (EKWC) in the Netherlands.

**My inspiration**
I believe the modern surroundings of my childhood home rubbed off on me, such as eating off simple Arabia tableware

**D**

**isabel hamm**

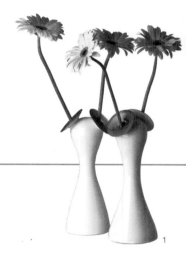

1

**Q. What types of products do you design?**

A. I work on glass and ceramic objects, table- and kitchenware and other small household products as well as lighting, especially glass chandeliers.

**Q. What or who has been of significant influence on your work as a whole?**

A. As a child, I wondered why we didn't have the kind of "cosy home" that other people had. Looking back now, I think growing up with Knoll furniture, Pott cutlery and Arabia tableware had a very big influence on me.

**Q. What was your big break?**

A. After working as a potter for quite a long time, my big change came when I started working with glass. It wasn't just about changing materials but also my approach to designing things. For the first time, the design was not linked to my craft skills.

**Q. What drives your designs?**

A. It may sound a bit superficial, but first of all it's fun and joy. Second, though, I like to improve things that annoy me in my everyday life, and, third, I like the challenge of solving any given task.

**Q. How important are trends in your work?**

A. Trends are impulses that certainly influence the work. I either go with or against trends – they sharpen your awareness.

**Q. How important is it for your work to reflect a German design tradition?**

A. German design history is very rich and to be aware of a "German" aesthetic is important in terms of analysing my own design approach. I don't think that my designs are very German, but my personality certainly is.

**Q. Is your work an individual statement or a team solution?**

A. Most of my work is an individual statement, especially the glass and ceramics. For the product design projects I prefer teamwork, but still most of it I do as an individual.

**Q. What elements of the design process do you find particularly frustrating?**

A. Waiting! – for phone calls, promises, a decision, a job, the money to arrive, a great idea…

**Q. To what level will you compromise to satisfy your client?**

A. In product design, I don't see compromises in a negative way. I believe that good compromises play a strong role in any kind of teamwork, either with another designer, or with the company you're working for.

**Q. What do you still aspire to design?**

A. Designing non-elitist, affordable products that people buy because of what they're for and their shape, and not just because of the label.

**Q. How would you describe your design approach in one sentence?**

A. If the gut reaction isn't right, the design isn't ready yet.

**My work**
1. "Kosmonauten" ceramic vases, self-production (1995)
2. "Stagno" glass bowl for Salviati (2003)
3. "Goeffel" for WMF (2004)
4. "Fish" hand blown coloured glass vases, self-production (2000)
5. "Hydrant" porcelain water jug made at the European Ceramic Work Center (EKWC, Holland) (2003)
6. "Tigrati" series of vases for Salviati (2000)

**Thomas Heatherwick**
born 1970 in London, UK
**Studio Location**
Thomas Heatherwick Studio
London, UK

Thomas Heatherwick's talent for three-dimensional design led him to study at Manchester Polytechnic (1989–92), where he undertook his first project, "Pavilion" – a sculpture made from aluminium, polycarbonate, timber and Velcro that was subsequently acquired by the Sculpture Park at Goodwood. Next came postgraduate training at the Royal College of Art , London (1992–94), and in 1994, he opened his own studio in the capital to carry out experimental projects involving architecture, engineering, design and sculpture.

A decade later, Heatherwick and his team have a diverse portfolio. Many projects are one-offs, such as "Blue Carpet" – a Newcastle square paved with blue recycled-glass tiles; a bridge across a canal that unfurls when required; and a sculpture just unveiled, "B of the Bang" – an explosion of steel spikes that rising 56 metres in front of Manchester City stadium. There are smaller scale works, too, from an award-winning Harvey Nichols window display to a range of bags for Longchamp.

In all his work there is a profound concern for our sense of place – which has led to his appointment as lead artist for Milton Keynes and to another of his current projects, a mountainside Buddhist temple in Kagoshima, Japan.

**My inspiration**
As a child, the making process that my mother used to undertake in her workshop at home transfixed me

# thomas heatherwick

**GB**

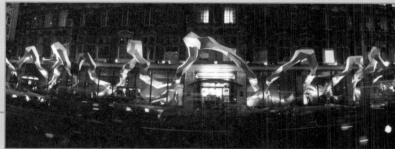

**Q. What types of products do you design?**

A. I don't really design products as such but rather anything in three dimensions possessing some element of function. My studio has worked on infrastructure, landscapes, urban design and public art. We are developing a Buddhist temple in Kagoshima, Japan; the UK's tallest sculpture at the entrance of Manchester City football stadium; and a thirty-storey building in North London. Our focus tends to be architectural but we've recently designed an expandable handbag for Longchamp – a bit of a departure for us, but very enjoyable.

**Q. What or who has been of significant influence on your work?**

A. My mother has been a huge influence on my work. She had a workshop in our house where I used to watch her making things. I remember being really proud of her having "maker's hands", with lumps of tough skin, rather than manicured nails like my friends' mums.

**Q. What was your big break?**

A. It has not been a question of one big break, but an accumulation of little big breaks. However, a couple of moments stand out as having made a difference to the development of the studio. Meeting Terence Conran when I was at the RCA was a great boost. He was excited by ideas and gave me the space to develop some of mine. Something else that springs to mind was winning the D&AD Gold award for the studio's Harvey Nichols installation for London Fashion Week. We won and suddenly many more people knew about our work.

**Q. What human emotions and necessities drive your designs?**

A. I tend to be driven by the needs and opportunities of a given situation or context. Something might look quite expressive in the end, but it develops from pragmatic and strategic decisions. I don't feel that I am expressing myself but instead the possibilities of a brief.

**Q. How important are trends in your work?**

A. In my area of work, trends have a particular influence on the briefs and opportunities that are put forward. The commissioning process is extremely susceptible to trends: at the moment, many cities are striving to build iconic cultural buildings or works of art as a way of increasing their status and achieve social and economic regeneration.

**Q. Is your work an individual statement or a team solution?**

A. Neither. I make a process happen and it involves many people – client groups, my studio team, engineers, contractors, manufacturers – even my granny sometimes!

**Q. What elements of the design process do you find frustrating?**

A. For me, the design process is difficult and challenging and I accept this, so I don't find it frustrating.

**Q. To what level will you compromise to satisfy your client?**

A. If a client has a concern or objection, there tends to be a good reason for it. In addressing this, I'm not compromising; I'm working with constraints inherent to the project.

**Q. What do you still aspire to design?**

A. More buildings.

2

3

4

**My work**
1. "Autumn Intrusion" window installation for Harvey Nichols (1997)
2. Model for "B of the Bang" 56-metre high sculpture for Manchester City Stadium (2004)
3. Model for Buddhist temple in Kagoshima, Japan (not complete)
4. "Blue Carpet Square" in Newcastle upon Tyne city centre, UK (2002)
5. "Sitootery" summerhouse at Barnards Farm, Essex (2003)

**Client list**
Arts Council England
**Barnards Farm, Essex**
Crafts Council, London
**English Heritage**
Guy's Hospital, London
**Harvey Nichols, London**
Hat Hill Sculpture Foundation
**Manchester City Council**
MEC/Stanhope plc
**Milton Keynes Council**
Newcastle City Council
**Paddington Basin Developments Ltd**
Royal Borough of Kensington & Chelsea
**Science Museum, London**
St Francis Initiative
**Temple, Japan**
Terence Conran
**The Lighthouse, Glasgow**
Victoria & Albert Museum, London
**The Wellcome Trust**

5

**Sam Hecht**
born 1969 in London, UK
**Studio Location**
London, UK

Sam Hecht undertook his training as an industrial designer in his native London at Central St Martins College of Art and Design, followed by postgraduate studies at the Royal College of Art (RCA). On completing his studies in 1993, he worked in the studio of the architect David Chipperfield (pp 76–77) as well as with the Studia Design Group in Tel Aviv. In 1994, he joined Naoto Fukasawa (pp 106–107) in the San Francisco and Tokyo offices of the international design agency IDEO. In 1999, the company invited him back to London to become head of industrial design for IDEO Europe.

Hecht is a keen observer of human behaviour, able to identify the core problems of specific as well as day-to-day interactive difficulties. By stripping back these difficulties in a working zone free from preconceptions, Hecht is able to develop concepts that truly address the design issues at hand. Rigorous analysis coupled with an understanding of complex technological applications form the foundation on which he and his team have formed highly effective project outcomes. Hecht doesn't want technology to confuse the end consumer, choosing to build interfaces that are clear and refined, letting him or her carry out their function with pleasurable ease. His designs have won countless awards and have been showcased in exhibitions across the world.

In 2002, Hecht co-founded Industrial Facility in London with his partner, Kim Colin, a teacher of architecture at the RCA, whose concern is with investigating themes that merge product and landscape.

**My inspiration**
The lifetime work of sculptor Isamu Noguchi (1904–1988) who also seamlessly applied his seductive forms to objects for the home, such as these Akari light shades

**GB**

**sam hecht**

**Q. What types of products do you design?**

A. There are few borders, and I don't mean to say that in a light way. We design the product, and invariably the client asks for thoughts on the packaging, and then sometimes for the shop or an exhibition… I try to avoid the design of gifts… and steer clear of weapons.

**Q. What or who has been a significant influence on your work?**

A. The writings and works of the Japanese designer Shiro Kuramata and the Japanese-American sculptor Isamu Noguchi were a strong influence on me at a young age. They continue to hold many secrets, and I find myself continually reappraising them. The films of Jaques Tati are also an influence because the humour is born from observing people in daily life – something I find so inspiring. I must also mention Tokyu Hands [an eight-storey craft store in Tokyo], a treasure-trove of everything imaginable and to which I make a pilgrimage four times a year.

**Q. What was your big break?**

A. Meeting my partner, Kim Colin – an architect by training. She has broadened my horizons, opened my eyes to many new things…

**Q. What emotions drive your designs?**

A. I'm not an emotionally driven designer. I attempt to start a project rationally – with a clear head. In this way, I think, the project's essential elements and parameters start to become visible. Emotions don't really play a role in our studio – I find they can get in the way of what really matters. If you start out from emotions, you can get emotional when a client disagrees, and that isn't useful. A client once told me – I was designing an aeroplane – that I "lacked emotion", and it was the perfect compliment. We do an enormous amount of research for each project, often without the client realising it. I have no time for mediocrity, so it's important for me to understand all of the issues in hand.

**Q. How important are trends in your work?**

A. Looking and finding things beyond trends is invariably more inspiring than looking at them. The element of discovery and mystery is important in opening up the mind. I cherish oddity, which, if you look hard enough, can always be found. Sometimes in our research we look at trends because they can be valuable in revealing shifts in cultural values that might impact on the use of a new product. But, in themselves, they are not worth looking at. And the least important place to absorb trends is from the design world.

**Q. Is your work an individual statement or a team solution?**

A. It's always about the team – the people around me. It's a falsity that design is created in some kind of cultural isolation.

**Q. To what level will you compromise to satisfy your client?**

A. There are always layers of compromise, but as long as the idea remains a fundamental focus, it's easier to ride these out. When the idea is weak, compromises bring into question the very point of the project.

**Q. What do you still aspire to design?**

A. Hi-fi. The time is right for a revolution.

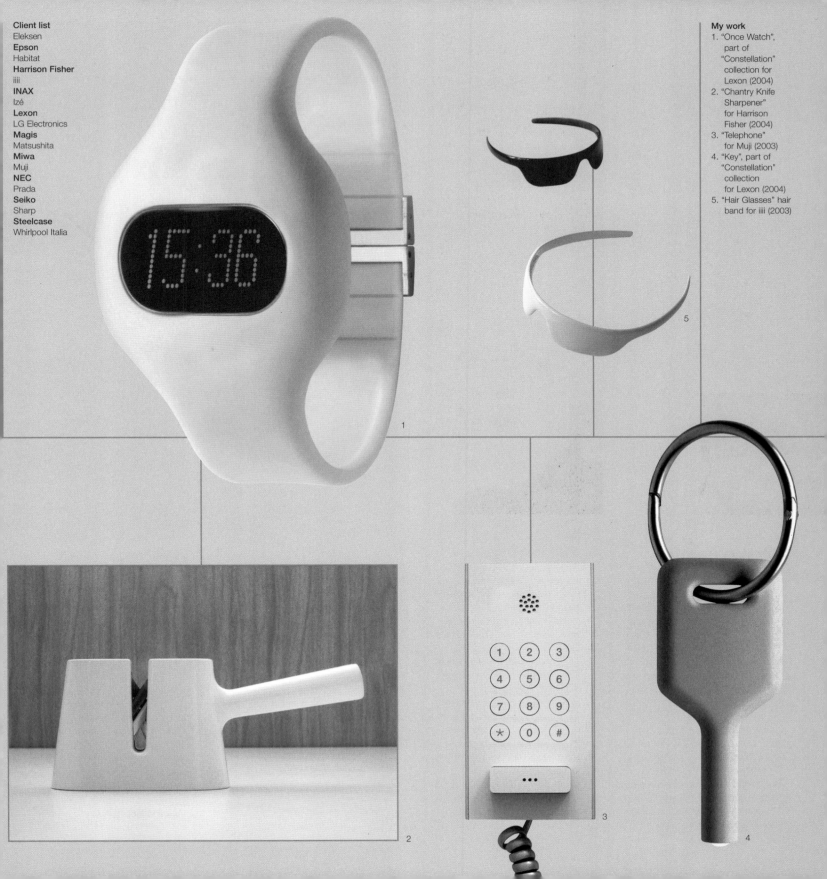

**Stefanie Hering**
born 1967 in Stuttgart, Germany
**Studio Location**
Berlin, Germany

Stefanie Hering is widely considered to be one of the leading designers in contemporary porcelain. From the age of 16, she spent six years learning ceramics and working as an apprentice in Ireland, Denmark and Germany, before starting formal studies at the Fachschule für Keramikgestaltung in Höhr-Grenzhausen, Germany. After graduating in 1992, she set up her own porcelain workshop in Berlin, working as a freelance designer while producing her own limited-edition objects, which she exhibited in galleries, shops and trade fairs around the world. In 1999, Hering launched her own label, in collaboration with her husband, the architect Götz Esslinger, and the ceramics specialist Wiebke Lehmann.

Hering creates elegant contemporary forms that expose the ethereal and fragile qualities of porcelain through expert handcrafting. The individual limited-edition items, which are always moulded on the wheel, continually push the boundaries of what can physically be achieved in production – featuring, for example, paper-thin walls, vast internal volumes or perilously towering forms, as in the spectacular and humorous "Size Queens" series of vases (2003). Her ever-increasing range of vases, bowls, tableware and lights often incorporate subtle surface patterning, normally without the use of colour, celebrating the silk-like tactility of the material. Her collections continue to grow – a chandelier being a recent addition.

**D**

## stefanie hering

**My inspiration**
The German pavilion at the World Expo 1967 designed by architects Rolf Gutbrod & Frei Otto

**Q. What types of products do you design?**

A. We design everything that can be used and which at the same time pleases the eye. We work mainly on tableware and lighting design, as porcelain is our main line of business.

**Q. What or who has been a significant influence on your work?**

A. Space, light and food. In terms of architecture, it's the Modern Movement – buildings that are lightweight, transparent, full of daylight. Individual architects might be Frei Otto, Renzo Piano and Buckminster Fuller. Fresh food and the slow food movement…

**Q. What was your big break?**

A. There has been no big break in my life. My way of working has been steadily progressive, without giant leaps. Since work is an integral part of my life, I try to create holistically, organically… without breaks.

**Q. What human emotions and necessities drive your designs?**

A. We try to bring warmth into functional objects and emotions into everyday culture. We don't think it's necessary to spin up design theories to back up our work. "A cup is a cup is a cup…" means that a cup, after being designed, will still be used as a cup.

**Q. How important are trends in your work?**

A. Trends are not very important in our work. We prefer to be the trendsetters, but we wouldn't like to sacrifice our soul just to be trendy. We hope that our design survives trends.

**Q. How important is it for your work to reflect the design characteristics of your nation?**

A. It's not important at all… Craftsmanship, technical skill, technology that reflect a certain region or generation are important in our work, of course, but we work with people, not with nations.

**Q. Is your work an individual statement or a team solution?**

A. At the start of my career, it was an individual statement. Today it's more of a team solution, achieved through collaboration with my husband, Götz Esslinger.

**Q. What elements of the design process do you find particularly frustrating?**

A. What annoys us are long, dragged-out decision-making processes. To achieve good design you need a strong-minded and decisive commissioner.

**Q. To what level will you compromise to satisfy your client?**

A. We compromise, of course, within our own rules. Design isn't a dictatorship, and the client is a member of the team. Design without compromise involves a lot of mutual understanding. This is why, in the design process, both sides need to learn from each other.

**Q. What would be your second career choice after design?**

A. I would love to work on a large-scale landscaping project, and Götz would like to be a "gentleman of independent means".

**My work**
1. "01.01.04"
   perforated bowl for
   Hering-Berlin (1995)
2. "01.11.05" plate for
   Hering-Berlin (2003)
3. "03.28.k" chandelier
   with 29 modules for
   Hering-Berlin (2004)
4. "05.10.01/2/3"
   teapots for
   Hering-Berlin (2000)

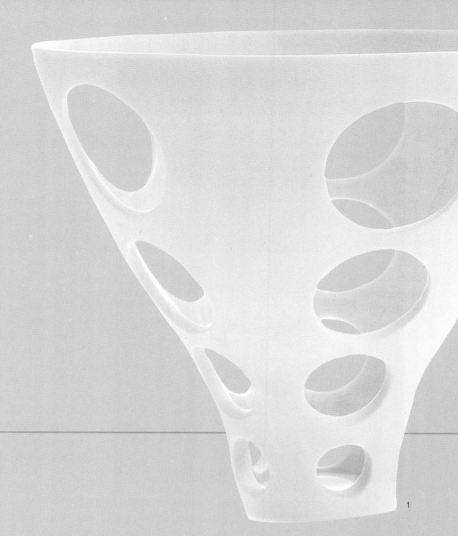

1

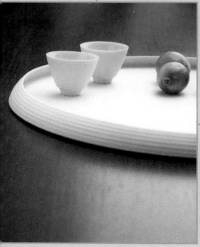

2

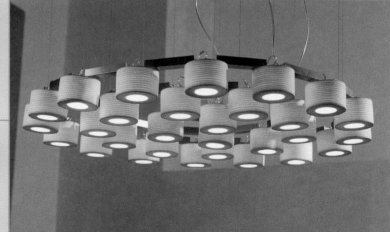

3

4

**Matthew Hilton**
born 1957 in Hastings, UK
**Studio Location**
London, UK

One of the UK's leading furniture designers, Matthew Hilton studied 3-D Design and Furniture at Kingston University during the late 1970s. After graduating, he worked as an industrial designer for Capa before founding his own studio and workshop in 1983. Very quickly, his high-value, low-volume designs were selling at such London emporia as Liberty's and the Conran Shop, bringing him to the attention of

Sheridan Coakley, head of the London manufacturer and retailer SCP. This was the beginning of a collaboration that has produced classics such as the "Balzac" leather armchair (1992) and the "Flipper" coffee table – both must-have icons of 1990s loft living. Hilton has also worked for many other manufacturers including Authentics, Driade, XO and Montis. In 2000, Tom Dixon (pp 96–97) asked him to head the Habitat furniture team, where he worked until 2004.

Typical of Hilton's low-key approach is the "Wait" chair he produced for Authentics in 1998–99, 3,000 of which were deployed in the Millennium Dome.

Economically priced, "Wait" has all the qualities you might expect from an injection-moulded plastic chair – strong, light and stackable – but differs by being sleek, classy and environmentally responsible (it's made from recycled plastic). Humour, too, plays a part in his work, as seen in the zoomorphic references of designs such as the "Swan" candlesticks – a pair of zigzagging metal forms that resemble courting swans – and his "Antelope" table.

Hilton's furniture has entered the permanent collections of the Victoria and Albert Museum, London, and the Geffrye Museum, London.

GB

**matthew hilton**

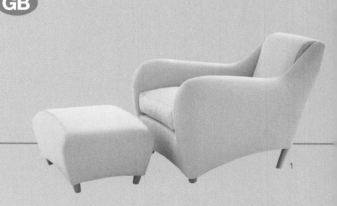

1

**Q. What do you design?**
A. I have mostly designed furniture, lighting and accessories for the European domestic retail market. I have also recently designed school furniture and furniture for hospitals. Early in my career I worked on computer designs, telephones, a motorbike, and interiors of a chain of computer retail shops.

**Q. Who has influenced your work?**
A. I was very influenced by architects Richard Rogers and Renzo Piano and the Pompidou Centre in Paris. Industrial designers like Dieter Rams, the Italian 'Masters' Magistretti, Enzo Mari, Castiglioni, and also Arne Jacobsen. Also Arte Povera, and the artist Tom Friedman.

**Q. What was your big break?**
A. There have been lots of breaks but the most significant one has to be

meeting Sheridan Coakley, the owner of British furniture manufacturer and retailer SCP. We met at the start of SCP in 1985 and I designed some of his first products, which were shown at the Salone del Mobile in Milan in September 1986. I have designed products for SCP every year since.

**Q. What human emotions and necessities drive your designs?**
A. I have learnt to always try to do and say what I truly believe rather than try to please the people I work for. I had to learn to trust my own judgment.

**Q. How important are trends in your work?**
A. Trends are something that are apparent after the designer has done the work. Designers should be leaders not followers as there is an evolution of ideas happening constantly in all areas of life.

**Q. How important is it for your work to reflect the design characteristics of your nation?**
A. This is not something I consciously consider but I think it comes through naturally in my work. I value the idea of developing a new British style, but with so little manufacturing left in Britain and few companies producing modern furniture here, the opportunities are limited. Undoubtedly, when working for an international company the characteristics unique to that country, often most apparent in the manufacturing process or structure of the company, influence the work.

**Q. Is your work an individual statement or a team solution?**
A. My work is mainly an individual statement bolstered by technical and product development support.

**Q. What elements of the design process do you find frustrating?**
A. An unsound reason for the product to exist in the first instance. A bad start is the worst thing, an unclear direction, a badly communicated or unclear brief. The last stage of developing a product can also be very frustrating when working on prototypes and the final details that are so important. These are often the hardest elements to design and resolve at this final stage.

**Q. How much will you compromise to satisfy your client?**
A. Compromise is not a dirty word but an inherent part of the design process. I find it difficult to understand designers who see compromise as giving in and as a consequence somehow spoiling the purity of their original concept.

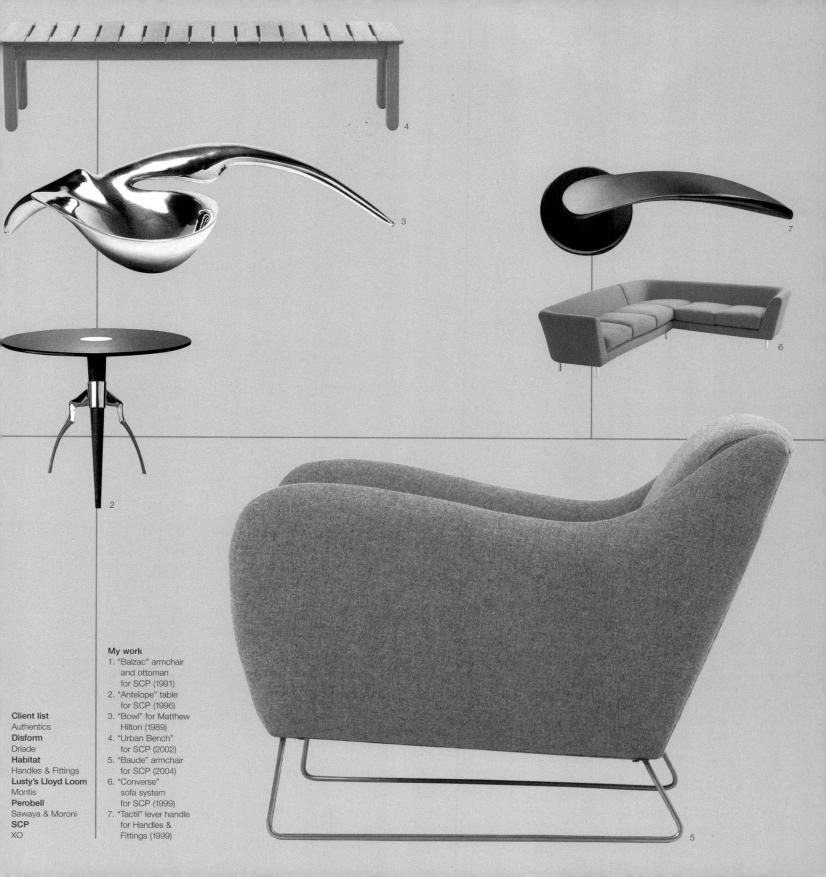

**Client list**
Authentics
**Disform**
Driade
**Habitat**
Handles & Fittings
**Lusty's Lloyd Loom**
Montis
**Perobell**
Sawaya & Moroni
**SCP**
XO

**My work**
1. "Balzac" armchair
 and ottoman
 for SCP (1991)
2. "Antelope" table
 for SCP (1996)
3. "Bowl" for Matthew
 Hilton (1989)
4. "Urban Bench"
 for SCP (2002)
5. "Baude" armchair
 for SCP (2004)
6. "Converse"
 sofa system
 for SCP (1999)
7. "Tactil" lever handle
 for Handles &
 Fittings (1999)

**Geoff Hollington**
born 1949 in Essex, UK
**Studio Location**
London, UK

Geoff Hollington studied Industrial Design at London's Central School of Art and Design, followed by postgraduate training in Environmental Design at the Royal College of Art. In 1974, he joined the Milton Keynes Development Corporation – the organisation charged with building the new town of Milton Keynes in the South Midlands, UK – where he worked on street furniture and landscaping. From 1977 to 1980, Hollington went into partnership with the architect Michael Glickman, designing interiors for clients such as Island Records and Vidal Sassoon.

In 1980, Hollington founded his own London-based studio and since then has secured his position as one of Britain's leading product design consultants. Examples of his work include his "Sonnet" Parker pen -- a classic that has remained in volume production since 1993; an office-seating and systems project for US manufacturer Herman Miller; and camera designs for Kodak. The firm's award-winning products avoid a signature style or ostentatious "look" – the focus instead is on their being easy and pleasurable to use, pleasant to look at and economic to manufacture. Hollington's studio works on small, low-tech objects, global high-tech consumer goods and large-scale projects such as interactive exhibition design.

Hollington also teaches at several design schools and lectures at conferences around the world, while contributing regular opinion columns for various periodicals.

**My inspiration**
The optimistic era of Americana in the 50s and 60s, optimised by the Cadillac Eldorado Brougham of 1957

GB

geoff hollington

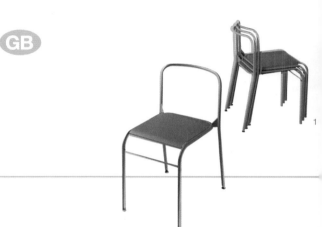

1

**Q. What types of products do you design?**

A. Over the years I've designed many different kinds… At one time, I was doing a huge amount of office workplace stuff… If you ask me what I do now, I'd say I design iconic products… Incidentally, an iconic product is one that is memorable, timeless and ultimately reaches people.

**Q. What or who has been a significant influence on your work?**

A. I used to say Charles and Ray Eames because I have a history of Eames-related connections… I worked for years as a consultant to Herman Miller [the manufacturer of many Eames designs] in Michigan… But when I look at my work it has absolutely no "Eamesness" to it at all; none. I wish it had. So, looking for a more honest answer, I'd say it's '50s and '60s Americana. It's that "Masters of the Universe", post-war, everything-is-possible and life-is-rosy design zeitgeist that gave us the Frigidaire Iced Diamond refrigerator and the 1957 "Cadillac Eldorado Brougham". I love (have always loved) the fact that those products are sexy, emotional, exciting, visceral, glossy and accessible.

**Q. What was your big break?**

A. It seems to me that careers are more complex these days and an individual can have several "breaks" as they bump along. My first was when Herman Miller in the United States "discovered" me and asked me to do a chair…

**Q. Is your work an individual statement or a team solution?**

A. Sometimes I work on a design alone if it's a relatively simple product, but often in a team when complexity demands it. It's well known that groups can solve some kinds of problems better than a lone individual with a mug of coffee and a pencil. It's also clear to me that visual and structural clarity sometimes comes best from the solo brain.

**Q. What elements of the design process do you find particularly frustrating?**

A. I must be completely honest here and risk commercial suicide when I say that it's bad marketing people. Let me be clear: good marketing people are great and many are my friends. Good marketing people can be at least as responsible for great products as we designers are. But there's a particular breed of product manager that just gets it all wrong: they don't have the confidence and understanding to drive and get value from creative agencies or from research. They let their personal taste drive product decisions… and when they do use research they ask the wrong questions and then slavishly follow the routes indicated by the results. This way they can hire a great designer and end up with a dog of a product.

**Q. To what level will you compromise to satisfy your client?**

A. Compromise is an ugly word! Charles Eames famously said that good design is the product of constraints. Constraints strengthen design the same way geography and weather can strengthen a tree… they make you work harder and… think more creatively. The client is one channel for those constraints; if they're valid, you work with them. If the client says the target sales price is £19.95 and that's based on good research, that's a valid constraint. Working to that price isn't a compromise.

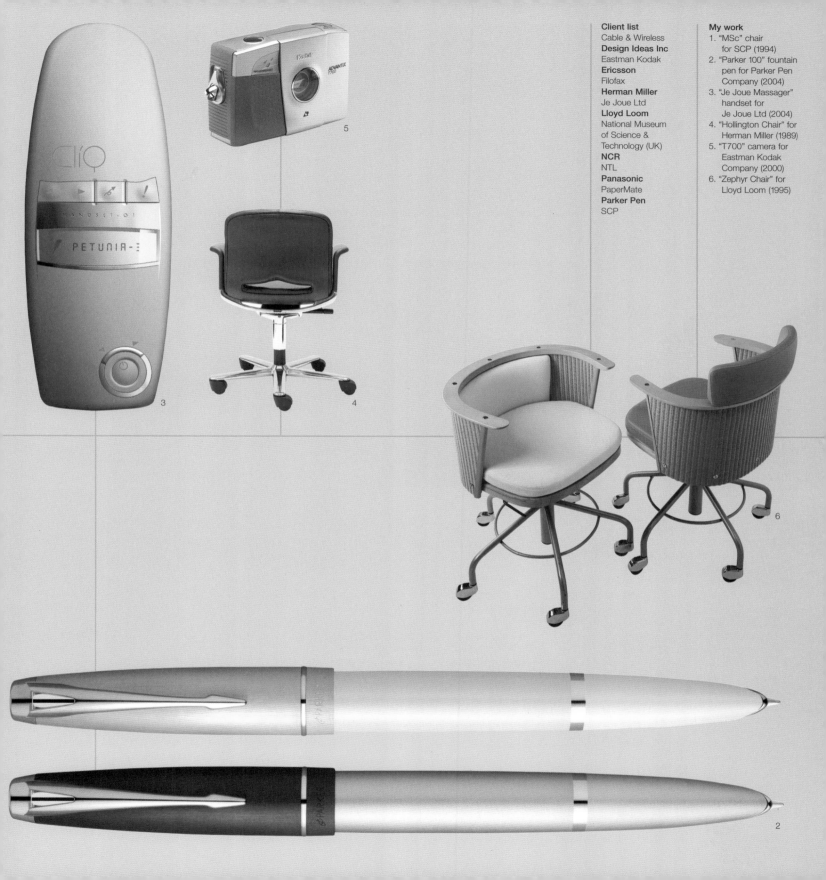

**Richard Hutten**
born 1967 in Zwollerkerspel, Holland
**Studio Location**
Rotterdam, Holland

In 1993, two years after graduating from the Academie voor Industriele Vormgeving in Eindhoven, Richard Hutten presented his works as one of the founder members of the Dutch design collective Droog Design at the Milan Furniture Fair. His success at the event made him internationally known, and he is now one of Holland's most successful designers.

Hutten's furniture designs, such as "Table-upon-Table" barstool (1991) and "The Cross" table (1993), are reinterpretations of the basic wooden table and chair. Retaining the table's structural honesty and simplicity, he altered the scale and combined different elements to "suggest" functional applications. By removing the finery of styling – a move he has dubbed the "No sign of design" – Hutten challenges our preconceptions of design where form and material can dictate its worth and restrict its functional interpretations. Employing a clarity akin to Modernism, he doesn't dictate the function but rather invites playful interaction.

His works have been exhibited internationally and form part of many permanent museum collections. He is currently setting up the Richard Hutten International Design Academy (RHIDA) in Seoul, Korea.

**My inspiration**
Daily life spent with my two sons, Abel and Boris. Their direct and playful behaviour is the biggest source of inspiration in my work

NL

richard hutten

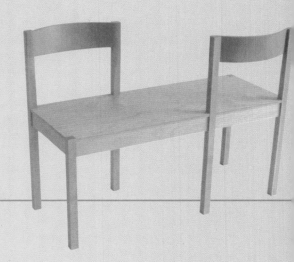

**Q. What types of products do you design?**
A. Being a Homo Ludens [playful human], I design objects to play with – "Toys for Life". With my designs I don't provide solutions, but possibilities. The ability to play is essential to the evolution of man. My goal is not to seduce but to amuse people.

**Q. What was your big break?**
A. Right after my graduation in 1991, I founded my own design studio. In 1992, I won the Dutch Furniture Award, which was my breakthrough in the Netherlands. In 1993, Droog Design, during the Milan Furniture Fair, presented my work, and this started my international career.

**Q. What emotions and necessities drive your designs?**
A. Every emotion imaginable drives my designs, but the most important ones are enjoyment, pleasure, having fun and loving. Self-expression, self-realisation, humour and the ability to play together are the most important necessities in life, and therefore also in my work.

**Q. How important are trends in your work?**
A. Trends don't play any role at all in my work. The word "trend" indicates something very temporary. My work is more enduring.

**Q. Is being Dutch important to your work?**
A. It's not important at all. But in Holland design is part of our daily life. Every square inch of the country is designed – even most of the land is artificial. And modern design was almost invented in Holland by Gerrit Rietveld. "Dutch" design, therefore, runs through my veins, and I'm surrounded by an environment that helped create it, so perhaps its influence on my work is inevitable.

**Q. To what degree will you compromise to satisfy your client?**
A. The idea of having to compromise is a general misunderstanding. It implies that the client is the enemy. In the way I work, the client is part of a team with a shared goal – that is, to make the best product. Both the designer and the client use their skills to achieve this goal. A strong idea or concept can't be destroyed by the modifications that, for whatever reason, have to be made.

**Q. What would be your second career choice after design?**
A. Being a designer implies that you already have many simultaneous careers. You're not only "a creator of form"… you are a philosopher, engineer, politician, joker, architect, environmentalist, economist, adventurer, scientist, artist, architect, teacher, photographer, entertainer… You don't choose to be a designer, you're born one. Perhaps, though, I could focus more strongly on one of the aspects I just mentioned…

**Q. Is there something you really dream of designing?**
A. The biggest challenge for me is always to design something I haven't done before. I want to explore the unknown. Since of all the things that can be designed I have designed only a few so far, there's still a lot left for me to explore!

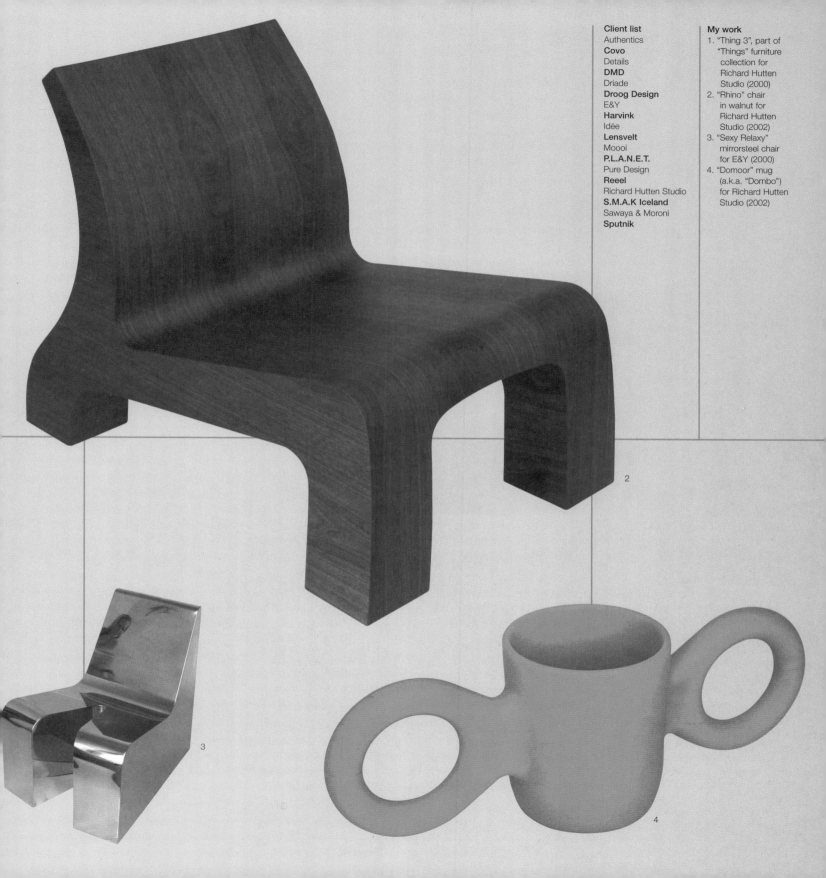

**Client list**
Authentics
**Covo**
Details
**DMD**
Driade
**Droog Design**
E&Y
**Harvink**
Idée
**Lensvelt**
Moooi
**P.L.A.N.E.T.**
Pure Design
**Reeel**
Richard Hutten Studio
**S.M.A.K Iceland**
Sawaya & Moroni
**Sputnik**

**My work**
1. "Thing 3", part of "Things" furniture collection for Richard Hutten Studio (2000)
2. "Rhino" chair in walnut for Richard Hutten Studio (2002)
3. "Sexy Relaxy" mirrorsteel chair for E&Y (2000)
4. "Domoor" mug (a.k.a. "Dombo") for Richard Hutten Studio (2002)

Massimo Iosa Ghini
born 1959 in Bologna, Italy
**Studio Locations**
Bologna and Milan, Italy

After completing his studies in architecture in 1982, Massimo Iosa Ghini took a break from designing buildings to create comic illustrations for the Italian style magazines *Frigidaire*, *Fashion News* and *Vanity* showing the adventures of spy hero Capitano Sillavengo against a backdrop of dynamic cityscapes. He also worked on television studio sets, and in 1986 his futuristic imagination brought him to the attention of the Austrian-born avant-garde designer Ettore Sottsass, who invited him to take part in the activities of Memphis, the unconventional design group Sottsass had founded a few years earlier.

At the same time, Iosa Ghini also collaborated with a group of Bologna architects to form Bolidismo, whose work, with its streamlined curves and dynamic lines, exulted in speed and movement. In Iosa Ghini's work, this aesthetic came to the fore with the release, in 1986, of his "Dinamic" collection of upholstered furniture for Moroso – a manufacturer with whom he has continued to work.

The growth of Studio Iosa Ghini has been brought about not only by his design work for a string of international companies but also his development of projects within the realm of architecture, exhibition design, installations, retail design, corporate identity and communications.

In addition to directing activities at his studios in Bologna and Milan, Iosa Ghini lectures and holds conferences at a number of universities across Europe.

**My inspiration**
The notion of the speed, interchange, and movement of society has always informed the creative direction of my work

## massimo iosa ghini

**Q. What types of products do you design?**

A. I've had different phases. First, a phase of experimental projects with an evocative – I should say, artistic – design, during which I paid careful attention to what the designs were communicating through their systems of signs. Then, a second phase, in which the requirements of the market have been integrated within the product, but still in an innovative way… What I design still has to match what I am.

**Q. What or who has been of significant influence in your studio?**

A. Design is the interpretation of society through objects. My theme is speed. I don't mean that it's my idea of the world; it is, I repeat, my theme. For me, speed also includes the theme of ubiquity, of people's relationships, and consequently also their lifestyles.

**Q. What was your big break?**

A. In 1989, Ettore Sottsass and Barbara Radice [US design critic] launched me with an important solo show at the Design Gallery in Milan. It was then that I realised that my work could be understood.

**Q. What human emotions and necessities drive your designs?**

A. An object increasingly turns into an icon, losing its utility in favour of its own power of representation. It should be a shared "place", which also provides me with a sense of belonging. It must be sensual, clean and elegant, but it should also have a certain "pop" emotion with which I can identify.

**Q. How important are trends in your work?**

A. They are like waves that modify the highway of my work; some trends create wide curves; others sharp chicanes.

**Q. How important is it for your work to reflect the design characteristics of your nation?**

A. I suppose they are automatically reflected in my work, but the idea of permanent mutation, creativity and renewal always takes precedence.

**Q. Is your work an individual statement or a team solution?**

A. Design is an intuitive synthesis of data. The creative act itself is individual, but both in the research phase, before, and in the production phase, after, design is teamwork.

**Q. What elements of the design process do you find particularly frustrating?**

A. I would not use the word "frustrating". I believe there is a great tension between the technical and creative phases. Being able to control the production aspects from a technical and economic point of view requires a great mental elasticity, even when working in a team.

**Q. What would be your second career choice after design?**

A. As Andrea Branzi says, in Italy, design is a strategic phase that introduces architecture.

**Q. What do you still aspire to design?**

A. I like the very Italian idea of style and of quality, no matter how big or small the object is.

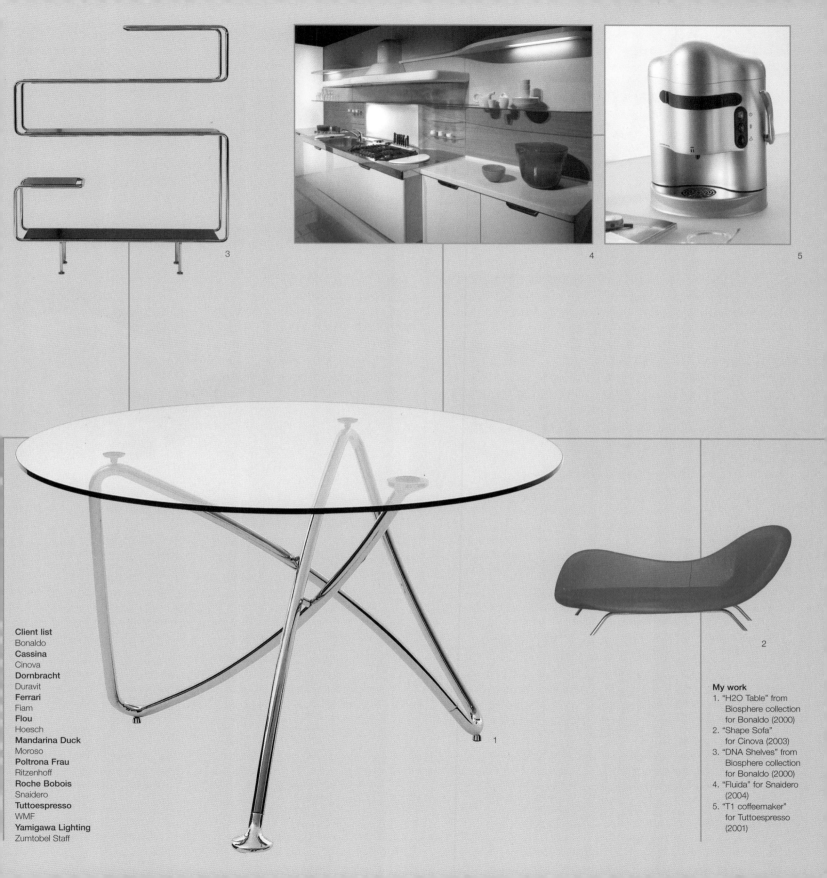

Client list
Bonaldo
**Cassina**
Cinova
**Dornbracht**
Duravit
**Ferrari**
Fiam
**Flou**
Hoesch
**Mandarina Duck**
Moroso
**Poltrona Frau**
Ritzenhoff
**Roche Bobois**
Snaidero
**Tuttoespresso**
WMF
**Yamigawa Lighting**
Zumtobel Staff

**My work**
1. "H2O Table" from
   Biosphere collection
   for Bonaldo (2000)
2. "Shape Sofa"
   for Cinova (2003)
3. "DNA Shelves" from
   Biosphere collection
   for Bonaldo (2000)
4. "Fluida" for Snaidero
   (2004)
5. "T1 coffeemaker"
   for Tuttoespresso
   (2001)

**James Irvine**
born 1958 in London, UK
**Studio Location**
Milan, Italy

Irvine studied Furniture Design at Kingston University and then at the Royal College of Art, London; fellow student and friend at both institutions was designer Jasper Morrison. After graduating in 1984, Irvine worked at the Olivetti design studio in Milan and, for a year, at the Toshiba studio in Tokyo. In 1988, he returned to Milan, where he founded his own studio as well returning to work for Olivetti under the direction of Ettore Sottsass. From 1992 to 1998, he became a partner in Sottsass Associati, before finally deciding to concentrate on his own projects full time. Together with his compact, three-person team, he designs for an impressive and diverse range of industrial, product and furniture manufacturers, including Cappellini, Magis, Artemide and Swedese.

Operating in what he perceives to be a saturated consumer culture, Irvine is committed to creating designs that he believes to be justifiable and responsible. Such a commitment has resulted in a succession of stylistically low-key, elegant designs that include the "Tubo" stacking chairs for BRF, the "Stand-by" public seating (2000) for Mageb and the "Hold-it" stacking boxes (2002) for Danese. In many of such designs, cool restraint is gently offset by the use of areas of monochrome colour and by a dry and self-effacing wit. The spatial, visual and ergonomic lucidity of Irvine's work is particularly impressive in his designs (in collaboration with Mercedes Benz) for a fleet of buses for the city of Hannover, Germany.

**I**

## james irvine

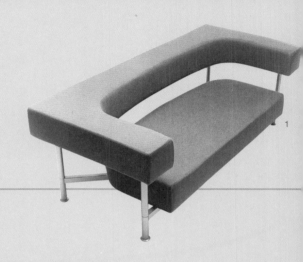

1

**Q. What types of products do you design?**
A. Whatever comes my way, as long as I feel that I can do something worthwhile. Recently, I have been designing shoes, and once I designed a bus. I actually find it more difficult to repeat the same product again and again. I never understand those designers who have done fifty sofas. It must get rather boring!

**Q. What or who has inspired your work as a whole?**
A. Hundreds of things and hundreds of people. Every time I hear this question I never know what to say, but I do believe that one should look at bad things and bad people so as to understand what not to do. There is inspiration in vulgarity as well as beauty, in horror as well as love...

**Q. What was your big break?**
A. Having a father who is an architect and a mother who is an artist. They opened my eyes.

I once wanted to be a graphic designer ... I thought I was good at it until one day my tutor, Dinah Casson, said I would be better off designing products. I followed her advice. Perhaps her telling me indirectly that I was a bad graphic designer was my biggest break.

Then coming to live in Italy certainly changed my life.

**Q. How important are trends in your work?**
A. I try to ignore them because once you have identified them they are already over.

**Q. How important is it for your work to reflect British design characteristics?**
A. Not at all. By now, everything we do can go anywhere. However, I cannot deny that I feel British. I will never be an Italian, even though I have been living in Milan for twenty years. Perhaps subconsciously what I do has something British about it, but I never try to be British.

**Q. Is your work an individual statement or a team solution?**
A. I have a wonderful team who are very good at developing my ideas.

**Q. What elements of the design process do you find frustrating?**
A. Discussing fees with clients and waiting too long to be paid. Apart from that, it is almost all wonderful.

**Q. To what level will you compromise to satisfy your client?**
A. As little as possible, but fortunately my clients usually like what I do. If they don't, then I have usually made a mistake. Then, of course, there can be those times when you are the wrong designer for the client. The art is to realise that before you even start working for them.

**Q. What would be your second career choice after design?**
A. Once I thought it would be great to be a pilot. But then, a few years ago (way before 9/11), I visited the flight-deck on a 747 and I realised it was the most boring job in the world.

**Q. What do you still aspire to design?**
A. Products that improve the quality of not just people's lives but also the relationship between industry and the world around us. I have a feeling that we need to reconsider the parameters of what is considered successful. Pure consumerism is getting rather banal.

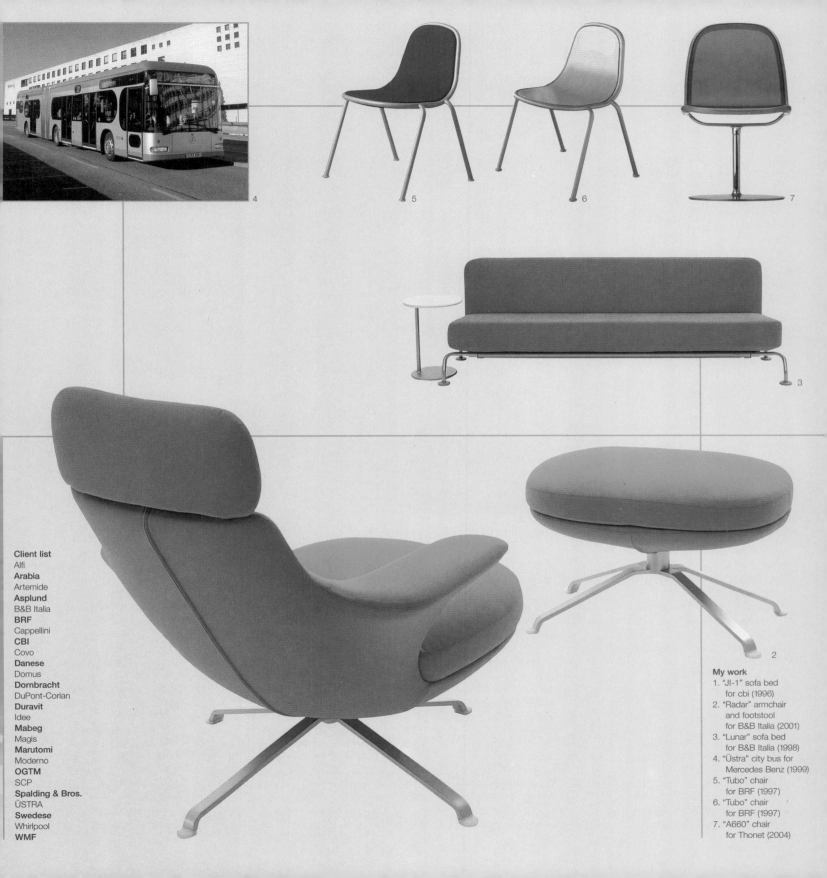

**Client list**
Alfi
**Arabia**
Artemide
**Asplund**
B&B Italia
**BRF**
Cappellini
**CBI**
Covo
**Danese**
Domus
**Dornbracht**
DuPont-Corian
**Duravit**
Idee
**Mabeg**
Magis
**Marutomi**
Moderno
**OGTM**
SCP
**Spalding & Bros.**
ÜSTRA
**Swedese**
Whirlpool
**WMF**

**My work**
1. "JI-1" sofa bed
   for cbi (1996)
2. "Radar" armchair
   and footstool
   for B&B Italia (2001)
3. "Lunar" sofa bed
   for B&B Italia (1998)
4. "Üstra" city bus for
   Mercedes Benz (1999)
5. "Tubo" chair
   for BRF (1997)
6. "Tubo" chair
   for BRF (1997)
7. "A660" chair
   for Thonet (2004)

**Jonathan Ive**
born 1967 in London, UK
**Studio Location**
Cupertino, California, USA

Jonathan Ive is the Vice-President of Industrial Design for the US computer manufacturer Apple. He and his team of designers have revolutionised the face of computer design, never standing still but continually striving to set new standards. They package the technologically confusing world of gigabytes, hard drives and circuit boards within sexy and desirable exterior housing that is far removed from the nondescript beige boxing often used by computer manufacturers.

Jonathan Ive graduated in Industrial Design from Newcastle Polytechnic, UK, in 1989. The following year, he joined the design consultancy Tangerine (pp 226–227), where he worked on everything from power tools to sanitary ware. In 1992, one of his clients, Apple, offered him a job as design director, and he hasn't looked back since. The release of the first iMac in 1998 grabbed the world's attention with its candy-coloured translucent casing, selling more than two million units in its first year. Subsequent products include the iSub speakers (1999), the iPod MP3 player (2001), the new iMac (2002) and the PowerBook G4 laptop (2003), featuring materials such as aluminium, white plastics and titanium in clear, easy-to-use, pleasing forms.

Ive's award-winning work is the result of close internal relationships across the various Apple teams – from R&D to sales and marketing. In just a few years, Ive has arguably become one of the most influential industrial designers of our time.

USA

**jonathan ive**

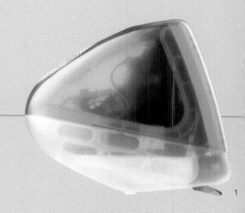

1

**Q. What types of products do you design?**

A. We are responsible for the industrial design of all Apple's hardware, from desktop and mobile computers, to displays, digital music players, headphones, web cameras, servers, mice, cables and packaging.

**Q. What or who has been a driving influence in your studio?**

A. In the 1970s, Apple talked about being at the intersection of technology and the arts. The broader goals and values of Apple, established when the company was founded, inform our approach to designing and developing products.

**Q. Do you want to surprise or soothe people with your designs?**

A. While objects elicit an emotional response and have a significance way beyond traditional views of function, our preoccupation remains with trying to design and make simple, well-made products.

**Q. What is it like working within a large company like Apple?**

A. It is critical that the leadership of a company clearly understands its products and the role of design, and that the development, marketing and sales teams are equally committed to the same goals. I am aware that what we have achieved with design is massively reliant on the commitment of lots of different teams to solve the same problems and on their sharing the same goals.

I like being part of something that is bigger than design.

**Q. How important are trends in your work?**

A. We invest significantly in the research and development of new materials/composites and processes and have consequently developed a number of new product architectures. Technology obviously defines the capabilities of our products and therefore informs their design.

**Q. Is it important for your work to express a national design aesthetic?**

A. Our work is really about solving problems, not self-expression.

**Q. Are you prepared to compromise to satisfy your client?**

A. On a number of occasions, we have delayed product launches or restarted the development of products that did not seem good enough. The same commitment to the quality of the founding idea or solution can be seen across the company.

**Q. What would be your second career choice after design?**

A. I cannot imagine doing anything other than design.

**Q. What do you still aspire to design?**

A. I remain completely obsessed with the challenges associated with digital products and believe there are significant opportunities to develop better products.

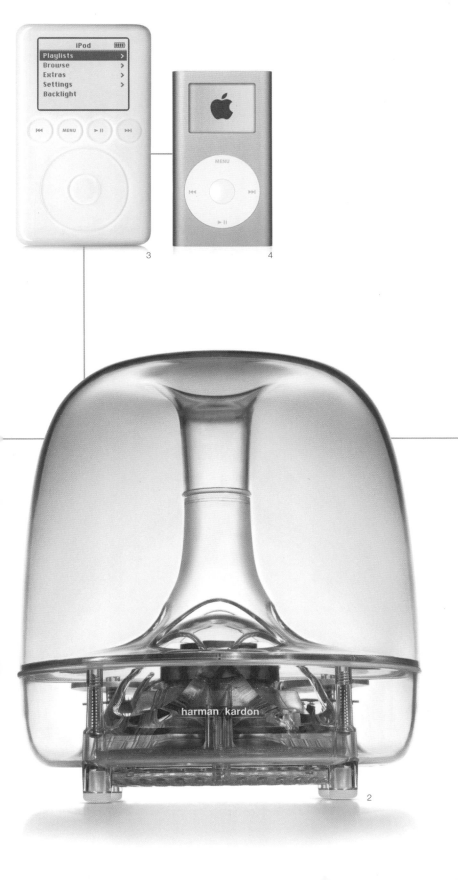

**My work**
1. "iMac" computer
   for Apple (1998)
2. "iSub" subwoofer
   for Apple (1999)
3. "iPod" MP3 portable
   music player
   for Apple (2001)
4. "iPod mini" MP3
   portable music
   player for Apple
   (2004)
5. "G5 Power Mac"
   computer for
   Apple (2004)
All products designed
by Jonathan Ive and
the Apple Design Team

**Client list**
Apple

Jamie Anley
born 1972 in Kingston, Jamaica
**Astrid Zala**
born 1968 in Hanover, Germany
**Studio Location**
London, UK

The prolific multidisciplinary brand consultancy Jam was founded by Jamie Anley, Astrid Zala and Matthieu Paillard in 1995. Anley and Paillard met first whilst working together on a sculpture project recycling fighter plane parts from an Aerospace dump near Nice. Anley then met Zala at an exhibition in London in 1991 and are now partners in life as well as in business. Paillard left the business in 1998 to return to his home country, France.

Taking their cue from Marcel Duchamp and Andy Warhol, Jam finds its inspiration in existing materials and technologies, literally "jamming" with them to explore their untapped potential. The trio's first design was a washing-machine drum that they redefined as a stool. "We believe," Anley has said, "that it's not important that viewers realise whether or not materials are found or new. With a new function and a new environment, the objects will project a new experience."

Despite – or perhaps because of – their independent, radical approach, Jam has attracted clients from large-scale corporate industry who are looking to enhance communication between brands and their market audience. Jam aims to extract the core brand values from their clients in order to reassess and ultimately invent new outlets for marketing – from products to exhibitions and printed media to online interfaces.

**Our inspiration**
The creative interaction of the people in our studio – the team shown together here in our Christmas card design of 2002

**jam** ———— **GB**

---

**Q. What products do you design?**
A. Our clients are leading brands, and our purpose is to bring meaning to their values and develop a contemporary cultural currency for them. Most of our projects therefore begin with the question: What should we design? We like to say that we design projects. The output from these projects ranges from furniture made with car parts, like we did with Audi, through to a series of bus tours for Channel 4, interiors and art pieces for Vodafone and an exhibition for Woolworths. Currently we're designing a watch, a bespoke brand environment (including the furniture and lighting), a concept magazine, a couple of installations for a large exhibition and an on-line entertainment-based project. We rarely get a brief to design something specific; more often we co-create the idea of what needs to be designed with the client.

**Q. What or who has been of significant influence in your studio?**
A. It is the people in our studio who are the biggest influence. We work as a team on all creative projects.

**Q. What was your big break?**
A. There was no one thing really. The break came over time due to a relentless belief and tenacity in our approach. We constantly develop our work to stay fresh and relevant.

**Q. What human emotions and necessities drive your designs?**
A. An understanding of emotions helps the creative process. As a group, we bring excitement and passion to the projects we work on.

As for necessities, we tap into contemporary culture, so an up-to-date awareness of leading-edge creativity in every discipline is important to us. A further necessity is the knowledge of what is possible and available in terms of materials, technologies, skills and processes.

**Q. Is your work an individual statement or a team solution?**
A. It is always a team solution. We design bespoke teams to work on specific projects. Selecting the right people for the right project is vital to see any project through to a successful conclusion. Our role then becomes one of leading and facilitating the creative process. We often have clients who participate in the team that delivers the solution.

**Q. What elements of the design process do you find frustrating?**
A. Time. Time nearly always frustrates us; the lack of it, I mean.

**Q. To what extent will you compromise to satisfy your client?**
A. We always aim to agree on the purpose and vision of a project with a client before we proceed to the design phase. Then the only compromise we both have to accept is based on financial and time constraints.

1

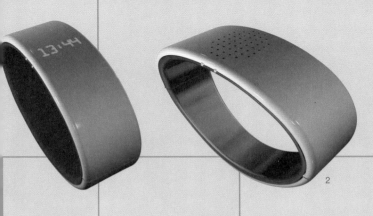

2

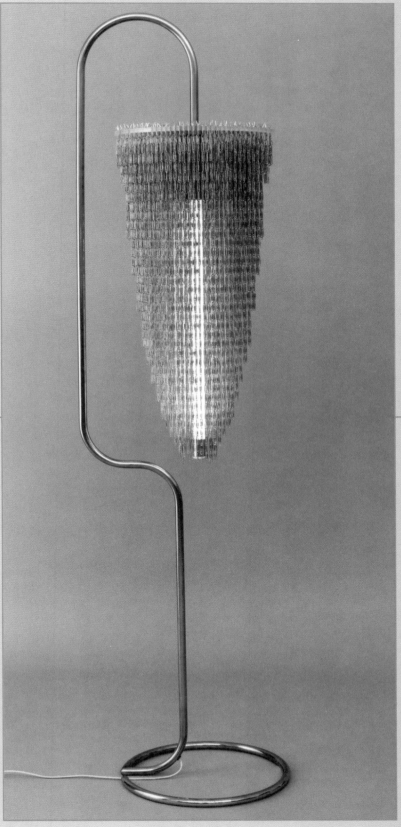

4

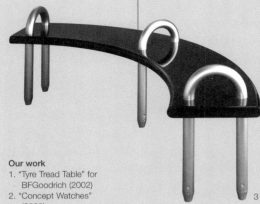

3

**Client list**
100% Design
**Audi**
BFGoodrich
**BP**
Channel 4
**Egg**
Evian
**Reebok**
Sony
**Unilever**
Vodafone
**Whirlpool**
Woolworths

**Our work**
1. "Tyre Tread Table" for BFGoodrich (2002)
2. "Concept Watches" (2003)
3. "TT Bench", part of Audi Uncovered Design Initiative for Audi (2001)
4. "Paperless" floor standing light made from paperclips for Waste to Taste Exhibition at Sotherby's (2003)

**Hella Jongerius**
born 1963 in De Meern, Netherlands
**Studio Location**
Rotterdam, Netherlands

Hella Jongerius studied at the Design Academy Eindhoven from 1988 to 1993. Her final-year exam subject was bathroom floors, and her resulting polyurethane "Bathroom Mat" was swiftly picked up by the newly formed avant-garde Dutch design collective Droog Design – a relationship that kick-started her career as a designer. She started JongeriusLab in 2000.

Jongerius works in an intriguing area between design, art, craft and technology, juxtaposing the traditional with the new, high with low tech, and the industrial with the artisanal. Her approach is primarily concerned with materials, so that, for her, process is much more important than the creation of new forms. She works by trial and error, far more interested in the chance discovery than in the finished product. For example, her "Soft Vases" (1994), made from soft polyurethane, expose the story of their making, showing scratches, bubbles and moulding joints.

Jongerius has enjoyed widespread exposure at museum exhibitions and installations around the world. In her "7 Pots/3 Centuries/2 Materials" project (1998) with the Museum Boymans van Beuningen, Rotterdam, she merged medieval pottery shards with modern industrialised pots, while in the "Kasese Chair" (1999) she transformed a traditional African wooden prie-dieu into a contemporary product using knitted carbon fibre and neoprene. She has also developed two sets of upholstery designs for Maharam – "Dot" and "Classic" (2001) – which repeat their patterns only once every two to three metres.

Jongerius' designs are either produced by external manufacturers or in limited editions from her studio. Many of her award-winning products are part of museum collections across the Netherlands and the USA. She also teaches as Head of Department at the Design Academy, Eindhoven.

**hella jongerius**

**NL**

1

---

**Q. What types of products do you design?**
A. Products with the right balance between an industrially made serial product and the handmade one-off, whereby both worlds lose their limitations, and products with an identity appear.

**Q. What or who has been a significant influence in your studio?**
A. David Byrne singing "Burning Down the House". It keeps me sharp.

**Q. What was your big break?**
A. The early-90s shows in Milan with Droog Design.

**Q. What human emotions and necessities drive your designs?**

A. I make my design decisions first with my intuition, my most important tool. Intuition is based on all the human emotions that exist. My head follows later, with analysis and strategies.

**Q. How important are trends in your work?**
A. My own truth is important. Trends are marketing bullshit.

**Q. How important is it for your work to reflect the design characteristics of your nation?**
A. It's not a goal – but I can't deny that my handwriting is Dutch and that my designs are standing on fat, wet clay.

**Q. Is your work an individual statement or a team solution?**
A. It starts as an individual statement, but I need my team to realise and fine-tune the idea.

**Q. What elements of the design process do you find particularly frustrating?**
A. Narrow-minded marketing guys, whose minds are fixed on economics, [and] journalists, who are always in a hurry and who don't have a thought in their heads and have no understanding of the design profession.

**Q. To what level will you compromise to satisfy your client?**
A. It's a game of two players – a game that I like. My clients are always good friends at the end of the process. But before we start, I'm very particular about with whom I start playing. I need vision, money and trust to make the best product.

**Q. What would be your second career choice after design?**
A. As a child, I wanted to be a hippie.

**Q. What do you still aspire to design?**
A. Something that stops violence.

**Client list**
Atlantis Crystal
**Auping**
Cappellini
**Design Museum,
London**
DMD
**Donna Karan**
Droog Design
**Frozen Fountain**
Hema
**JongeriusLab**
Maharam
**Museum of Modern
Art, New York**
Royal Tichelaar
Makkum
**Swarovski**
Textile Museum,
Tilburg
**The Product Matters**

**My work**
1. "Soft Urn" vases for
   JongeriusLab (1999)
2. "Giant Prince" specially
   designed for Museum
   Het Princessehof
   Leeuwarden, Holland
   (2000)
3. "Long Neck & Groove"
   Bottles for
   JongeriusLab (2000)
4. "Repeat" fabric designs
   for Maharam (2002)
5. "Repeat" fabric designs
   for Maharam (2002)
6. "Kasese Foam Chair"
   for JongeriusLab (1999)

4

5

2

6

3

**Patrick Jouin**
born 1967 in Nantes, France
**Studio Location**
Paris, France

Patrick Jouin's training incorporated not only the study of industrial technology, which he undertook at the Ecole Nationale Supérieure de Création Industrielle (ENSCI) in Paris, but also science and painting. He was also influenced by the work of his father, the mechanical engineer Jean-Claude Jouin.

After graduating in 1992, Jouin started his career designing for Thomson Multimedia under the artistic direction of Philippe Starck (pp 224–225). Not long after that, Starck put him in charge of furniture and product design at his agency, where he remained from 1995 until 1999. During that period, Jouin continued the development of his own pieces and gained recognition, with the invaluable financial and promotional support of France's Valorisation de l'Innovation dans l'Ameublement (VIA).

In 1998 Jouin began to work independently, setting up his own studio in Paris. He has successfully attracted an assortment of clients, bringing in projects ranging from a spatula/spoon for Nutella to a furniture collection for Cassina (2003) and restaurant interiors for Michelin-star chef, Alain Ducasse.

Jouin has quickly established an international reputation, and his portfolio looks set to grow rapidly, with projects underway in Russia, the USA, UK, Malaysia and, of course, France.

**My inspiration**
At the age of 16, my first visit to the industrial monolith that is the Centre Pompidou in Paris

F

**patrick jouin**

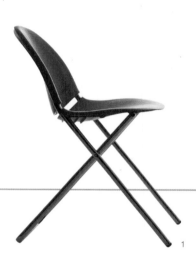

1

---

**Q. What types of products do you design?**

A. Anything – from buildings to cars to spoons.

**Q. What or who has been of significant influence in your studio?**

A. A visit to Leonardo da Vinci's house near Amboise when I was 11; my first visit to the Centre Pompidou in Paris when I was 16; and Philippe Starck, of course, because I worked with him for five years. My family, my friends… life, life, la vie…

**Q. What was your big break?**

A. My carte blanche from VIA (Valorisation de l'Innovation dans l'Ameublement), who financed the prototypes for the "Wonderwall" lamp and shieldscreen, the "Méliès" projector support, the "Cosmic Thing" table/rug, the "Fluxus" trestles/shelves and the "Morphée" sofa bed, which was then produced by Ligne Roset.

**Q. What emotions and needs drive your designs?**

A. The need for invention and my pleasure in inventing. Sensuality, intelligence, peace…

**Q. How important are trends in your work?**

A. I don't follow any trends. I might be unconsciously under their influence, but I'm not trying to be a trendy designer.

**Q. How important is it for your work to reflect the design characteristics of your nation?**

A. It's not important, but I am sure that my Frenchness is evident in my work.

**Q. Is your work an individual statement or a team solution?**

A. My work is always a team solution with an individual statement: me and the client, me and the producer, me and the model-maker, me and my team, me and myself, the client with the user. I am creating products to be used, so every element – beginning with the idea to its eventual application by the user – must be taken into consideration.

**Q. What elements of the design process do you find particularly frustrating?**

A. When I have a better idea but the project has already finished!

**Q. To what level will you compromise to satisfy your client?**

A. The project evolves from the first sketch to the final product. Any change that makes the project more clever or more efficient, even if the idea doesn't come from me, is positive. When we lose or weaken the spirit of the project, I stop. Once a change or evolution looks like a compromise, then there's a problem. This might mean that I wasn't clear or that my answer to a problem is not what my client wants. Perhaps it's the wrong client – or the wrong idea!

**Q. What would be your second career choice after design?**

A. A filmmaker – that's my answer today, but it would change tomorrow. Tomorrow is another day…

**Q. What do you still aspire to design?**

A. A house for myself and the love of my life.

**Client list**
Alain Ducasse
**Cassina**
CNAP
**BEAUBOURG**
**Fagoë Toys**
Fermob
**Ferrero**
Gien
**Lexon**
Ligne Roset
**Moderno/Pianca**
Proto Design
**Renault**
Thomson
Multimedia
**Ville de Vallauris,
Délégation aux
arts plastiques
(DAP)**
XO

**My work**
1. "Fol.D Chair"
   for xO (2001)
2. "Tarti'Nutella"
   spoon/spatula
   for Ferrero (2002)
3. "Mabelle" armchair
   for Cassina (2003)
4. "Lebeau" table for
   Cassina (2003)
5. "Kami" sofa for
   Cassina (2003)

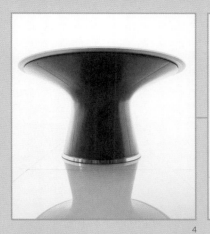

4

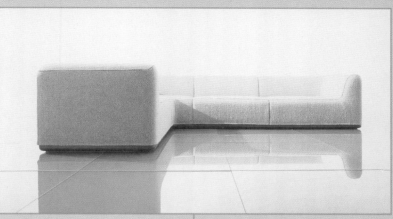

5

2

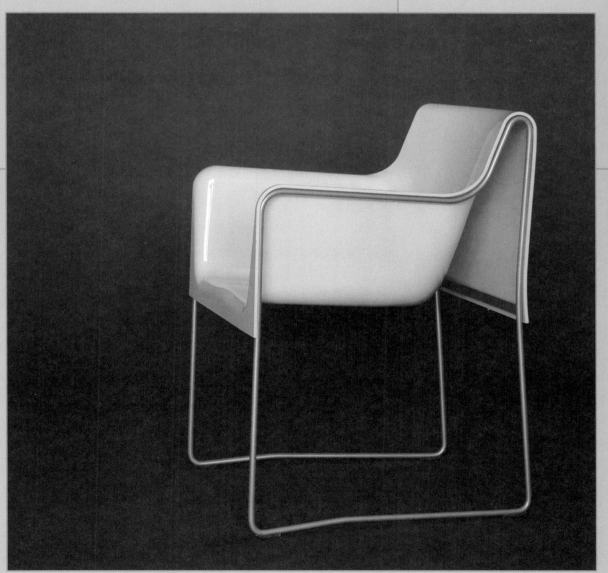

3

**Toshiyuki Kita**
born 1942 in Osaka, Japan
**Studio Location**
Osaka, Japan

Toshiyuki Kita graduated in Industrial Design from Naniwa College in Osaka in 1964 and soon after opened his own studio designing furniture and industrial products. In 1969, Kita moved to Milan, where he worked with Mario Bellini (pp 46–47) and Silvio Coppola. Kita now divides his work time between Italy and Japan.

Kita's work considers the link between humans and nature and often includes subtle or light-hearted references to the feet and bodies of animals or birds. This, together with his concern for injecting soul into his objects, connects him closely to the Japanese arts and crafts tradition. Kita also undertakes interior design projects, the most renowned being the hall for the Sony Centre in Tokyo in 1989 and the chairs and interior for the rotating theatre in the Japanese Pavilion at the Seville EXPO'92.

Beginning in 1975, when he won the Japan Interior Designers Association Award, Toshiyuki Kita has developed a worldwide reputation. In 1981, his "Wink" chair (1980) became part of the prestigious permanent collection at the Museum of Modern Art in New York, followed, in 1984, by the "Kick" table (1983) and, in 1997, by the "Multilingual" chair. His designs have been exhibited in cities as diverse as Barcelona, Vienna, Milan, Osaka, Helsinki, Hamburg and Hiroshima, to name but a few.

**My inspiration**
The organic evolving occurrences of nature, such as this Agapanthus bud about to bloom in spring

# toshiyuki kita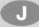

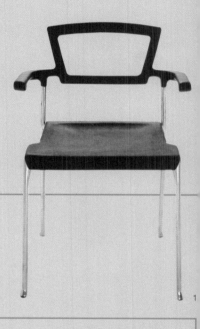

**Q. What types of products do you design?**

A. Mainly, I design objects for daily life such as clocks, TVs, chairs and sofas, as well as interiors and larger-scale projects.

**Q. What or who has influenced your work as a whole?**

A. Nature has always been of inspiration to me. For example, the flow of water, flowers blossoming in the spring, and trees bearing fruit in the autumn. I find natural phenomena and their colours hugely impressive.

**Q. What would you identify as having been your big break?**

A. The books I read and the stories people told me in my childhood.

They were unforgettable, and it formulated the direction for my life as a result.

**Q. Is your work usually an individual statement or a team solution?**

A. The inspiration could be individual but its development from an initial idea to reality is typically a team performance calling on many different kinds of expertise. At the beginning, it is an individual statement but it quickly becomes a group effort.

**Q. How important are trends in your work?**

A. About 30 per cent. The remaining 70 per cent would be spent calculating the function, production and the

type of market for the design. We have all kinds of work to do for design. Trends relate to each age.

**Q. What elements of the design process do you find particularly frustrating?**

A. When meeting a client, some problems that arise make me feel nervous. Communication is therefore key here, and the ability to adjust to other people's thinking and imaginations can cause a lot of stress.

**Q. To what extent will you compromise in order to satisfy client's wishes?**

A. About 80 per cent – products need be introduced smoothly into the

market. Designs should therefore be formed within the limited conditions for distribution. It is very important for designers to compromise while keeping balance with the insistence of clients needs. The remaining 20 per cent is the designer's freedom to innovate.

**Q. What would be your second career choice after design?**

A. A chef or an artist.

**Q. How would you summarise your design approach in one sentence?**

A. To recognise design issues in designed products, identifying potential problems for a client or maker and balancing all these issues ready for the marketplace.

**Harri Koskinen**
born 1970 in Karstula, Finland
**Studio Location**
Helsinki, Finland

From 1989 to 1998, Finnish designer Harri Koskinen undertook his training at the Lahti Polytechnic Design Institute and Helsinki's University of Art and Design. After graduation, he scored an immediate success with the release of "Block Lamp" (1998), produced by Design House Stockholm, which consisted of a block of glass cut in half and hollowed to accommodate a light bulb and its flex. The design caught the attention of the industry, consumers and the media alike, who were allured by its simplicity, playfulness and sheer beauty.

Subsequently, from 1998 to 2001, Koskinen worked on projects for the Finnish glass manufacturer iittala and its sister companies, Hackman and Arabia, designing elegant and seductive glass candleholders, graphic stainless-steel kitchen utensils, and highly practical plastic food containers. In 2001, Koskinen finally set up his own studio – Friends of Industry Ltd – where he continues to take a multidisciplinary approach to design, incorporating a plethora of techniques but always combining practicality with seduction. Many of Koskinen's designs have won awards and have entered public collections across the world.

**My inspiration**
The precision of vast production lines in factories illustrates man's affinity with the machine

FIN

# harri koskinen

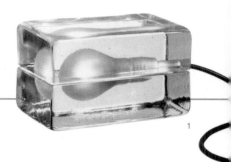

1

**Q. What types of products do you design?**
A. The objects I design vary from electronics to toys, glassware to lighting, packaging to graphics. Usually I find every project I do interesting because there are many viewpoints to examine in each case.

**Q. What or who has influenced your work?**
A. Industry in general. Production lines in factories, material technologies…

**Q. What was your big break?**
A. If there was one big break, I would say it was the release of the "Block Lamp" for Design House Stockholm in 1998. It was selected for the permanent collection of New York's Museum of Modern Art, has sold nearly 200,000 copies, and has been featured in hundreds of magazines all over the world.

**Q. What drives your designs?**
A. Questions about life, mysteries, behaviour, quality of life, and how to create good feelings.

**Q. How important are trends in your work?**
A. I don't find trends interesting at all. Trends are temporary and mostly hyped by the media.

**Q. How important is it for your work to reflect a typically Finnish or Scandinavian tradition of design?**
A. In a way, it's not important. On the other hand, it comes naturally to me to continue in the tradition of Finnish design – it just happens to be a pertinent approach.

**Q. Is your work an individual statement or a team solution?**
A. In most cases, I work for industrial companies, and there's a great deal of intensive collaboration. The solutions are shaped from several directions, but sometimes it happens that the end result is still very individual.

**Q. What elements of the design process do you find particularly frustrating?**
A. Nothing specifically. However, when designing pieces for mass production there might be several producers making the various components for that item, and communications can break down. Every now and then, economics can alter the essential details of the original design.

**Q. To what level will you compromise to satisfy your client?**
A. It's up to a client… Usually nothing gets compromised since every party is learning something new during a project, so views and visions are evolving together all the time.

**Q. What would be your second career choice after design?**
A. A farmer. Being a farmer is a whole lifestyle. You are very close to nature and it's kind of a partner to you, and somehow you are very close to your origins. Actually, my father was a farmer.

**Q. What would you most like to design?**
A. A perpetual-motion machine.

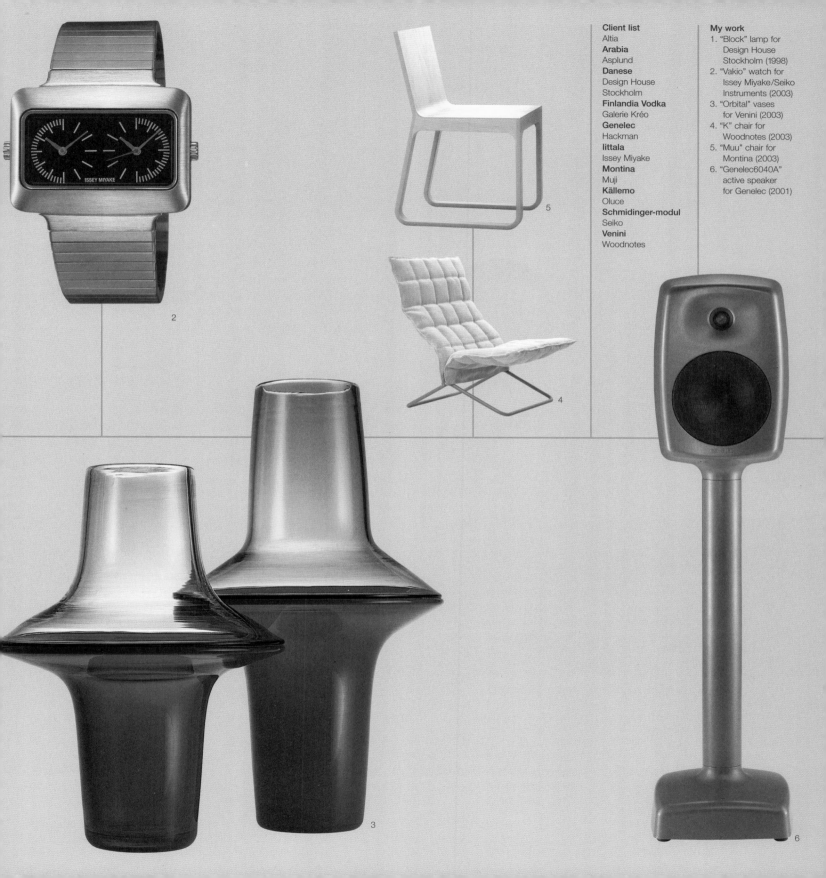

**My work**
1. "Block" lamp for
   Design House
   Stockholm (1998)
2. "Vakio" watch for
   Issey Miyake/Seiko
   Instruments (2003)
3. "Orbital" vases
   for Venini (2003)
4. "K" chair for
   Woodnotes (2003)
5. "Muu" chair for
   Montina (2003)
6. "Genelec6040A"
   active speaker
   for Genelec (2001)

**Tsutomu Kurokawa**
Born 1962 in Tokai,
Aichi Prefecture, Japan
**Studio Location**
OUT.DeSIGN studio
Tokyo, Japan

Despite having always practised in his home country, Tsutomu Kurokawa is a Japanese three-dimensional designer with a surprisingly acute sensibility to Western culture and lifestyles. In 1986, he graduated in Interior Design from Tokyo Designer Gakuin College in Nagoya, Aichi Prefecture, after which he gained his first professional experience at ICS Inc. Not long after, he joined Super Potato Co. in Tokyo as chief designer, working on projects such as bars, restaurants, shop interiors and buildings under the direction of the company's founder, Takashi Sugimoto.

In 1992, Kurokawa established H. Design Associates in partnership with Masamichi Katayama. The duo initially focused on spatial design but soon expanded into furniture. They first showcased their designs at their exhibition called "H. Design – Furnitures BALANCE" in Tokyo in 1997.

In 2000 the partners decided to work independently – Katayama launched Wonderwall and Kurokawa founded OUT.DeSIGN. Kurokawa has since undertaken many interior commissions for boutique shops in Japan and increased his portfolio of furniture designs, most of which are produced under his own brand.

**My inspiration**
The purity of nature versus the hi-tech of my urban life in Tokyo, Japan

## tsutomu kurokawa

**J**

**Q. What types of products do you design?**
A. I have mainly designed items that are specifically for domestic interiors, such as chairs, tables and lights. I have designed some shop interiors, such as those for Adam et Rope and Uth, and I have also worked on designs for various exhibitions.

**Q. What or who has been influential in your studio?**
A. The City (the evolution of technology) and Nature (the sea). Influences from these two elements are an integral part of my designs.

**Q. What was your big break?**
A. I have only ever taken one step at a time in relation to what I am working on at that moment. I think that all things happen by chance.

**Q. What human emotions and necessities drive your designs?**
A. The desire to be surrounded by good design, and dissatisfaction with modern society.

**Q. How important are trends in your work?**
A. I find that it is important to maintain a distance from passing trends as much as possible.
[…] I think you need to look inside yourself, although at the same time designs do need to face up to the important trends of the present time.

**Q. How important is it for your work to reflect a Japanese design aesthetic?**
A. I don't consciously attempt to make my designs reflect a Japanese style or aesthetic, but I have a deep feeling for Japanese nature – including our four beautiful seasons – that cannot but be inherent to my design work. Our Tokyo office has a garden with a beautiful cherry tree, as the seasons pass and the leaves change colour, it provides a environment perfect for fresh design ideas.

**Q. Is your work an individual statement or a team solution?**
A. I always work as part of my team at OUT.DeSIGN.

**Q. What elements of the design process do you find particularly frustrating?**
A. I am increasingly frustrated by contemporary society – Japan has become an information and consumer society to far too great a degree.

**Q. To what level will you compromise to satisfy your client?**
A. I always consider what will work best for the end-users of my designs.

**Q. What would be your second career choice after design?**
A. A craftsman.

**Q. What do you still aspire to design?**
A. I would like to design products that strike a balance between high technology and nature. Real design involves conceiving something entirely new, something outside the currently accepted parameters of design, that's why I named my company OUT.DeSIGN.

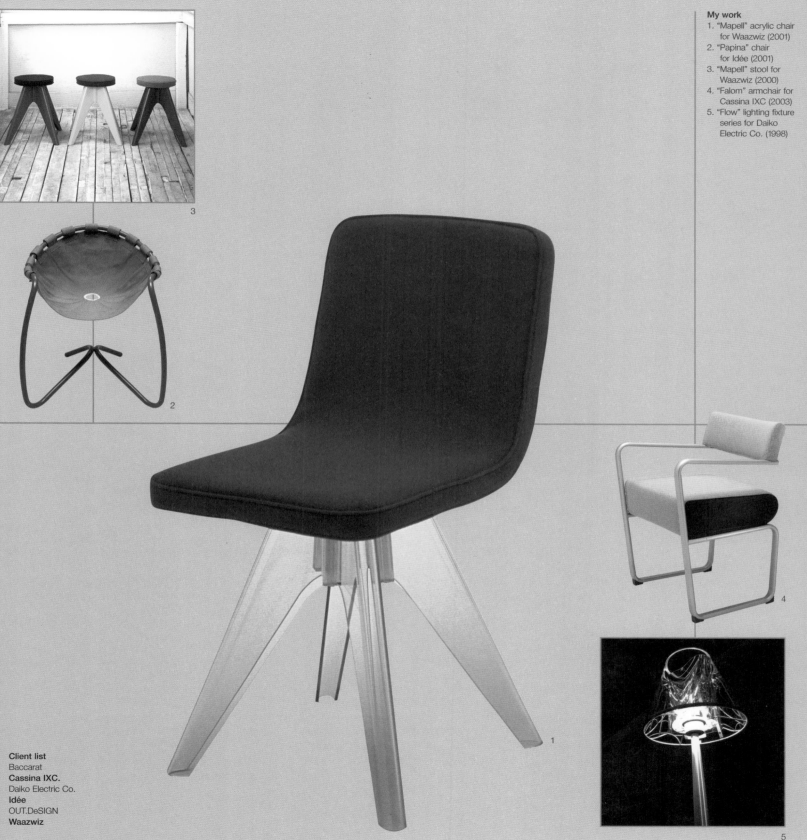

**My work**

1. "Mapell" acrylic chair for Waazwiz (2001)
2. "Papina" chair for Idée (2001)
3. "Mapell" stool for Waazwiz (2000)
4. "Falom" armchair for Cassina IXC (2003)
5. "Flow" lighting fixture series for Daiko Electric Co. (1998)

**Client list**
Baccarat
**Cassina IXC.**
Daiko Electric Co.
**Idée**
OUT.DeSIGN
**Waazwiz**

**Arik Levy**
born 1963 in Tel Aviv, Israel
**Studio Location**
Paris, France

Arik Levy left his home country, Israel, at the age of 27, having spent his mid-twenties working in graphic design and sculpture. He initially moved to Switzerland, where he graduated in Industrial Design from the Art Center College of Design in 1991. In the same year, he won the Seiko Epson Inc. Competition, enabling him to work for the company on prospective design projects and exhibitions in Japan for a year.

Cn his return to Europe, he based himself in Paris where, from 1992 to 1994, he taught at the Ecole Nationale Supérieure de Création Industrielle (ENSCI), while also creating stage designs for contemporary dance and opera productions. In 1995, he founded L Design, a collaborative partnership with fellow designer and friend Pippo Lionni. Together, they have embraced a multidisciplinary approach to design, able to offer their clients services across the domains of 2- and 3-D design.

Levy's industrial designs often explore the application of either new or familiar materials, each time inventing simple yet innovative concepts such as the "Liko" table (2003) for Desalto, which uses a wooden honeycomb top for lightness, or the eco-aware "Need" (1999) recycled-cardboard lamps for the Sentou Galerie, Paris.

While predominantly working for commercial clients, L Design also produces some of its own, more experimental designs, which have been exhibited around the world.

**My inspiration**
Water, because it can take the shape of a container, but can also break it. It is quiet and yet powerful

arik levy

F

**Q. What types of products do you design?**

A. Prospective studies in industrial design, product development, light design, corporate identity, packaging, display and point of sales, interior architecture, signage and exhibition design for the European and international markets, as well as stage design for contemporary dance and artwork.

**Q. What or who has influenced your work?**

A. My life, my brain and my years in Israel. My cultural identity, my social context before and after arriving in Europe. In Israel, you need to work hard to make your way open in front of you… to insist, persist and have a lot of will-power… Then I arrived in Europe – the origin of culture, the root of social architecture and structures, where there's a different way of thinking.

**Q. What was your big break?**

A. My "light light" exhibition in Paris [at the Galerie Passage de Retz, 1998] gave me presence on the design scene in Paris and later on in Europe.

**Q. What human emotions and necessities drive your designs?**

A. Emotions that create experience, contact and exchange, side by side with the need to innovate, to create the new, and the simple enjoyment of doing it.

**Q. How important are trends in your work?**

A. Not important at all! Once a trend is declared as one, it's history. It can be important to a client, but it's not the way I choose to do the things I do.

**Q. How important is it for your work to reflect a national design aesthetic?**

A. I live and work on Earth, my message is to the Earth. It's not nationalistic, even if it originates from a particular nation.

**Q. Is your work an individual statement or a team solution?**

A. Both. L Design is my company that I run with my partner, Pippo Lionni, generating design work as team solutions. When it concerns my personal work, it's me who originates the idea, but it often requires a small team to bring it alive.

**Q. To what level will you compromise to satisfy your client?**

A. It's not about a compromise; neither is it about client satisfaction. It's about giving the best answer to your client's question, or helping him ask the right question. I see it all as a challenge. The market is mostly taken up by unsuccessful companies who need a lot of help in the area of design. It is challenging to work with such companies and to help them succeed.

**Q. What would you be if you weren't a designer?**

A. A scientist.

**Q. What do you still aspire to achieve?**

A. To raise awareness of design among the public and in industry so that it becomes accepted just like food is. Design is a necessity of our time.

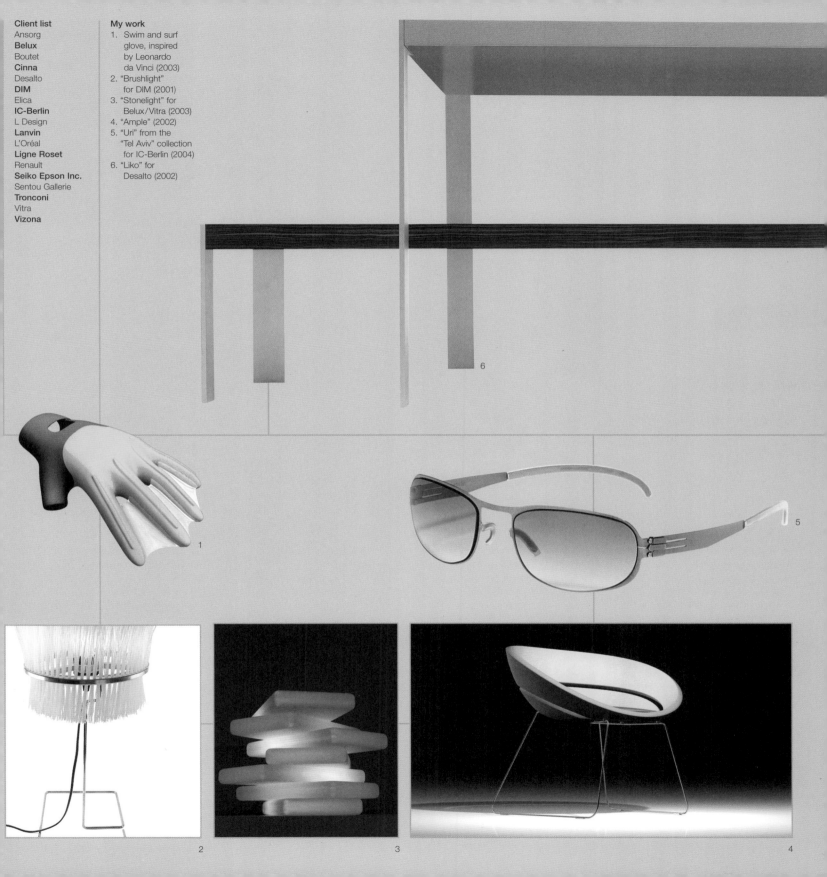

**Client list**
Ansorg
**Belux**
Boutet
**Cinna**
Desalto
**DIM**
Elica
**IC-Berlin**
L Design
**Lanvin**
L'Oréal
**Ligne Roset**
Renault
**Seiko Epson Inc.**
Sentou Gallerie
**Tronconi**
Vitra
**Vizona**

**My work**
1. Swim and surf glove, inspired by Leonardo da Vinci (2003)
2. "Brushlight" for DIM (2001)
3. "Stonelight" for Belux/Vitra (2003)
4. "Ample" (2002)
5. "Uri" from the "Tel Aviv" collection for IC-Berlin (2004)
6. "Liko" for Desalto (2002)

**Jonas Lindvall**
born in 1963 in Malmö, Sweden
**Studio Location**
Malmö, Sweden

Initially training as a visual artist, Jonas Lindvall progressed into interior architecture via a Masters degree in the subject from the Högskolan för Design och Konsthantverk (HDK) at the University of Göteborg, Sweden, in 1993. During this time, he also studied furniture design as a guest student at London's Royal College of Art. He opened his own studio in his home town of Malmö in 1994.

Most of Lindvall's clients have been concentrated in Sweden, where he has undertaken interior work on a Japanese restaurant, a hotel, numerous offices, apartments, villas and showrooms as well as exhibition design concepts, notably for one of his ongoing clients, Skandiform. His appeal as a designer lies in his ability to produce items that consistently make minimal reference to contemporary styles. He prefers simplicity, focusing attention on clarity of form, accuracy of detailing and material honesty. The sheer elegance of his designs creates its own serene poetry.

Since the turn of the millennium, Lindvall has been forging relationships in Japan, earning commissions for a private apartment and store concepts for Plantation, which is owned by Japanese fashion designer Issey Miyake, and the porcelain manufacturer Royal Copenhagen. In addition, he has released furniture pieces for the Japanese interior and lifestyle brand Idée.

**My inspiration**
A plethora of individual artists, designers, and architects who strive for a better design solutions, such as Le Corbusier – his Ville Savoye in Poissy-Sur-Seine of 1929 shown here

jonas lindvall S

1

**Q. What types of products do you design?**

A. Mainly furniture, but I have also designed things such as candlesticks, coat hangers, cutlery, lighting, umbrella stands, partitions, ashtrays, a cradle, a yo-yo, bathtubs, washbasins, kitchen systems and a railway wagon as well.

**Q. What or who has been the most significant influence on your work?**

A. Architects, artists and designers like Adolf Loos, Le Corbusier, Mies van der Rohe, Vermeer, Gunnar Asplund, Bruno Mathsson, Baldessari... indeed any artist or architect/designer who tried hard to make our world a better place. Even more influential on me is secular architecture from the Early Christian period... But to tell the truth, the entire history of anything designed has been a great influence on me. Also seeing how pieces or buildings interact (or function on any level with their users) has provided me with important lessons... Texts about psychology, sociology and especially philosophy have changed the way I look upon design. Films and music also influence me a lot. But the biggest influences probably come when I am travelling. Seeing new places and meeting people seems to "open up" something in me...

**Q. What was your big break?**

A. The first real project I did was a Japanese restaurant in my home town, Malmö, [in 1992], and it got a lot of publicity. That opened up lots of opportunities for me... I saw that I could make a living out of doing architecture and design.

**Q. How important are trends in your work?**

A. I try as much as I can to avoid being influenced by trends and to make something that has other values – those of a longer-lasting nature. As much as design is a way of helping manufacturers to sell products, it should also be about creating a better environment for the people who buy and use these objects.

**Q. Is there anything about the design process you find particularly frustrating?**

A. Not being respected for the kind of know-how I have as a designer. I'm terrified of working on projects where clients think of you as a happy-go-lucky kind of guy who likes shapes and colours but who hasn't got any idea about finance and so on...

**Q. To what degree will you compromise to satisfy your client?**

A. To any degree as long as I don't find myself in a position where I don't believe in the product or project anymore... collaboration is the keyword here. Collaboration between two strong parties seems to give the best end results... The reason for this is that when both parties manage to challenge the other's preconceived ideas, you find that, as a professional and maybe as a person, too, you have grown in the process and progress has taken place.

**Q. How would you briefly describe your design approach?**

A. My design approach is scrupulous. I don't stop working on a project until it is as complete as it can be in all respects.

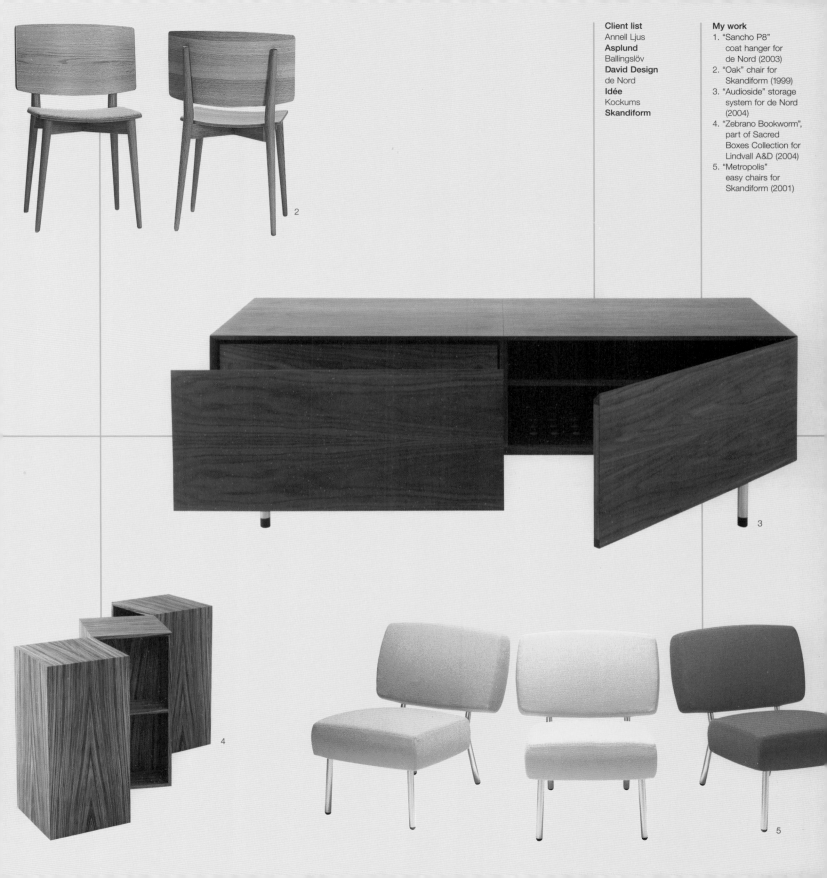

**Client list**
Annell Ljus
**Asplund**
Ballingslöv
**David Design**
de Nord
**Idée**
Kockums
**Skandiform**

**My work**
1. "Sancho P8"
   coat hanger for
   de Nord (2003)
2. "Oak" chair for
   Skandiform (1999)
3. "Audioside" storage
   system for de Nord
   (2004)
4. "Zebrano Bookworm",
   part of Sacred
   Boxes Collection for
   Lindvall A&D (2004)
5. "Metropolis"
   easy chairs for
   Skandiform (2001)

**Piero Lissoni**
born 1956 in Seregno, Italy
**Studio Location**
Milan, Italy

A year after graduating in Architecture from the Politecnico di Milano in 1985, Piero Lissoni founded Studio Lissoni with the graphic designer Nicoletta Canesi. The partnership's destiny was determined by its early collaboration with the exclusive Italian kitchen manufacturer Boffi, which employed the duo to redesign some of its kitchens as well as its corporate image. This relationship has matured into an ongoing partnership that now also comprises designing the company's exhibition stands and showrooms around the world. The studio has also gone on to provide a similar service for other Italian manufacturers, including Living Divani, Porro, Matteograssi and Lema.

The 3-D talent of Lissoni coupled with the graphic skills of Canesi has given rise to a holistic involvement with clients' operations. The team develops new products and also collaborates with clients to shape a total company profile – as presented in everything from advertising to global showroom design.

In all his designs Lissoni combines simplicity of form and discreet functionality with a determined eye for detail and high-quality production values. He does not care for trendy objects but prefers instead a timeless, unobtrusive aesthetic.

**My inspiration**
The charm, wit, and industrial know-how of Italian design master Achille Castiglioni (1918–2002)

## piero lissoni

**Q. What types of products do you design?**
A. Contemporary furniture, storage units, upholstery and accessories; office, kitchen and bathroom furniture and equipment; lighting fixtures.

**Q. What or who has been of significant influence on your work?**
A. My curiosity has been sharpened by: Achille Castiglioni, Alexander Calder and Donald Duck.

**Q. What was your big break?**
A. The collaboration with Boffi in 1986, when, just after my degree in Architecture at the Polytecnico di Miliano, I decided to open a two-person studio with Nicoletta Canesi. Boffi saw our potential and began asking us to redesign some of their kitchens. Catalogues, fair stands, showrooms and more new products followed. In addition, we took over the art direction. Since then, the studio has expanded to its present team of around 45 people.

**Q. What drives your designs?**
A. My guiding idea is always one of understatement, which I prefer to call "discretion". Besides this, my point of view always starts from a consideration of space – I cannot start to imagine any object without first thinking about its surroundings, about where it's going to be placed. I also like to think about the ways in which the object will be used – I call them "rituals". When I design a kitchen… I think about what kind of rituals will be performed there: dealing with food, handling it, transforming it… and the rituals of body movement around or inside the kitchen.

**Q. How important are trends in your work?**
A. Public approval and trends are important, but more important are what I call discretion and honesty in a project – qualities that make pieces of furniture "timeless". On the other hand, a designer today should not only look at his own field but also pay attention to music, cinema, fashion and everything that happens around him to make his design the result of a 360-degree analysis of life.

**Q. Is your work an individual statement or a team solution?**
A. I choose graphic designers, industrial designers and architects who conform to my tastes… At the same time, the people in my studio come from all over the world; as well as Italians, we have designers from Holland, Brazil, Turkey, Greece, America, Germany, Sweden and Colombia… It's important to carry on a dialogue with different points of view – engaging with other cultures brings real richness. Nevertheless, what remains fundamental is a careful dialogue with the client.

**Q. What elements of the design process do you find particularly frustrating?**
A. Probably the whole idea of the "image": today, even if something has little substance, it can gain an inflated importance if it's communicated in a clever way. New design gurus! – who appear only to disappear like soap bubbles six months later, like a pop song…

**Q. To what extent will you compromise to satisfy a client?**
A. If I do not like or am not convinced by the proposals of a potential new client, I do not accept the job… If somebody commissions me to design an interior in their home, they understand that the final decision will always be mine – it can't be any other way.

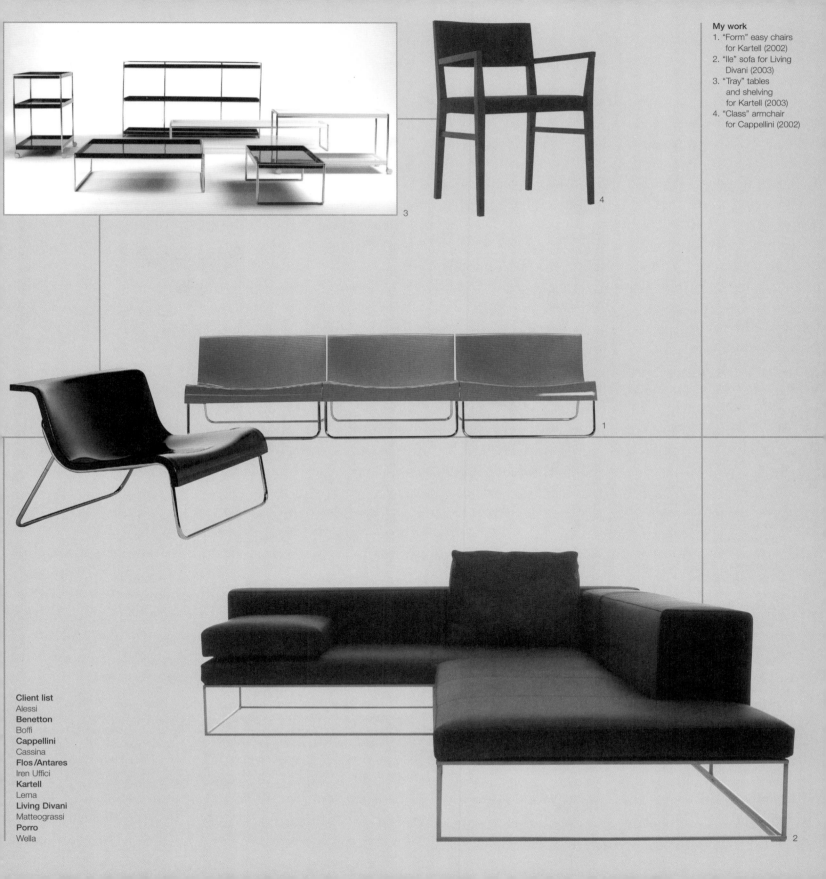

3

4

1

**Client list**
Alessi
**Benetton**
Boffi
**Cappellini**
Cassina
**Flos /Antares**
Iren Uffici
**Kartell**
Lema
**Living Divani**
Matteograssi
**Porro**
Wella

2

**Ross Lovegrove**
born 1958 in Cardiff, UK
**Studio Location**
London, UK

Ross Lovegrove initially studied Industrial Design at Manchester Polytechnic and went on to gain a postgraduate qualification in the same discipline from the Royal College of Art, London, in 1983. He then spent time gaining professional experience in France collaborating with architect Jean Nouvel and Philippe Starck (pp 224–225) on various projects for brands, including Cacharel, Louis Vuitton and Hermès.

His partnership with Julian Brown (pp 68–69) (Lovegrove Brown Design Studio) gave rise to early projects for influential European manufacturers, including a thermos range for alfi Zitzmann. In 1990, the duo separated and it was at this time that Lovegrove set up Studio X in London. Since then, Lovegrove has emerged as one of the leading designers of our time through his pioneering application of computer technology in the creation of organic, ergonomic, 3-D designs ranging from cutlery and tableware to lighting, furniture, electronic devices and airline seating.

Lovegrove wholeheartedly embraces the challenges of new technology, materials and processes, attracting a long list of international clients. Lovegrove has been presented with numerous awards and honours, and examples of his work have entered several permanent museum collections.

# ross lovegrove · GB

1

**Q. What types of products do you design?**

A. I design all types of products but mainly those that relate to everyday life but I also consider the car as a large product.

**Q. What or who has been of significant influence on your work?**

A. A variety of people and ideas: I admire the individualism and invention of Issey Miyake, primitive art that transcends design and its debate. George Nelson for his intellect and risk taking, Isamu Noguchi who, like Henry Moore, moves my soul with something very deep. Today, the sculpture of Anish Kapoor that I believe is a linking force between architecture, material and humanity.

**Q. What was your big break?**

A. The Figure Of Eight Chair for Cappellini 1990. It was shown at the Design Museum as a model between a chair by Eames and one by Saarinen. Giulio Cappellini was there with Tom Dixon (p96–97) and Tom called me immediately on his behalf to make the connection based on Giulio's instinctive reaction to it. Tom is a valued friend and his selflessness means that he is probably the only designer who ever introduced me to their client...quite special. Thank you Tom.

**Q. What human emotions and necessities drive your designs?**

A. I am motivated by a sincere need to contribute to the quality of our three-dimensional world with design that embodies a spirit of our times... conveying a respect for the value of material, our collective environment and the enriching nature of thoughtfulness.

**Q. How important are trends in your work?**

A. Intelligent trends are very rare.

**Q. How important is it for your work to reflect the design characteristics of your nation?**

A. I live in London, I am published here occasionally, I rarely receive invitations to the Design Museum (London), and my phone never rings from potential clients here. I constantly feel like a misfit so I'm afraid I can't relate to the question.

**Q. Is your work an individual statement or a team solution?**

A. I am an individual designing for individuals.

**Q. What elements of the design process do you find frustrating?**

A. Companies come to my studio, I open up my heart with ideas and trust and more and more they just take notes and don't come back... Design is still treated like a cheap accessible commodity and I fundamentally don't believe in this... It makes people like me close up, which is against my nature... It makes me very disillusioned and I regularly consider giving up.

**Q. To what level will you compromise to satisfy your client?**

A. I am not here to compromise because compromise is very often related to convenience and not progress... There are plenty of "Do It All" design consultancies out there who can excel at this.

**Q. What would be your second career choice after design?**

A. Something that has the minimum impact on resources yet has the maximum impact on our imagination.

**Q. What do you still aspire to design?**

A. An ecological, lightweight, minimum material, slow car.

**Q. In one sentence, please describe your design approach.**

A. My design seeks to link logic and beauty... I call this Organic Essentialism.

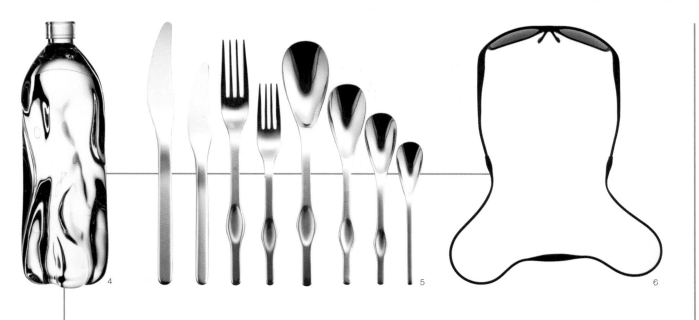

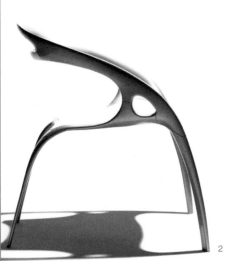

**Xavier Lust**
born 1969 in Bruges, Belgium
**Studio Location**
Brussels, Belgium

Xavier Lust graduated in Interior Design from the Instituut Sint-Lucas, Brussels, in 1992, and subsequently founded his own studio, working on the design and production of furniture and accessories. From 1991 to 1993, he worked on the "Cartomania" furniture collection, which explored the use of recycled cardboard and honeycomb boards to create commercially viable and highly functional designs. He spent much of the decade developing his own range of furniture designs, while also undertaking projects for shops, offices, bars, restaurants and private interiors.

Lust has worked mainly with metal, exploiting both the material's technical and aesthetic qualities to create elegant, sculptural, monochromatic furniture. Pieces, such as "Le Banc" (2000), "La Table Basse" (2002) and "La Chaise" (2002) – all for MDF Italia – are often constructed from one or two thin sheets of metal, which are then cut and manipulated. Such an economic use of materials might suggest that Lust's work is minimalist, but the starkness and sterility that that term might imply is offset and softened by Lust's use of curved, sensuous edges. The edges, however, are not purely aesthetic but an important technical innovation, adding strength and stability along, for example, the span of a table, without the need for additional supports.

He has recently collaborated with fellow Belgian designer Dirk Wynants (pp 244–245) on "Picnic" (2002) – an innovative and extremely practical integrated garden table and chairs.

**My inspiration**
Amid thousands of potential choices, one such individual would be conceptual artist Richard Serra, who created this Trip Hammer sculpture in 1988

# xavier lust  B

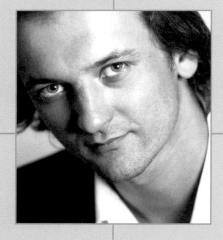

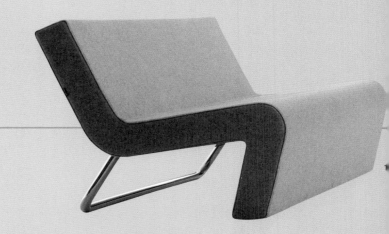

**Q. What types of products do you design?**

A. Domestic furniture, urban furniture, office furniture, light fittings and accessories, objects, interior architecture and industrial design.

**Q. What or who has been of significant influence in your studio?**

A. My creative work is informed by an alchemy of a thousand and one influences, some of them contradictory… If I must cite names, I would speak of the great… painters, sculptors, scientists and philosophers who have revolutionised thought. Perhaps Leonardo da Vinci… or David and Ingres, with their depictions of idealised, Classical beauty. Or in the contemporary world, the more conceptual work of Sol LeWitt or Richard Serra and, more recently, of Damien Hirst… I would probably also cite Philippe Starck's statement about design being above all a human step towards a better quality of life. While many designers make a deliberate break with the past, I like to reference old furniture in my work – long in the making and perfectly proportioned.

**Q. What was your big break?**

A. The discovery of a technique that I call the "(de)formation of surfaces", which permits the creation of new volumes without a mould. In terms of a single design, my big break was "Le Banc" and its presentation at Milan in 2000. Its design form was born out of the optimisation of material. This aluminium bench describes the different parameters found in my work – in terms of aesthetic, production costs, technique and cultural meaning – in perfect equilibrium.

**Q. Is your work an individual statement or a team solution?**

A. After working alone for a long time, and then in technical partnership with a factory in Liège, I have now been collaborating for some years with 3-D designers and draughtsmen. Even so, I continue to keep total control of my projects.

**Q. What elements of the design process do you find particularly frustrating?**

A. Having to implement a project right down to the minutest detail can be particularly annoying, as can having to accept modifications at the last minute and keeping to a tight production schedule. Industry and I do not always share the same notions about what constitutes perfection.

**Q. What do you still aspire to design?**

A. To create an object that is just as it should be – beautiful, intelligent, useful and perfect – one that responds to a real need and which meets the desires of the greatest possible number of human beings.

**Q. How would you describe your design approach?**

A. Keeping simple things simple and making the complex possible.

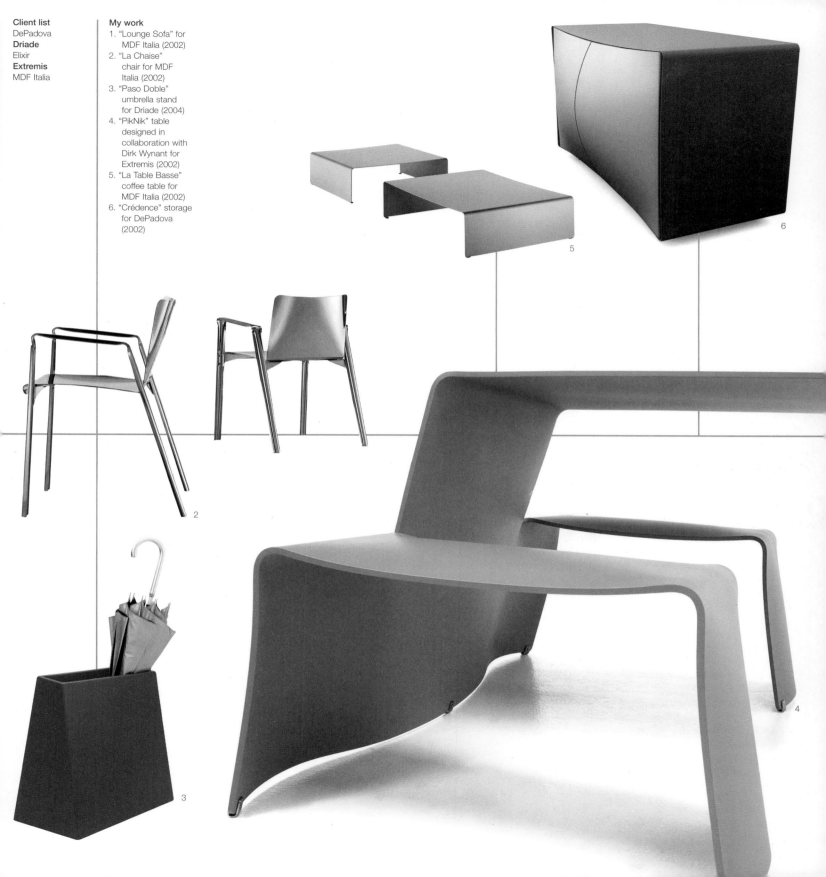

**Client list**
DePadova
**Driade**
Elixir
**Extremis**
MDF Italia

**My work**
1. "Lounge Sofa" for MDF Italia (2002)
2. "La Chaise" chair for MDF Italia (2002)
3. "Paso Doble" umbrella stand for Driade (2004)
4. "PikNik" table designed in collaboration with Dirk Wynant for Extremis (2002)
5. "La Table Basse" coffee table for MDF Italia (2002)
6. "Crédence" storage for DePadova (2002)

**Christophe Marchand**
born 1965 in Fribourg, Switzerland
**Studio Location**
Zürich, Switzerland

In 1981, Christophe Marchand undertook a one-year course at Zürich's Hochschule für Gestaltung und Kunst followed by a four-year apprenticeship as a furniture carpenter until 1986. He worked for Senn + Kühne as an architect before returning to the Zürich design school to study Interior and Product Design, graduating in 1991. In 1993, he founded his own product development studio in Zürich, where he collaborated with Alfredo Häberli (pp 116–117) for a number of years on furniture and product design projects as well as exhibitions at the Museum für Gestaltung in Zürich. In 1997, he co-authored (with Peter Erni and Martin Huwiler) the book *Transfer: Recognition and Implementation*, which deals with ecology as a concept in design.

Many of Marchand's industrial designs seem typically Swiss in character, with their refined material palette, flawless quality of manufacture and timeless aesthetic. Along with his team, Marchand supplies a full project management service to his clients, ensuring a unified vision across the design process – from concept to product. This inclusive package helps give his clients the confidence to go ahead with high-investment projects, such as the "PAC" (the ProActivChair; 2002) designed for ICF.

Since 1996, this award-winning designer has lectured at the Ecole Cantonale de l'Art de Lausanne (ECAL), Switzerland, and today he is an advisor to Thonet, the famous German furniture manufacturer.

**My inspiration**
This motor race in Caerphilly, Wales, in 1924 inspired me. It shows both irony and intuition: irony as the car is more in control than the driver and intuition as this driver relies on it to keep him on the road

**CH**

**christophe marchand**

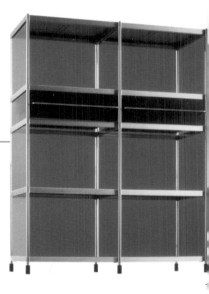

**Q. What sort of products do you design?**
A. Domestic and office furniture, system furniture, reading lamps, store design, books, watches, bags, kitchen tools, fair stands, exhibitions, bathroom objects…

**Q. What or who has influenced your work as a whole?**
A. Books and exhibitions about the life-work of designers, entrepreneurs and artists, such as Charles Eames, André Citroën, Yves Klein and so on… I'm fascinated, in particular, by the personal vision that lies behind their work.

**Q. What was your big break?**
A. The "PAC" chair, which I designed for ICF. It's an innovative chair that was realised in cooperation with an expert, demanding team.

**Q. What drives your designs?**
A. Design is my passion. I like the freedom of coming up with an idea and then trying to realise it as a product, given certain basic limitations.

**Q. How important are trends in your work?**
A. They keep me informed of the main currents in design and give me something with which to compare my work. However, I always try to put my own vision forward in my designs.

**Q. How important is it for your work to reflect a Swiss design aesthetic?**
A. An uncompromising attitude towards the achievement of precision, perfection, innovation and quality… is a Swiss national attribute that I strive for in my work.

**Q. To what degree will you compromise to satisfy your client?**
A. Successful products are realised through a close cooperation with the client. It is becoming increasingly easy for me to satisfy my clients as I'm given more and more space to put myself into the project.

**Q. What would be your second career choice after design?**
A. Doctor or surgeon.

**Q. Describe your design approach**
A. Design is my life. It's important that I realise products whose existence I can justify…

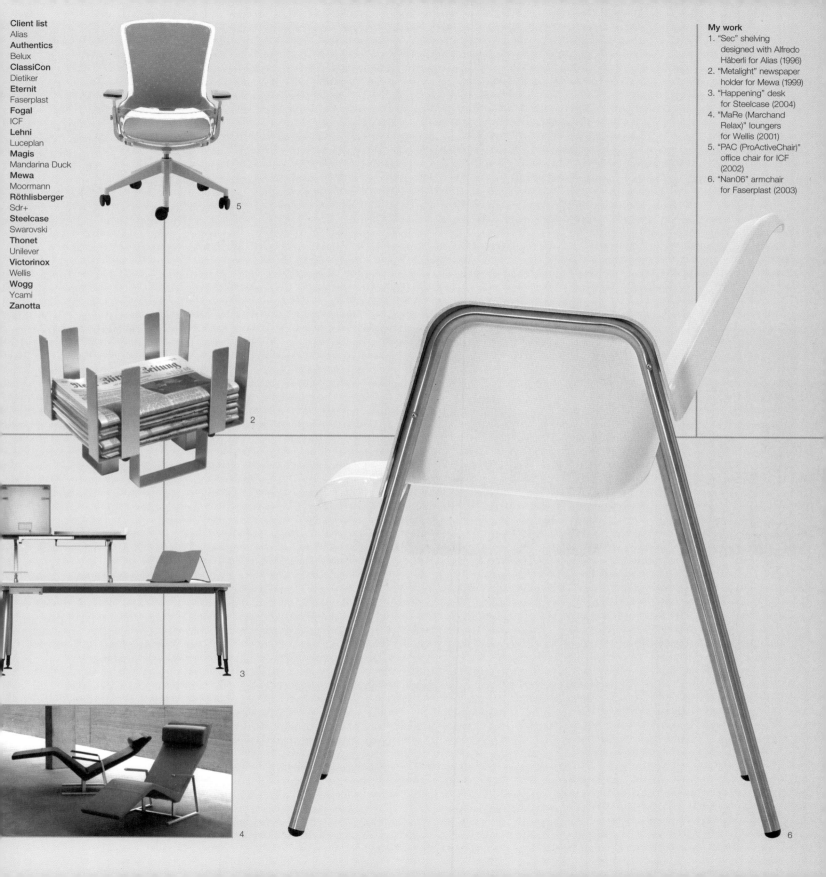

## Enzo Mari
born 1932 in Novara, Italy
**Studio Location**
Milan, Italy

Enzo Mari, one of the masters of Italian furniture and product design as well as an artist and theorist, can lay claim to more than 1,700 projects for Italian and foreign manufacturers over his prolific career. Despite this impressive track record, he cannot for one minute be accused of ever having churned out designs for design's sake.

After studying at the Accademia di Belle Arti di Brera in Milan in the early 1950s, Mari dedicated much of that decade researching the psychology of vision and the methodology of design. Towards the end of the decade he concentrated on design itself. Aware of the dangers of excess in the growing culture of mass consumption, he was quick to champion lasting quality in the face of fatuous overproduction.

Mari pushes himself and his industrial collaborators to question the validity of introducing new objects into an already oversaturated market. His theories have been published in several publications, and commented upon by designers and cultural critics such as Max Bill, Ettore Sottsass and Alessandro Mendini. His works have been exhibited around the world and have joined many permanent museum collections. His research work has won him some 40 awards, including the Compasso d'Oro prize in 1967, 1979, 1987 and 1999. Mari has taught across Italy and Europe, and is regarded as one of the leading design theorists of our time.

**My inspiration**
The mastery of Giotto, 14th-century architect of the mighty *Campanile of Santa Maria del Fiore* in Florence

enzo mari

**Q. What types of products do you design?**
A. Chairs, tables, bookshelves; cutlery, dishes, glasses…
**Q. What or who has been of significant influence in your studio?**
A. Giotto; the I-beam; Mari.
**Q. What was your big break?**
A. Participating in the post-war reconstruction of Milan.
**Q. What necessities drive your designs?**
A. Work as transformation and not work as alienation.
**Q. How important are trends in your work?**
A. Very important. In the sense that they allow me to identify my enemies.
**Q. How important is it for your work to reflect the design characteristics of your nation?**
A. It is important – for 2,000 years my country, Italy, has shown the way towards quality.
**Q. What elements of the design process do you find particularly frustrating?**
A. Idiocy and dishonesty in marketing.
**Q. To what level will you compromise to satisfy your client?**
A. I accept some compromise when the client accepts my desire… to pursue the dignity of utopia.
**Q. What would you be if you weren't a designer?**
A. A farmer.
**Q. What do you still aspire to design?**
A. A teaching programme for a school.
**Q. How would you describe your design approach in one sentence?**
A. Design is accomplished by identifying, in order of priority, the components that determine the process.

**My work**
1. "Putrella" dish for Danese (1958)
2. "16 Animali" wooden child's toy for Danese (1957)
3. "7 Archetipi" glassware for Driade (1998)
4. "Tonietta" chair for Zanotta (1980)
5. "Dondolo" chair for Thonet (2001)

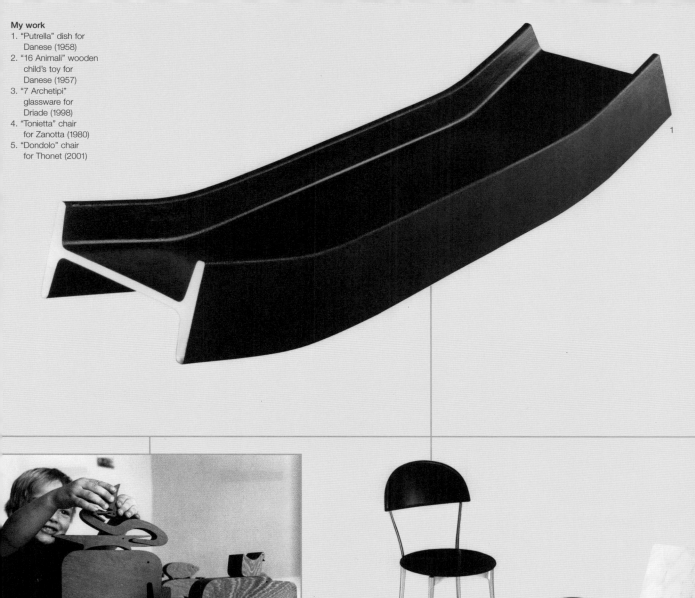

1

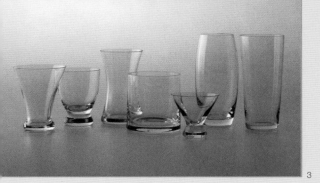

2

3

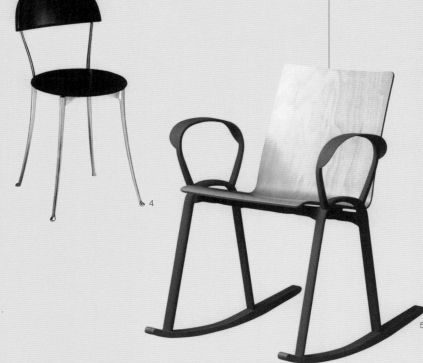

4

5

**Michael Marriott**
born 1963 in London, UK
**Studio Location**
London, UK

Michael Marriott spent much of his childhood designing and making "things" from discarded items or found oddities, piecing them together and manipulating the form to create objects that were often free from rational justification. His youthful fascination with the capabilities of industrial production lines – where raw materials are transformed from one end of a factory into uniform useful products at the other – is something that would later influence his furniture designs.

Marriott graduated from the London College of Furniture in 1985 and, several years later, continued with postgraduate studies at the Royal College of Art in London. On completing the course, he set up his own studio. He is interested in making everyday, and often overlooked, objects beautiful, and feels more at home in a hardware store than in a design gallery, opting to use readily available materials and components such as wing nuts, clothes-pegs, shelving brackets and even sardine tins instead of traditional furniture-making materials and techniques.

In the late 1990s, SCP and Inflate commissioned various designs for production. Marriott won the first-ever Jerwood Furniture Prize in 1999 and co-directed a children's furniture collection for Oreka Kids in 2000. He also works on exhibition design while undertaking other peripheral aspects of design such as teaching, writing and curating.

**My inspiration**
A long list of Modernist masters, including Marcel Breuer whose bent plywood "Isokon Long Chair" of 1936 is shown here

GB

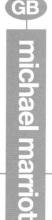
michael marriott

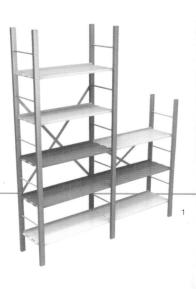

1

**Q. What types of products do you design?**
A. I trained as a furniture designer, and although that is still a kind of core activity, I seem to get involved in a wider and wider variety of projects, the main one being exhibition design.

**Q. What or who has been of significant influence on your work as a whole?**
A. The most significant thing is that old Modernist chestnut material/process/construction plus the usual things like function, people, travel, music, art, cinema, books, architecture… In terms of specific designers, there are loads – Achille Castiglioni, Enzo Mari, Norman Potter, Breuer, Rietveld, Eames…

**Q. What was your big break?**
A. Just getting by really. I feel extremely lucky to be doing a varied and constantly evolving job, doing something I love.

**Q. What human emotions and necessities drive your designs?**
A. The usual everyday ones I guess. Specific projects may draw more on one thing than another though.

**Q. How important are trends in your work?**
A. I resist the notion of trends, but I'm sure I'm somehow affected by them.

**Q. How important is it for your work to reflect the design characteristics of your nation?**
A. Not at all. I feel that what I try to do is as relevant anywhere – in the developed world at least. I've never consciously tried to at all, but people have occasionally said my work has a very "English" feel.

**Q. Is your work an individual statement or a team solution?**
A. Most of the time I work on my own, but at the same time I aspire to make things without an obvious "signature".

**Q. Is there anything about the design process that you find particularly frustrating?**
A. The time taken up administrating a project can sometimes be frustrating.

**Q. To what level will you compromise to satisfy your client?**
A. I never consider compromise. If adjustments need to be made, it comes out as part of a conversation that informs you of the need for change, so in the end it's part of the whole process of finding the most appropriate solution.

**Q. What would you be if you weren't a designer?**
A. A shoe repairer.

**Q. What do you still aspire to design?**
A. Better systems.

**Q. How would you describe your design approach in one sentence?**
A. I see my role primarily as a problem-solver – to find intelligent, resourceful and cunning solutions that will provide objects with a long, rich and satisfying life.

**Jean-Marie Massaud**
born 1966 in Toulouse, France
**Studio Location**
Paris, France

Jean-Marie Massaud trained as a designer at the renowned Les Ateliers, Ecole Nationale Supérieure de Création Industrielle (ENSCI) in Paris. After graduating in 1990, he lived and worked in Hong Kong before returning to Paris to work with Marc Berthier on product as well as town-planning projects – an experience that opened his eyes to the rewards of designing on differing scales.

In 1994, Massaud opened his own studio in Paris, focusing mainly on industrial and interior design for European and Japanese companies. He is inspired by the challenges presented by high technology and industrial materials, exploring the application of new developments within these fields. Massaud designs objects whose sculptural elegance and quality make them both functional products and objets d'art. His products – whether a perfume bottle for Paloma Picasso (2002), a series of desk accessories for BACK (2000) or even a concept

for a submarine for Yamaha (1992) – are reduced to their structural necessities, their minimalism softened, however, by their curvilinear, organic forms and sense of visual lightness.

In 2000, Massaud entered into partnership with the architect Daniel Pouzet and widened his operations to involve architecture. Subsequently Studio Massaud has realised a concept store for Lancôme (2003) and a vast motorshow stand for Renault (2002), whilst developing concepts for private homes, housing towers and a 50,000-seat stadium in Mexico.

**My inspiration**
The insatiable humour of master impressionist Peter Sellers, seen here in *Pink Panther: a shot in the dark*, filmed in 1964

**F**

# jean-marie massaud

**Q. What types of products do you design?**

A. I am especially interested in things that promote well-being. I have designed perfume bottles, a submarine, furniture and both interior and large-scale architecture.

**Q. What or who has been of significant influence on your work as a whole?**

A. Nature: it is the context and the whole. Life: it is the subject and the very aim. Emotions: they are the consequence and the synthesis. Albert Einstein: who fundamentally questioned generally accepted ideas. Mark Rothko: for his strength. Sergey Rachmaninoff: for his passion. Oscar Niemeyer: for his

elegant thoughts. Japanese culture: for its juxtaposition of simplicity and sophistication, roughness and refinement. My wife. My friends.

**Q. When did you realise that you wanted to be a designer and why?**

A. As a child, I dreamt of becoming an inventor. At seventeen, I realised that design was a field that allowed you to approach diverse subject matter – something that had a great deal in common with the role of inventor.

**Q. Are trends important in your work?**

A. Hardly. We are subject to cultural influences from early on in our lives, but my personal nature prefers essence to anecdote, content to form, the suggested to the said,

durability to fleetingness.

**Q. How important is it for your work to reflect the design characteristics of your nation?**

A. The fact that I lived in France during the first few years of my life has, of course, inevitably influenced my view on the world, and if ideas about humanity and quality of life, and about appetite and laughter, are specifically French attributes then ... but I don't think like that!

**Q. Is your work an individual statement or a team solution?**

A. Intentions and intuitions are always personal, but the results of complex projects necessarily arise from the addition of the talents of a whole team. This is especially the case

in the architectural projects I work on with Daniel Pouzet.

**Q. What elements of the design process do you find particularly frustrating?**

A. I am really impatient, and an architectural project can take three to five years. I am sure that 90 per cent of your energy is taken up explaining your convictions to everyone involved on a project so as not to lose the essence of the idea on the way.

**Q. To what level will you compromise to satisfy your client?**

A. As far as it is relevant, I am able to question my opinions, but I don't do compromise. If I think I am losing sight of my original intention, I stop everything. Life is too short.

**Client list**
Armani
**Authentics**
Baccarat
**Cacharel**
Cappellini
**Cassina**
Daum
**De Vecchi**
Dornbracht
**E&Y**
Habitat
**ICM**
**Lancôme**
**Parfums**
Lanvin
**Ligne**
**Roset**
Magis
**Mazzega**
Offecct
**Paloma**
**Picasso**
Renault
**Tronconi**

**My work**
1. "Goshthome" chair
   for Heaven (2001)
2. "Miroir 1-2-3"
   mirror/dish for
   De Vecchi (2002)
3. "Life Reef"
   housing towers
   in Guadalajara,
   Mexico (2003)
4. "In Out" sofa/bench
   for Cappellini (2001)
5. "Outline" sofa for
   Cappellini (2002)

1

2

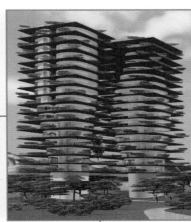

3

4

5

**Ingo Maurer**
born 1932 on the island of Reichenau, Lake Constance, Germany
**Studio Location**
Munich, Germany

The designer and entrepreneur Ingo Maurer is widely considered to be one of the greatest light designers of our time. He began his career, however, working in the fields of typography and graphic design in Germany and Switzerland. In 1960, he emigrated to the USA and worked as a freelance designer in New York and San Francisco. A few years later, he returned to Europe, eventually settling in Munich, where, in 1966, he founded his studio – Design M. His first lamp was the humorous "Bulb", a light bulb housed within a crystal glass shade shaped like an oversized bulb.

Maurer launched his work at a time when the notion of "good design" was being challenged by groups of designers across Europe. Breaking the rationalist mould that dominated German design at the time, he defined his own conceptual approach to his diverse products – introducing a "story" that could be humorous, affectionate, powerful or symbolic. As the creator and producer of his own designs, Maurer has always enjoyed total expressive freedom.

Despite his long-standing status as a classic European designer, Maurer continues to offer refreshing and entertaining work. Known as the "Poet of Light", he has managed to release innovative and magical lights year after year at numerous exhibitions around the world. One of his greatest personal qualities is his insatiable and childlike desire to understand and question the world coupled with a delightful aura of calm and modesty.

**My inspiration**
My best friend and wife Jenny Lau who understands me to the core – my strengths, weaknesses, passions, and ambitions

**D**

# ingo maurer

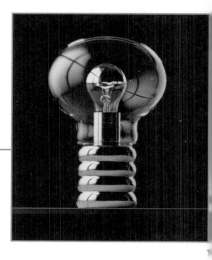

**Q. What types of products do you design?**
A. We produce mainly lights – they are my passion! But we also do other projects: light planning and one-of-a-kind installations.

**Q. What or who has been of most influence in your studio?**
A. Working in my studio is like being a rope-dancer, a power station, but also a waste bin. Influences? Everybody and nobody. I am the one who sets the direction. Or is it feelings, my intuition? Certainly one of the most important influences is my passion and the necessity to make ends meet. Last, but certainly not least, there's my wife, Jenny Lau – she lets me fly high – very high – only to bring me back to earth again.

Since I am not only a designer but a producer as well, I have more freedom but also much more risk and responsibility – most importantly a social responsibility. Risk at all levels of life is important for everybody. Tension and harmony, and diversity within the team, are essential for me, too.

**Q. What was your big break?**
A. I am still waiting for it.

**Q. What human emotions and necessities drive your designs?**
A. First, absolute freedom and peace of mind. Chaos as well as discipline. Sometimes it is like stepping into a centrifuge, with dozens of ideas swirling around, going crazy… only to recognise the importance of getting out of the centrifuge. Going against this fast-and-furious mindset is an opposing and just as powerful will to come back to myself, purified – to know what I should not do.

**Q. How important are trends in your work?**
A. I don't like trends. Do you see trends in my work? Technical developments certainly make certain things possible. But I consider those technical lifts.

**Q. Is your work an individual statement or a team solution?**
A. Most of my work comes out of my brain and is definitely my own statement, at least in most cases. Even so, I love working with my great team.

**Q. What elements of the design process do you find particularly frustrating?**
A. Most frustrating is when I think of a particular element in a design, and then find out the production cost… Also frustrating for me is putting a lot of energy into generating energy within the other people involved. I am very impatient!

**Q. What would be your second career choice after design?**
A. Running a circus, but in some ways I do that already.

**Q. What do you still aspire to design?**
A. Aladdin's wonderlamp.

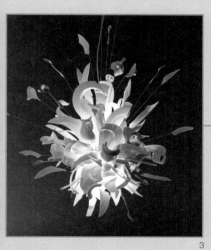

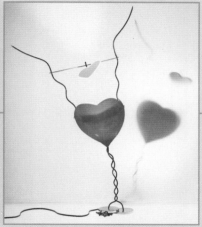

3

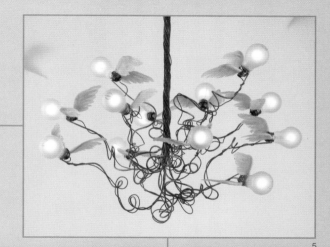

4

5

**My work**
1. "Bulb" light (1966)
2. "Zettel'z 5" light (1997)
3. "Porca Miseria!" Chandelier (1994)
4. "One From The Heart" light (1989)
5. "Birdie" light (2002)
All self-production for Ingo Maurer GmbH

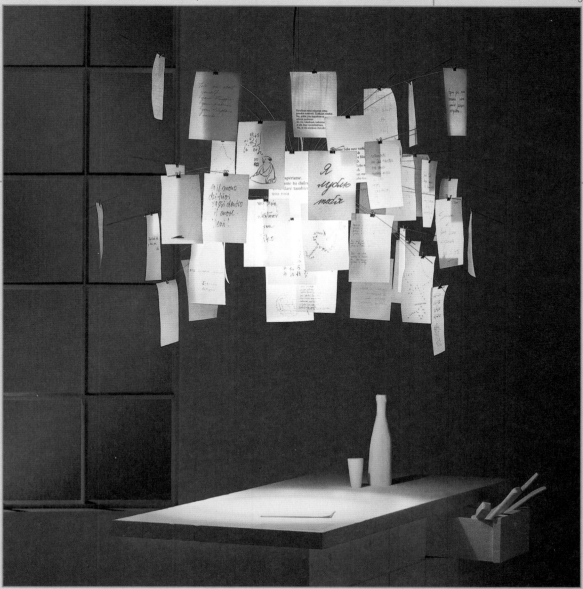

2

**Client list**
Self-production

**Alberto Meda**
born 1945 in Lenno Tremezzina (Como), Italy
**Studio Location**
Milan, Italy

Alberto Meda is an industrial and furniture designer who began his training in mechanical engineering, when he graduated with a Masters from the Politecnico di Milano in 1969. In 1972, his talent was spotted by Giulio Castelli, who employed him as Technical Manager at Kartell, the pioneering manufacturer of plastic household goods and laboratory equipment. The company's dedication to the research and development of plastic materials enabled Meda to explore and define his engineering capabilities.

In 1979, Meda launched himself independently as an industrial designer. Since then, he has never shied away from new technological and material advances, as can be seen in his "Light Light" chair (1987) for Alias. Produced from carbon fibre and aluminium, the chair weighs just under a kilogram.

Meda is also a willing collaborator. For example, with Paolo Rizzatto he has produced award-winning lighting projects for Luceplan, such as the intricate "Titania" hanging lamp (1989) and the lightweight "Lola" floorlamp (1987).

Meda continues to work with reputable manufacturers who have the vision and wherewithal to embrace new complex technologies and to invest in the ensuing development costs. The result are timeless products that combine highly considered detailing with ergonomic and graphic clarity.

## alberto meda

**Q. What types of products do you design?**

A. Mass-produced objects such as lamps, tables, office chairs, chairs, knives, watches and so on…

**Q. What drives your designs?**

A. I personally am interested in the world of technology because it seems to me to be the contemporary expression of man's imaginative capacity and ingenuity, fed by his scientific knowledge… Technology widens the scope of knowledge. If you look at it with interpretative eyes, technology… is to my mind full of creative suggestiveness. The point is not to use technology to project an image that emphasises scientific and technical thinking, and hence technology for its own sake, but to use it as a means for aesthetic-figurative interpretation and exploration of possible performances. I mean that technology should be used discretely; owing to our biological need for simplicity, the complexity of an object's manufacture should not be displayed.

**Q. How important are trends in your work?**

A. I don't think in terms of trends.

**Q. How important is it for your work to reflect the design characteristics of your nation?**

A. Your local culture is reflected in every aspect of your life, but there's also the consciousness that you are part of global thinking.

**Q. Is your work an individual statement or a team solution?**

A. Normally I work alone in my studio, but I also collaborate with other designers such as Paolo Rizzatto, Denis Santachiara and Marco Zanuso. Of course, you'll find more stimuli if you can interact with someone else. The interesting thing is to find someone to play a sort of ping-pong with. You throw out an idea, discuss it, then up pops another one behind it… until eventually something good comes of it.

**Q. What elements of the design process do you find particularly frustrating?**

A. When technical people of the company I work with do not want to risk a new solution.

**Q. To what degree are you ready to compromise with your client?**

A. I try to satisfy my client by generating new ideas that can legitimate both my project and his product.

**Q. What would be your second career choice after design?**

A. Architect.

**Q. What do you still aspire to design?**

A. At the moment I am very attracted by things on a large scale. I realise that I am attracted by bridges, large structures… classical engineering. But the small scale is very interesting, too. I am convinced the micro is just as rich as the macro.

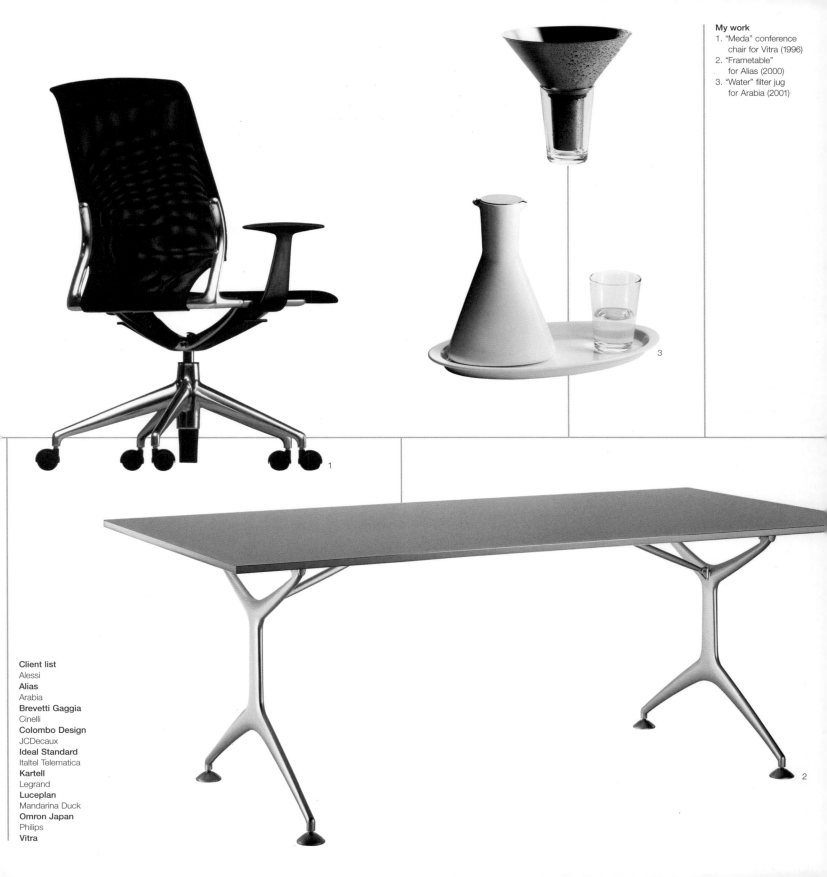

1

3

2

**Marre Moerel**
born 1966 in Breda, Holland
**Studio Location**
Madrid, Spain

To pigeon-hole Marre Moerel as "only" a designer would be to ignore the multilayered approach she adopts in her work, practising across the disciplines of art, photography, installations, furniture, lighting and product and interior design as well as the organisation and curating of exhibitions.

Moerel was born and raised in the Netherlands, where she studied Fashion Design at the Akademie van Beeldende Kunsten in Rotterdam in her early twenties. After that, she changed direction, undertaking a degree course in Sculpture at Exeter College of Art and Design, after which she rounded off her education with a Masters in Furniture Design at the Royal College of Art in London in 1991. Leaving England for the United States in 1993, Moerel spent ten years in New York working as a freelance artist and designer, while teaching Furniture Design at Parsons School of Design from 1995 to 1999.

Creating objects that range from one-offs to the batch or mass-produced gives Moerel the freedom to pursue her curiosity for materials and processes, either craft-based or industrial. Her designs are often inspired by nature – whether it's the human form or molecular cell division. Such starting points are translated into sensuous organic sculptures into which Moerel then incorporates, for example, a light, transforming the object into a functional item that straddles an ambiguous zone between art and design.

In 2003, Moerel moved to Madrid where she now runs her own design studio/gallery and works as Art Director for Kult Design.

**My inspiration**
Growing up in Holland and the contrast between the 17th-century Dutch houses and the modern '70s home environment in which I was brought up

E

**marre moerel**

**Q. What types of products do you design?**
A. Furniture, lighting, tiles and tableware, as well as some products and clothes.

**Q. What or who has influenced your work?**
A. My parents and growing up in Holland.

**Q. What was your big break?**
A. In terms of my design work, it was when Cappellini decided to put my "Soft Box" [1998] lighting series into production.

**Q. What human emotions and necessities drive your designs?**
A. Beauty, simplicity, intuition, an appreciation for the everyday, trying to understand things that I don't understand, and to re-create these elements in a new and hopefully inventive way.

**Q. How important are trends in your work?**
A. I like to think not at all, but it's hard not to be influenced by them.

**Q. How important is it for yourwork to reflect the design characteristics of your nation?**
A. In no way whatsoever. Design for me is a personal expression rather than a "nationalistic" one. Especially having lived in several different places around the world, I find it hard to think in terms of a single country or culture, even though I know my work is still very much a reflection of my background.

**Q. Is your work an individual statement or a team solution?**
A. Individual; I always do everything on my own, which I presume is the result of my education as a sculptor.

**Q. What elements of the design process do you find particularly frustrating?**
A. Making decisions. For me that's the only drawback of working alone as there is no one around to get feedback from, and there are just too many possibilities…

**Q. To what level will you compromise to satisfy your client?**
A. I don't believe in compromises, only in good solutions.

**Q. What would be your second career choice after design?**
A. Fine artist/sculptor/photographer.

**Q. How would you describe your design approach in one sentence.**
A. Trying to understand and question everyday objects and/or materials and their use, and to reinvent them in an innovative way.

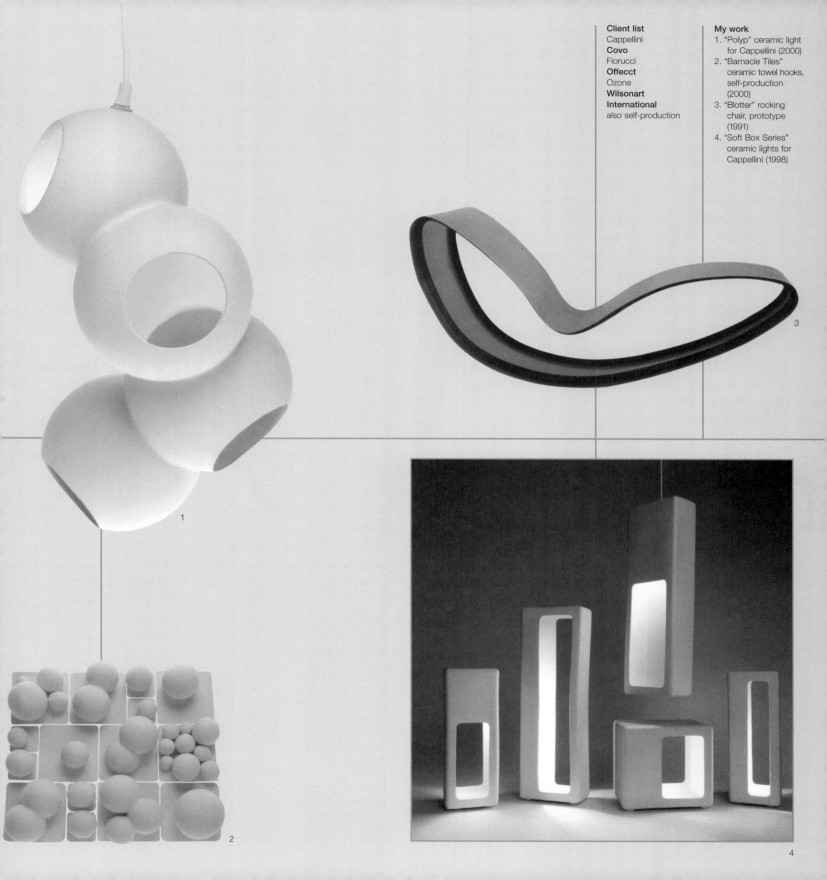

**Client list**
Cappellini
**Covo**
Fiorucci
**Offecct**
Ozone
**Wilsonart
International**
also self-production

**My work**
1. "Polyp" ceramic light for Cappellini (2000)
2. "Barnacle Tiles" ceramic towel hooks, self-production (2000)
3. "Blotter" rocking chair, prototype (1991)
4. "Soft Box Series" ceramic lights for Cappellini (1998)

**Jasper Morrison**
born 1959 in London, UK
**Studio Location**
London, UK, and Paris, France

One of the world's leading industrial designers, Jasper Morrison graduated in Design at Kingston Polytechnic Design School in 1982 and completed his training at the Royal College of Art in London in 1985, having undertaken a year-long scholarship at the Hochschule der Künste in Berlin. Before he even graduated, his work had attracted the attention of SCP and Aram in London, who produced and exhibited some of his earliest designs. These in turn caught the attention of furniture producers Vitra, Cappellini and FSB (a German door-handle maker), who became Morrison's first international collaborators. By then, his London-based studio Office for Design was open and, together with Andreas Brandolini and Axel Kufus, he was working on exhibitions, town-planning and seating projects in Germany under the banner Utilism International.

In 1992, his relationship with Cappellini was strengthened when he organised, with James Irvine (pp 134–135), Progetto Oggetto – a collection of household objects designed with a group of young European designers.

In 1994, the scale shifted with a commission from the Hannover public transport company, ÜSTRA, to design the city's new tram system. Since then, he has developed best-selling mass-produced products for the likes of Alias, Magis, Alessi, Flos and Rosenthal.

Morrison reduces objects to their essentials, creating designs that are characterised by understated elegance, perfect proportions and quality of manufacture. Mass-production methods are crucial in his design approach to everyday objects, their regularity and anonymity a reflection of his personality. In 2001, he was elected a Royal Designer for Industry (RDI).

**My inspiration**
Objects without authorship – seemingly anonymous artefacts where a personality has not been attached and simple efficient functionality reigns strong

GB

# jasper morrison

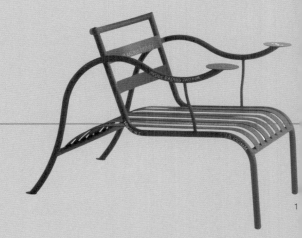

1

---

**Q. What types of products do you design?**
A. No weapons, no pharmaceuticals, otherwise most types of products. Everything from bird tables to trams including furniture, lighting, door handles, tableware, storage, shelving, and consumer goods.

**Q. What or who has been of significant influence on your work as a whole?**
A. Everyday life. For example, anonymous objects free of any association with a particular personality are quite often more appealing than the character of pedigree objects, where the creator's ego may have replaced some of the object's usefulness.

**Q. Can you cite some examples of previous designers who you admire?**
A. There are of course many... Jean Prouvé, Charles Eames, Franco Albini, Vico Magistretti, Achille Castiglioni, Enzo Mari, Dieter Rams...

**Q. And what about some of your contemporaries?**
A. There are some extraordinary talents like James Irvine, Marc Newson, Stefano Giovannoni, Konstantin Grcic... the list could go on.

**Q. At what age did you realise you wanted to design?**
A. Around about the age of 16. I had an older cousin who was beginning to design and it seemed like an appealing profession. Then I saw a great exhibition at the Victoria & Albert Museum in London and it seemed like something I could do. Previous to design, a mechanic was my first profession.

**Q. What was your big break?**
A. My first major article in *Domus* magazine written by Manolo de Giorgi in 1988.

**Q. What human emotions and necessities drive your designs?**
A. A need to feel useful.

**Q. With whom do you discuss your designs?**
A. Aside from with the people in my office, only the client.

**Q. What elements of the design process do you find frustrating?**
A. Dealing with marketing people.

**Q. Which of your products are you most satisfied with?**
A. Normally, it's the one I'm working on at the moment. Once a project is produced and it has arrived in the shops, it sustains a nice memory. I live with a lot of the products that I create, and some of them give more satisfaction than others... it really is hard to pick one...

**Q. To what level will you compromise to satisfy your client?**
A. We aim to please.

**Q. What would be your second career choice after design?**
A. A second-hand book-dealer.

**Q. How would you sum up your design approach.**
A. Erratic at first, then concentrated.

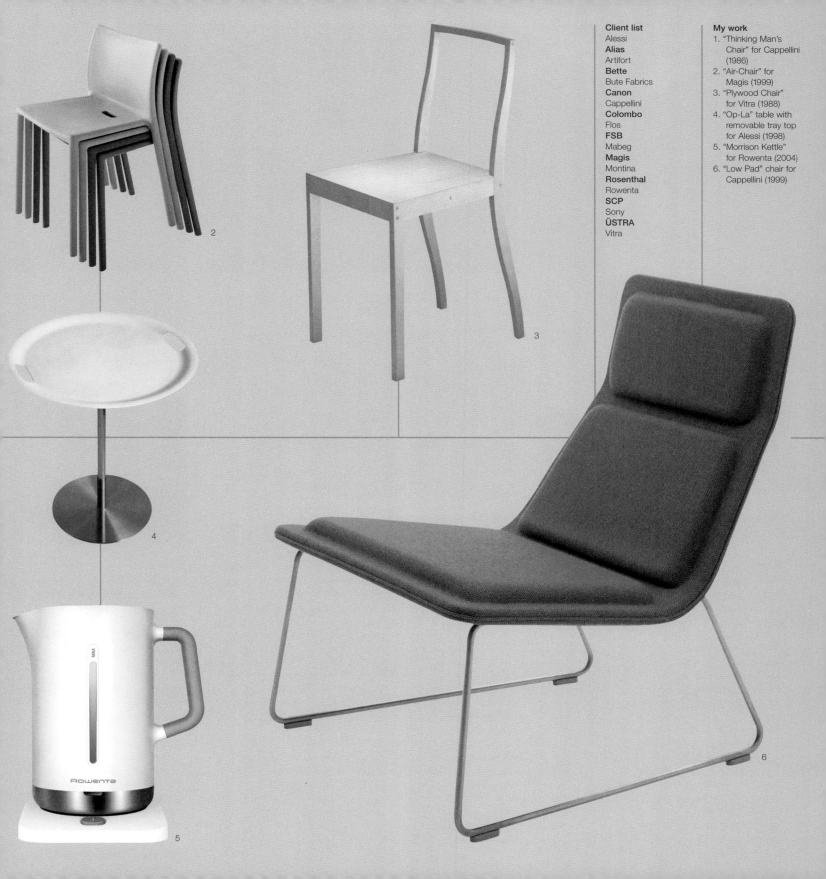

2

3

4

5

6

Rowenta

**Pascal Mourgue**
born 1943 in Neuilly, France
**Studio Location**
Montreuil-sous-Bois, France

French designer Pascal Mourgue pursued two educational paths in his early twenties, graduating in Sculpture from the Ecole Boulle in Paris in 1962 and then in Interior Design from the capital's Ecole Nationale Supérieure des Arts Décoratifs (ENSAD) in 1964. His career as a designer began in Italy in the late 1960s when he worked for Mobel Italia. Back in France, he developed low-price furniture with the supermarket chain Prisunic throughout the 1970s, whilst also exploring some of the more neglected areas in interior design, such as hospitals and nurseries.

In 1973, Mourgue co-founded his studio in the Paris suburb of Montreuil with Patrice Hardy. Initially, he concentrated on office furniture, but in the 1980s his interests shifted towards domestic furniture and he established long-term collaborative relationships with French manufacturers such as Fermob, Artelano and Ligne Roset. Not one to stand still, Mourgue enjoys the crossover into other design disciplines and has undertaken sailing boat projects for Cartier, crystal objects for Baccarat, houses for private clients, a string of international showrooms for Ligne Roset and graphic arts for the Musée de la Poste (the postal museum) in Paris. He also produces drawings, paintings and sculpture.

Mourgue is passionate about industry, and his portfolio of mass-production designs has gained him considerable commercial success. His work has entered many permanent museum collections and has won him the Designer of the Year award at the Salon du Meuble trade fair in Paris in 1984, the City of Paris Creator of the Year award in 1992, and the French Culture Ministry's Industrial Creation First Prize in 1996.

**My inspiration**
The multi-functional space in Moroccan homes called *Sideri* where one can work, relax, eat, and entertain – a concept attuned to modern day living

F

**pascal mourgue**

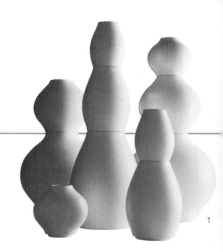

1

**Q. What types of products do you design?**
A. All types of housing products – furniture, lamps, objects, kitchenware and so on.

**Q. What or who has been a particular influence on your work as a whole?**
A. The following is an example of something that has influenced my work. A *sideri* is a multi-purpose living space commonly found in Middle Eastern and North African homes in which you can have meals, entertain friends or work. [...] I thought the concept would perfectly fit into today's small city flats and with our new way of living, so I used it to design a new furniture line [...] called "Tazia" (2004) for Ligne Roset.

**Q. What product was your first big break?**
A. The "BISCIA" chair I designed in 1970 for Mobel Italia, of which several thousand units have nowbeen sold since it was first produced.

**Q. What human emotions and necessities are the driving force behind your designs?**
A. The analysis and intuition of different behaviours.

**Q. How important are trends in your work?**
A. Fashions are really not significant for me.

**Q. How important is it for your work to reflect the design characteristics of your nation?**
A. I wouldn't say this is important, although the culture of my own country has certainly been an influence.

**Q. Is your work an individual statement or a team solution?**
A. A bit of both – it is an individual research process that is then developed by a team.

**Q. To what level will you usually compromise in order to satisfy your client?**
A. Compromises are often just the result of bad analysis by either party. This is obviously something I aim to avoid.

**Q. Are there any elements of the design process that you find particularly frustrating?**
A. I'm interested in every step of the development of a project.

**Q. What would be your second career choice after design?**
A. Archaeologist.

**Q. What do you still aspire to design?**
A. Every new project is for me a necessary new dynamic force.

**Q. What is your favourite project?**
A. Its is obviously the latest one. For over 30 years I have been moving from one experience to the next and I have always wanted to keep going. Creation is never a quiet persuit.

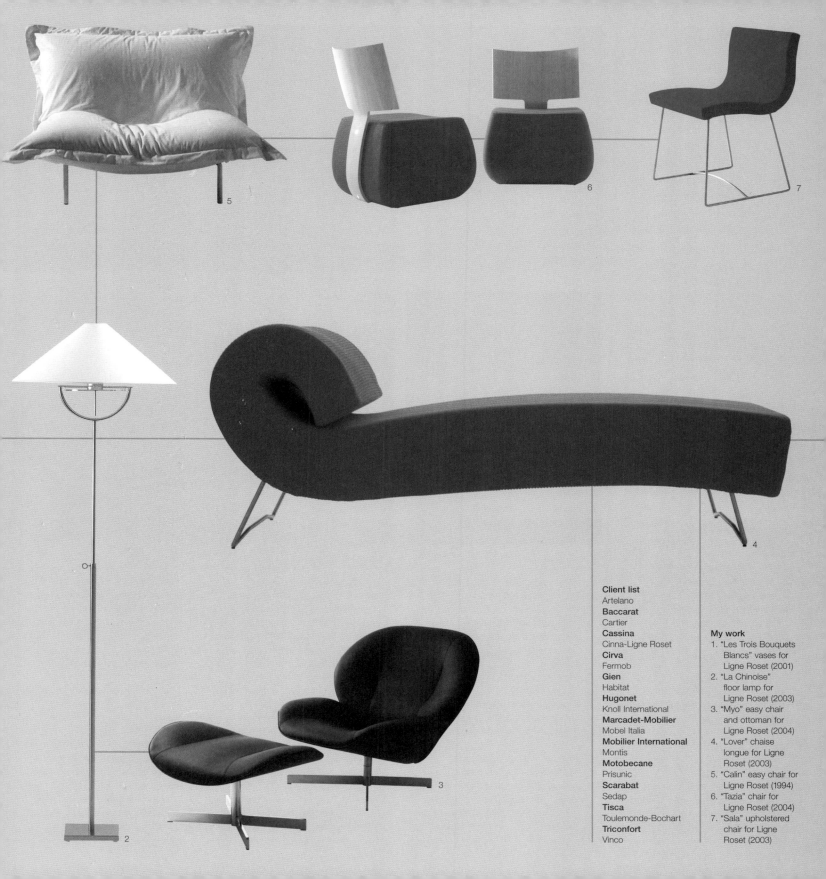

5

6

7

4

3

2

**Marc Newson**
born 1963 in Sydney, Australia
**Studio Location**
London, UK, and Paris, France

Marc Newson studied Jewellery Design and Sculpture at the Sydney College of Arts, during which time he experimented with furniture design. After graduating in 1984, he staged an exhibition at the Roslyn Oxley Gallery, Sydney, in which he featured the "Lockheed Lounge" (1986), a sculptural, organically shaped lounger. A tribute to the US aircraft manufacturer Lockheed, the design featured aluminium sheets welded together with blind rivets like aircraft cladding.

In 1987, Japanese entrepreneur and owner of Idée, Teruo Kurosaki, offered to put Newson's designs into production, resulting in the designer moving to Tokyo where he stayed until 1991. Some of his most iconic pieces, such as the "Embryo" (1988) and "Orgone" (1991) chairs, were first produced at this time. In 1991, he set up a studio in Paris and began collaborations with European companies such as Flos, Cappellini and Moroso. In 1994, he set up, with Oliver Ike, the company Ikepod to manufacture his watch designs. In 1997, Newson moved to London, where he founded a large-scale studio capable of handling more ambitious industrial

projects. His output has been significant, encompassing everything from furniture, glassware, lighting, consumer goods and luggage to bicycles, concept cars and aircraft.

With its bright colours and organic shapes, Newson's design style could be described as "retro-futuristic". His influences range from the 1930s sculptures of John Arp and the streamlined aesthetic of 1950s Americana to contemporary culture and the world of science and technology. One of his generation's most accomplished designers, Newson's award-winning work is sold, published and exhibited across the world.

GB
F

**marc newson**

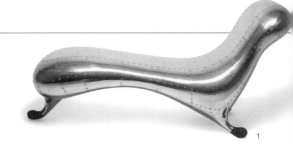

1

**Q. What types of products do you design?**

A. Everything from a sex toy to a concept jet.

**Q. What or who has most influenced your work?**

A. Contemporary culture, the advancement and possibilities of science and technology and the relative ease of global travel.

**Q. What was your big break?**

A. I suppose the success of the "Lockheed Lounge" and meeting Teruo Kurosaki of Idée, who bought everything I made.

**Q. What human emotions and necessities drive your designs?**

A. First, I want to make something beautiful. Then I want to apply new

technology. Next, I think, humour is important. I don't take design all that seriously, and I think it's almost the equivalent of making jokes. There's no reason that design should be as serious as religion. Basically, I like to improve things.

**Q. How important are trends in your work?**

A. I don't consciously follow trends, but as I am interested in popular culture I guess I may be indirectly influenced by them.

**Q. Is your work an individual statement or a team solution?**

A. I am a serious control freak. I design everything, every last detail. When a client asks me to do something, they get a little bit of my DNA.

I would rather go and live on a desert island than have a bunch of designers designing for me. I have a small team of about ten people, CAD and graphic designers, architects and administrative people, and I work closely with them.

**Q. What elements of the design process do you find particularly frustrating?**

A. Sometimes, as within the aviation industry, which is very conservative, it is difficult to change things… It is like pulling teeth. I also hate to do all the other stuff like giving interviews… all that press stuff.

**Q. To what level will you compromise to satisfy your client?**

A. There are parameters in every job,

and it is the job of a designer to work to specific parameters set by the client. Peculiarly, this can prove to be a stimulus – the limitations set can stimulate thoughts and ideas.

**Q. What would be your second career choice after design?**

A. Aeronautics and astronautics.

**Q. What do you still aspire to design?**

A. I'm fascinated by space and aeronautics. I guess my dream project would be to work with NASA, designing for space travel.

**Q. How would you describe your design approach in one sentence?**

A. My ultimate goal is to express order and, most importantly, simplicity, revealing the essence of the object or the space I am designing.

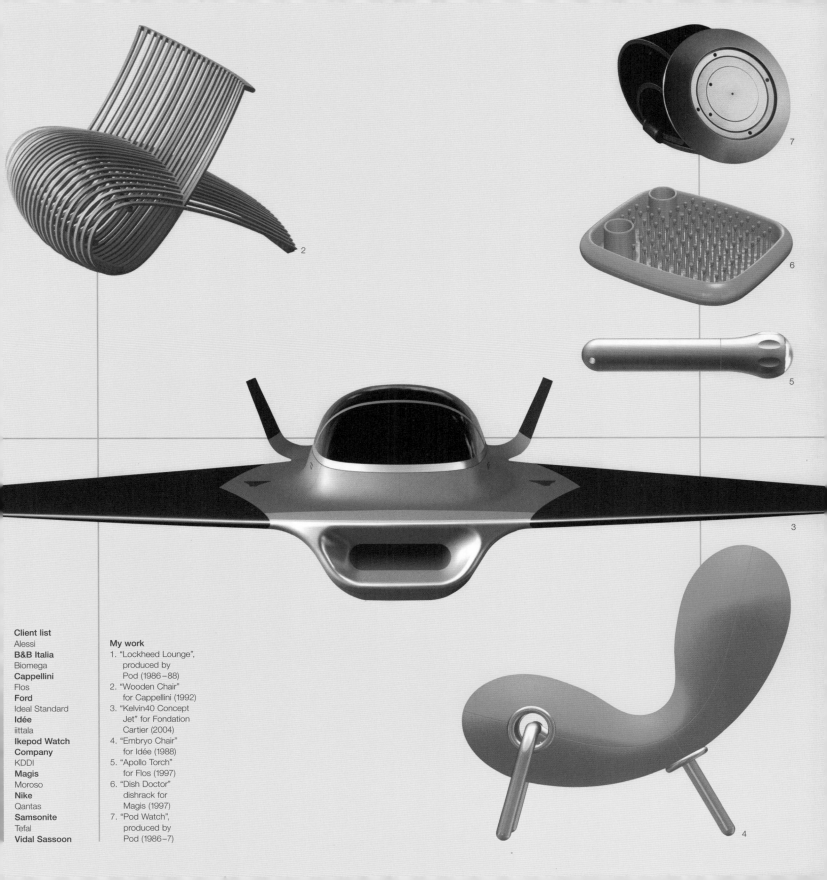

**Torbjørn Anderssen**
born 1976 in Elverum, East-Norway
**Andreas Engesvik**
born 1970 in Svolvær, North-Norway
**Espen Voll**
born 1965 in Trondheim, Mid-Norway
**Studio Location**
Oslo, Norway

Norway Says was originally the name given to a project this trio of designers first presented at the Milan Furniture Fair in 2000. The name stuck following the subsequent industrial uptake of their furniture designs. Anderssen, Engesvik and Voll officially formed a design partnership in autumn 2002.

The Nordic trio mainly work on product, furniture, installation and interior design, as well as graphics, corporate identity and photography in close collaboration with like-minded exterior designers. The group has been careful to position themselves at design events in cities such as Milan, London, Stockholm, Cologne and New York, attracting the attention of the media and national and international clients, such as Swedese, David Design, Classicon and LK Hjelle, as well as commissions from the Norwegian Design Council and Norwergian government. Norway Says products are already represented in permanent museum collections at the Victoria and Albert Museum, London, and the Kunstindustrimuseet, Oslo.

**Our inspiration**
Engesvik is inspired by his girlfriend and days at the race track racing his 1970s Alpha Romeo. For Voll it's ice sculpture, while Anderssen cites Konstantin Grcic's work

norway says

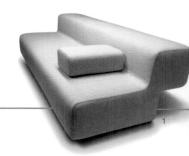

1

**Q. What types of products do you design?**
A. We focus on interior related objects, but we have also done interiors, exhibition design, lighting, furniture fabrics, bicycles, porcelain and glassware.

**Q. What or who has been of significant influence in your studio?**
A. Swedish design outfit Claesson Koivisto Rune (pp 80–81) has been and continues to be an inspiration, especially in how they've been integral in the development of Swedish companies like Swedese, Offecct and Skandiform. We are very grateful for their good advice and friendly attitude. We're also very impressed by the work of designers such as the Bouroullec brothers (pp 64–65) – by the "poetry" in their work and how they manage to create new relevant categories of products. Other inspirations include Patricia Urquiola (pp 232–233), Konstantin Grcic (pp 114–115) and Jasper Morrison (pp 174–175).

**Q. What was your big break?**
A. Our appearance at Salone Satellite at the Milan Furniture Fair in 2000. This was the first time we exhibited as Norway Says. At the time, the economy was good and there was a real appetite for new stuff. The good weather helped us, too. As a group, we were really shaped during that fair.

**Q. How important is it for your work to reflect the design characteristics of your nation?**
A. Norwegian design characteristics are hard to define. We feel very free to apply unique rules to every new project. It's important… to have this feeling of freedom even if it's not real. People tend to place us squarely within the Scandinavian tradition, and we've no problem with that. The Italians describe us as "multo nordico"!

**Q. Is your work an individual statement or team solution?**
A. Norway Says has developed from an exhibition project of loosely connected careers into a studio where everything is signed by Norway Says as a team. Seeing possibilities, establishing close personal contacts with the people we're working for and pursuing spin-off ideas are all core issues in keeping speed and developing ourselves as designers. This is easier as a team.

**Q. What elements of the design process do you find particularly frustrating?**
A. Time is a paradoxical factor in the design process. Tight time schedules can be frustrating, but, at the same time, such constraints often seem to bring out unexpected and interesting results. We get particularly frustrated when we get the feeling of having designed ourselves into a dead end. Once again, though, it's this kind of creative block that can give the most rewarding results because often the way out is to break your routine patterns of thinking.

**Q. How much would you compromise to make your client happy?**
A. We'll compromise as long as it doesn't harm the idea and we can recognise our voice in the final result.

**Q. What do you still aspire to design?**
A. Norway Says is a young office so we feel we still have lots to do in the field of interior-related objects, but we'd also like to be involved in design projects that include technically innovative materials and processes.

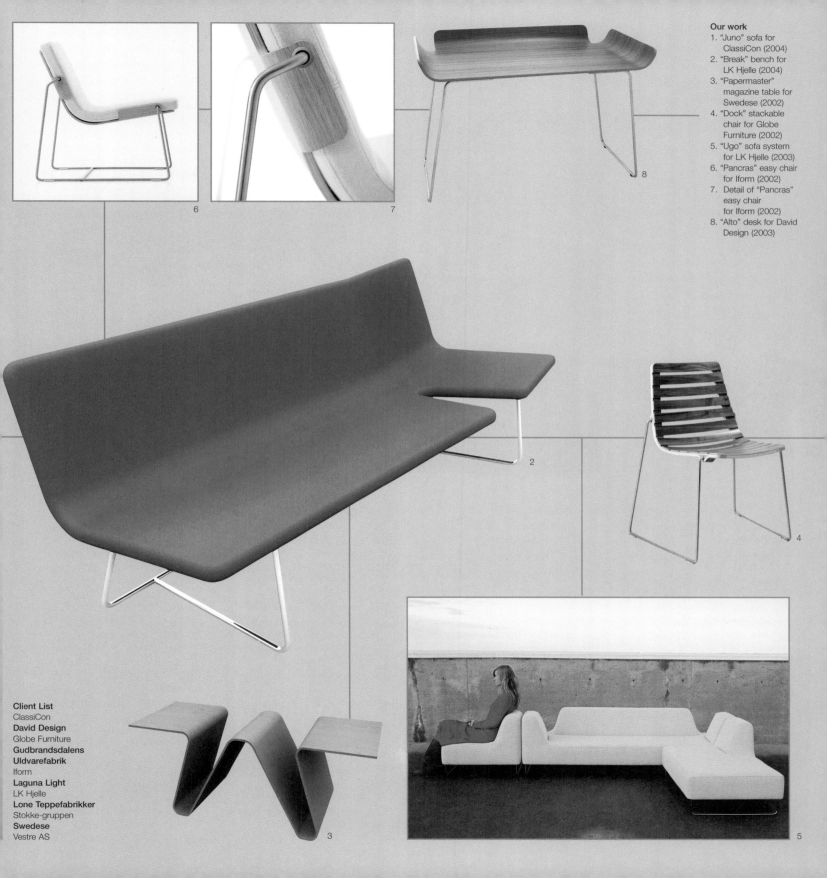

6

7

8

2

4

**Client List**
ClassiCon
**David Design**
Globe Furniture
**Gudbrandsdalens Uldvarefabrik**
Iform
**Laguna Light**
LK Hjelle
**Lone Teppefabrikker**
Stokke-gruppen
**Swedese**
Vestre AS

3

5

**Patrick Norguet**
born 1969 in Tours, France
**Studio Location**
Paris, France

Self-taught designer Patrick Norguet began his career in the world of fashion and luxury goods; from 1987 to 1990, he was in charge of window displays and special events conception at Louis Vuitton. He later became Head of Visual Identity and Merchandising at the same company. His relationship with the fashion world also led to numerous projects with such famous brands as Christian Dior, Guerlain, Bally and Lanvin.

His multidisciplinary design approach and creative curiosity led him to start his own design agency in Paris in 1997. Cappellini put his "Rainbow" chair, made from layers of translucent coloured plexiglas, into production in 2000, launching his name onto the international design scene. The "Rive Droite" collection of seating systems (with Pucci fabrics) followed in 2001.

Although still involved in fashion, Norguet has increasingly focused on the world of interior product design, working on furniture, lighting and ceramic designs for some of the top international manufacturers. In addition, 2001 saw the start of a new relationship with Renault, working on their "event architecture" at car shows as well as concepts for new car showrooms.

**My inspiration**
Design pioneers like Eames and Castiglioni as well as contemporary masters like Morrison and Newson, whose "Aluminium Orgone Chair" of 1993 is shown here

**patrick norguet**

F

1

**Q. What types of products do you design?**
A. All products that have an industrial dimension or potential, with a manufacturing process that includes a serial production vision to them. Furniture, objects, lighting, rugs, tableware in ceramics, glass, silver… I'm also involved with the fashion industry.

**Q. What or who has been of significant influence to the work of your studio?**
A. I don't have any mentors, only "fathers" like the Eameses, George Nelson, Achille Castiglioni and Raymond Loewy – the pioneers who established the basis of industrial production – or the contemporary designers Marc Newson (pp 178–179) and Jasper Morrison (pp 174–175), both of whom I admire.

**Q. What was your big break?**
A. A product for Cappellini – the "Rainbow" chair – which attracted a lot of attention and stirred up a lot of reactions.

**Q. What drives your designs?**
A. The search for balance and lightness are some of the main leads in my work. I strive to create simple straightforward objects in a complicated world – the search for clear "readability" is very important to me.

**Q. How important are trends in your work?**
A. Trends are frozen in time; they quickly vanish and become part of the past.

**Q. How important is it for your work to reflect the design characteristics of your nation?**
A. There is perhaps an unconscious French sensibility that underlies my designs. Each project is the result of numerous different collaborations with clients, manufacturers and others, so a cultural blend emerges, giving each of my projects a somewhat European "feel" – something which is, in any case, closer to my vision of what I want.

**Q. Is your work an individual statement or a team solution?**
A. At the beginning of the process, my work starts as an individual statement, but it quickly becomes a group effort through the intervention of many participants.

**Q. What elements of the design process do you find particularly frustrating?**
A. Incomprehension – when a project is aborted for irrational reasons.

**Q. To what level will you compromise to satisfy your client?**
A. Compromise might come as part of a project's constraints. Sometimes it can grow in a more negative way and it can threaten the whole project. That's when one has to say "no" to save the project and the design. There is a notion of ethics that becomes involved.

**Q. What would be your second career choice after design?**
A. Something closer to the senses, like music, sound, or musical composition. I would set up a world stemming from all of that.

**Q. What do you still aspire to design?**
A. The projects I get to work on are so varied that I can't think of anything I still want to design at present. The journey I'm on at the moment is more than exciting enough!

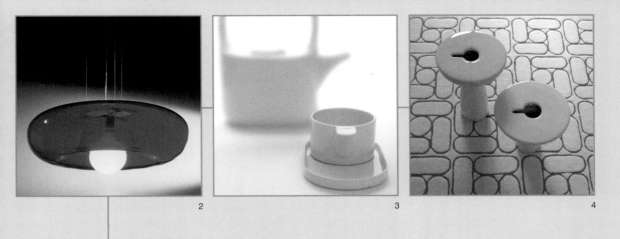

2    3    4

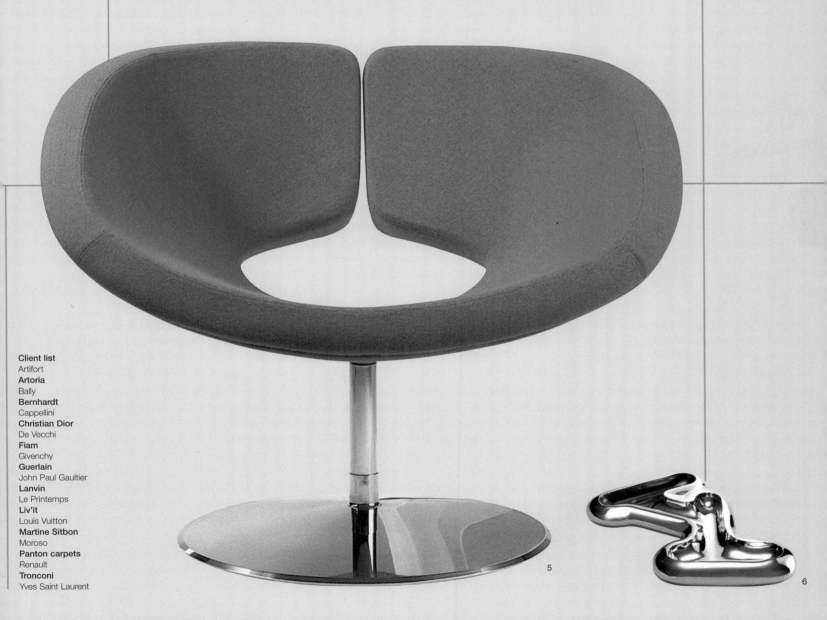

**Client list**
Artifort
**Artoria**
Bally
**Bernhardt**
Cappellini
**Christian Dior**
De Vecchi
**Fiam**
Givenchy
**Guerlain**
John Paul Gaultier
**Lanvin**
Le Printemps
**Liv'it**
Louis Vuitton
**Martine Sitbon**
Moroso
**Panton carpets**
Renault
**Tronconi**
Yves Saint Laurent

5            6

**Fabio Novembre**
born 1966 in Lecce, Italy
**Studio Location**
Milan, Italy

Avant-garde Italian designer Fabio Novembre rose to prominence in the 1990s with a series of spectacular interior-design projects for restaurants, bars, clubs, hotels and showrooms across the world. Having studied architecture at the Politecnico di Milano, Novembre departed to the United States to pursue his interest in filmmaking. A chance meeting with the fashion designer Anna Molinari in New York landed him the job of designing her first shop in Hong Kong in 1994, which led on to several other commissions for shop designs in London, Singapore and Taipei. His flamboyant style attracted commissions back in Italy, his "otherworldly", expressive and playful environments proving especially ideal for the entertainment industry.

In most of his interiors, Novembre has exploited the possibilities of mosaic tiles to painterly effect, so it hardly came as a surprise when, in 2000, he joined the highly regarded Italian manufacturer of mosaic tiles Bisazza as Creative Director. The company's showrooms around the world were invigorated by Novembre's playful and rather ornate aesthetic, perfectly demonstrating the possibilities of the Bisazza product.

The designer injects mystery, excitement and surprise into all his interior spaces, triggering intrigue and a sense of discovery in all those who visit, as illustrated by his design for the Una Hotel Vittoria in Florence. Novembre's playfulness is further explored in his designs for individual objects for Cappellini – a relationship that began at the turn of the millennium and which has extended his reputation into the world of furniture design.

**My inspiration**
The imaginative and bizarre stories of cinema, in particular the expressive genius of actor Federico Fellini seen here on the set of *Eight and a Half* in 1963

**fabio novembre**

I

Q. **What types of products do you design?**
A. I don't know if I can call the things I do "products". When I design something, the last thing I think of is its production. The things I do are my way of talking, and I concentrate on the message, not on the medium. In any case, I'm aware I belong to the last defenders of "tri-dimensionality" – design is the last medium that reminds us we are made of flesh and blood, that at the end of everything, there we are, surrounded by matter, by people we can touch, hug and take to bed…

Q. **What or who has been a significant influence on your work?**
A. I have a very big passion for cinema, which I've always conveyed in my work. When still a student, I recognised the total freedom of expression in the movies of Fellini. Everything was so unconventional and dreamy, both in terms of the stories and in the way they were told…

Q. **What was your big break?**
A. I was living in New York when I accidentally met Anna Molinari, who was a successful fashion designer. Probably fascinated by my bohemian trappings more than by my experience in architecture (I had never even worked in a studio), she offered me the chance to design her first shop in Asia, asking me to move to Hong Kong to take care of the site. It was 1994, and that was it!

Q. **What drives your designs?**
A. I believe that LOVE is the password for everything. All I do is moved by love, and love is like rain – it falls democratically, all you have to do is to get wet.

Q. **How important are trends in your work?**
A. I absolutely don't believe in trends. Trends are for followers, not for someone who is aware of himself. Trends are induced; all I look for is authenticity.

Q. **How important is it for your work to reflect the design characteristics of your nation?**
A. You can't be anything but yourself. That includes, of course, what you have breathed since a child. But I really don't care about being Italian in my work. Ever since I could afford it, I've travelled so much and I feel like loving and belonging to the whole planet Earth…

Q. **Is your work an individual statement or a team solution?**
A. As I said, my work can't be anything but my individual statement. There's no division between my life and my work, so that all I do is just a magic mirror of the time I'm living.

Q. **What elements of the design process do you find particularly frustrating?**
A. I accept all elements of the design process as part of the whole thing. You can't appreciate spring and summer without fall and winter, and vice versa…

Q. **To what level will you compromise to satisfy your client?**
A. I think there's nothing to compromise. I see my clients as sponsors of my ideas, and I can afford to live this way because I do very little. And then once in a while someone crazy comes to me…

Q. **What do you still aspire to design?**
A. Every day is another new story. I like surprises!

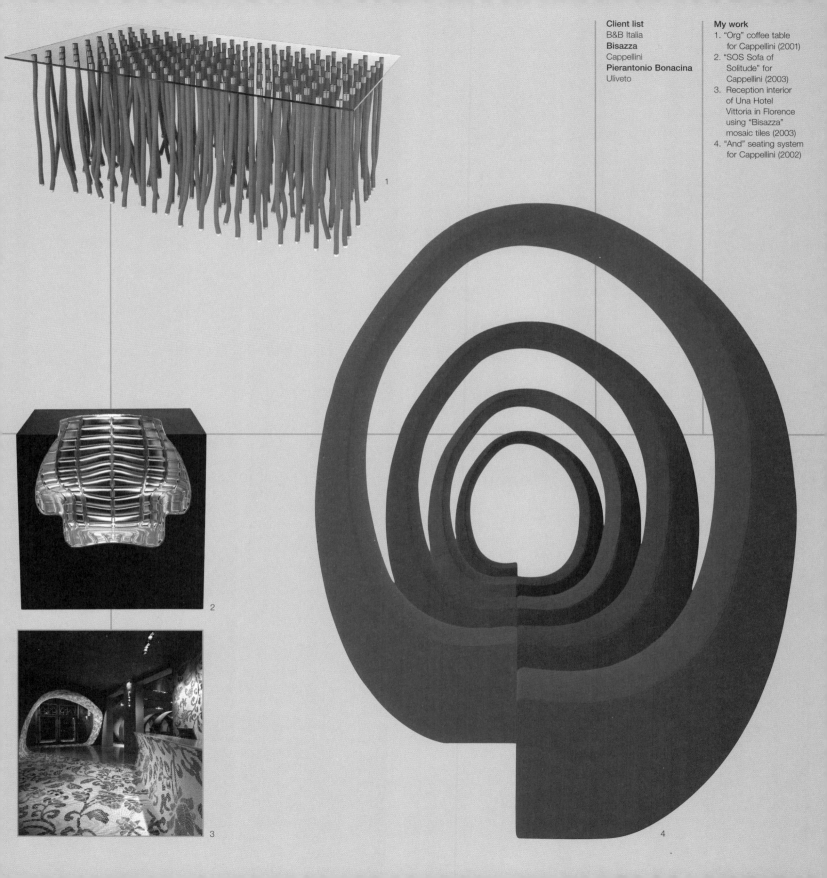

**My work**
1. "Org" coffee table for Cappellini (2001)
2. "SOS Sofa of Solitude" for Cappellini (2003)
3. Reception interior of Una Hotel Vittoria in Florence using "Bisazza" mosaic tiles (2003)
4. "And" seating system for Cappellini (2002)

**Frank Nuovo**
born 1961 in Monterey, California, USA
**Studio Location**
Nokia Design (USA)
based near Los Angeles, USA

The growth of the mobile communications market in the mid-to late 1990s was a huge global sales phenomenon. At the start of the decade, Nokia was a virtually unknown Finnish company; today, it is one of the most recognisable brands and the largest producer of mobile phones and communication devices in the world. The Nokia phone owes its success largely to Frank Nuovo, Vice-President and Chief Designer for Nokia Design.

After graduating in Product and Automotive Industrial Design from the Art Center College of Design in Pasadena, California, in 1986, Nuovo joined Designworks USA/BMW, where he gained expertise in the design of furniture, consumer electronics and medical instruments along with general consumer and automotive products. His initial work for Nokia also started here, before he joined the company in 1995.

Nuovo has directed the design development of the mobile phone for over a decade, continually setting market precedence in the user-interface design that houses the fast-changing mobile technology. He sets the trends – introducing the mass-customisation possibilities of changeable phone casings, refined ergonomics and colour screens, as well as the use of other material finishes from plastics to rubber, chrome to aluminium, and even titanium.

In 2002, the award-winning Nuovo introduced Vertu – a sister brand for the luxury market that launched the world's most exclusive precision communications instrument, using materials such as platinum and sapphire and offering advanced services and features.

**My inspiration**
Leonardo da Vinci – his inventions, his exploration of anatomy and human proportions, and his expression in Fine Art

USA

frank nuovo

**Q. What or who has influenced your work?**
A. We are mainly talking about inspiration here. My life has been immersed in creative exploration and improvisation from music and communication to visual and industrial arts. Since I was a young kid, I was fascinated by Leonardo da Vinci… Influence on my work today is mostly due to the creative people across the disciplines that I work with. Mostly, though, I must credit my father, Frank Joseph Nuovo. He blended a professional music career with a business-management career while raising a loving family. It showed me that, with hard work, the rational – practical and emotional – artistic sides can be successfully mixed to create an excellent life.

**Q. What was your big break?**
A. I was working late over the Christmas holiday at Designworks USA/BMW, and a mobile car phone project from an unknown Finnish company called Nokia came in. I was the only one around to handle the project, and I was really excited to work on it…

**Q. What human emotions and necessities drive your designs?**
A. Desire and delight with positive emotion and expression. Beautiful form and line with balanced composition and visual simplicity. All of this is linked to elements of natural attraction.

**Q. How important are trends in your work?**
A. Anticipating, leading and/or following trends are all very important with personal accessory design (like a mobile phone). Some product categories and/or style targets are not affected by short-term trends – the measures are more classic and long-lasting. Others are all about the here and now with timing – speed to market – being critical for success. It's fun to make a splash once in a while, but I prefer the long-term "timeless" approach to design.

**Q. Is your work an individual statement or a team solution?**
A. My work as Chief Designer for Nokia is about principles of the Nokia brand design, not about any one individual statement. While I have and continue to play a lead role in the creation and continuity of Nokia solutions, it is a statement that is formed via the team. It takes a variety of different technical disciplines to make a product successful. My most individual design statement so far is found with Vertu. It was a dream to create holistically a new product category, brand and brand style. As founder, creative director and designer for Vertu, I was able to form most of what you see today, but it would not have been possible without a strong multidisciplinary team.

**Q. What elements of the design process do you find frustrating?**
A. With the speed of industry today, there is little time to develop a good idea to its best possible solution. It is a huge challenge to build, test and refine in such short timeframes, so we constantly also develop new design and technology processes aiming to improve solution quality. Vertu was a luxury in my experience of product development… We achieved impressive mechanics and manufacturing firsts by slowing the clock speed of design and manufacturing. The result is a product line of incredible precision and quality that is only possible in limited volumes.

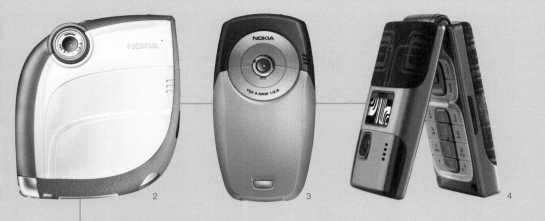

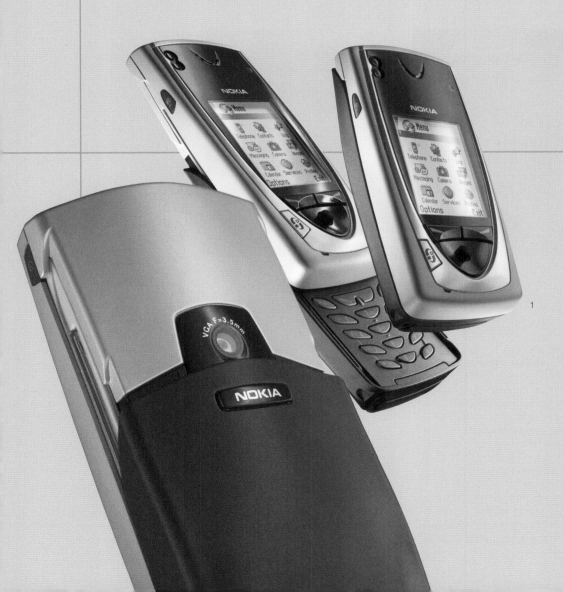

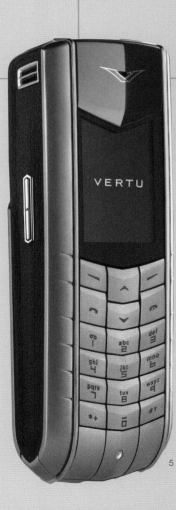

**Client list**
Nokia
**Vertu**

**My work**
1. "7650" mobile
   phone for
   Nokia (2004)
2. "7600" mobile
   phone for
   Nokia (2003)
3. "6600" mobile
   phone for
   Nokia (2003)
4. "7200" mobile
   phone for
   Nokia (2004)
5. "Ascent" mobile
   phone for
   Vertu (2004)

**Jan Nemecek**
born 1963 in Prague, Czech Republic
**Michal Fronek**
born 1966 in Prague, Czech Republic
**Studio Location**
Prague, Czech Republic

Founding partners of Studio Olgoj Chorchoj, Michal Fronek and Jan Nemecek, first met during their years of study in product design at the Prague Academy of Arts, Architecture and Design at the end of the 1980s. It was in 1990, during the workshop of the Italian designer Denis Santachiara at the Vitra Summer Workshop in Weil am Rhein, Germany, that the duo decided to set up a studio together, based on a similarity and compatibility that they recognised in each other's approach to design. Their famously unpronounceable name was chosen purely on the sound of the words and not on the characteristics of the mythical figure from Mongolian folklore from which it derives.

Fronek and Nemecek embrace a variety of 3-D projects ranging from the small-scale, such as jewellery, to the vast domain of buildings. Depending on the project, they call in a flexible team of associates to collaborate to sustain a fresh outlook and varied pattern of approach. Craftsmanship plays an important role in the designs of the studio, explored through collaborations with traditional companies such as Kavalier Glassworks to produce new objects using established techniques.

Indeed, their respect for tradition inspired them to establish another company in 1993 called Artel to produce and preserve outstanding Czech designs from the 20th century. In addition to this, Fronek and Nemecek became heads of the product design studio at Prague Academy of Arts, Architecture and Design in 1999.

**My inspiration**
The Czech designer Ladislav Sutnar whose work in industrial glass as well as graphics in the 1930s has helped inform our design approach

CZ olgoj chorchoj

**Q. What types of products do you design?**
A. Studio Olgoj Chorchoj designs furniture, lights, decorative glass, stemware, jewellery, exhibition design, interiors and buildings.

**Q. What or who has influenced your studio?**
A. The Czech industrial and graphic designer Ladislav Sutnar was a great inspiration to our work. His pioneering designs with heat-resistant glass in the 1930s led us to work with a glassworks for our borosilicate-glass pieces, and his graphic work influenced our designs, too.

**Q. What was your big break?**
A. We never had a big break, but rather a continual stream of small breaks.

**Q. What human emotions and necessities drive your designs?**
A. During the design process, we find it necessary to add a small amount of humour to the work.

**Q. How important are trends in your work?**
A. We are not influenced by trends; we are creating them.

**Q. How important is it for your work to reflect a Czech design tradition?**
A. We have created a separate foundation to preserve and promote Czech design from the 20th century. Our work is definitely influenced by our respect for Czech designers and thus reflects certain characteristics found in older Czech designs.

**Q. Is your work an individual statement or a team solution?**
A. Studio Olgoj Chorchoj functions as a team, although not everybody works on each project. Sometimes only two or three designers are involved on a given project.

**Q. What elements of the design process do you find particularly frustrating?**
A. Marketing and administration.

**Q. To what level will you compromise to satisfy your client?**
A. We seldom need to compromise because our clients for the most part are included in some way in the creation process.

**Q. What would be your second career choice after design?**
A. Jan Nemecek: a doctor.
Michal Fronek: a designer.

**Q. What do you still aspire to design?**
A. A new Tatra automobile.

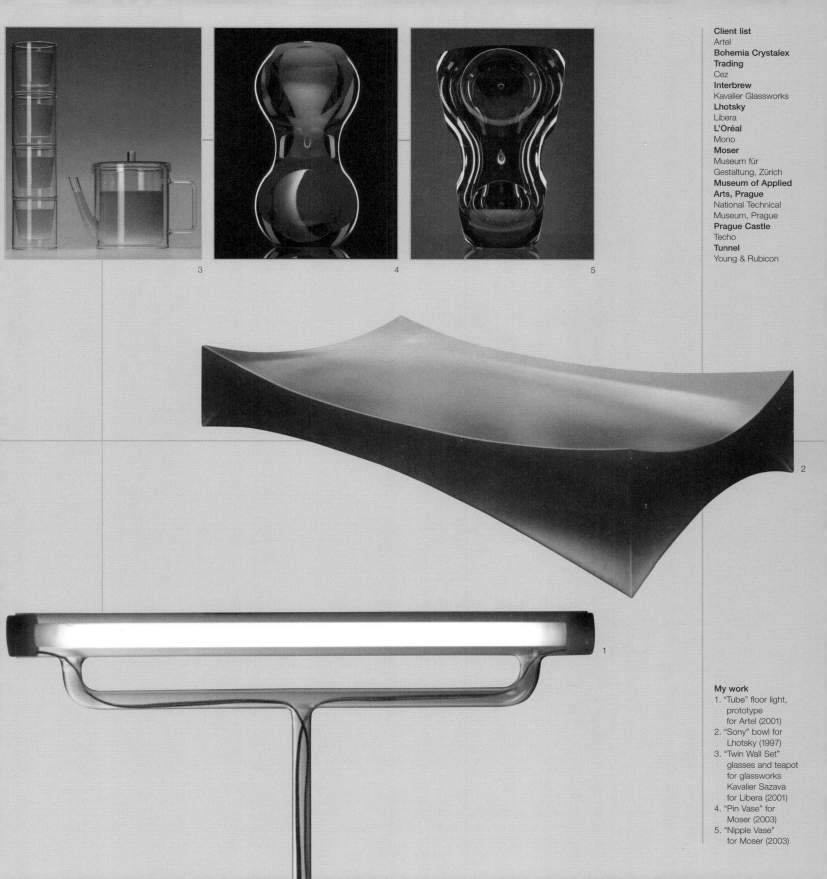

**My work**
1. "Tube" floor light, prototype for Artel (2001)
2. "Sony" bowl for Lhotsky (1997)
3. "Twin Wall Set" glasses and teapot for glassworks Kavalier Sazava for Libera (2001)
4. "Pin Vase" for Moser (2003)
5. "Nipple Vase" for Moser (2003)

**Ludovica Palomba Serafini:**
born 1961 in Rome, Italy
**Roberto Palomba:**
born 1963 in Cagliari, Sardinia, Italy
**Studio Location**
Vigasio, Italy

Husband-and-wife duo Ludovica and Roberto Palomba first met in 1988 while studying architecture in Rome. They completed their degrees together and began working in partnership on design projects in 1994, under the name Palomba Serafini Associati. Their output of design work includes large-scale projects such as exhibition designs as well as object, furniture, bathroom, and kitchen designs. For a handful of clients, they also undertake the art direction of brands and advise on communication and marketing strategies. This multidisciplinary involvement with clients ensures the implementation of a creative vision that extends across the business: from a collection to its presentation in print, online, in showrooms and even exhibitions.

The Palombas have worked almost only with high-end Italian companies, such as furniture manufacturer Crassevig and sanitaryware producer Ceramica Flaminia. Pieces such as the "Anna" chair (1997) for Crassevig, the "Twin Column" basin (1997) for Flaminia and the "Ice" (2001) basin for Cappellini are cool and restrained, remarkable not for their unusual forms or groundbreaking technology but for their seductive proportions, tactility and sculptural confidence. The result is commercially viable, high-quality interior products.

The duo's work has won numerous prizes, such as a prestigious Compasso d'Oro in 2001.

**My inspiration**
Rationalist architecture such as *La Casa de Fascio* in Como, Italy (1932–36), designed by Giuseppe Terragni

**l + r palomba**

**Q. What types of products do you design?**
A. We design everything from small-scale objects such as ceramics to furniture, bathrooms and exhibitions. We also like to design for both industrial and limited-edition projects. We think this versatility is important because it helps keep our minds open. We undertake art direction for Bosa, Ceramica Flaminia, Crassevig, and Kos, whilst working with a variety of clients like Bisazza, Dornbracht, Foscarini, Lema, Poltrona Frau, Salviati, Schiffini, and Tronconi, amongst others.

**Q. Can you suggest a source of inspiration for your design?**
A. We are particularly inspired by Rationalist architecture. A good example of this is Giuseppe Terragni's Casa del Fascio (local Fascist Party headquarters, 1932–6) in Como […].

**Q. What was your big break?**
A. The "Acquagrande" basin designed with Giulio Cappellini for Ceramica Flaminia in 1997. It proved to be the right product at the right time and has gone on to enjoy commercial success.

**Q. With what human emotions do you start the design process?**
A. Sometimes we feel vulnerable, as if we don't have any skin and everything could harm us. In this state every emotion becomes a necessity to think about and creation is likely to be purified.

**Q. How important are trends in your work?**
A. Absolutely not important to us at all. You can often feel yourself operating in line with a certain mood, but we believe that "those who follow others are never the first". Naturally there is an element of air du temps, but you don't have to follow it.

**Q. Do the design characteristics of your nation affect your work?**
A. We are both Italian, and it is very difficult for us to forget to be Italian. Fortunately, in the last five years, we have had opportunities to travel around the world more or less twice, making it impossible not to be affected by other cultures, but naturally we are Italian.

**Q. How far will you allow yourselves to compromise?**
A. We have noticed that if we don't make any compromises, then our success rate is 100 per cent. Nowadays, clients know that and they trust us. Sometimes problems emerge on technical issues, so we simply make the necessary alterations to solve them, but that isn't compromising. It means that you can ask a client to fly to the moon with butterfly wings.

**Q. What else do you aspire to design?**
A. This kind of work helps you keep your mind active. What we sincerely aspire to is to continue doing this job for as long as possible – designing useful objects for other people.

**Q. Describe yor design approach**
A. Ludovica: rational.
Roberto: emotional.
That's why we work together!

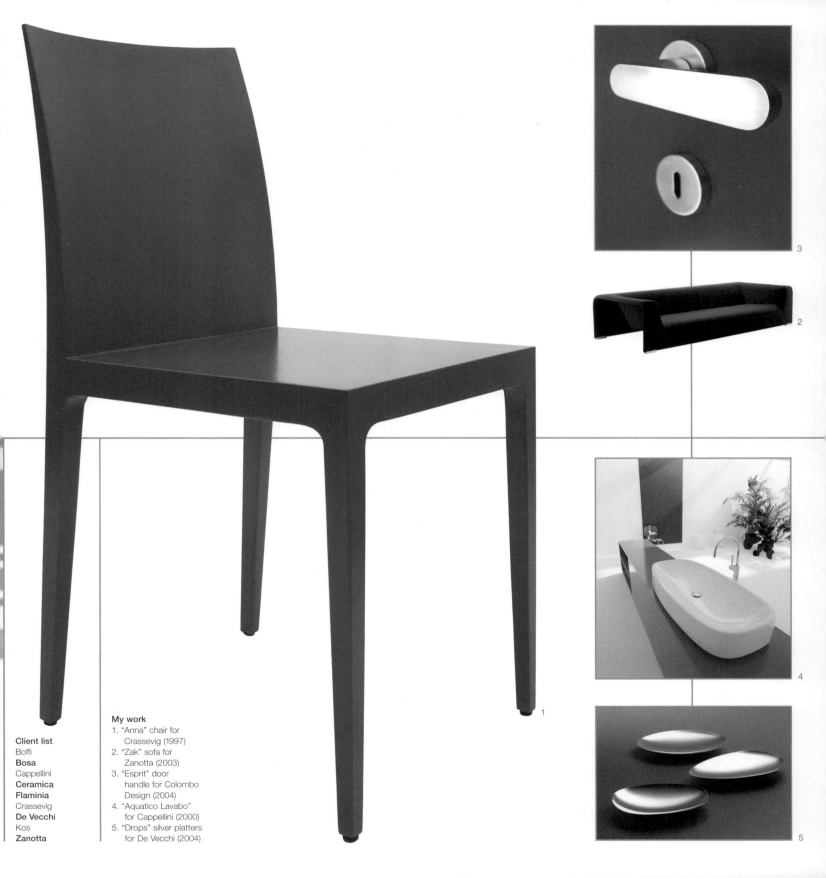

**Client list**
Boffi
**Bosa**
Cappellini
**Ceramica**
**Flaminia**
Crassevig
**De Vecchi**
Kos
**Zanotta**

**My work**
1. "Anna" chair for
   Crassevig (1997)
2. "Zak" sofa for
   Zanotta (2003)
3. "Esprit" door
   handle for Colombo
   Design (2004)
4. "Aquatico Lavabo"
   for Cappellini (2000)
5. "Drops" silver platters
   for De Vecchi (2004)

**John Pawson**
born 1949 in Halifax, UK
**Studio Location**
London, UK

John Pawson is, of course, best known as an architect, well known for such high-profile projects as Calvin Klein's flagship store in Manhattan (1995) and the Cistercian Novy Dvur Monastery in the Czech Republic (2002), as well as numerous houses and apartments for private clients, including the author Bruce Chatwin (1882). Pawson is also, however, an astute designer, who applies the same concern with simplicity and rigour evident in his architecture to a range of furniture and product designs.

The Eton-educated Pawson initially worked in the family textile mill, before spending four years teaching English in Japan. He came to architecture relatively late, studying at the Architectural Association in the 1970s and setting up his own studio in 1981. Often billed as the father of architectural Minimalism, Pawson defines the movement "as the perfection that an object achieves when it is no longer possible to improve it by subtraction." For him, the pursuit of simplicity is a way of ordering life, of refining and purifying everyday rituals. In his non-architectural designs, this has been translated into the spare geometry of his "Tray" and "Bowl" (both 2002) for the Belgian company When Objects Work, the luxurious austerity of the American cherrywood "Bed" and "Table" for Driade and the Pawson kitchen (1996) for Obumex, with its fluid, pared-down surfaces and sculptural fittings.

In 2002 a major exhibition of John Pawson's work was shown at the Instituto Valenciano de Arte Moderno (iVAM) in Valencia.

**GB**

**My inspiration**
Time spent in the studio of architect and designer Shiro Kuramata whose mentoring helped focus my move into architecture

john pawson

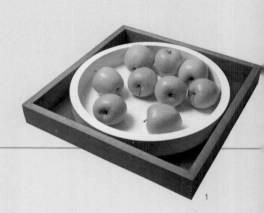

1

**Q. What types of products do you design?**

A. The range is wide – from a new Cistercian monastery to museums, gallery spaces, stores, an airport lounge and private houses. From time to time, I do also become involved in product design. Whether it's a kitchen, a bowl, a table or a door handle, the common thread is a domestic application.

**Q. What or who has significantly influenced your work?**

A. The Japanese architect and designer Shiro Kuramata had a considerable influence on my work. I spent some time on an informal basis in his studio in Tokyo. I remember being impressed by his boundless capacity for hard work and his absolute determination to get things right. It was Kuramata who, along with teaching me the value of discipline, also gave me the final impetus to pursue a career in architecture.

Hester van Royen, who was also my partner for ten years and is the mother of my elder son played an important role in bringing about the early gallery commissions, as well as helping me to be clearer about what I thought and about how that might be expressed in physical space.

**Q. What was your big break?**

A. Commercially, it was winning the competition to design the Cathay Pacific Wing inside Norman Foster's new Hong Kong airport. In terms of raising my profile, it was the commissions from Calvin Klein.

**Q. What drives your designs?**

A. On a personal level, I am driven by a passion for getting a building right and the pleasure one derives from a space where proportion, light and materials are perfect. The challenge is to keep pushing for the new whilst remaining true to the vision.

**Q. How important are trends in your work?**

A. Trends are of little significance to me. In a sense, I dread when minimalism is fashionable because there is always then the terrible hunger to predict its demise. My work will never interest everyone, but then I don't set out to design for everyone.

**Q. How important is it for your work to reflect the design characteristics of your nation?**

A. There is a sense in which I feel British, and I certainly have a strong affinity with Yorkshire where I was born and grew up, but I have also travelled extensively and have spent periods living abroad – I was in Japan for four years. I suppose I am a product of all the places I have called home and so, therefore, is my work.

**Q. Is your work an individual statement or a team solution?**

A. Architecture is never just about one person.

**Q. To what level will you compromise to satisfy your client?**

A. I don't think of it as compromise as such. Architecture is the result of a dialogue between client and architect. Usually the exchanges are sporadic, although sometimes this need for mutual understanding translates into near daily conversations – on one occasion, Calvin Klein woke me at two in the morning to discuss a fitting.

**Q. What do you still aspire to design?**

A. The perfect house.

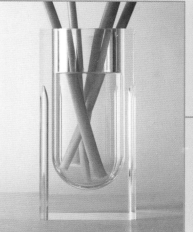

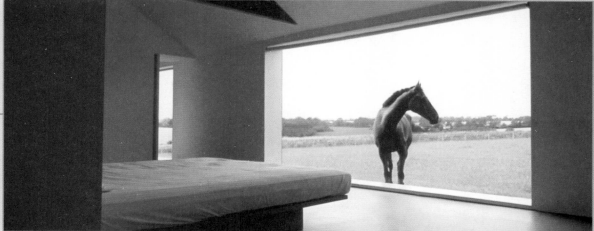

3

4

2

**My work**
1. "When Objects Work" collection (tray, bowl, vase) (2002)
2. "When Objects Work" collection (tray, bowl, vase) (2002)
3. "When Objects Work" collection (tray, bowl, vase) (2002)
4. "Tilty Barn", Essex, UK (1995)
5. "Marks & Spencer Lifestore House", Gateshead, UK (2004)

**Client list**
B&B Italia
**Bulthaup**
Calvin Klein
**Cathay Pacific**
Driade
**Jigsaw**
Novy Dvur Monastery
**Marks & Spencer**
Obumex
**When Objects Work**

5

**Tom Lloyd**
born 1966 in London, UK
**Luke Pearson**
born 1967 in Portsmouth, UK
**Studio Location**
London, UK

Having completed degrees in Furniture and Industrial Design respectively at separate UK institutions, Tom Lloyd and Luke Pearson first met during their postgraduate studies at the Royal College of Arts in London. After graduation in 1993, they initially went their separate ways to pursue professional experience – Lloyd working with Daniel Weil at Pentagram and Pearson with Ross Lovegrove (pp 156–7) at Studio X. In 1997, however, they combined their knowledge, talents and experience to form PearsonLloyd.

The studio embraces projects across the fields of furniture, lighting, transport and interior design as well as the public realm, working with clients on award-winning designs including the Upper Class Suite for Virgin Atlantic Airways, contract furniture for Walter Knoll and street-lighting for Westminster City Council, in development with Artemide. Both Pearson and Lloyd enjoy the unknown factor of an entirely new brief, thriving on the challenges of designing to a new scale and function. Their passion for materials, coupled with a desire to experiment and investigate production processes across craft- and mass-production methods, gives rise to designs that push technological innovation.

In addition to their design work, this award-winning duo lecture at the Ecole Cantonale d'Art de Lausanne (ECAL) in Switzerland and at the Royal College of Art in London.

**Our inspiration**
This "ladder" is a beautiful example of ingenuity, simplicity and appropriation. An elegant reminder not to overcomplicate the simple things in life

GB

pearsonlloyd

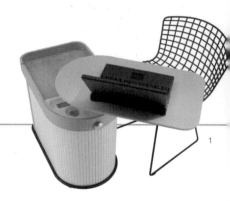

1

**Q. What types of products do you design?**
A. Product, furniture and lighting; airline seating; and design for the public realm. Anything that excites us and makes us nervous.

**Q. What or who has influenced your studio most?**
A. Discovering and witnessing the mystery and magic of how things are made, and the machines that make them. Nothing is so inspiring as the peculiar energy of a factory at work. There are piles of strange components, and nothing seems to fit. But out the other end arrives understandable functional objects.

**Q. What was your big break?**
A. Deciding to form the partnership and believing in ourselves. Finding great clients early on who believed in us. Then making great friends.

**Q. What motivates your designs?**
A. Curiosity, invention, beauty, joy.

**Q. How important are trends?**
A. There is a strange conceit within some parts of the design community that true design somehow operates independently of trends. The reality is that everyone works within in a commercial environment. We all have customers, be it a gallery, an architect, a community, or a domestic buyer. By definition, we all operate within a contemporary moment that both influences and reflects our work. PearsonLloyd believe in, and want to design for, manufacture. Designing for production involves us in both traditional craft processes and modern manufacturing intelligence. Trends are OK, and occasionally we might be clever or lucky enough to set them.

**Q. How important is it for your work to reflect the design characteristics of your nation?**
A. Not important at all. Living and working in a metropolis such as London provides its own peculiar energy and magnetism that transcends national boundaries. However, we can't really help but reflect our cultural, historical and industrial roots.

**Q. What elements of the design process do you find frustrating?**
A. Unfortunately, the design industry is now so wrapped up in its own public presentation around issues such as lifestyle and the next big thing that serious professional and cultural debate and critique about the value of design and its contribution to modern life is often profoundly lacking.

**Q. To what level will you compromise to satisfy your client?**
A. Design is rarely a solitary endeavour. We are in constant communication with other partners in the process of generating and manufacturing and selling a 'product' – from the design studio, to the client, to the engineer, to the factory floor, to the customer.

**Q. What do you still aspire to design?**
A. Luke: My own house, but not from an architectural perspective but more from the view of it as a series of elements providing a series of functions – from the purely practical to the purely emotive.
Tom: The role of design in the public realm needs to be strengthened to improve people's lives through better function and more beauty. It also has a role in managing and interpreting cultural, technological and material change. I'd like to be a part of that.

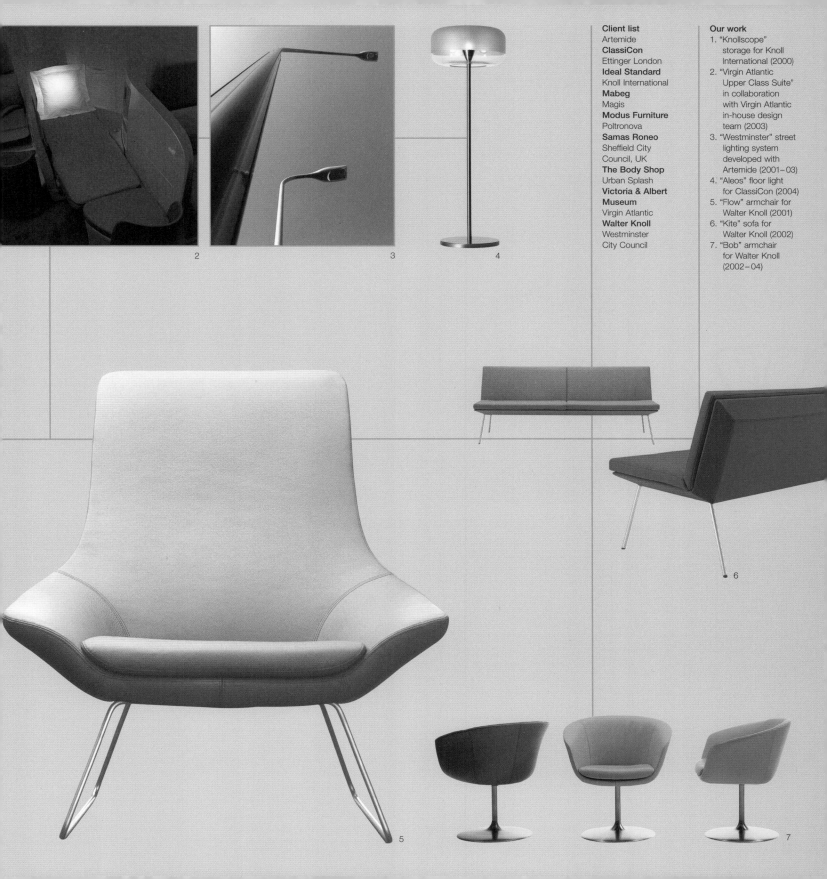

2

3

4

5

6

7

**Simon Pengelly**
born 1967 in Henley-on-Thames, UK
**Studio Location**
London, UK

Simon Pengelly has been making furniture from the age of eight, using his father's workshop in their back garden in Henley-on-Thames in Oxfordshire. He cut his first dovetail joint aged ten, and by fifteen he was producing award-winning cabinets. After pursuing his passion at Rycotewood College (in Thame, Oxfordshire), and later at Kingston University, Pengelly headed to the studios of the Conran Design Group in 1988 before moving over to Habitat, where he developed the commercial know-how he needed for the launch of his own studio in 1993.

Whilst other designers have risen to international prominence with the release of one acclaimed product, Simon Pengelly has built his profile more gradually, with the steady development of understated, timeless and cleverly engineered furniture. He has a strong loyalty to British manufacturing as is reflected in his UK-dominated client list. Pengelly possesses a fascination with materials and manufacturing capabilities and applies a detailed hands-on approach in his exploration of innovative solutions to problems that arise during the development process. While bearing his clients' markets firmly in mind, he nevertheless creates accessible production furniture with "soul".

Pengelly continues in his determination to restore the British furniture industry to a level both more competitive and aligned with those of other European countries.

**My inspiration**
The quiet confidence and total understanding in the crafting of materials demonstrated by furniture designer Hans Wegner. His *Wishbone* chair of 1950 is shown here

GB

**simon pengelly**

**Q. What products do you design?**
A. Predominantly furniture, although I do design lighting, kitchens and household products, such as bathroom ranges and cutlery for Habitat. However, furniture is my love, and it's what I'm known for.

**Q. What or who has been of significant influence in your studio?**
A. Obviously I have many influences. If I was to say "what" I would say wood as a material because of the way it has shaped my career and attitudes towards designing for manufacture and getting the best out of the materials used. If I had to choose a person I would have to say Hans J. Wegner, a Danish designer whose designs are all quiet classics, and whose pragmatic approach to the craft of design has significantly influenced mine.

**Q. What was your big break?**
A. I don't think I've ever had a big break, in that extremely hard work and small breaks have shaped my career. This is why it has taken as long as it has to establish a profile, but this the way I've consciously done things because I believe in a volume of work speaking for itself rather than a couple of products or the things I say creating a presence.

**Q. What human emotions and necessities drive your designs?**
A. Comfort, both physical and mental. Accessibility, honesty, calmness, quietness, beauty, familiarity, pragmatism, usefulness and perceived value (value for money and affordability). A product should be intrinsically appealing without shouting its intent. It should assure the user of its quality and longevity.

**Q. How important are trends in your work?**
A. Trends are important to be aware of and to understand. They establish parameters and indicators that help me understand what is important to include into the "feel" of a design. Paradoxically, I endeavour to create objects that will always be relevant and timeless but never trendy.

**Q. How important is it for your work to reflect a British design aesthetic?**
A. I think that depends on the client and how much of their aesthetic depends upon Britishness. My work tends towards a European sensibility. An overly British aesthetic can manifest itself as rather traditional and inward looking.

**Q. Is your work an individual statement or a team solution?**

A. My work is a statement about the needs and aspirations of my clients, based on my need to express my own statements about materials, processes, market forces and everything else that influences me. However, I'm not in the business of creating a dominating signature. I want people to commission me because of my work's quietness – which speaks as much about their confidence in creating quiet pieces as it does of mine.

**Q. What elements of the design process do you find particularly frustrating?**
A. The comparative lack of understanding and commitment from British industry with regard to investment in design and the value that it can add to a product and the perception of a company.

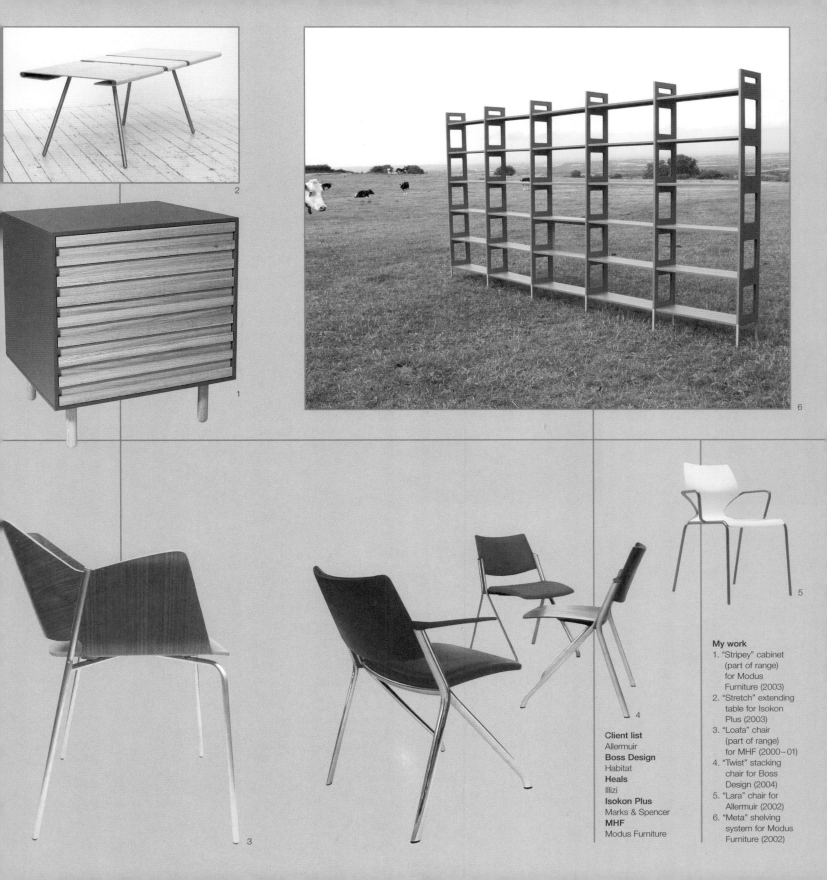

**Client list**
Allermuir
**Boss Design**
Habitat
**Heals**
Illizi
**Isokon Plus**
Marks & Spencer
**MHF**
Modus Furniture

**My work**
1. "Stripey" cabinet
   (part of range)
   for Modus
   Furniture (2003)
2. "Stretch" extending
   table for Isokon
   Plus (2003)
3. "Loafa" chair
   (part of range)
   for MHF (2000–01)
4. "Twist" stacking
   chair for Boss
   Design (2004)
5. "Lara" chair for
   Allermuir (2002)
6. "Meta" shelving
   system for Modus
   Furniture (2002)

**Jorge Pensi**
born 1949 in Buenos Aires, Argentina
**Studio Location**
Barcelona, Spain

Born and raised in the Argentinean capital, Jorge Pensi graduated in Architecture from the Universidad de Buenos Aires in 1973. In 1975, he moved to Spain, and in 1977 he established a collaborative partnership with Alberto Liévore, Noberto Chaves and Oriol Piebernat called Group Berenguer in Barcelona, where he has lived and worked ever since. In 1984, he founded his own product design studio, working with predominantly Spanish companies on furniture, lighting, exhibition designs and art direction.

Two years later, Pensi designed the cast-aluminium "Toledo" chair for Amat-3, a product originally destined for outdoor use in Spanish street cafés. Its popularity soon made it an international sales success and it became a classic symbol of Spanish design. Pensi's reputation rocketed – he has since lectured widely at conferences and seminars and has won numerous awards, including the National Design Prize bestowed by the Spanish Ministerio de Industria y Energía in 1997.

Pensi is a keen collaborator, working with his wife, Carme Casares, on graphic design projects and with Eduardo Campoamor on architecture and interior design projects. He pays considerable attention to comfort and ergonomics, and often uses lightweight materials such as aluminium with consistently elegant results.

**My inspiration**
A number of individuals working across various creative disciplines, such as musician Joni Mitchell

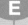 

**jorge pensi**

1

**Q. What types of products do you design?**
A. All kinds of furniture for contract or domestic use, lighting, emotional objects, musical compositions and songs.

**Q. What or who has been of significant influence in your studio?**
A. Different artists who have worked in various fields: Eames, da Vinci or the musician Joni Mitchell.

**Q. What was your big break?**
A. 1. Deciding to cross the Atlantic in 1975.
2. The "Toledo" chair, which I designed in 1986.
3. The decision to be a singer.

**Q. What human emotions and necessities drive your designs?**
A. The desire to be timeless – to be always fresh, vibrant and young.

**Q. How important are trends in your work?**
A. I watch trends carefully, but only in order to avoid following them.

**Q. How important is it for your work to reflect the design characteristics of your nation?**
A. Which is my nation? I was born and trained in Buenos Aires, I live in Barcelona and I work for companies in Spain, Germany, Italy and the USA.

**Q. Is your work an individual statement or a team solution?**
A. A mixture of both: I begin, we continue and reflect; I decide, we decide.

**Q. What elements of the design process do you find particularly frustrating?**
A. All the parts that have more to do with technology and less to do with art and the emotions.

**Q. To what degree will you compromise to satisfy your client?**
A. My client will be satisfied only if I am satisfied and enthusiastic.

**Q. What would be your second career choice after design?**
A. Composer, singer and sound engineer.

**Q. What do you still aspire to design?**
A. A new, modern and exciting home for my family, design studio included.

**Q. How would you briefly describe your design approach?**
A. The best is yet to come. Just wait and see…!

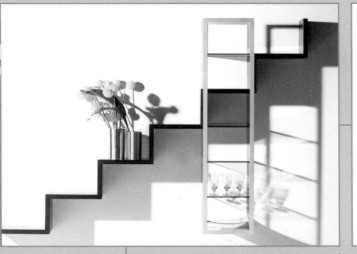

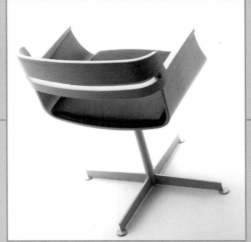

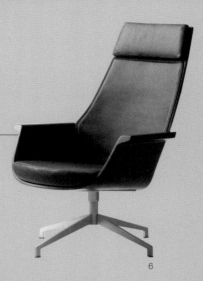

4

5

6

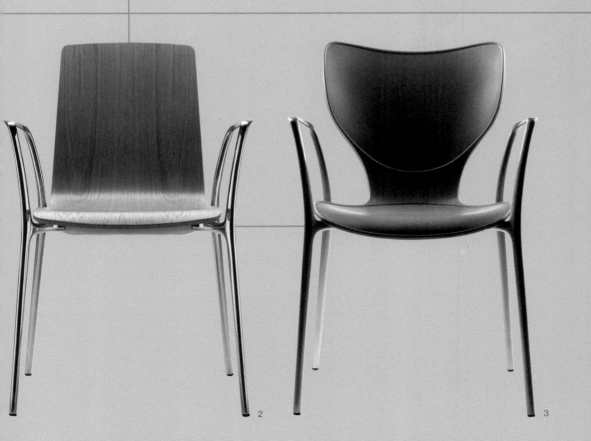

2

3

**Client list**
Akaba
**Amat-3**
Andreu World
**Azcue**
B.Lux
**Casprini**
Cassina
**Ciatti**
Disform
**Driade**
Frighetto
**IBM**
Knoll International
**Kron**
Kusch + Co
**Leucos**
Mobles 114
**ON Design**
Perobell
**Punt Mobles**
Santa & Cole
**Thonet**

**My work**
1. "Peppermint"
   armchair for
   Kron (2000)
2. "Gorka" chair series
   for Akaba (1993)
3. "Gorka" chair series
   for Akaba (1993)
4. "Maila" shelving
   for Sare (2001)
5. "Kayak" chair
   for Sare (2002)
6. "BKAI" armchair
   for Sare (2004)

**Philips Design**
founded in 1891
**Studio Location**
Global headquarters
Eindhoven, The Netherlands

The origins of Philips go back to 1891, when Gerard Philips set up the company as a manufacturer of carbon-filament lamps. Today it is one of the world's largest electronics companies, boasting a vast portfolio of mass-produced and globally distributed products, including lighting, medical systems and personal and domestic appliances. Philips retains its market lead in these competitive fields by researching and developing new technologies and design.

CEO and Chief Creative Director of Philips' design wing since 1991 is Stefano Marzano (born 1950 in Milan), who manages one of the largest global design studios – with around 450 employees spread across 12 offices around the world. Working as a tightly networked team, Philips Design aims to add value to products through a future-oriented design approach that fuses research into people, societies, cultures and markets with a passion and expertise for high technology and innovation. The Philips Design team implements designs that humanise and strengthen the relationship between product and user.

In early 1998, Philips Design became an independent unit, able to provide design services to clients outside the Philips Group. This has led to innovative projects with companies such as Cappellini, Alessi and Felicerossi.

**NL**

**philips design**

**Q. What types of products do you design?**
A. All of Philips' products – consumer electronics, medical systems, lighting and domestic appliances.

**Q. What or who has most influenced Philips' work?**
A. All Philips Design's work is influenced by Stefano Marzano's vision: which is to use design as a transformative agent for the development of sustainable technological solutions for people. Stefano Marzano's original thinking was strongly influenced by Italian design masters such as Alessandro Mendini and Andrea Branzi and by theorists of design such as Ezio Manzini from the Domus Academy in Milan.

**Q. What was your big break?**
A. In terms of product design, the breakthrough came somewhat earlier, in 1994, with the launch of the Philips–Alessi line of domestic appliances. Through that project, Marzano's design vision […] was for the first time applied to the development of a commercial product – and a highly successful one at that. Product management thus understood the value of design as the creator of a new type of value for consumers.

**Q. How important are trends in your work?**
A. We use aesthetic trends analysis in our short-term design work (0–2 years from now) in order to help designers define colours, textures, materials and finishes for products that are at advanced development stage. We use social and cultural trends research in our long-term design work (3–5 years from now). This type of research, which we carry out through a team of psychologists, anthropologists and sociologists, helps us understand people's cultural values, their attitudes towards technology and their expectations for the long term.

**Q. What do you find frustrating about the design process?**
A. It is sometimes difficult to make people understand, especially in a large company, that design is more than just aesthetics or an effective marketing tool (or, worst of all, a fashion); that it is the thinking at the basis of the process of creation.

**Q. How far are you willing to compromise with other departments within Philips?**
A. We will not compromise when the ease of use, the relevance or the attractiveness of our solution is truly put at risk. But then, again, Philips Design is, within Philips, the expert on these issues, and we have the final say in what can be accepted as a design that can be Philips branded.

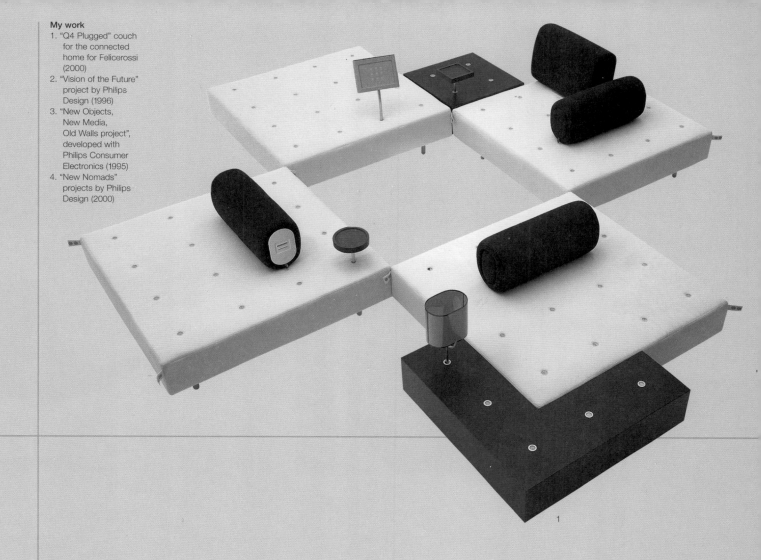

1

2

3

4

**Christophe Pillet**
born 1959 in Montrajes, France
**Studio Location**
Paris, France

Christophe Pillet graduated from the Ecole des Arts Décoratifs in Nice in 1985 and attained a Masters degree from the prestigious Domus Academy in Milan a year later.

After working for two years in collaboration with ex-Memphis designer Martine Bedin, he joined the offices of design supremo Philippe Starck (pp 224–225) in 1988, a valuable professional experience that inspired him to start up his own design studio in 1993.

Pillet's products as an independent designer attracted the attention of the industry very early on and earned him the Designer of the Year Award in 1994 at the Salon du Meuble trade fair in Paris. His work extends across the disciplines of 3-D design, incorporating everything from glass, lighting and furniture to interior design and architecture. While his material language varies greatly, his work is always characterised by a graphic clarity of form pronounced by precision manufacturing. The rigidity and slick aesthetic of much of his furniture contrasts with its surprising comfort and tactility, elevating his work into the realm of the sexy and seductive.

With his reputation firmly established in France, Pillet's list of international clients continues to grow, earning new project commissions of varying scales and budgets from clients across the world.

## christophe pillet

F

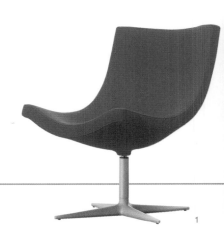

1

**Q. What types of products do you design?**
A. Any kind, from tableware to interiors, microwave ovens to furniture, urban furniture to lady's handbags… That might sound frivolous, but that's the way it is. Design is no longer the work of "specialists" – people expect a global point of view from you and a vision of an entire lifestyle.

**Q. What or who has influenced your work as a whole?**
A. I suppose comics, sci-fi movies and music are – or have been – my significant influence. Not one in particular, but the spirit in a big mix of all of them. I like unreal universes, built only by the imagination.

**Q. What drives your designs?**
A. I believe design is not a matter of products, but a matter of people… a matter of behaviour. Design's purpose is to build alternative environments for people to live better lives and not to add more and more insignificant products to the market.

**Q. How important are trends in your work?**
A. I don't know what trends are. I just look around me and see what could be better, what is useless, and what is missing.

**Q. How important is it for your work to reflect the design characteristics of your nation?**
A. Singularity or exotism has become an essential value in what we are doing. Uniformity leads to anonymity and boredom. Although I don't care about the expression of something national or local in my work, I feel it is important to use and share specific languages or specific points of view, which could, of course, come from my specific education or specific environment.

**Q. Is your work an individual statement or a team solution?**
A. I believe that historically the important products or projects have been the result (as in love affairs) of an important encounter between you and someone who is expecting something from you. In that sense, I think my work (even if I rarely achieve important results) is a personal statement dedicated to people who I feel are essential to me. There is not much of a team solution or a marketing matter in this.

**Q. Are there any elements of the design process you find frustrating or annoying?**
A. Imagine a world where you spend most of your time doing nice little sketches on a piece of paper, and a few weeks later you see a prototype, and a few months after that your work is available to people… Is there anything frustrating about that?

**Q. To what degree are you prepared to compromise in a design?**
A. The only compromise I will make is to adapt my language so that it can be better understood.

**Q. What would be your second career choice after design?**
A. My second choice of career would be, perhaps, a millionaire cruising between the islands of Indonesia.

**Q. How would you sum up your design approach?**
A. Simple, sensual, elegant and tasty.

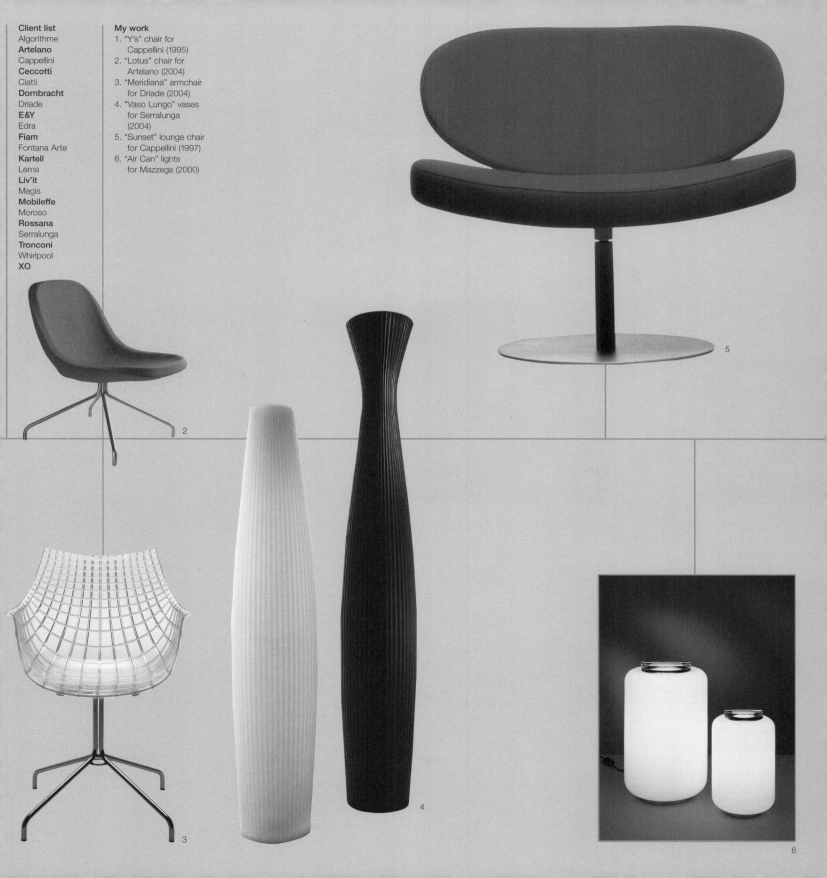

**Client list**
Algorithme
**Artelano**
Cappellini
**Ceccotti**
Ciatti
**Dornbracht**
Driade
**E&Y**
Edra
**Fiam**
Fontana Arte
**Kartell**
Lema
**Liv'it**
Magis
**Mobileffe**
Moroso
**Rossana**
Serralunga
**Tronconi**
Whirlpool
**XO**

**My work**
1. "Y's" chair for
   Cappellini (1995)
2. "Lotus" chair for
   Artelano (2004)
3. "Meridiana" armchair
   for Driade (2004)
4. "Vaso Lungo" vases
   for Serralunga
   (2004)
5. "Sunset" lounge chair
   for Cappellini (1997)
6. "Air Can" lights
   for Mazzega (2000)

**Porsche Design GmbH**
founded 1972 in Stuttgart, Germany
**Studio Location**
Zell am See, Austria

Ferdinand Alexander Porsche (born 1935) was responsible for the design and launch of the first "Porsche 911" in 1963, a classic vehicle that, having undergone several evolutionary advancements, continues to enjoy impressive international sales.

Porsche headed the design studio of the luxury sports-car brand in Stuttgart until 1972, when he decided to set up his own product design

consultancy in Germany with four staff, moving to its current base in Austria a few years later. In 1979, he set up another company in Salzburg, Austria, to manage the licensing of the Porsche Design brand.

More than 30 years later, the company can boast an impressive client list and an even more impressive project portfolio, spanning products, furniture, lighting, accessories, architecture, transportation, exhibition, shop interiors, graphics and packaging design. Working on numerous mass-market consumer goods for clients with heavy global competition, Porsche Design

carries out rigorous research into the functional dynamics of the item as well as paying meticulous attention to the styling and materials. Often designing within the fast-changing, rapid-turnaround, technology-driven markets where product models are superseded within months of release, Porsche Design manages nevertheless to counteract this disposable culture by enriching the product integrity through elegant, timeless design. It is no surprise, therefore, that clients of this award-winning consultancy choose to include the F.A. Porsche brand name directly on their best-selling products.

**My inspiration**
Along with various individuals from the Hochschule für Gestaltung design school inUlm, Germany, there is also the pioneering work of Italian designer Mario Bellini

porsche design

**Q. What types of products do you design?**

A. The scope of industrial products we design is fairly limitless: from trains and trams to watches and pens; from incubators and gynaecological chairs to hearing-aids and insulin pens; from consumer and IT products to electrical kitchen appliances; from escalators to grand pianos… So far fashion and other related items haven't featured, but that looks set to change.

**Q. What or who has been of significant influence on your work?**

A. There is no particular "what" and "who" – only a multitude of different influences relating to design, contemporary society and many cultures around the world. If we had to specify, we would have to cite the Hochschule für Gestaltung in Ulm,

Germany, where Ferdinand Porsche as well as Dirk Schmauser (Second Managing Director) learned to follow the "form follows function" maxim. Among designers, we would cite Max Bill, Hans Gugelot and Walter Zeischegg, all of whom worked at the Hochschule, as well as Mario Bellini in Italy. Because teamwork is one of the primary strategic principles of Porsche Design, the experiences of every member of our international staff have a strong influence on our work.

**Q. What was your big break?**

A. Each period of our 32-year history has had its big break. In the 1970s, it was the famous black chronograph and the sunglasses with exchangeable lenses, which have remained synonymous with the Porsche Design brand until today. In the 1990s, the

"Premium Line" kitchen appliances for Siemens started the biggest break of our history, something that's still going strong today.

**Q. What human emotions and necessities drive your designs?**

A. As mentioned above, the teamwork strategy of our studio involves emotional influences from all sorts of personalities and lifestyles. Much the same can be said about the human necessities.

**Q. How important are trends in your work?**

A. No designer is immune to trends, but we have always been careful to make a responsible evaluation of their worth – for people/users, for society and for the environment.

**Q. What elements of the design process do you find particularly frustrating?**

A. Stupidity, intolerance and the lack of willingness to think and understand… However, if these things were peculiar to design, we wouldn't be designers.

**Q. To what degree will you compromise to satisfy your client?**

A. For every design, the degree of compromise may be different depending on how your business is going, how important you estimate the project to be for your business and where you draw the line.

**Q. Could you sum up your studio's attitude to design.**

A. "Culture is evolution; revolution destroys it." Porsche Design is searching for new directions without burning bridges. Visions can only be a supplement to, not a substitute for, perspective… in the end, someone has to do the work!

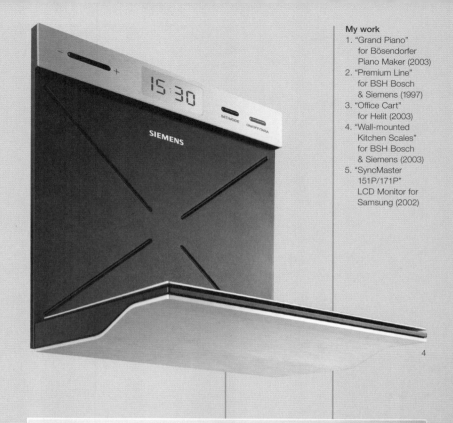

4

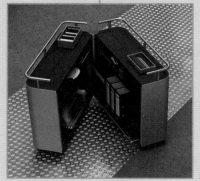

1

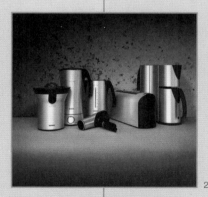

2

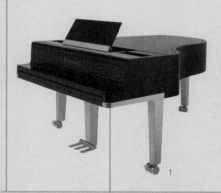

3

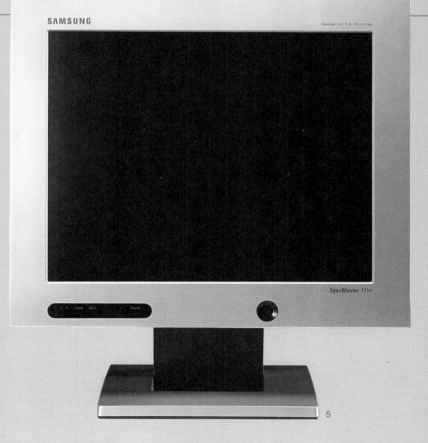

5

**Ingegerd Råman**
born 1943 in Stockholm, Sweden
**Studio Location**
Stockholm, Sweden

Råman's position as one of Sweden's best-qualified glass and ceramic designers has been earned through her steady and consistent commitment to her craft since graduation from Stockholm's Konstfack (University of Arts, Crafts and Design) in 1968.

Starting off as a designer at Johansfors glassworks, Råman set up her own ceramics studio on the outskirts of Stockholm in 1972. She spent much of the following decade merging formal beauty with functional precision in her work as a potter. This dedicated approach translated neatly across into her in-house collections at the glassworks of Skruf in south-east Sweden, where she worked from 1981 to 1998. Large glass objects that eschewed bold decorative statements dominated Råman's work in the 1980s, whilst her functional restraint was evident in small pieces of consummate visual clarity, harmony and purity.

Råman's love of clear glass continually evolves in new directions as could be seen when she began work for the world-renowned Swedish glassworks Orrefors in 1999. Her inquisitive nature and close working relationship with the technical masters of glass production has given rise to expressive new objects that have been polished, sanded, carved and painted with sharp lines, swirling movements and circular smudging.

**My inspiration**
The mysterious, intriguing and imaginative freedom of artists such as Barnett Newman, his "Canto III" (1963–64) painting shown here

s

**ingegerd råman**

1

**Q. What types of products do you design?**

A. Functional objects in ceramic and glass – I aim to design everything on the table.

**Q. What or who has been of significant influence on your work?**

A. I have often been inspired by art, literature and pictures in books. Contact with art and artists has given me my own security to master the craft. Some of my favourites are Barnet Newman, Donald Judd and Piet Mondrian. The seasons and the snow and ice formations of my country in winter also influence me.

**Q. What was your big break?**

A. I don't really think that I have had one big breakthrough. My progression has been gradual and, as it has progressed, people have slowly recognised my work.

**Q. What human emotions and necessities drive your designs?**

A. I don't speculate about other people's needs. I prefer, instead, to trust my own needs when I create my designs. I find I am able to work only on pieces that I could live with myself. I hate accumulating unnecessary "stuff".

**Q. How important are trends in your work?**

A. Not at all. I am more interested in defining my own genre with little or no reference to a particular era. The rapid turnaround and short-lived lifespan of trends has no appeal.

**Q. How important is it for your work to reflect a Swedish aesthetic?**

A. I was born in Sweden, trained in Sweden and have worked here mainly for Swedish companies, so this must effect my work. That said, I also involve mixed references from art, culture, books and music.

**Q. Is your work an individual statement or a team solution?**

A. The entire decision-making process is in my control. However, I rely on the expertise of the glassmakers, and often their capabilities will trigger a new idea that will steer the piece in a new direction.

**Q. What elements of the design process do you find particularly frustrating?**

A. I find it particularly difficult to sit down and finalise the proportions and details ready for production.

**Q. To what degree will you compromise to satisfy a client?**

A. I always want my client to be satisfied, but it's important for them to see the reasons why I have made my decisions. Talking to others is a way of learning how people see things, and I will make changes only if I can identify valid reasons.

**Q. What would be your second career choice after design?**

A. I'd choose to be a designer but would like to start again with the knowledge that I possess now.

**Q. How would you sum up your design approach?**

A. Simple. I don't need people to know that I designed it. I care about what I do, and know that every day I work I have a chance to improve.

**My work**

1. "Water Carafe" for Johansfors/Skruf (1968–81)
2. "A Drop Of Water" for Orrefors (2001)
3. "Basket" bowls for Orrefors (2004)
4. "Slowfox" shot glasses for Orrefors (2004)
5. Ceramic "Bowls", self-production (1991)
6. "Oil bottle" with frosted ball as stopper for Skrufs (1997)

3

2

4

5

6

**Client list**
Figgjo
**Gustavsberg**
Icopal
**Johansfors**
Orrefors
**Skruf**
Svensk Slöjd

**Karim Rashid**
born 1960 in Cairo, Egypt
**Studio Location**
New York, USA

Half Egyptian, half English, raised in Canada, and now living and practising in New York with a long list of clients around the world, Karim Rashid has certainly benefited from, and capitalised on, cultural diversity.

Rashid believes that new products should be powerful and poetic enough to enhance our daily lives, offering consumers fresh experiences and joys to replace the useless over-consumption of a globally saturated market. This attitude allows him to transcend disciplines, producing everything from products to interiors, fashion to music, art to installations.

After graduating in Industrial Design at Carleton University, Ottawa, in 1982 and postgraduate studies in Italy, Rashid worked for Rodolfo Bonetto in Milan. In 1984, he moved back to Canada to work at KAN Industrial Design, whilst also co-designing the Babel Fashion Collection. Feeling trapped, he moved to New York and founded his own design practice in 1993. At a time when minimalism was standardising the visual language of design, Rashid counteracted what he perceived as elitism with a new aesthetics and accessibility.

Using his knowledge of materials and manufacturing processes, he has invented new forms but remains acutely aware of unit costs and consumer perception. Having designed more than 2000 products during his career, his work is widely recognisable. Many are part of permanent museum collections or have earned design awards.

**My inspiration**
The cross-fertilisation of creative disciplines and democratisation of art into popular culture as practiced by artist Andy Warhol

USA

**karim rashid**

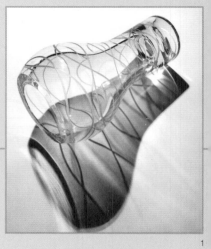

**Q. What types of products do you design?**

A. I design everything with interface – anything with which we engage – from televisions to lamps to jewellery, to housewares. I've even expanded into interiors, architecture, fashion, painting and music. I design objects for $1 like a disposable lighter or a $4 wastebasket, as well as one-off pieces that exist only in art galleries.

**Q. What or who has been of significant influence in your studio?**

A. There are two people that I would reference immediately – the French philosopher Jean Baudrillard and Andy Warhol. Baudrillard inspired me years ago, and I have used his essays in my pedagogy for the last fifteen years. Warhol democratised art; he created a cross-disciplinary factory of popular relevant projects that were a reflection of his time. Anytime he had a dream he would make it happen.

**Q. What was your big break?**

A. I always feel like I am waiting for my big break. Any well-known person looks like they have made it, but in actual fact the artist spends their life tormented by the feeling they have yet to really accomplish something.

**Q. What human emotions and necessities drive your designs?**

A. Passion, obsession; the need to create everything; the need for challenge; the desire to touch new areas; the love of the sensorial and experiential world; the hunger for innovation and the overwhelming desire to live, participate and contribute to contemporaneity.

**Q. How important are trends in your work?**

A. Trend is the red herring of the creative act. The challenge is to continue with your own agenda, and at the same time appease the market, clients, production issues and economic constraints. Designers and companies need more credit for actually getting something on the market that is even just 90 per cent beautiful!

**Q. How important is it for your work to reflect the design characteristics of your nation?**

A. As an American designer the cultural significance is casualisation. The world is shrinking, and global is the only way to perceive culture and to think freely… Local thinking is the nemesis of free spirit and creative thought in our new globalisation.

**Q. Is your work an individual statement or a team solution?**

A. Individual for a collective audience.

**Q. To what level will you compromise to satisfy your client?**

A. It is a myth that designers have an idea and a company produces it; the real work is a collaborative merging of minds, vision and ideology.

**Q. What do you still aspire to design?**

A. Still? There is so much to do. Our entire physical world is designed, and 95 per cent of it is atrocious. I try to design everything in our built environment that informs a sense of wellbeing, energy and innovation.

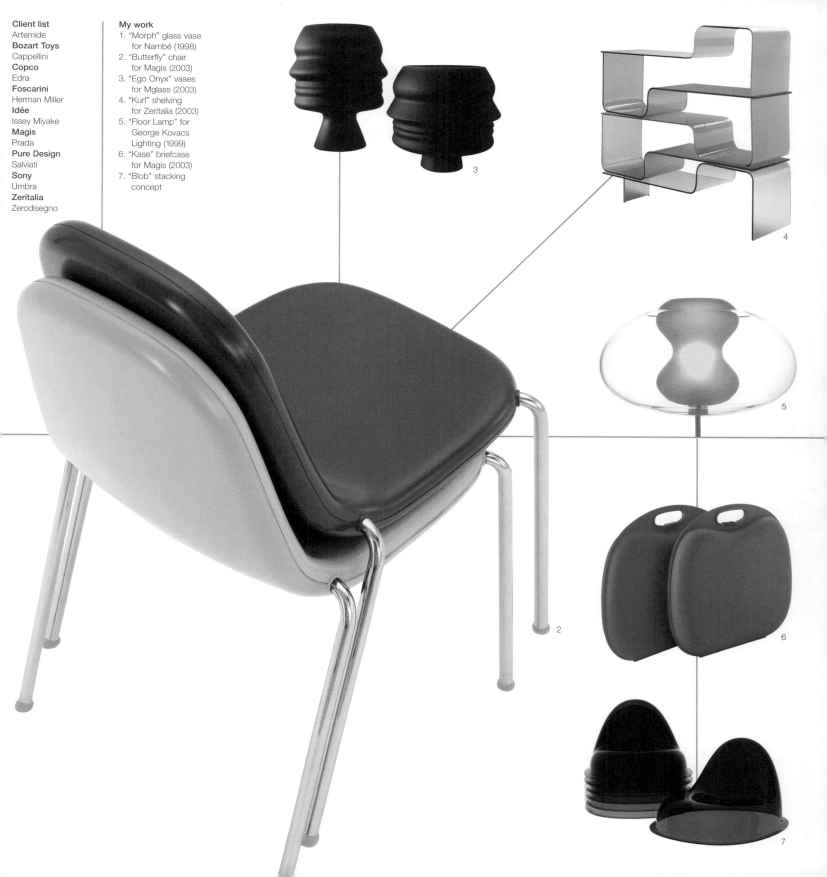

**My work**
1. "Morph" glass vase for Nambé (1998)
2. "Butterfly" chair for Magis (2003)
3. "Ego Onyx" vases for Mglass (2003)
4. "Kurl" shelving for Zeritalia (2003)
5. "Floor Lamp" for George Kovacs Lighting (1999)
6. "Kase" briefcase for Magis (2003)
7. "Blob" stacking concept

3

4

5

2

6

7

**Thomas Sandell**
born 1959 in Pietarsaari (Jakobstad),
Finland
**Studio Location**
Stockholm, Sweden

Finnish-born Thomas Sandell grew up
in Sweden and trained as an architect
at Stockholm's Kungliga Tekniska
Högskolan (Royal Institute of Technology)
from 1981 to 1985. On graduation, he
was employed briefly in the architectural
office of Jan Henriksson before
embracing his own commissions –

collaborating with fellow architect
Jonas Bohlin on the interior design of
the Rolfs Kök and Tranan restaurants
in Stockholm, as well as independently
tackling office interiors, shops,
private houses and furniture designs.

In 1995, Sandell joined forces with
the advertising expertise of Ulf Sandberg
and founded sandellsandberg, a
consultancy set up to unite architecture,
design and advertising. The company is
able to implement a holistic approach to
the building of creative concept solutions,
working to develop a brand-aware

tailor-made communications strategy
for their clients across the disciplines
of 2- and 3-D design. Sandell has built
a reputation as one of Sweden's leading
architects, translating his visual language
of graphic clarity and truth to materials
into his furniture and product design work
for brands such as B&B Italia, Swedese
and Asplund. He was part responsible
for the introduction of the more design-
led "PS" collection for IKEA in 1995.

In 1999, Sandell became President
of the National Association of Swedish
Architects (SAR).

**My inspiration**
Summer trips to Finland
when I first encountered
Alvar Aalto's masterful
works, such as the
"Finlandia Concert Hall"
(1962/1967–75) in Helsinki

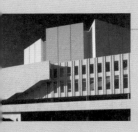

**s**

**thomas sandell**

Q. **What types of products
do you design?**
A. Furniture, objects and some
industrial design.

Q. **What or who has been
a significant influence on
your work?**
A. My childhood and upbringing in a
typical small town in the north of
Sweden. Nature was always close,
and I did a lot of winter sports
such as cross-country skiing.
Summers spent in Finland also had
an impact on me and gave me
a chance to experience some of
Alvar Aalto's projects.

Q. **What was your big break?**
A. As a designer, it was the "Proggetto

Oggetto" exhibition in 1991 with
Cappellini in Milan.

Q. **What human emotions
and necessities drive
your designs?**
A. Humour, happiness and the joy
of producing things. I love to
see my first sketches turned into
a prototype and, later on, into
a production piece.

Q. **How important are trends
in your work?**
A. Probably more important
then I think. Of course,
it depends on the way you
define a trend, but I'm very
aware of, and interested in,
contemporary life.

Q. **How important is it for your
work to reflect a national
design aesthetic?**
A. Not at all. But I think I do it anyway
because I'm a Swede and have
my references in the Swedish
(as well as Finnish) culture.

Q. **Is your work an individual
statement or a team solution?**
A. The first ideas are individual, but
to realise them I really need a team
of assistants and producers and
marketing people.

Q. **What elements of the design
process do you find
particularly frustrating?**
A. The time between the first prototype
and the next one.

Q. **To what extent will you
compromise to satisfy
your client?**
A. A lot... they have to make a living
out of my design, after all... but
they should also be proud of it, too.

Q. **What would be your second
career choice after design?**
A. A diplomat in the foreign office...
or an artist.

Q. **What do you still aspire
to design?**
A. I have a lot of projects that are
yet to be done, such as a nice
stackable chair.

Q. **How would you describe your
design approach in one sentence?**
A. Joy with responsibility.

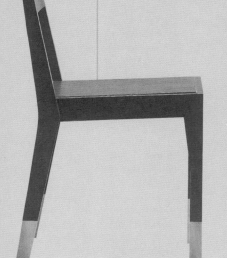

2

1

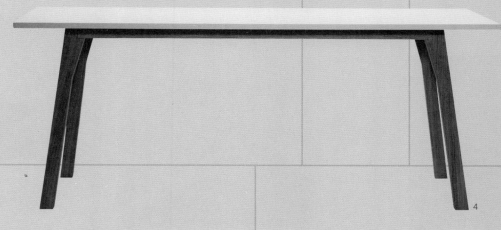

4

3

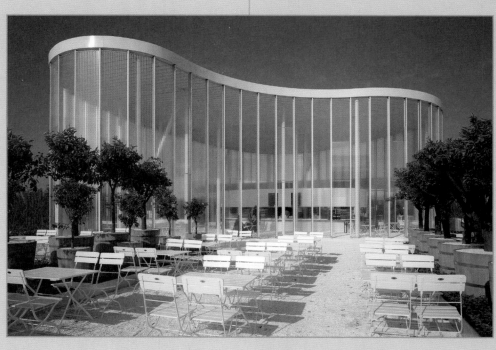

5

**Aziz Sariyer**
born 1950 in Istanbul, Turkey
**Studio Location**
Istanbul, Turkey

Aziz Sariyer has been fascinated with making things ever since he was a child. He was especially passionate about carpentry and spent his summer holidays working for furniture manufacturers. In 1971, while still at college, he founded his own one-man furniture company, Derin, displaying his work in his own showroom.

A decade later, Sariyer set up a workshop to produce his designs – designs that, in the context of 1970s Turkey, were daringly progressive. With his small team of assistants, he designed and produced bespoke furniture for specific projects. In 1987, he started representing various international design brands for the first time in Turkey, incorporating their products into his many interior projects. His son, Derin Sariyer, joined the business as a partner in 1999, having previously worked on product design

development for Cappellini in Italy. Aziz has handed over the management of the company to Derin and now provides the company with technical and artistic assistance, whilst creating new products for other reputable European manufacturers.

Sariyer's work possesses a visual clarity that is communicated by the designer's confident application of uncomplicated geometric and sculptural forms. The result is high-quality furniture that is suitable for both domestic and contract interiors.

## aziz sariyer — TR

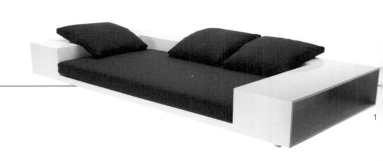

1

**Q. What or who has been a significant influence on your work?**
A. "Creativity is more important than knowledge." Albert Einstein's saying totally coincides with my inner understanding. We create everything we can imagine.

**Q. What was your big break?**
A. The seating element I designed for Cappellini has been my motivational strength.

**Q. What human emotions and necessities drive your designs?**
A. We humans are unaware of why we exist or where we come from, so we desperately try to understand where we are heading and why. We need love and comfort for our weakness and subsequent sadness. Like a child who loses his mother's hand and gets lost in the playground

of the world. Every exciting thing in this playground becomes a passion. Even though we feel sorrow from time to time, it feels good to play and to amuse ourselves. Yes, this is what I do, and I want to share this with everybody.

**Q. How important are trends in your work?**
A. I approach trends created by the fluctuations of modern living and social awareness in a common-sense way. People who create trends, but who nonetheless manage to find a spirit of timelessness, are among the rare geniuses in their fields.

**Q. How important is it for your work to reflect a national design aesthetic?**

A. Our interests stretch to infinity, but we usually choose those that are closest to us. This is entirely natural. We capture more easily that which is close to us. Ethnic characteristics can only be valuable if they can be translated into a universal language and be appropriated for everyone. I know that I have been able to free myself from them.

**Q. Is your work an individual statement or a team solution?**
A. My work is individual, though it feeds from […] the spirit of the time.

**Q. What elements of the design process do you find particularly frustrating?**
A. None is frustrating for me. I enjoy every step very much. The formation of the idea is like an orgasm; the solution is like giving birth; the

concrete object is like life itself. The design reaches its greatest meaning when it is resolved. It finds its essence.

**Q. To what degree are you willing to compromise with your client?**
A. The designer should be able to adjust to every expectation within his/her own truths, just like every step in life.

**Q. What would be your second career choice after design?**
A. I guess that everything in this life is design. Even doing nothing is design.

**Q. What do you still aspire to design?**
A. I would like to design a space for a location outside our planet. It might be a space station or on another planet. It could be just a single object for such a space…

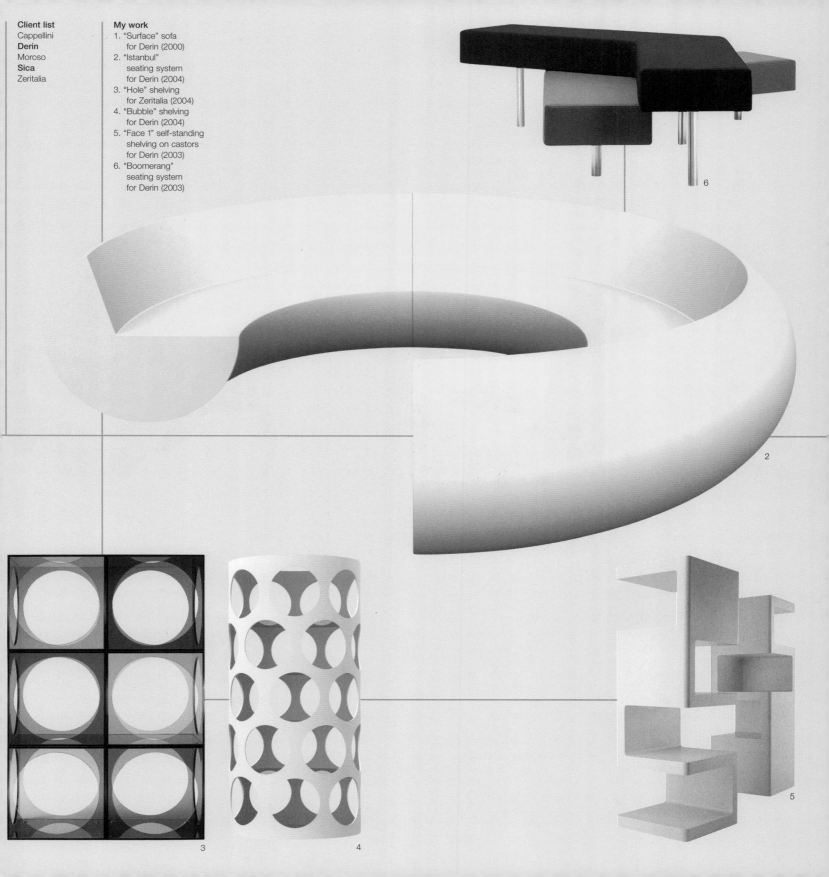

**Client list**
Cappellini
**Derin**
Moroso
**Sica**
Zeritalia

**My work**
1. "Surface" sofa
   for Derin (2000)
2. "Istanbul"
   seating system
   for Derin (2004)
3. "Hole" shelving
   for Zeritalia (2004)
4. "Bubble" shelving
   for Derin (2004)
5. "Face 1" self-standing
   shelving on castors
   for Derin (2003)
6. "Boomerang"
   seating system
   for Derin (2003)

**William Sawaya**
born 1948 in Beirut, Lebanon
**Studio Location**
Milan, Italy

William Sawaya undertook his education in architecture at the National Academy of Fine Arts in Beirut, graduating in 1973. His first professional experiences were focused in Lebanon, where he worked on internal spaces for various residences, later extending his practice to France, Italy, Japan, Greece, Russia, the USA and the Gulf states. During this period, he also studied furniture design in Paris and Milan.

In 1978, he moved to Italy and established Sawaya & Moroni Design with fellow designer Paolo Moroni. Six years later, the duo went on to form Sawaya & Moroni Contemporary Furniture, which produced not only their own designs but also those of other talents such as Michael Graves, Zaha Hadid, Jean Nouvel, Michael Young (pp 250–251) and Christian Ghion (pp 110–11). Sawaya's brief to such designers is simple – to explore their own style, free from restraints. The results often push the boundaries of manufacturing possibilities, giving rise to an eclectic collection of interior products.

Sawaya's own work has a similar expressive freedom and is constantly evolving, making it difficult to identify a signature style. Varying from a craft-based approach that produces a quieter, more classic look through to the highly sculptural and technologically advanced – as seen in the "Maxima" chair (2002) – it is understandable why his work reaches such a broad customer base around the world as well as acceptance into numerous museum collections. Sawaya also undertakes commissions for other companies and individuals, and has curated exhibitions and installations, such as Abitare il Tempo in Verona, Italy.

**My inspiration**
The rich creative palette of numerous individuals and eras, including the myriad talents of French artist and writer Jean Cocteau (1889–1963)

## william sawaya

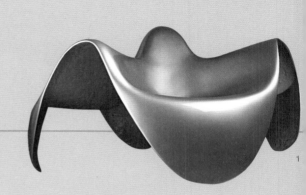

1

**Q. What types of products do you design?**

A. In general, joyful and elegant interior products. Before, they were meant for the lucky few who had everything in life, but over the last few years, I have designed products that are attainable by almost anybody.

**Q. What or who has been a significant influence on your work?**

A. My inspirations are diverse: the art deco period; films from the 1930s up to the 1950s; Frank Lloyd Wright; Jean Cocteau; Khalil Gibran; Florence Knoll; Pierre Paulin…

**Q. What was your big break?**

A. In 1987, with my "Diva" chair. It was completely made of solid wood, but it had all the sinuosity and the fluidity of an object made out of plastic.

**Q. What drives your designs?**

A. The kind of beauty that leads to a *coup de foudre* is something I always aim to include in my design. Within the field of furniture design, almost everything has been done. I am a product designer not an inventor of technology, but I do believe that a contemporary object should combine modern design appeal with the available technology; otherwise we would not call it contemporary.

**Q. How important are trends in your work?**

A. Trends come and go. A good design must have the appeal of a trend but the durability of rational design.

**Q. Is your work an individual statement or a team solution?**

A. It's definitely very individual in the concept phase, and then it becomes a team solution during the execution phase.

**Q. What elements of the design process do you find particularly frustrating?**

A. After the first prototype and the initial applause (if that happens!), the routine production problems make me a bit frustrated. My brain is already racing ahead to the end product, but in the meantime you have the day-to-day grind of keeping an eye on the production process.

**Q. To what extent will you compromise to satisfy your client?**

A. When it is a private commission or a design collector… and I've a strong regard for that person, I am willing to compromise on very minor details in order to personalise the design. At the opposite end of the scale, with architectural or interior design projects, it's a different approach – there has to be a basic trust between the client and the designer so you usually have to be prepared to make lots of alterations, modifications, improvements…

**Q. What would be your second career choice after design?**

A. A film director or an archaeologist.

**Q. What do you still aspire to design?**

A. When your mind and your imagination are working properly, you want to design everything. I would certainly love to design things other than furniture.

**Q. Could you sum up your design approach?**

A. It's more a question of what I avoid. I don't like the presumptuous design, the constipated design, the impotent design, the sad design, the unsexy design, the stingy design, the flat design, the re-design and especially the ideological design!

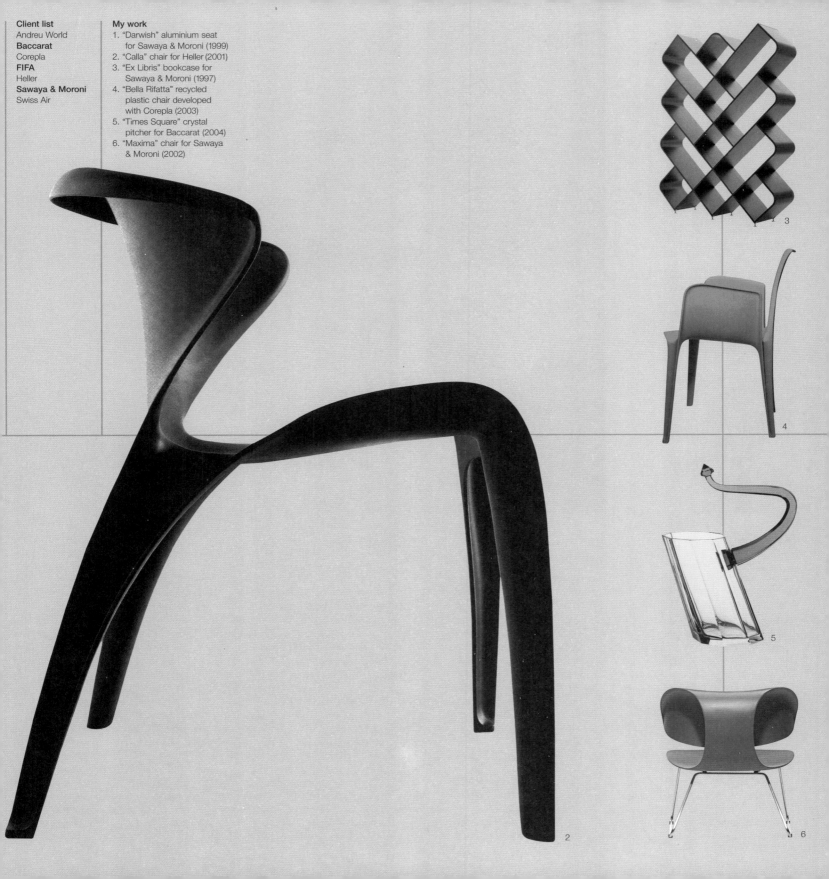

**Client list**
Andreu World
**Baccarat**
Corepla
**FIFA**
Heller
**Sawaya & Moroni**
Swiss Air

**My work**
1. "Darwish" aluminium seat for Sawaya & Moroni (1999)
2. "Calla" chair for Heller (2001)
3. "Ex Libris" bookcase for Sawaya & Moroni (1997)
4. "Bella Rifatta" recycled plastic chair developed with Corepla (2003)
5. "Times Square" crystal pitcher for Baccarat (2004)
6. "Maxima" chair for Sawaya & Moroni (2002)

**Jerszy Seymour**
born 1968 in Berlin, Germany
**Studio Location**
Milan, Italy

Born in Germany, Jerszy Seymour and his family moved to England when he was two years old. He grew up in London's "multicultural concrete landscape" and spent his teens immersed in 1980s street culture – creating club flyers and playing hip-hop, electro, dub and ska music as a DJ on the underground club scene. He studied Engineering Design at London's South Bank Polytechnic, and in 1991 gained a scholarship to study at the Royal College of Art, where he developed his interest in design and sculpture. After graduation in 1994, he travelled the world, snowboarding, skating and collaborating with other artists.

In 1996, he collaborated with Stefano Giovannoni (pp 112–113) in Milan, before moving to New York the following year to work with Smart Design. In 1999, he returned to Milan where he opened his own studio and workshop to undertake experimental productions such as "Bonnie and Clyde" (2001), "House in a Box" (2002) and "Scum City" (2003), all of which have been exhibited internationally. Running parallel to his own work are his designs for companies such as Magis, Nike, Idée, Sputnik and Covo.

Seymour has become one of the *enfants terribles* of the design world, recklessly treading on toes with creations that deal with sinister or disturbing themes such as sex, death, ugliness and vandalism. At the same time, he loosens his "message" by mixing playful colours and forms with humorous allusions. He is not interested in material styling but rather in ideological expression, using inventive materials and techniques to communicate this. Seymour continues to surprise, shock and delight from his bases in Milan and Berlin.

**My inspiration**
I communicate the weird, wonderful, beautiful, ugly, or sordid contradictions of people and society in my collage designs, a detail of one shown here

# jerszy seymour

1

**Q. What types of products do you design?**

A. I work on a mixture of projects ranging from experimental work for galleries and museums like "Scum City", "Ken Kuts", "Suicide Air" and "House in a Box" to popular products like the "Easy Chair" for Magis.

**Q. What or who has been a significant influence on your work?**

A. My work is based on my action and reaction to the world situation; this includes bombs, bums, pollution and petrol pipes. The basis of my (re)action is influenced by: my life experiences, love, sex, drugs and hip-hop, Peter Sellers, Che Guevara and the hooligan down the road.

**Q. What was your big break?**

A. There hasn't been one moment; I have just kept fighting forward. I have been fortunate to meet some special people who have understood me and helped in the fight.

**Q. What human emotions and necessities drive your designs?**

A. Positivity, integrity and humour.

**Q. How important are trends in your work?**

A. Trends come and go – it's the soul that remains.

**Q. What was the idea behind "Scum City"?**

A. When I created "Scum City", there was the idea of another place that was free of constructed systems, where people are not judged by race, class, nationality and other such socially restricting boundaries.

**Q. Is your work an individual statement or a team solution?**

A. The idea of my work is to transcend differences and create an honest dialogue. This means recognising one's individuality as well as recognising what we share. The people who collaborate with me are all strong individuals, but there is something we share in common, which is a certain irreverence to the status quo, the belief in a positive future, and a feeling for the general comedy of things.

**Q. To what level will you compromise to satisfy your client?**

A. My client is me, everybody and the world. In this sense, there can be no compromise – what matters is that you do the best work possible and move forward.

**Q. What would be your second career choice after design?**

A. World domination or death.

**Q. What do you still aspire to design?**

A. In "Scum City", I proclaimed "the death of design". The discussion now is how to find equilibrium between capital consumerism and social and natural integrity and sustainability. Viva la design!

**My work**
1. "Pipe Dreams" watering can for Magis (2000)
2. "Scum Light" lampshade made in polyurethane foam for Kreo Gallery (2003)
3. "Welcome to Scum City" installation at Milan Furniture Fair, Italy (2003)
4. "Free Wheelin' Franklin" remote controlled side table for Idée/Sputnik (2000)
5. "Ken Cuts" handblown Murano glass vase for Covo (2001)
6. "Stackable Easy Chair" for Magis (2001)

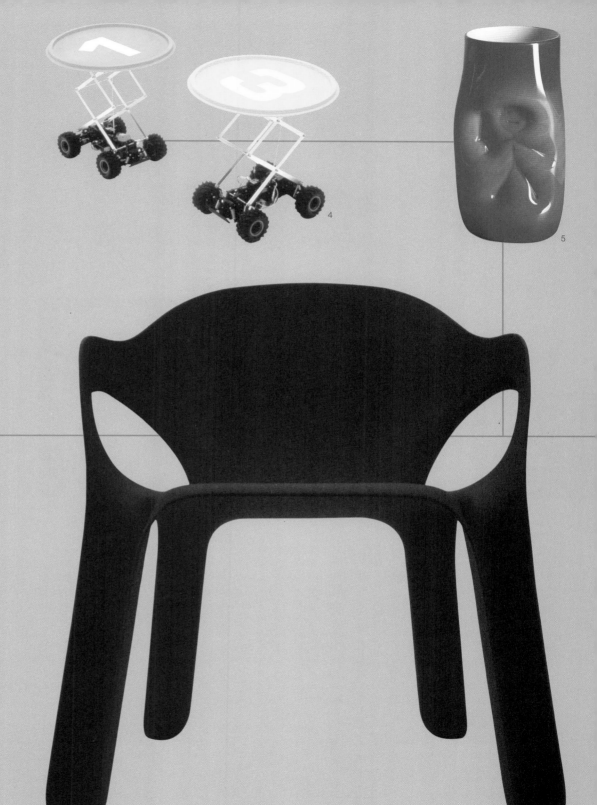

**Richard Seymour**
born 1953 in Scarborough, UK
**Dick Powell**
born 1951 in Great Kingshill,
Buckinghamshire, UK
**Studio Location**
London, UK

Design consultancy seymourpowell was
established in 1984 by Dick Powell and
Richard Seymour – both graduates
of London's Royal College of Art, where
they studied Product Design and Graphic
Design respectively in the 1970s.
Employing more than 50 designers

today, the company is one of Europe's
leading product design consultancies,
collaborating on consumer goods with
worldwide manufacturers, from Connolly
to Casio and Tefal to Toyota.

Their portfolio embraces a wide
spectrum of product areas, from cars,
bras and mobile phones to computers,
domestic appliances and handmade
luggage, making it impossible to pinpoint
a "look" or style. Seymourpowell
is dedicated to researching, analysing
and forecasting human characteristics
and behaviours. People are the
inspiration for its products, providing

the foundation on which the technology,
ergonomics, marketing and branding
are overlaid. Technology is linked strongly
to human needs, and is never applied
to the extent that it compromises usability
or becomes incomprehensible.

Recognising that the look and feel
of a product is a key element for market
appeal, award-winning seymourpowell
nonetheless only release designs
that revolutionise, or at the very least
improve on, existing design features.
They generate "unexpected but relevant
solutions", responsibly defining market
progressions for the future.

**My inspiration**
Richard Seymour:
The futuristic portrayal
of the world of pilot
Dan Dare in the
hugely popular 1950s
science-fiction
strip-cartoon series by
Frank Hampson.

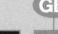 GB

**seymourpowell**

**Q. What types of products
do you design?**
A. Every kind of mass-produced
consumer product from trains
to planes, home appliances
to home hi-fi and digital watches
to cellphones.

**Q. What or who has influenced
your work?**
A. *DP:* My business partner, Richard
Seymour. Also Apple – from the
first Mac through to Jonathan Ive
– for providing me with the tools
and for their contribution to design.
*RS:* Bob Gill – designer, illustrator,
teacher, copywriter and founding
partner of Pentagram Design. Dan
Dare – science-fiction strip-cartoon
character by Frank Hampson.

**Q. What was your big break?**
A. Meeting each other and setting
up seymourpowell. The attraction

of opposites has acted as the
mainspring for our company's
20 years of success.

**Q. What human emotions and
necessities drive your designs?**
A. *DP:* A belief that design is about
making things better; better for
people, better for industry and better
for the world.
*RS:* Curiosity and delight –
"how to make ordinary things
emotionally rewarding".

**Q. How important are trends
in your work?**
A. *DP:* Trends provide the context
within which we work, but it's always
more rewarding to set them than
follow them.
*RS:* We don't talk about trends that
much. We tend to talk more about
spotting emergent behaviour
in people and cultures and looking

for unexpected relevant solutions…

**Q. How important is it for your
work to reflect a British
design aesthetic?**
A. It depends on the product. We're not
British designers in that sense – we help
create products that match their brand's
etymology, not ours. If it's a Jaguar car,
national provenance matters; if it's
a Nokia phone, it doesn't. We're
much more interested in the way an
object interacts with different cultures
than where we happened to be born.

**Q. Is your work an individual
statement or a team solution?**
A. It is always a team solution whose
focus and character lies with our
client. For us, design is rarely a
form of self-expression as in art.
More often, our task is to create
better products that support the
manufacturer's brand.

**Q. What elements of the
design process do you find
particularly frustrating?**
A. *DP:* Inevitably, market research!
It dulls the exciting, compromises
the daring and drives everything
towards the lowest-common-
denominator solution…
*RS:* Fighting the supply chain in
companies that believe that good
enough is good enough. It isn't.

**Q. To what level will you compromise
to satisfy your client?**
A. *DP:* Whatever it takes or we don't
get paid! There is always another
better solution that will satisfy us
as well as the client.
*RS:* Compromise suggests that
one side hasn't understood what
is required. We like to get our
"compromises" out of the way
before we start designing.

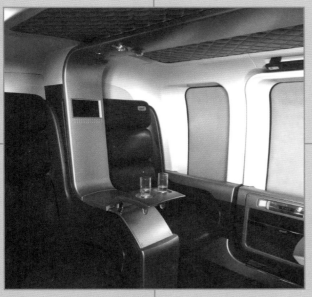

**Client list**

BMW
**Cadbury Schweppes**
Casio
**Cathay Pacific**
Connolly
**Dell**
Dualit
**Ford**
General Motors
**Hasbro Europe**
Hewlett Packard
**Ideal Standard**
Jaguar
**Mercury Appliances**
Minolta
**National**
Nissan
**Nokia**
Panasonic
**Renault**
Rowenta
**Shimano**
SmithKline Beecham
**Tefal**
Toyota
**Yamaha**

**Michael Sodeau**
Born 1969 in London, UK
**Studio Location**
London, UK

Michael Sodeau began his career in 3-D design with the co-founding of Inflate, straight after graduating in Product Design from London's Central Saint Martins College of Art and Design in 1994. After three years' working with Nick Crosbie (pp 88–89) and his brother, Mark Sodeau, on inflatable reinterpretations of traditional products,

Michael chose to branch out on his own in 1997 when he launched Michael Sodeau Partnership with his partner Lisa Giuliani. Their first collection, called "Comfortable Living" – comprising woven-cane lights, ceramic homewares, rugs and furniture – attracted international attention when it was showcased at Twentytwentyone, a gallery and retailer in London.

Sodeau's consistent exposure through international exhibitions built up interest from manufacturers such as Asplund in Sweden and Christopher

Farr in London. His debut at the Milan Furniture Fair came in 1999 with his "Bolla" collection of sculptural lights and tables made from woven cane, produced by the Italian company Gervasoni. While continuing to build relationships abroad with reputable companies like Tronconi and Liv'it in Italy and E&Y in Japan, Sodeau has maintained a firm footing in Britain. He has designed for established UK manufacturers such as SCP, Gordon Russell, Isokon Plus, Bute and Wedgwood, as well as for newer brands such as Modus Furniture and Illizi.

**My inspiration**
The journey from home to my office on the bus gives me time alone to compose my thoughts for the day ahead

**GB**

## michael sodeau

1

**Q. What types of products do you design?**
A. The furniture and objects that I design are simple in their aesthetic. The materials used in their production give the objects a defined function, while my design process breathes life into them.

**Q. What or who has been of significant influence in your studio?**
A. My bus journey to work allows me time to think and clear my head – a space where I have no external distractions.

**Q. What was your big break?**
A. In 1997, I set up my design studio with Lisa Giuliani and designed a collection of objects and furniture for the home. Simon Alderson and Tony Cunningham, the owners of Twentytwentyone

design shop in Islington, were kind enough to let me showcase my new designs there, even though they had seen nothing by me. The show was a great success with both the international design press and retailers.

**Q. What human emotions and necessities drive your designs?**
A. I am driven by a need to keep things simple by adopting an uncluttered approach to design. I like to allow the materials the opportunity to speak, and the objects to relate to each other by way of their function. I tend to create relationships between objects – families of objects.

**Q. How important are trends in your work?**
A. They tend not to be that important, although they are a good way to market objects.

**Q. How important is it for your work to reflect British design characteristics?**
A. Not important at all. I don't feel that my work has a particularly British flavour; it's more European if anything. The contemporary market is only a small proportion of the market as a whole, so it's imperative that the furniture and objects have international appeal.

**Q. Is your work an individual statement or a team solution?**
A. It's more of an individual statement brought about by teamwork.

**Q. What elements of the design process do you find particularly frustrating?**
A. Each project inevitably has positive and negative aspects; the bits that are particularly frustrating tend to be the areas

that are out of my control.

**Q. To what level will you compromise to satisfy your client?**
A. I'd like to think that there are no compromises but rather many routes to a final solution that is beneficial to all.

**Q. What would be your second career choice after design?**
A. It's difficult to say... possibly either a chef or a gardener.

**Q. What do you still aspire to design?**
A. There are a few things: alarm clock, bike, car, door handle, easel, fork, glasses, house, igloo, jug, knife, light bulb, mallet, napkin, office chair, perfume bottle, quilt, roller-skate, scissors, television, umbrella, vacuum cleaner, whisk, xylophone, yacht and Zeppelin.

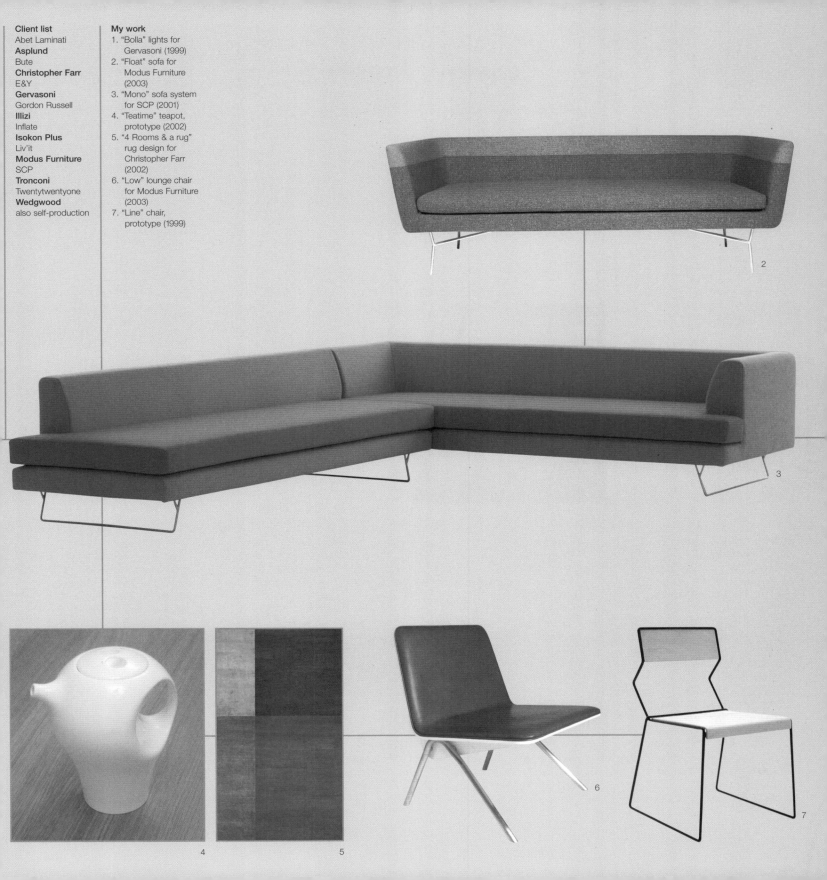

**Client list**
Abet Laminati
**Asplund**
Bute
**Christopher Farr**
E&Y
**Gervasoni**
Gordon Russell
**Illizi**
Inflate
**Isokon Plus**
Liv'it
**Modus Furniture**
SCP
**Tronconi**
Twentytwentyone
**Wedgwood**
also self-production

**My work**
1. "Bolla" lights for
   Gervasoni (1999)
2. "Float" sofa for
   Modus Furniture
   (2003)
3. "Mono" sofa system
   for SCP (2001)
4. "Teatime" teapot,
   prototype (2002)
5. "4 Rooms & a rug"
   rug design for
   Christopher Farr
   (2002)
6. "Low" lounge chair
   for Modus Furniture
   (2003)
7. "Line" chair,
   prototype (1999)

**George Sowden**
Born 1942 in Leeds, UK
**Studio Location**
Milan, Italy

George Sowden originally trained as an architect at Gloucester College of Art in Cheltenham, England, in the 1960s. Shortly after graduating, Sowden went to Milan to find work as an architect and started a job with Ettore Sottsass in Italy in 1970. At around the same time, he also began his collaboration with Olivetti, the renowned Italian manufacturer of office machines, computers and office furniture. The relationship flourished for 20 years, during which Sowden witnessed the company's progression from early electro-mechanical devices to the microchip boom of the late 1980s.

During the 1970s, Sowden found himself working at the heart of the Italian radical design movement. In 1981, he became one of the founding members of Memphis, the maverick group of designers, artists and architects whose work defined the Post-Modern movement. In the same year, he founded SowdenDesign, where he pursued the design of electronic consumer items while also exploring low-tech creations made from wood, textiles, ceramic and glass.

The computerised design tools of the early 1990s revolutionised the studio's design approach and gave it the opportunity to embrace new industrial processes using ever-advancing software programs. George Sowden and his team now work almost exclusively on the design and engineering of electronic or electro-technical products for industrial production.

**My inspiration**
Searching for an antidote to the prominence of "Good Design" during my early career in the 1970s, I shifted my attention to William Morris and the Arts & Crafts Movement

## george sowden

**Q. What types of products do you design?**

A. We work in different fields of product design from complex industrial products such as telecom products, a professional automatic coffee-maker and an ATM cash point to handmade craft goods including glassware, ceramics, textiles and furniture.

**Q. What or who has been a significant influence in your studio?**

A. During my time in art school and my early career, I was influenced by William Morris and the Arts and Crafts movement as a reaction to what was considered "good design" in the 1970s. The Grateful Dead ambience was the start of a lot of things that led up to Memphis. More recently, I have felt uneasy with economic developments that are affecting our society: aggressive capitalism and globalisation. This instinctively pushes me to look for values and meanings at a smaller, more local level.

**Q. What was your big break?**

A. A job with Sottsass in 1970, a consultancy with Olivetti, and being involved with one of the last big European manufacturing industries. Olivetti had its roots back in the 1920s. I spent 20 years there, from 1970 to 1990, and witnessed first hand the change from mechanical to electronic culture. At the same time, I was in contact with the Italian radical design movement of the 1970s, which anticipated the Postmodern changes of the 1980s. These two experiences led me to becoming one of the founder members of Memphis in 1980.

**Q. What human emotions and necessities drive your designs?**

A. Sensuality and usefulness.

**Q. How important are trends in your work?**

A. Trends require us to believe, but, unlike ideology, trends are short-term – we can change our minds. Trends create space for a particular kind of uncertainty, which I find challenging but fragile. I am not at all sure about a consumer society, which accepts trendy uncertainty as a principle and disregards the hope that accompanies ideology.

**Q. Is your work an individual statement or a team solution?**

A. The projects on which I work alone – furniture, ceramics, textiles and glassware – are a direct reflection of my personality and vision. The more complicated industrial products require involvement from other people, including the client. Their influence happens within the framework of the studio, and this is reflected in the final product.

**Q. What elements of the design process do you find particularly frustrating?**

A. There is often a frustrating moment towards the end of any industrial process, when the design activity is taken over by the developing inertia of the commissioning client. I feel a paternity towards a project, which is more than a simple professional responsibility. I often feel I would like to be involved in everything, like packaging, colour variations and publicity, but these aspects are usually taken over by marketing.

**Q. What do you still aspire to design?**

A. Anything that is intrinsically useful.

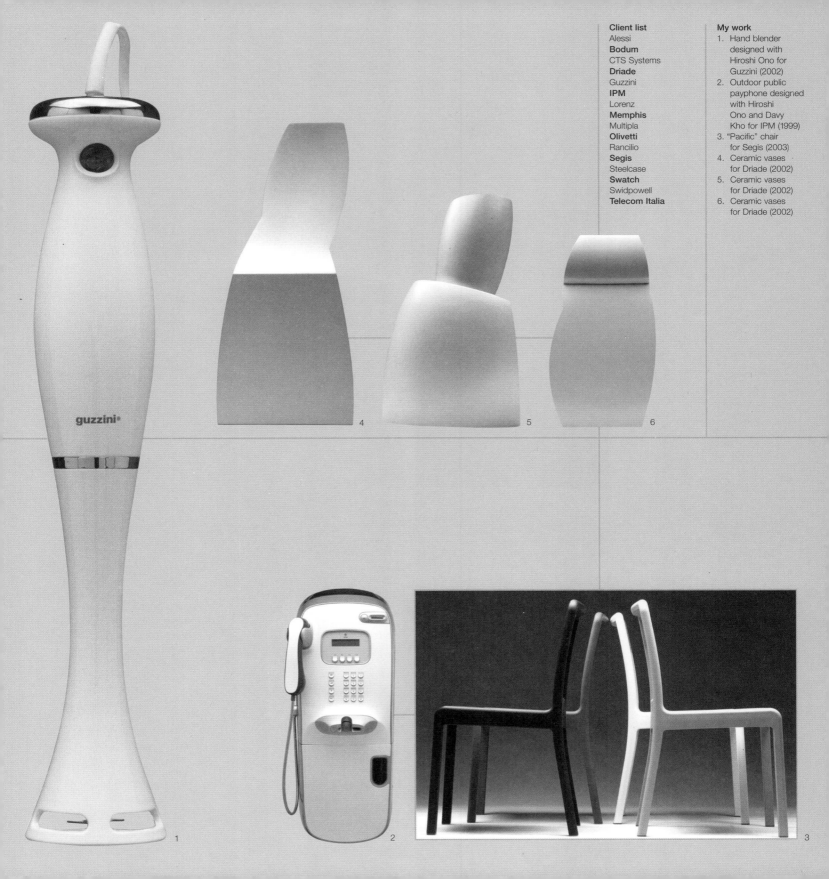

**Philippe Starck**
born 1949 in Paris, France
**Studio Location**
Paris, France

Philippe Starck studied at the Ecole Nissim de Camondo in Paris and established his first design company – specialising in inflatable products – in 1968. In 1979, he founded the Starck Product Company, and during the 1980s became highly sought after as an interior designer, executing projects such as an apartment for François Mitterrand at the Elysée Palace (1982) and the ultra-fashionable Café Costes (1984).

As a product designer, Starck is remarkable for a diverse range of work: from kitchen accessories, toothbrushes and a pasta shape, to chairs, televisions, radios, a motorbike, kayak and yacht. Unlike most other exponents of the New Design movement, who often produced expensive, one-off pieces intended to shock or provoke, Starck has sought to create affordable mass-produced consumer goods with wide appeal. In this vein, he created a range of products for the US discount chain store Target. Other products – most notably the "Juicy Salif" (1990) for Alessi – have gained an iconic, populist status.

Starck's eclectic designs are often unashamedly stylish and emotional, featuring organic or streamlined forms and striking combinations of materials – fabric and chrome, for instance, or glass and stone. Beneath the exterior, however, lies a strong utopian vein that has grown stronger over time – Starck aims to change the way we live.

Examples of Starck's work have entered the collections of numerous European and American museums, including the Brooklyn Museum in New York, the Musée des Arts Décoratifs in Paris, and the Design Museum in London.

F

philippe starck

1

Q. **What types of products do you design?**
A. Everything that can speak about something else.

Q. **You have designed many sucessful products over the years. But is there one in particular of which you are most proud?**
A. I hate everything I do. Every product that I design shows up how I am weak, lazy, and stupid.

Q. **Where do environmental issues now rank on your list of considerations when designing?**
A. By definition, a consideration for environmental issues is now an automatic obligation. It is so obligatory that the issue needn't even be raised.

Q. **What human emotions and necessities are the drive behind your designs?**
A. Love, passion, and mutation.

Q. **What or who has been of significant influence on your work as a whole?**
A. Life, astrophysics, and Darwin.

Q. **What was your big break?**
A. I cannot identify one particular big break.

Q. **How important are trends in your work?**
A. I am not at all interested by the process of trend.

Q. **When did Starck as a brand emerge, and what would you consider to have been the determining factor of its success?**
A. I guess I knew that the Starck brand was a success when people in the street started to say thank you. However, I would be unable to remember exactly when that began.

Q. **How important is it for your work to reflect the design characteristics of your nation?**
A. Perhaps France can have the elegance of intelligence.

Q. **Would you say that your work is an individual statement or a team solution?**
A. It is an autistic statement.

Q. **Is there any element of the design process that you regularly find particularly frustrating?**
A. The process of design is structurally frustrating.

Q. **To what level will you compromise to satisfy your client?**
A. I never compromise but I respect their life and money.

Q. **Are there any other contemporary designers whose work you particularly admire?**
A. I am not at all interested in the architecture or design of others.

Q. **What would be your second career choice after design?**
A. A scientist, a politician, or a musician… and if none of those careers succeed then perhaps I would become a designer afterwards.

Q. **What do you still aspire to design?**
A. Design is easy and I know how to do it.

Q. **In one sentence, describe your design approach.**
A. I try to give the best to the maximum of people.

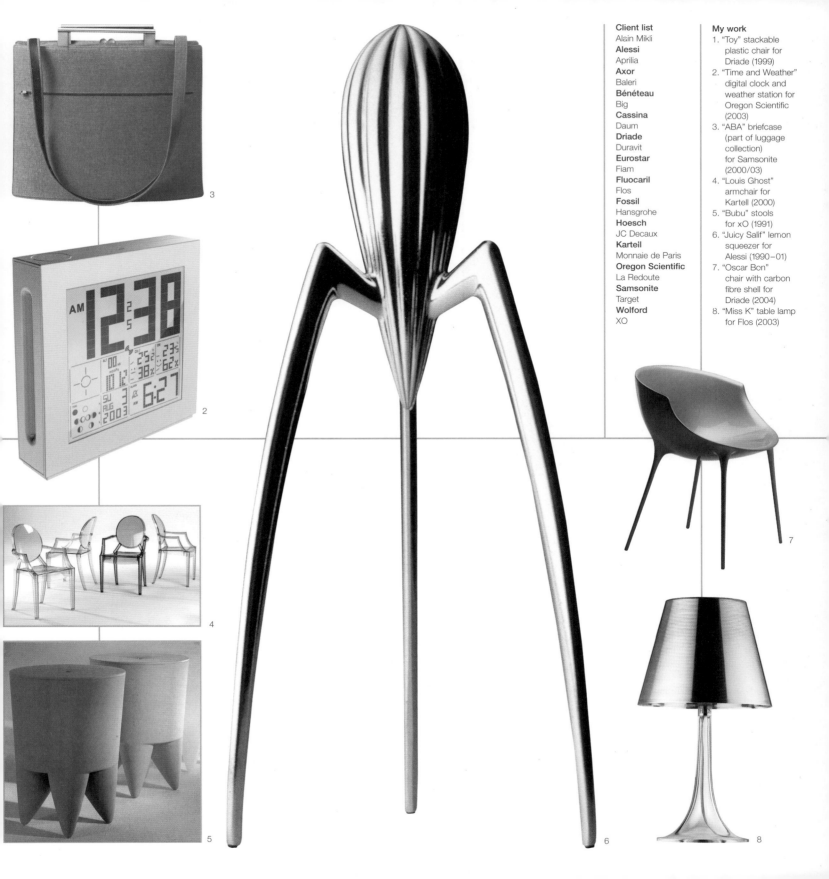

**Client list**
Alain Mikli
**Alessi**
Aprilia
**Axor**
Baleri
**Bénéteau**
Big
**Cassina**
Daum
**Driade**
Duravit
**Eurostar**
Fiam
**Fluocaril**
Flos
**Fossil**
Hansgrohe
**Hoesch**
JC Decaux
**Karteil**
Monnaie de Paris
**Oregon Scientific**
La Redoute
**Samsonite**
Target
**Wolford**
XO

**My work**
1. "Toy" stackable plastic chair for Driade (1999)
2. "Time and Weather" digital clock and weather station for Oregon Scientific (2003)
3. "ABA" briefcase (part of luggage collection) for Samsonite (2000/03)
4. "Louis Ghost" armchair for Kartell (2000)
5. "Bubu" stools for xO (1991)
6. "Juicy Salif" lemon squeezer for Alessi (1990–01)
7. "Oscar Bon" chair with carbon fibre shell for Driade (2004)
8. "Miss K" table lamp for Flos (2003)

**Tangerine**
Founded 1989 in London, UK
**Studio Location**
London, UK

In 1989, Martin Darbyshire and Clive Grinyer established tangerine as a consultancy to guide and manage product direction and strategies for some of the world's leading brands. Grinyer left in 1993, leaving Darbyshire to run the day-to-day management tasks as well as heading project direction and client liaison. The design team embraces an enormous variety of challenges, ranging from cutlery to mobile phones and airline seats. Darbyshire has built a loyal team and an intimate working environment that inspires dialogue and exploration in the consultancy's ongoing quest to identify design issues relating to human interaction with products and services. Tangerine has shown clients that the days of second-guessing consumer desires have long since passed – increased market choices have educated the man or woman on the street to question product validity to an ever greater degree.

Darbyshire trained in product design at Central St Martins College of Art and Design and pursued professional experience in design consultancies in the UK and USA from 1983, working with such clients as the Ford Motor Company. His knowledge of big-name brands and their values are well aligned with consumer aspirations, so that he is able to address real design issues while protecting yet progressing the long-term business interests of his clients.

**GB**

**tangerine**

**Q. What types of products do you design?**

A. We class our design as lifeware, lifespace and lifetech. The common theme is "design for real life". Lifeware describes primarily low-tech objects such as furniture and domestic appliances. Lifespace encompasses environmental solutions, such as the British Airways Club World seating concept. Lifetech describes high-technology industrial design, from mobile phones and digital TV boxes through to office products and complex medical devices.

**Q. What or who has been of significant influence in your studio?**

A. Our most significant influence is our studio dynamic. We've worked together for a long time. This builds understanding and intuition, but we're still open to diverse influences from all sorts of areas. We view tangerine as more a collection of minds than people, including clients, collaborators and suppliers. We try to value all these inputs equally. We don't hold with gurus, by and large.

**Q. What was your big break?**

A. Working for Apple in the early 1990s gave the tangerine brand credibility. The design of the British Airways Club World seat in the late 1990s proved that we could deliver significant innovation and business success in the most competitive of markets.

**Q. What drives your designs?**

A. Finding what's appropriate for who, what and where people want to be. We try to explore the balance between the future and now, between the possible, the desirable and the practical. We design objects to perform a service rather than as products. The difference is fundamental and significant.

**Q. How important are trends in your work?**

A. It's more important to be aware of a trend before it becomes one. Technology throws up a host of possibilities that fail to become trends because people don't identify with the need they seek to satisfy. There are just as many examples where design values have pushed products into the mainstream, such as the iPod effect on MP3 or the Walkman on audio cassettes… We see it as more important to try to get a product's bearing, and work out where a product figures, or will figure, in peoples' lives.

**Q. How important is it for your work to reflect British design characteristics?**

A. Not at all. We all love products that reflect national identities, but there is nothing peculiarly British… about our design. London is more important as a referential position because of the vibe and because we happen to be here, but we don't carry or wave any national flags.

**Q. Is your work an individual statement or a team solution?**

A. Virtually all of our ideas are collaborations. Our studio dynamic is conversational, informal and we are not precious about "design". So we are not too keen on "statements".

**Q. What elements of the design process do you find particularly frustrating?**

A. When good ideas get away or when clients commission good work and only value or use 25 per cent of it…

**Q. To what level will you compromise to satisfy your client?**

A. Clients trust us to be right or wrong, but at the same time they expect us to adopt an approach… that will limit risk and… provide the confidence to make big leaps! We take our responsibility to try to guide them in the right direction very seriously.

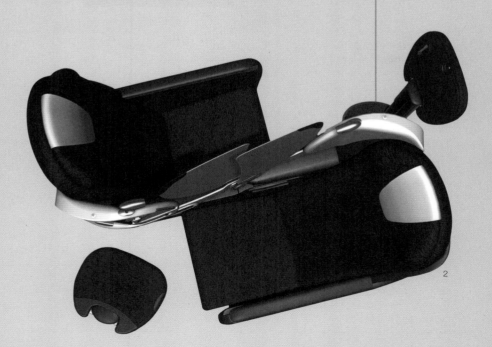

**Matteo Thun**
born 1952 in Bolzano, Italy
**Studio Location**
Milan, Italy

Matteo Thun graduated as an architect from the Università degli Studi di Firenze in 1975. He quickly became associated with the renowned Austrian-born designer Ettore Sottsass, co-founding Sottsass Associati and the radical Memphis Group in 1981, which questioned the existing parameters of functionalist beauty in design. The works of the group sent shock waves through the industry, attracting considerable media attention and exposure for the individuals involved. Shortly after this initial success, Thun opened his own design studio in Milan in 1984. Today the studio can boast a team of more than 50 architects, designers and graphic designers.

While design work from the Memphis period of the 1980s possesses a recognisable aesthetic, the subsequent work of Thun is much harder to categorise, which is, in part, owing to the fact that his studio works across the overlapping disciplines of architecture, design and communication. He likes to remove his personal signature from projects, choosing instead to explore custom-made strategies for his clients that are reached by constant dialogue both within his company and with industry. Working across both the large and small scale, Matteo Thun and his team apply their vast knowledge of materials, technologies and processes to a wide variety of projects, striving to create enduring products that are remarkable without being ostentatious.

**matteo thun**

**Q. What types of products do you design?**

A. We create anything from a wristwatch to a bathtub, from a hotel interior to the hotel architecture itself. We try to create things that last, whether it's a building in the desert, a nightclub in the Alps, a hotel interior, or a product design… aesthetic and technical durability are what counts.

**Q. What or who has been of significant influence on your work as a whole?**

A. My family. My father showed me how to act like an entrepreneur, while working with my mother in our family company making handmade ceramics stimulated my creativity.

**Q. What was your big break?**

A. At 14 years old: being accepted at the Oskar Kokoschka Sommerakademie für Bildende Kunst, Salzburg. At 22: graduating in Architecture *summa cum laude*.

**Q. What human emotions and necessities drive your designs?**

A. As far as emotions are concerned, I feel driven by beauty, serenity of spirit, the sensuality of materials, and light.

As far as necessities, I am driven by *genius loci*, meaning that all projects should respect nature so that our children should find the planet in the same condition as we found it when we were born.

**Q. How important are trends in your work?**

A. Trends are important, as they can be an inspiration to the creative process. Trends never govern our way of creating, however. What is much more important is to realise the right architecture, atmosphere or shape for any specific project or location.

**Q. Is your work an individual statement or a team solution?**

A. My work is a team solution. I don't want it to be the expression of a single ego, but rather the collective ego of a team made up of young architects, engineers and graphic designers.

**Q. What elements of the design process do you find particularly frustrating?**

A. Design is today divided into two categories: design as styling and design as the evolution of an architectural project. What I find frustrating is the first category. That's why I don't know what design means anymore.

**Q. To what degree will you compromise to satisfy your client?**

A. I always want to satisfy my clients – that's very important to me – but I don't think that means compromising myself – it's rather a form of respect.

**Q. What would be your second career choice after design?**

A. My second career would be the same as my first career: remaining a curiosity-driven architect.

**Q. What do you still aspire to design?**

A. I would like to redesign my agenda – transforming it from a 24-hour day into a 12-hour one.

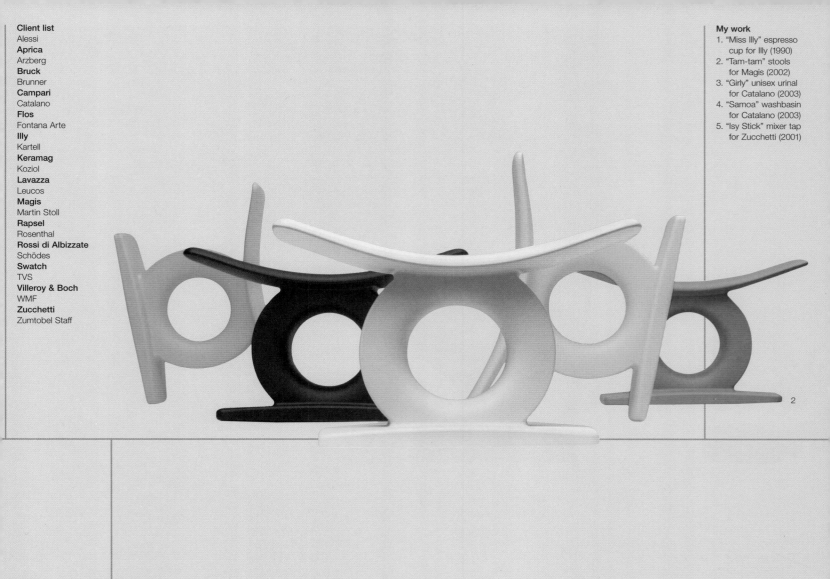

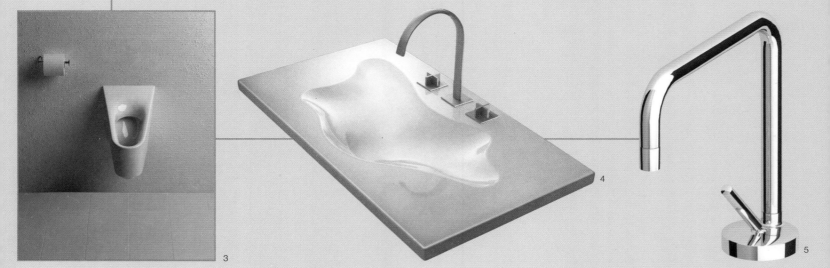

**Andy Davey**
born 1962 in Eton, Berkshire, UK
**Annie Gardiner**
born 1961 in Cuckfield, Sussex, UK
**Studio Location**
London, UK

TKO Design founders Andy Davey and Annie Gardiner met in the mid-1980s, at London's Royal College of Art, during their postgraduate studies in Industrial Design and Design History respectively. The duo opened their consultancy in 1990, to work on innovative design solutions ranging from toys to leading-edge consumer electronics and eyewear to professional medical products. The name TKO was an abbreviation of Tokyo, a city in which they already had many clients.

The world of mass-market high-technology product design is, in most cases, an industry driven by corporations and vast teams of contributors – and although designers, of course, play a crucial role in such teams, recognition is absorbed into the overall brand name. For that reason, you are likely to have come across TKO-designed items without even realising it – for instance, the famous "Freeplay" clockwork radio invented by Trevor Baylis in the early 1990s that subsequently won (in 1996) a BBC Design Award for Best Product and Designer of the Year.

In addition to its core base in product design, TKO Design has grown over the years to broaden its service to clients, offering trend research and prediction as well as graphics, branding, packaging and web design.

**My inspiration**
The revolutionary innovations produced in Japan such as Honda's ASIMO bipedal robot, shown here interacting with Honda's CEO and President Hiroyuki Yoshino

GB

tko design

**Q. What types of products do you design?**

A. TKO's core activity is product design; in other words, designing tools for living. We create products for information and entertainment – from mobile phones to audio equipment; for health and happiness – from medical products to toys…

**Q. What or who has most influenced your work?**

A. Without a doubt, the most enduring influence on my approach and attitude to design is Japan – it's culture, history and people. In fact, it goes deeper than that: I have experienced so many significant professional and personal moments during time spent in Japan that it feels part of my life as a whole.

I have been to Japan countless times over the past two decades, but still it is the very first visit that resonates the most. In March 1988… I met by great fortune Mr Eizi Hayashi, who has since become a guide, mentor and a great friend. Inseparable, in my mind, from his country and culture, he has been the most significant figure in my professional life. One lesson I have learnt from him is to be patient. As he says, "Sitting on the same rock for three years will bring enlightenment, and at the same time the stone becomes warmer."

**Q. What was your big break?**

A. …Professionally, I guess my decision to start TKO – a successful but impetuous, even slightly arrogant, reaction to feeling constrained – was a significant self-inflicted break.

**Q. What human emotions and necessities drive your designs?**

A. I have always suffered a slight insecurity in the form of a need to achieve approval or admiration, though, most importantly, my own approbation. This drives me, along with a work ethic based on doing the best job possible, going over budget, if needs be, to satisfy myself that I have done absolutely everything I can…

What still gets me out of bed in the morning (apart from my lad, Joey, aged two) is the hopelessly optimistic idea that every day I have another opportunity to bring about positive change… Emotion in design? I don't think there is any point searching for an erroneous emotional hook to hang an inappropriate design hat on. Equally, there is much to be lost if you ignore essential human reactions to certain objects, forms and colours.

**Q. How important are trends in your work?**

A. …Trends are important to us in many ways: for several overseas clients we provide regular "trends" reports, which offer a snapshot commentary based on ongoing observations. The difference is that as designers we filter the information we harvest differently from marketeers or cultural analysts. So we're able to offer clients a design trends perspective while also keeping our studio well informed. Still, as we know, "the best way to predict the future is to invent it".

**Q. To what degree are you willing to compromise to satisfy your client?**

A. No need. Accommodating the various demands of people in the design process – each with differing agendas and directions – is a skill that needs to be applied only if a project starts out without any flexibility and understanding between all parties. Compromise can be avoided if everyone is kept engaged, ensuring everyone feels part of the loop.

3

1

2

**My work**
1. "Millennium Diamond" Oyster jewel case for De Beers (1999)
2. "Titan" washing machine for Monotub Industries (2000)
3. "Titan" washing machine for Monotub Industries (2000)

**Patricia Urquiola**
born 1961 in Oviedo, Spain
**Studio Location**
Milan, Italy

Patricia Urquiola has certainly travelled along a stimulating career path to become what she arguably is today – one of Italy's key design figures. Her journey started in her country of origin, Spain, where she grew up and completed the first part of her 3-D training at the architecture faculty of the Universidad Politécnica de Madrid. In 1989, she graduated from the Politecnico di Milano, her thesis supervised by design master Achille Castiglioni. From 1990 to 1996, she was assistant lecturer on courses held by Castiglioni and Eugenio Bettinelli at both the Milan polytechnic and the Ecole Nationale Supérieure de Création Industrielle (ENSCI) in Paris. During this period, she was put in charge of Italian furniture producer De Padova's product development office where she met another master of Italian design, Vico Magistretti, with whom she later collaborated.

In 1993, Urquiola opened an associated practice with the architects M. de Renzio and E. Ramerino, working on buildings, interiors, showrooms and restaurants. Then, in 1996, she coordinated the design group at Lissoni Peia Associati (pp 154–155) in Milan, which brought her to the attention of numerous major Italian manufacturers. Finally, in 2001, she opened Studio Urquiola to pursue her own avenues – in product design, furniture, architecture, exhibitions and art direction.

**My inspiration**
Italian design masters Vico Magistretti and Achille Castiglioni, the latter of whom designed this iconic *Arco* floor lamp for Flos in 1962

**patricia urquiola**

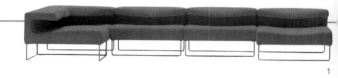

1

**Q. What types of products do you design?**

A. Mostly furniture designs and recently also lights, jewellery, carpets, handles, kitchen and bathroom furniture. Plus I like to design spaces. Being an architect by training, I like architecture, design and everything in between, like site installations and displays.

**Q. What or who has been a significant influence on your work as a whole?**

A. In terms of individuals, definitely Achille Castiglioni and Vico Magistretti. In different ways, they influenced my studies as a designer. More broadly, all aspects of life – namely art, travel, literature and everyday objects. I think that many objects have different lives, and often actual material possession is not so important. I can relate to objects through images, perceptions, by touching them once at a friend's house or seeing them in a museum. They are mine, even if I do not possess them.

**Q. What was your big break?**

A. Probably the "Lowland" and "Lowseat" collection for Moroso [in 2000]. It was the first time that one of my products had a large visibility and success. It was especially interesting for me because I was involved in every aspect of the process – including the advertising campaign to the display presentation.

**Q. What drives your designs?**

A. The urge to communicate, creating a sort of complicity, curiosity, seduction.

**Q. How important are trends in your work?**

A. Not at all. Most of the time, trends are useful only to critics and design journalists.

**Q. Does your work reflect your country of origin?**

A. Spain, the country where I come from, is a paradoxical society, and that's inside my work. I like, though, to use my Milanese side to "digest" my projects, so to speak.

**Q. Is your work an individual statement or a team solution?**

A. It's an individual statement, enriched by a dialogue with the people I work with at large, such as my collaborators, the editors, the prototype technicians…

**Q. To what degree are you ready to compromise to satisfy your client?**

A. Industrial design means working with industry; that is to say, finding compromises for mass production. I focus hard on the technical or material limitations so that they won't affect the original concept of the project. It often happens that in doing so… I can make improvements.

**Q. What would be your second career choice after design?**

A. Wine-making.

**Q. What do you still aspire to design?**

A. A lot. I have more ideas than the production rhythms allow me to do. I hope to find different ways – using limited editions, for example – to be able to bring these ideas to fruition.

**Q. Can you sum up your design approach?**

A. Instinctive. Straightforward. Ironical. Synthetic.

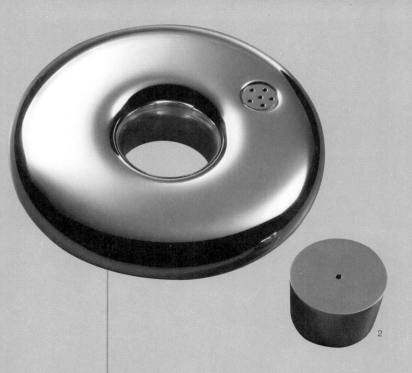

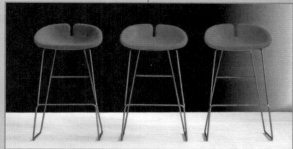

2

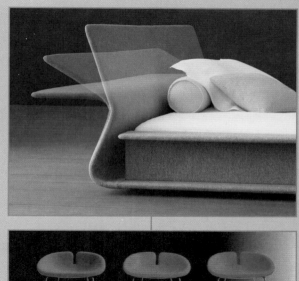

5

4

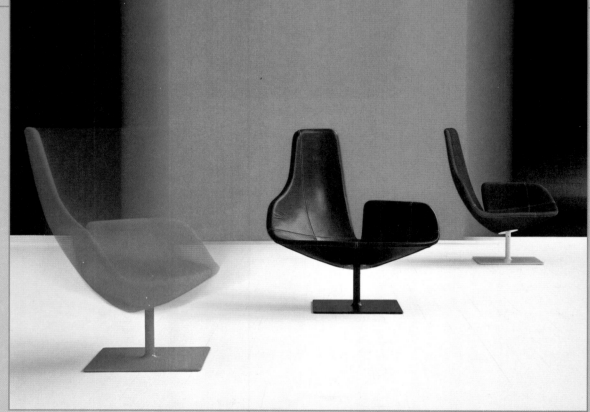

3

**Client list**
Agape
**Alessi**
B&B Italia
**Bosa**
De Padova
**De Vecchi**
Driade
**Fasem**
Foscarini
**Kartell**
Kerasan
**Liv'it**
MDF Italia
**Molteni & C.**
Moroso
**San Lorenzo**
Tronconi
**Viccarbe**

**My work**
1. "Lowseat" seating
   system for
   Moroso (2000)
2. "Sgt.Pepper" salt
   and pepper shakers
   for De Vecchi (2002)
3. "Fjord" armchair
   for Moroso (2002)
4. "Fjord" stool for
   Moroso (2002)
5. "Clip" bed for
   Molteni & C. (2002)

**Maarten van Severen**
born 1956 in Antwerp, Belgium
**Studio Location**
Ghent, Belgium

Maarten van Severen initially studied Architecture at the Hogeschool voor Wetenschap und Kunst Sint-Lucas in Ghent, Belgium. During the 1980s, he undertook interior design and furniture projects in various agencies and, in 1986, also began making his own furniture designs. The first – a long, slender steel table – had many of the qualities that were to characterise all of his subsequent work in the discipline – simplicity, visual clarity and perfection of form and detail.

In 1990, van Severen turned his attention to chairs, producing his designs by hand in limited editions or batch-production. By controlling both design and production, he was able to experiment freely with materials and to ensure the quality of the finished product. It was an approach that appealed to the Dutch architect Rem Koolhaas, with whom van Severen collaborated on the interior and furniture design of several projects, including private residences, a concert hall (2004) in Porto, Portugal, and the Seattle Public Library, Washington, USA.

In 1996, he began working on furniture, lighting and kitchen designs for industrial production, notably the visually rigid yet comfortable polyurethane ".03" stacking chair (1998) for Vitra. More recently, Kartell began production of the "LCP" ("Low Chair Plastic") lounge chair, created from a single piece of transparent acrylic, following van Severen's original design in aluminium called "Lage Stoel".

**My inspiration**
Collaborations with certain key visionaries such as Dutch architect Rem Koolhaas with whom I developed the "Villa Floirac library project" in Bordeaux, France (1995–98)

**B**

**maarten van severen**

**Q. What types of products do you design?**
A. Besides furniture – the main activity of our studio – we work on architectural projects and interior design, cutlery, carpets, bathrooms, paints, lights… I have stopped producing things in my own working – the MVS collection is now produced by Top Mouton in Proven, Belgium.
**Q. What or who has been of significant influence on your work as a whole?**
A. Daily life, the evolution of making things, my education, the collaboration with Rem Koolhaas (and Office of Metropolitan Architecture – OMP), Rolf Felhbaum (Vitra) and many others.
**Q. What was your big break?**
A. Making my first series of pieces, the making of my first aluminium table and, of course, the eight-page article in *Domus* in October 1994 by Federica Zanco.
**Q. What human emotions and necessities drive your designs?**
A. I try to comprehend life in everything I do.
**Q. How important are trends in your work?**
A. I hate "trends", but nobody can exclude from his work the fact that we are living now and that there are parallel ways of working.

**Q. How important is it for your work to reflect the design characteristics of your nation?**
A. I suppose I should talk about a regional tradition of making things, but in reality everything nowadays is more or less international.
**Q. Is your work an individual statement or a team solution?**
A. I work both individually and as a team, but now I'm moving more towards the collaborative side of things. Making things (furniture, architecture etc) still involves a certain amount of collaboration as it has done since medieval times. So nothing has changed that much.

**Q. What elements of the design process do you find particularly frustrating?**
A. None.
**Q. To what level will you compromise to satisfy your client?**
A. You can never speak about compromise in a negative way. Design is all about collaboration, working with different people but with a common goal.
**Q. What would be your second career choice after design?**
A. Artist.
**Q. What do you still aspire to design?**
A. Working with the latest new materials. "Making" is the most important thing, not "designing".

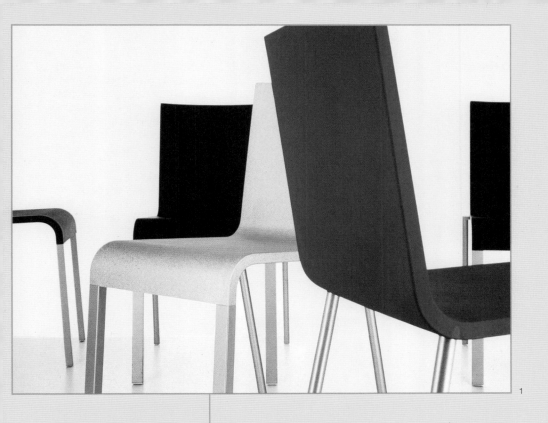

1

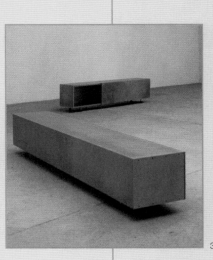

3

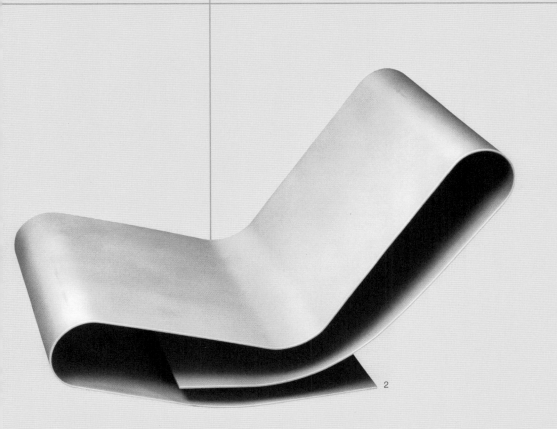

2

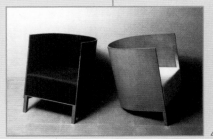

4

**Vogt + Weizenegger**
Oliver Vogt: born 1966 in Essen, Germany
Hermann Weizenegger: born 1963 in
Kempten, Allgäu, Germany
**Studio Location**
Berlin, Germany

Oliver Vogt and Hermann Weizenegger
both studied Industrial Design at the
Hochschule der Künste in Berlin. Whilst
studying, the duo collaborated on the
design and production of an ISDN
Videophone at ProduktEntwicklung
Roericht in Ulm in 1992, where they
worked as freelance designers. This

experience fostered a relationship that
they nurtured into a partnership, founding
Vogt + Weizenegger in Berlin in 1993.

The first major studio activity was
the "Blaupause" (Blueprint) project that
came about through the bankruptcy of
one of their early clients. Having already
developed the scale drawings of a chair,
they developed more chair designs and
sold the drawings with assembly
instructions and materials list.

Along with other self-initiated
undertakings, the duo launched the
"Imaginary Factory" (DIM) project in
1998, linking contemporary designers

with the Blind Persons' Institution in
Berlin. Branding a collection of innovative
designs using the skilled weaving
techniques of the blind workers, the duo
have art-directed a critically acclaimed
range of contemporary products that
now sell across the world.

Their design practice is wide and
varied and collectively represents their
ability to look beyond the perimeters of
product design. The award-winning duo
has more recently embraced the 3-D
printing process of rapid prototyping
technology (RPT) in the creation of one-
off chairs, such as the "Sinterchair" (2002).

**Our inspiration**
The geometric forms of
radiolarians – micro-
creatures that were
beautifully drawn by the
German philosopher
and biologist Ernst
Haeckel (1834–1919) –
inspired the structure
of our "Sinterchair"
design in 2002.

# vogt + weizenegger

D

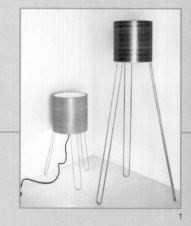

1

**Q. What types of products
do you design?**
A. We design products for everyday life,
always looking around us to rethink
conventional or existing approaches
to design. We also work on
brand re-launches and the rethinking
of product and communication
strategies as well as our
own self-initiated studio projects.

**Q. What or who has influenced
your work as a whole?**
A. Permanent curiosity drives our work,
including looking at theories and
ideas of numerous philosophers,
sociologists and artists. To give
an example: The inspiration for the
structure of our Sinterchair came
from Ernst Haeckel's (1834–1919)
biological studies of invertebrates –
including radiolarians, poriferans

(sponges) and annelids (segmented
worms). His immaculate drawings of
these creatures beautifully illustrate
their detailed geometry.

**Q. What was your big break?**
A. The Blaupause (Blueprint) project
that we devised in 1993 where
customers could buy the plans to
any one of our 12 models for home
or office furniture at a price of only
15 Deutschmark (8 Euros). For
that, they received the chair's design
plans, a licence number, a shopping
list for the chair components,
and instructions for its assembly.

**Q. How important are trends
in your work?**
A. It is important to create trends and
design is a powerful communication
tool with which to achieve that. One
must always create something new.

For a designer to justify their title,
they must create originals, not
copies or derivatives.

**Q. How important is it for your work
to reflect the design
characteristics of your nation?**
A. It is important to know one's own
history. However, the identity of
local history should be carried in
your backpack and not become a
concern when designing for much
larger European or global markets.

**Q. Is your work an individual
statement or a team solution?**
A. If you are a football player, you may
score a goal but you couldn't do so
without the support and framework
of your whole team – the same
analogy applies to design.

**Q. What elements of the design
process do you find frustrating?**

A. Time wasting through bad decisions
or wrong feedback can really
damage a project. Misunderstanding
can trigger it so communication
within the team is therefore crucial.

**Q. To what level will you compromise
to satisfy your client?**
A. The client relationship should be
based on a synchronised satisfaction
and everyone involved should
believe in what they are working on.
It is important to never forget your
own need for satisfaction, otherwise
you will waste your own time in life.

**Q. What would be your second
career choice after design?**
A. A film director or a chef… or perhaps
a kung fu fighter like Bruce Lee!

**Q. What do you still aspire to design?**
Q. A space ship… private space travel
is only around the corner.

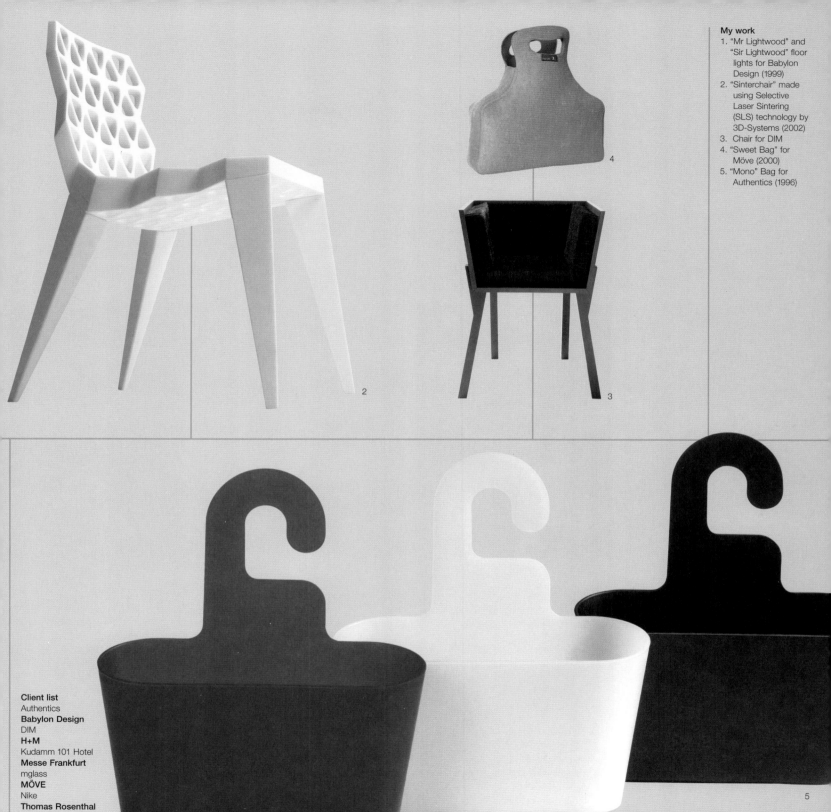

2

4

3

**Client list**
Authentics
**Babylon Design**
DIM
**H+M**
Kudamm 101 Hotel
**Messe Frankfurt**
mglass
**MÖVE**
Nike
**Thomas Rosenthal**
SIGG
**Smirnoff vodka**
WMF

5

## Marcel Wanders
born 1963 in Boxtel, Netherlands
**Studio Location**
Amsterdam, Netherlands

Marcel Wanders trained at various art schools during the 1980s, finishing up at the Hoogeschool voor de Kunsten in Arnhem in 1988. Until 1995, he alternated between working as an independent industrial product designer and stints with Landmark Design & Consult and Waac's Design & Consult, both in Rotterdam, as well as teaching. He was one of the early members of the Dutch collective Droog Design, founded in 1993 by Gijs Bakker (pp 40–41) and Renny Ramakers. His most significant release with Droog was the "Knotted Chair" (1996). Made from macramé-style hand-knotted aramid rope, dipped into epoxy resin, shaped and heat-dried for rigidity, the chair is a seemingly impossible "frozen" structure, combining tradition with high technology.

Wanders references historical crafts and applies them to new forms through his love of materials and inventive production methods. While his designs often tell a personal story that users may or may not pick up on, he is more interested in what people will read into them. The results can be intriguing – as in the porcelain "Sponge Vase" (1997), in which a sponge is used to absorb the clay only to be burnt off in the firing, or in "Egg Vase" (1997), a porcelain cast of a condom stuffed with eggs.

From 1995 to 2001, Wanders' studio, Wanders Wonders, handled the production of many of his designs before manufacturers finally had the confidence to take them on themselves. Nowadays, Wanders heads up the art direction for Dutch manufacturer moooi and can boast an international clientele, numerous awards and a vast array of designs as Director of Marcel Wanders Studio.

## marcel wanders
**NL**

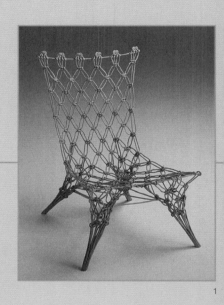

1

**Q. What types of products do you design?**
A. I design only "inspirational masterpieces" across a variety of mainly three dimensional disciplines such as furniture, objects, lighting, interiors, and exhibitions.

**Q. What or who has been of significant influence on your work as a whole?**
A. [Success guru] Anthony Robbins is an example and an inspiration to me and lots of others – his skills, techniques and strategies made me find my mission and targets more clearly and focus on them without fear or doubt.

**Q. What drives your designs?**
A. Security;
Variety and surprise;
Connection to my surroundings;
The wish to be unique;
The feeling of personal growth;
Contribution to a greater cause.

**Q. How important are trends in your work?**
A. Time challenges my thinking and feelings and influences my life and work.

**Q. How important is it for your work to reflect the design characteristics of your nation?**
A. I am a citizen of the world, and I want to express this.

**Q. Is your work an individual statement or a team solution?**
A. I don't make the best solutions, but they are my solutions.

**Q. What elements of the design process do you find particularly frustrating?**
A. Maintenance in general is frustrating to me.

**Q. To what degree are you ready to compromise with your client?**
A. I like my clients to influence my designs positively – I don't accept any influence that harms the quality of the design.

**Q. What would be your second career choice after design?**
A. I like cleaning windows but also going out with beautiful women, so I would probably search for a profession that combined the two.

**Q. What do you still aspire to design?**
A. I want to be the best "me" possible, grow in balance and be an inspiration to a large number of people in the process.

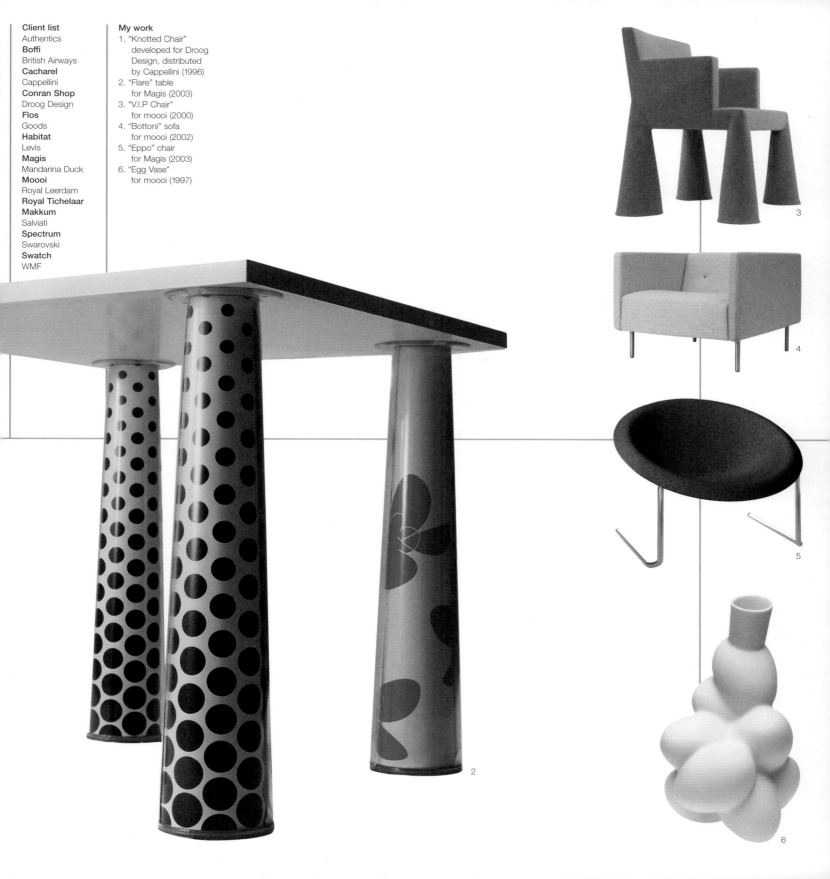

**My work**
1. "Knotted Chair"
   developed for Droog
   Design, distributed
   by Cappellini (1996)
2. "Flare" table
   for Magis (2003)
3. "V.I.P Chair"
   for moooi (2000)
4. "Bottoni" sofa
   for moooi (2002)
5. "Eppo" chair
   for Magis (2003)
6. "Egg Vase"
   for moooi (1997)

2

3

4

5

6

**Hannes Wettstein**
born 1958 in Ascona, Switzerland
**Studio Location**
Zürich, Switzerland

Hannes Wettstein founded zed., his Zürich-based design company working across the disciplines of product, interior and corporate design and architecture, in 1991. The zed. team – which includes product designers, architects, design specialists, graphic artists, strategic consultants and media and communications specialists – undertakes analysis and strategy development for a plethora of leading international brands, including Alessi, Philips and Artemide.

Under Wettstein's direction, the studio develops functional designs that are simple, elegant and unobtrusively beautiful but which are always carefully honed to the client's brand needs – whether it's watches for Ventura, sofas for Arflex, bicycles for Shimano, or the interior design for the Grand Hyatt Hotel in Berlin or the Swiss Embassy in Washington, DC.

Wettstein's skills as an art director have also been called upon over the years by such companies as Oluce (lighting), Arflex (furniture) and, more recently, Brionvega, which produces design-led consumer electronics.

Since 1994, Wettstein has taught as a Visiting Professor at the Staatliche Hochschule für Gestaltung, Karlsruhe, Germany.

**CH**

**hannes wettstein**

**My inspiration**
The conceptual, intellectual, and visual enlightenment of architecture and fine arts, and the similar audible richness of music

**Q. What types of products do you design?**
**A.** – Watches, bicycles, pens, optical products…
– Light, furniture, sideboards, chairs, lights, sofa, tables…
– Public space, private space…

**Q. What or who has been a significant influence on your work?**
**A.** – Music
– Architecture
– Fine Arts

**Q. What was your big break?**
**A.** I haven't had one until now. The only break has been my kneecap!

**Q. What human emotions and necessities drive your designs?**
**A.** – Interaction with engineers
– Proximity at inception of ideas
– To have fun…

**Q. How important are trends in your work?**
**A.** Trends aren't important for me. What I find much more interesting are the "codes" – the meanings – objects communicate.

**Q. How important is it for your work to reflect the design characteristics of your nation?**
**A.** My nation, or country, is important for my work.

**Q. Is your work an individual statement or a team solution?**
**A.** Both – with the emphasis on the teamwork. It depends on the client and the project. For example, furniture mostly reflects my own personality, while technological themes are the result of collaboration among the team.

**Q. To what level will you compromise to satisfy your client?**
**A.** Design is about a willingness to engage in dialogue. What matters is that the original "ambition" for the project isn't lost.

**Q. What would be your second career choice after design?**
**A.** Art, especially photography and music.

**Q. What do you still aspire to design?**
**A.** A cool car and a cool boat.

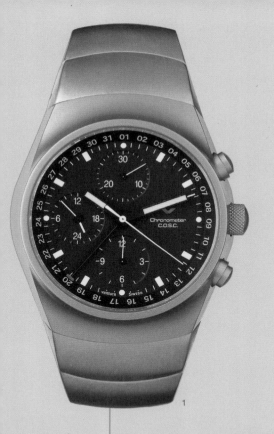

1

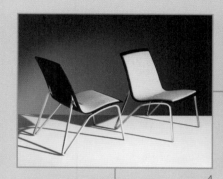

4

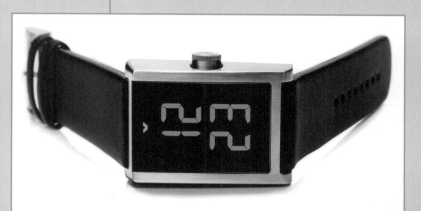

5

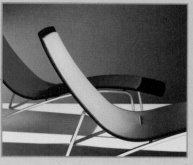

3

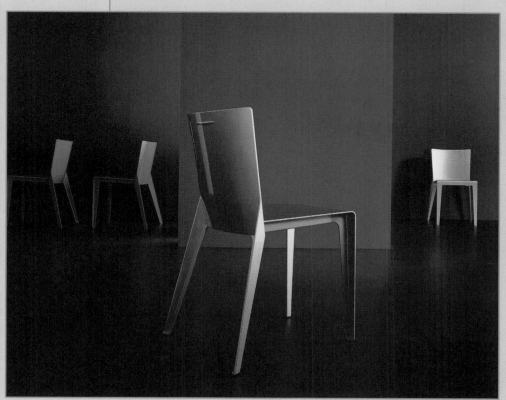

2

**Terence Woodgate**
born 1953 in London, UK
**Studio Location**
Mayfield, East Sussex, UK

Terence Woodgate's path into the furniture and lighting industry was gradual. He trained as an engineer in the 1970s, and after qualifying and with an engineering apprenticeship already under his belt, he worked as a freelance industrial designer, first in Brussels for Westinghouse and then in London for Kodak. It was during this period that he became fascinated with the ideals of the Bauhaus – formal purity, simplicity of construction, and truth to materials – a fusion that met his own twin interests in engineering and art. It was this discovery that shaped his decision to return to college to study Furniture Design and Production at the London College of Furniture in 1984.

Woodgate opened his first studio in London in 1988, attracting his first major client, th Spanish producer Punt Mobles (Spain), which put his "River" cabinet design into production a year later. He also carried out light designs for Concord Lighting in the UK. At this time, he also formed his relationship with the British furniture manufacturer SCP, which has commissioned new designs from him ever since. He moved back to Brussels in 1991, positioning himself nearer to the European hub of companies, earning him commissions from the likes of Cappellini (Italy), Casas (Spain) and Teunen & Teunen (Germany).

In 1995, he moved back to England and set up his home and studio in Mayfield, East Sussex. He works alone, continuing to expand his portfolio of understated yet well-defined high-quality designs.

**My inspiration**
The elegance, proportions and structural clarity of the Modernist era, expressed with perfection in Le Corbusier's "Grand Confort" armchair of 1928

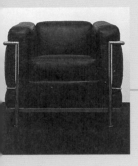

**GB**

terence woodgate

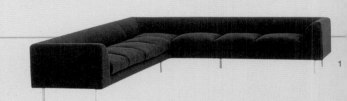
1

**Q. What types of products do you design?**
A. Furniture and lighting.

**Q. What or who has significantly influenced your work?**
A. I remember when I first came across the "Grande Comfort" armchairs by Le Corbusier. I loved the elegance, the proportions. That led me to Bauhaus and Modernism and that was it – I was hooked! I wanted to create things like that. I knew I was a Modernist as it suited my love of precision and my love of geometry. Anyone who creates something that I really like, be it an artist or a designer, enthuses me to get back to the studio and get down to work and can therefore, albeit indirectly, influence me.

Art has always influenced my work in one way or another. One of my first designs came about while lying in the sun at La Colombe d'Or [a hotel in Provence] in France. At the side of the pool is a free-standing mobile by Alexander Calder. I became fascinated by the ever-changing forms and juxtapositions. It led me to consider furniture in such an elementary building-block way. My sketches became "River", which was my first work for the Spanish manufacturer Punt Mobles.

**Q. What was your big break?**
A. "River" certainly got me started. Not long after that, Sheridan Coakley asked me to design for SCP and Tony Lawrence asked me to design for Concord Lighting. I still work for all three companies.

**Q. What human emotions and necessities drive your designs?**
A. Simply the love of creating things and coming up with innovative design solutions. The excitement of all the parts coming together is fantastic. It does give me a thrill to know that people use my designs.

**Q. Is your work an individual statement or a team solution?**
A. Definitely an individual solution – I work alone. I typically design for myself and hope others like it. It is a very selfish act!

**Q. To what extent will you compromise to satisfy your client?**
A. I would only compromise my time, working through the night if necessary to meet a deadline. With respect to my design work and submissions, I am always happy to try again if the client doesn't like my initial designs or concepts, but I would never allow my pen or mouse to be moved for me.

**Q. What would be your second career choice after design?**
A. I think I would have loved to have been an artist because it would be very refreshing to create something without the constraints of design.

**Q. What do you still aspire to design?**
A. I have various ideas for a hi-fi system as I think that this is one area that has not received sufficient design attention in recent years – many of the systems out there are really ugly and sit badly in contemporary room settings.

**Q. How would you briefly describe your design approach?**
A. I endeavour to keep it simple, pure and honest – a fusion of art and science.

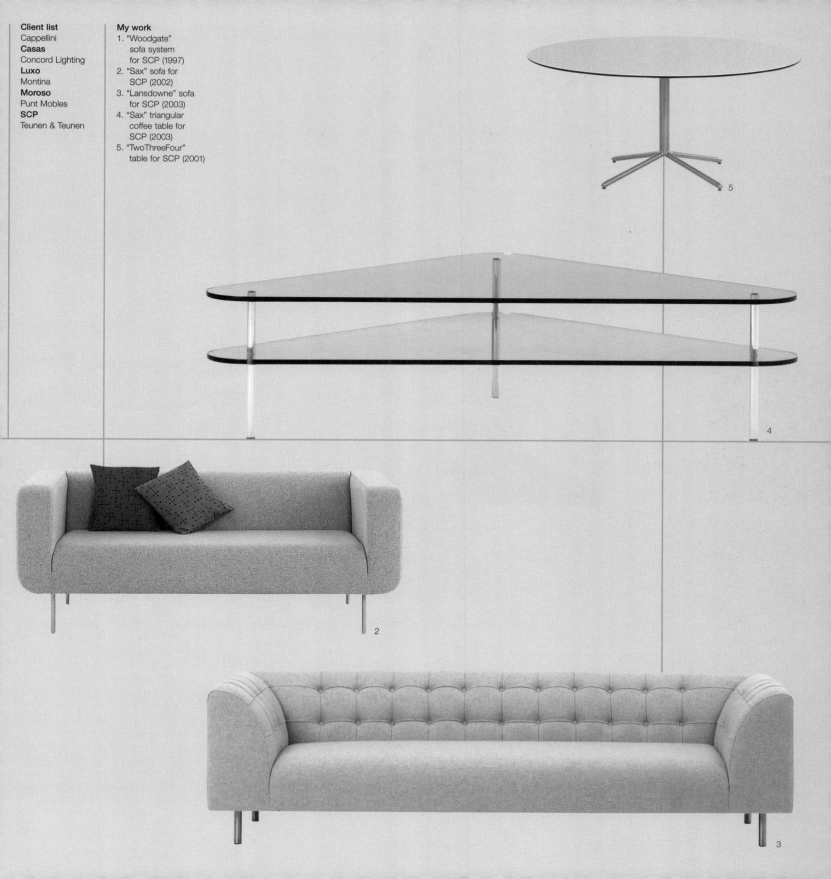

**Client list**
Cappellini
**Casas**
Concord Lighting
**Luxo**
Montina
**Moroso**
Punt Mobles
**SCP**
Teunen & Teunen

**My work**
1. "Woodgate" sofa system for SCP (1997)
2. "Sax" sofa for SCP (2002)
3. "Lansdowne" sofa for SCP (2003)
4. "Sax" triangular coffee table for SCP (2003)
5. "TwoThreeFour" table for SCP (2001)

**Dirk Wynants**
born 1964 in Turnhout, Belgium
**Studio Location**
Gijverinkhove, Belgium

The son of a cabinetmaker, Dirk Wynants studied at the Hogeschool Sint-Lukas Instituut in Ghent, Belgium, graduating in Interior and Furniture Design in 1987. Until 1990, he worked on various jobs in the field of interior design and gave over a year to Belgium's obligatory military service. Between 1990 and 1994, Wynants steered his career into distribution, acting as the Belgian/Benelux agent for the likes of Sawaya & Moroni (pp 214–215) and Ecart.

At the age of 30, Wynants set up his own company – Extremis – partly because he thought he was getting too cosy in his old job. It turned out to be a successful bid for freedom. While Wynants is the principal designer for his company, which specialises in outdoor furniture and accessories, he also commissions pieces from other talents, such as Xavier Lust (pp 158–159) and Michael Young (pp 250–251). His first big hit was the "Gargantua" round table (1994; named for Rabalais's gourmand giant hero), which has height-adjustable benches, while a more recent addition is the "Arthur" table (2004), inspired by the famous round table of British legend.

Wynants' work is characterised by the careful attention he gives to understanding the interactive and social behaviour of his fellow human beings. "When I think about creating a new product, I make up a list of requirements it has to comply with in the end. I won't accept a form that does not meet all those initial needs." As Belgium's winner of the Independent Entrepreneur of the Year Award in 2001, Wynants' portfolio and business look set to keep growing.

**B**

## dirk wynants

1

**Q. What types of products do you design?**

A. I like to call my products "tools to bring people together and to improve the quality of their togetherness." They can be any kind of object, but they mainly come in the form of furniture and can always be used outside, as that's a perfect place to spend a lot of good quality time with friends and family.

**Q. What or who has been influential on your work as a whole?**

A. I really am an information addict. I like to know everything about the most diverse kinds of things, so therefore my influences are extremely diverse, too. Every day I try to improve my knowledge about design, fashion, culture, philosophy, technique, skills, materials, history, trends, nature, biology, arts, management, economics… I have this urge to know and understand, and I find it satisfying to be able to combine all these interests. In every field, I can find something that affects my work in some way – from a contemporary stage design for opera to a clever snowboard design.

**Q. What was your big break?**

A. My professional career in design started in the distribution of international design brands. When I started designing for my own brand, I knew this business inside out. I designed what I thought I needed for my own family, following an extensive briefing I made up for myself. I managed to meet all the points I'd set myself, and when I introduced "Gargantua", it turned out that there were lots of people with the same needs that I had.

**Q. How important are trends in your work?**

A. Everything surrounding you has an effect on your thoughts, but I want to look further than today's trends. I try to analyse upcoming changes in how we live together and what values will take on more importance. The results of that form the basis for my design briefings. Then I try to find the perfect balance between all the points on my wish list…

**Q. Is your work an individual statement or a team solution?**

A. Because I take in so many impressions from the world around me, nobody can call my work purely individual, but I'm happy if I can add something to it that is. Lately the more practical part of the job – the marketing and branding – has become teamwork…

**Q. To what degree are you ready to compromise with your client?**

A. I consider the end user as my real and only client. After finding the perfect balance in aesthetics, ergonomics, society, environment, functionality and innovation, there is little space for other compromises. On a company level, I can be considered my own client, and I can assure you that that client is extremely difficult to satisfy, as he tends always to see himself as the final customer.

**Q. How would you describe your design approach in one sentence?**

A. I pick up as much as I can, then try to forget everything to be able to start from scratch, so that I can create original and intelligent solutions that emerge from a well-stocked unconscious mind.

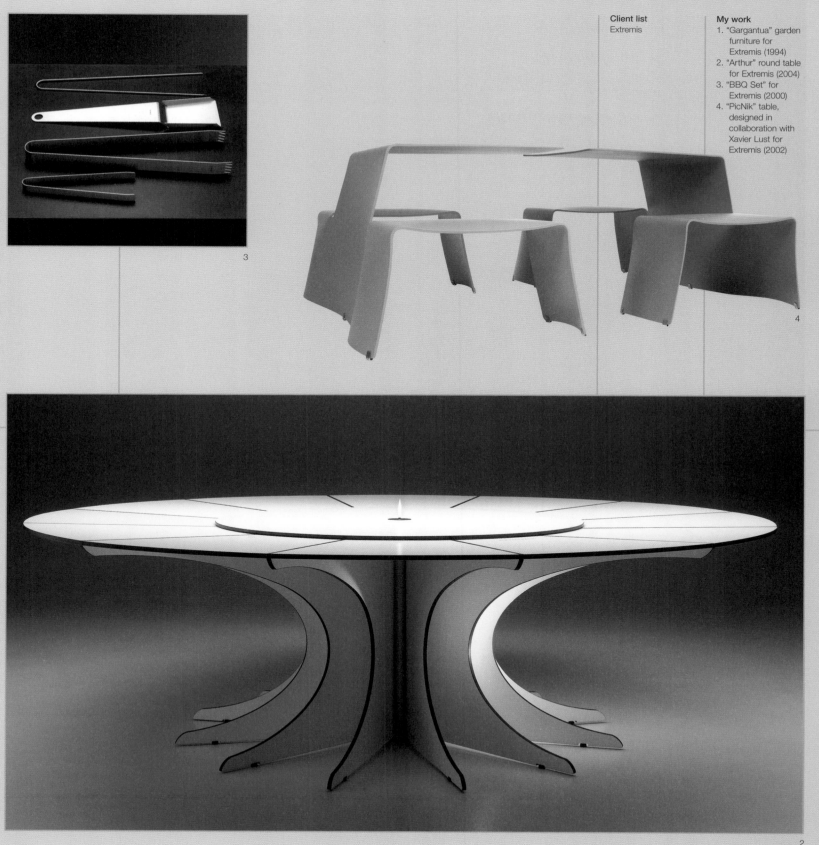

3

4

2

**Helen Yardley**
born 1954 in Plymouth, UK
**Studio Location**
London, UK

Yardley started her studies in Printed and Woven Textiles at Manchester Polytechnic in 1973, followed by a postgraduate degree at the Royal College of Arts in London, which she completed in 1978. A few years after, with some professional experience and a clear vision of what she wanted to pursue, she set up her own studio in London, designing and producing rugs, carpets and wall hangings for private as well as corporate clients.

The visual appearance of much of Yardley's work is undoubtedly painterly, an effect brought about by the sweeping, free-hand brush strokes that are applied to the large swathes of colour produced in hand-tufted, hand-knotted needlepoint or stitched and printed felt. Because she is so deeply involved in drawing and painting, as well as in craft and design, it is hard – and certainly unfair – to categorise her work. The functional requirements of a rug, for example, might seemingly consign it to the domain of design, but its creation, in her hands, bespeaks the freedom of an artist while its production uses the traditions of craft-based skills. That said, working on the floor plane requires a more controlled analysis of the surrounding environment with regards to scale, appropriation of colour, and balance of geometry.

Yardley's creations over the years have earned her a strong reputation, ensuring her involvement in exhibitions across the UK and abroad. Her textile work adds warmth, beauty and focus to every interior it adorns. She has recently opened a gallery in Clerkenwell, London.

**My inspiration**
The raw emotion asserted through the gestural painterly movements of abstract expressionist Robert Motherwell (1915–91), his "Elegy to the Spanish Republic no.131" (1974) shown here

GB

**helen yardley**

---

**Q. What types of products do you design?**
A. Textiles, in the form of rugs, carpets and wall hangings.

**Q. What or who has influenced your work?**
A. Colette, Carl Jung, Henri Matisse, Lucie Rie, Robert Motherwell, Antoni Tapies…

**Q. What was your big break?**
A. Getting into the Royal College of Arts. It had a huge effect on my whole outlook. It was after leaving there that I really learnt how to work. Success really does depend more on hard, hard work than talent, inspiration or luck. The harder you work, the luckier you get.

**Q. What human emotions and necessities drive your designs?**

A. Essentially I am driven by the… desire to make a mark – I make therefore I am. The process of making something is also deeply addictive. I begin full of hope and optimism, and then the process takes over. Sometimes it evolves easily, but often it is a battle between what is possible and not possible; what is rational or sensible and what is intuitive. On good days, there is a free flow between the head and the heart.

**Q. How important are trends in your work?**
A. Not particularly. One cannot be immune to them. It is impossible not to be affected by what is in the air, but you have to be led by your own internal stimuli. I find most designers… strive to be distinct by actively not following trends.

**Q. Is your work an individual statement or a team solution?**
A. An individual statement supported by a team.

**Q. What elements of the design process do you find particularly frustrating?**
A. Loss of control. You inevitably have to allow someone else to make a decision on your behalf. It is a part of the process that you… cannot avoid. I try to limit it by retaining a manufacturing studio so that I can personally oversee the making of prototypes and commissions.

Nothing is perfect – where would you go if it were? There is always that element of "what if?", which is what drives you to have another go.

**Q. To what degree are you ready to compromise with your client?**

A. It varies hugely depending on the client. Compromise could imply giving in in order to please, or it can mean yielding with respect and incorporating the new input in order to produce the best possible outcome.

**Q. What would be your second career choice after design?**
A. Psychologist or obstetrician… It's probably a bit late for either.

**Q. What do you still aspire to design?**
A. Something very big, physical and full of colour. Theatre sets would be wonderful, particularly for the opera.

**Q. How would you describe your design approach in one sentence?**
A. I approach with pleasure in mind. I want to make things that lift the heart and soothe the soul.

2

1

3

4

5

**Client list**
British Airways
**British Ambassadors
Residence: Jakarta,
Vienna, Moscow**
British Telecom
**Citibank plc**
Clarence Hotel
**Coca Cola Company**
Diageo
**Glaxo Pharmaceuticals**
Home Office
**Metropolitan Hotel**
Procter & Gamble
**Simpsons of Piccadilly**
Sony
**also private clients**

**My work**
1. "Ode" rug (2002)
2. "Twist Aqua"
   rug (2003)
3. Drawing of "Spice 1"
   rug (1999/2000)
4. "Strata" rug (2003)
5. "Triptych Lipstick"
   rug (2001)
All produced by
Helen Yardley

**Tokujin Yoshioka**
born 1967 in Saga, Japan
**Studio Location**
Tokyo, Japan

At the age of 19, Tokujin Yoshioka graduated from Kuwasawa Design School and continued to learn his trade in the studio of one of Japan's greatest 20th-century designers, the late Shiro Kuramata. From 1988, Yoshioka started working in the Miyake Design office in Tokyo, before launching himself as a freelance designer in 1992. At the turn of the millennium, he established Tokujin Yoshioka Design office in Tokyo,

although he continues his professional relationship with Issey Miyake to this day, undertaking exhibition and shop designs for Japan's most famous fashion designer.

Yoshioka's move into the world of furniture design began only recently, but to great effect. The "Honey-pop" chair of 2001 is a structurally clever yet materially primitive creation. Made from layers of paper that have been rolled and piled up, then cut to form the profile of the chair, "Honey-pop" unfolds like a concertina to transform into a three-dimensional chair based on a lightweight but very strong honeycomb

structure. The design has become part of the permanent collections of the Museum of Modern Art, New York, the Musée National d'Art Moderne de Georges Pompidou, Paris, and the Vitra Design Museum, Germany.

Yoshioka is a great experimenter, exploring materials and their possibilities long before he tries to apply them in any comprehensible form. The interplay of transparency and lightness, coupled with an element of surprise, are characteristics that can be observed in much of his work – across the disciplines of furniture, lighting, installations, exhibitions, interiors and architecture.

**My inspiration**
The creative flair of Japanese fashion designer Issey Miyake as illustrated by the model wearing one of his garments below

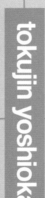

J

tokujin yoshioka

Q. **What types of products do you design?**
A. Something that has never been seen before and that surprises and moves people.
Q. **What or who has influenced your work?**
A. Mr Issey Miyake and Mr Shiro Kuramata.
On "Honey-pop" – honeycombs, the human body (bottom).
On "Tokyo-pop" – the human body.
On "ToFU" – tofu.
Q. **What was your big break?**

A. My installation for the exhibition "ISSEY MIYAKE: Making Things" at the Cartier Foundation in Paris.
Q. **What human emotions and necessities drive your designs?**
A. A sense of excitement.
Q. **How important are trends in your work?**
A. I have no interest in trends. I like to design things that create new values and which ultimately lead us into the future.
Q. **How important is it for your work to reflect a national design aesthetic?**

A. To many foreigners, my works seem… a reflection of a Japanese sensibility. However, that's not my intention, and I don't think I'm even aware of doing it. All I can say is that my designs are born naturally.
Q. **Is your work an individual statement or a team solution?**
A. The design idea is my individual statement. However, the work itself results from cooperation with many excellent technicians and experts, and also my staff.
Q. **To what level will you compromise to satisfy your client?**

A. When I first set out to design a concept, I already have in mind the ideals and philosophy of the client, so I don't think there's any need for me to make any compromises.
Q. **What would be your second career choice after design?**
A. Futuristic craftsman.
Q. **What do you still aspire to design?**
A. Possibilities and dreams for the future.
Q. **How would you sum up your approach to design?**
A. The essence of design lies not in form but in something invisible or intangible.

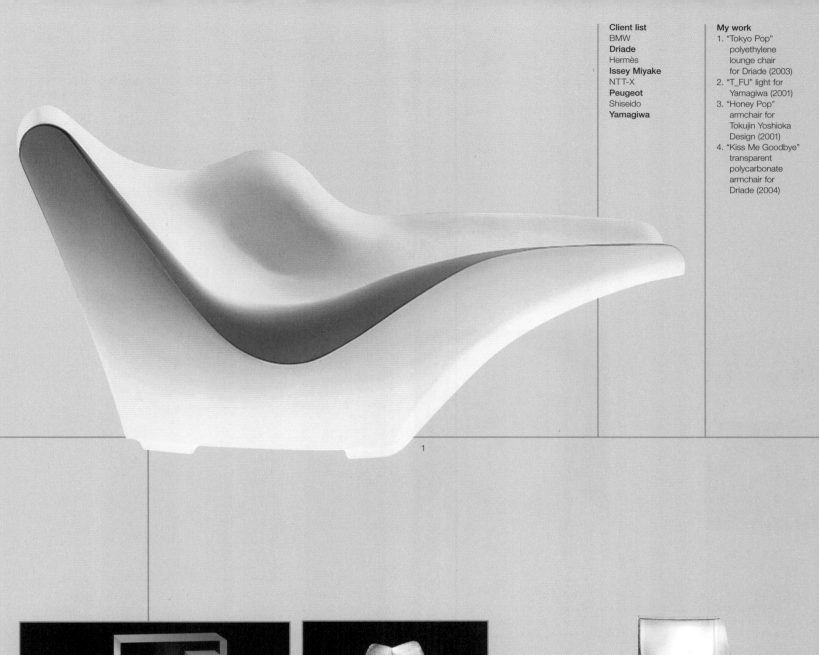

1

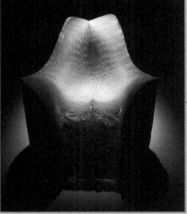

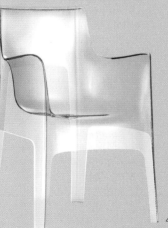

2

3

4

**Michael Young**
born 1966 in Sunderland, UK
**Studio Location**
Reykjavík, Iceland, and Brussels, Belgium

During his studies in Industrial Design at Kingston University, UK, Michael Young had the opportunity to work in Tom Dixon's Space Studio in London in the early 1990s. He launched his first collection of woven-steel furniture and "Smarty" furniture in Paris, Hong Kong and Tokyo, with the support of the Crafts Council. Subsequently, he formed a relationship with E&Y, the Tokyo-based manufacturer and distributor, which launched his "Magazine" and "Fly" furniture collection across the world to much acclaim in 1995.

In 1997, Young set up MY-022 Ltd – his creative studio in London. While collaborating with artists and graphic designers on exhibition designs across Europe and Japan, the studio also undertook commissions for the likes of Christopher Farr Carpets, Rosenthal, Eurolounge and Cappellini. In 1999, he founded M.Y. Studio in Iceland as well as a jewellery company, SMAK Iceland, with his wife Katrin Petursdottir, and later also set up a studio in Brussels.

In 2003, Young became a partner at SPOTS design studio in Taipei with Demos Chiang. The studio undertakes interior and construction projects in China and acts as a design consultancy for a number of Asian companies. The future of the partnership will involve the design, manufacture and licensing of products within the Asian markets and export.

**My inspiration**
The beauty, freedom, purity, and innocence of a field full of Icelandic horses

**B**
**IS**

**michael young**

**Q. What types of products do you design?**

A. It's pretty diverse – right now I'm working on interior concepts and industrial design projects, watches, pens, matchboxes etc. I never really know what awaits me. Recently I have done consultancy work for Corian DuPont and an observation shelter for a rare plant in an Asian swamp.

**Q. What or who has influenced your work?**

A. It might be hard to imagine, but a field full of Icelandic horses gives me the energy that I need!

**Q. What was your big break?**

A. There have been several factors or events that have helped me since 1992 when I finished design school, resulting in a more step-by-step progression. Recently, I set up a company in Taipei called SPOTS, which will be a massive leap. I adore the parameters of the Asian market and its manufacturing capacity.

**Q. What drives your designs?**

A. The need to feel free is primordial. I need to work for people who want to run along with me. I need to design several things at once to really enjoy the process.

**Q. How important are trends in your work?**

A. I don't really notice them, and if I did, I would avoid them.

**Q. How important is it for your work to reflect a British design aesthetic?**

A. It's not important. I acknowledge that we inherit traits through birth, but the world is too small and life's too short to care about that.

**Q. Is your work an individual statement or a team solution?**

A. It's an individual statement within an important team, but I'm the only designer.

**Q. What elements of the design process do you find particularly frustrating?**

A. The divide between designers and marketing departments – there is often no synthesis. If a project goes pear-shaped, it often comes down to problems in marketing departments.

**Q. To what level will you compromise to satisfy your client?**

A. They either take the design or they leave it. Naturally the manufacturing process is of prime concern to me, but most things are possible with proper consideration.

**Q. What would be your second career choice after design?**

A. Probably just walking dogs, though in my dreams I imagine writing must be nice.

**Q. What do you still aspire to design?**

A. I am really doing them all now.

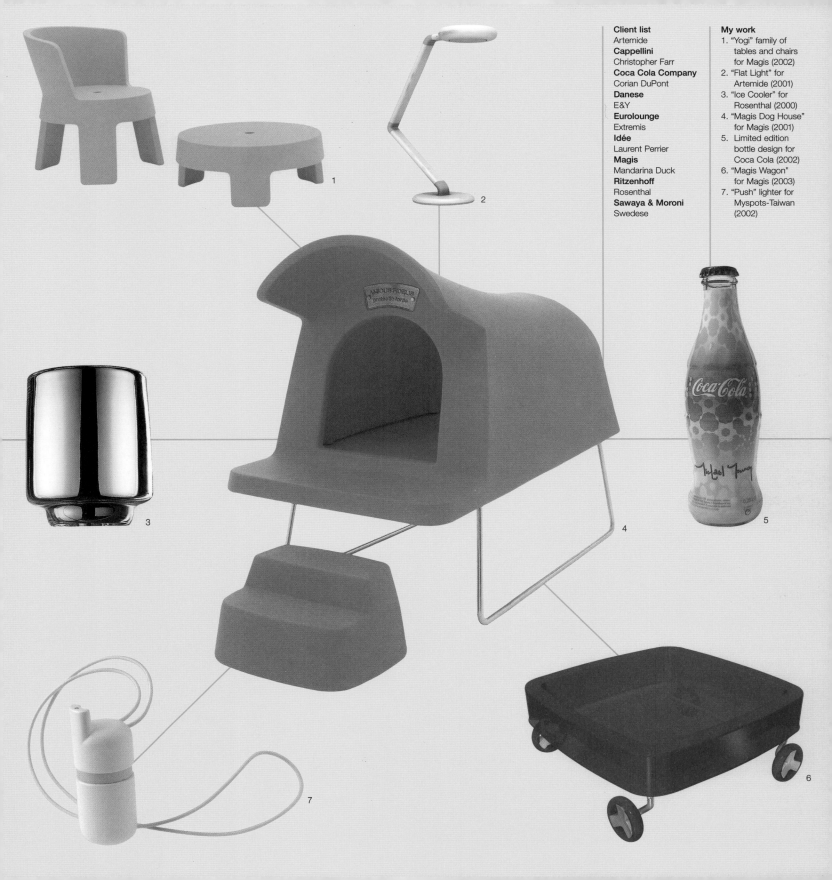

# index

The publisher would like to thank the following photographers, designers and organisations for their kind permission to reproduce the following photographs in this book.

10 left V & A Images/Victoria & Albert Museum; 10 centre reproduced by kind permission of the National Trust for Scotland; 10 right V & A Images/Victoria & Albert Museum; 11 left Archivo Storico Olivetti, Ivrea, Italy; 11 centre Property of AT&T Archives. Reprinted with permission of AT&T; 11 right V & A Images/Victoria & Albert Museum © DACS 2004; 12 left V & A Images/Victoria & Albert Museum © ARS, NY and DACS, London 2004; 12 centre Gunter Lepkowski/Bauhaus Archive, Berlin/Marianne Brandt ©. DACS 2004; 12 left & 13 Vitra Design Museum; 13 centre & right V & A Images/Victoria & Albert Museum; 14 left Vitra Design Museum; 14 centre Vitra Design Museum/© 2004 Lucia Eames; 14 right V & A Images/Victoria & Albert Museum; 15 left Vitra Design Museum © ARS, NY and DACS, London 2004; 15 centre V & A Images/Victoria & Albert Museum; 15 right Vitra Design Museum © Panton Design Basel; 16 left Scala (c) 2004 Museum of Modern Art NY/Scala, florence); 16 centre Vitra Design Museum; 16 right Kartell US, inc.; 17 left courtesy Modus PR; 17 centre V & A Images/Victoria & Albert Museum; 17 right Pentagram Design Ltd; 18 left Vitra Design Museum; 18 centre V & A Images/Victoria & Albert Museum; 18 right The Corning Museum of Glass, gift of Forma and Design Inc and Fiam Italia; 19 left V & A Images/Victoria & Albert Museum; 19 centre Modus Publicity; 19 right Mark Newson Ltd.; 20 left Cappellini; 20 centre John Ross; 20 right Moroso; 21 left Kartell US, inc.; 21 centre Jonathan Ive/Apple; 21 right courtesy of Nokia; 23 above Jam Design & Communications Ltd.; 23 below Architect: Piercy Conner; Graphics: Smoothe; 25 Stefan Eberstadt/ courtesy of Rocket Gallery, London; 27 above left and above right Sam Buxton (Technology: Electroluminescent Display); 27 below David Levene (Designed by Jiri Evenhuis & Janne Kyttanen); 29 Toyota Motor Corporation; 32 left courtesy of Magis Ltd; 32 right & 33 Steffen Janicke; 34 left Perry Hagopian; 34 right V & A Images/Victoria & Albert Museum; 35 (2) Moroso; 35 (3 & 4) Tom Vack (5) Swarovski; 36 left Bridgeman Art Library/National Museum of Scotland; 36 centre Mr Teruaki Yoshimura; 36 right Julian Hawkins; 37 (2) Lapalma (3 & 4) Aquio (5) Hitch Mylius (6 & 7) Azumi; 38 left G E Kidder Smith/Corbis (Architect: Oscar Niemeyer); 38 right Michael Wooley; 39 (2) Jean-Pierre Delagarde (5) Carlo Lavatori; 40 left courtesy of Gijs Bakker 40 right Ton Werkhoven; 41 courtesy of Gijs Bakker; 42 – 43 courtesy of Barber Osgerby; 44 left Reproduced by kind permission of Gallimard, Paris & Egmont, London; 44 right Todd Hido; 45 (1, 2 & 3) Marcus Hanschen (4) Nigel Cox; 46 left Bridgeman Art Library/Galerie Nationale, Palermo, Sicily, Italy; 46 right Naohiko Mitsui, 47 (1) Leo Torri (3) Tom Vack (4) Fabrizio Bergamo; 48 left The Art Archive/Museum of Modern Art, New York/Album/Joseph Martin (Succession Marcel Duchamp/ADAGP, Paris and DACS, London 2004); 48 right Cristina Dogliani; 50 left Dennis Gilbert/View (Architect: Peter Zumthor); 50 centre Lena Koller; 50 right Roland Persson; 51 (2) Designers Eye (3 & 4) Roland Persson, (5) Olle Jo (6) Rolf Lind; 52 left Lluis Real/Powerstock; 52 centre Anthony Nagelman; 52 right & 53 (1,2, 4 & 5) B & B Italia (3) Cappellini; 54 left Studio Jurgen Bey; 54 right Bob Goedewaagen; 55 (2) Studio Jurgen Bey (3 & 4) Bob Goedewaagen; 56 left The Felix Gonzalez-Torres Foundation/courtesy of Andrea Rosen Gallery, New York; 56 centre Philippe Chancel, 58 left Bridgeman Art Library/Bonhams, London, UK; 58 right & 59 (1 & 4) Cameron Wittig (2 & 3) Kris clover (5) Visko Hatfield; 60 left Sean Sexton Collection/Corbis; 62 left Studio Tord Boontje; 62 right Sivan Lewin/Transglass; 63 Studio Tord Boontje; 64 left © Vitra Gmbh; 64 centre Charles Fréger; 64 right Morgan Le Gall; 65 (2 & 6) Bouroullec Studio Image (3 & 5) Paul Tahon (4) Morgan Le Gall; 66 left Kristin Larsen; 66 right & 67 Boym Partners, Inc.; 68 left Julian Brown, reproduced by kind permission of the British Museum, London; 69 (1 & 2) Colin Hawkins; 70 left Adrian Marasigan; 70 centre Danny Bright; 70 right Bitetto Chimenti; 71 (2 & 4) Baldomero Fernandez (5) Kazushige Yamamoto; 72 left Martin Bond/Science Photo Library; 72 centre Anett Fröschl; 72 right & 73 (2, 5, 6, & 7) David Steets (3) Ivo Kljuce (4) Benjamin Dörries; 74 left Peter M Wilson/Axiom Photographic Agency; 74 centre & right Adriana Zebrauskas; 75 (1) Alessi (2) Andres Otero (3 & 4) Edra (5) Humberto Campana; 76 left Nick Knight, 77 (2) Carlo Lavatori (3 & 4) Alex Wilson; 78 left Antonio Citterio and Partners; 78 centre Gionata Xerra; 80 left Tate, London/Judd Foundation. Licenced by Vaga, New York/DACS, London 2004; 80 centre Knut Koivisto; 82 left Jim Holmes/Axiom Photographic Agency; 82 centre J-P Cousin; 82 right Noboru Mitani; 83 (2 & 7) C C Design (3) Fillioux & Fillioux (4) Risaku Suzuki (6) Nacása & Partners; 84 left Jeremy Sutton Hibbert/Rex Features; 84 centre Dawie Verwey; 86 left © National Museums and Galleries of Wales; 86 centre Yoshie Nishikawa; 87 (1,2 & 6) Uwe Spoering (3) Miro Zagnoli/Artemide (4 & 5) Patrick Gries; 88 left Eames Office © 2004 Lucia Eames; 88 centre Michele Hepburn; 88 right & 89 Jason Tozer; 90 centre Fredrik Reuterhall; 90 right Mathias Nero; 91 (2, 3 & 4) Jonas Linell (5) Mathias Nero (6) Åke E:son Lindman; 93 (2, 3, 4 & 6) Luca Tamburlini (5) Miro Zagnoli; 94 left Hergé/Moulinsart 2004; 94 right Albert Vecercka; 96 left Reproduced by permission of the Henry Moore Foundation/courtesy of Sotheby's Picture Library; 96 centre Ashley Cameron; 96 right Cappellini; 97 (2) Ashley Cameron (3, 4 & 5) Gideon Hart (6, 7, 8) Mika Tolvanen; 98 – 99 Dyson Appliances Ltd; 101 (3) Nathalie de Leval; 102 left courtesy of Eoos; 102 right Paul Prader; 103 (1 & 3) Walter Knoll (2) Matteo Grassi (4) Keilhauer; 104 left The Art Archive/ © 2004 Mondrian/Holtzman Trust; 104 right Goran Jonke; 105 (1) Matthew Brody & Grahame Montgomery (2 & 3) Studio Controluce (4) Marino Ramazzotti; 106 left Carolyn Djanogly; 106 right Pietro Carrieri/Tecno spa; 107 (2, 3 & 4) Nigel Young/Foster & Partners (5) Marc Eggiman, Basel (6) Peter Strobel Photodesign; 109 Hidetoyo Sasaki; 110 left courtesy of Haunch of Venison, London. © Bill Viola 2004; 110 centre Jean Baptiste Mondino; 110 right Inside Out; 112 left Sijmen Hendriks; 112 centre Donato di Bello; 112 right & 113 Carlo Lavatori; 114 left Daniel Mayer; 116 left Andrea Bachmann; 116 centre Menga von Sprecher; 116 right Hansjörg Schoedler; 117 (3 & 6) Menga von Sprecher (5) Moroso; 118 left Iitalia; 118 centre courtesy of Isabel Hamm; 118 right & 119 (2, 4, 5 & 6) Ralph Klein (3) WMF; 120 left courtesy of Thomas Heatherwick; 120 centre Charles Glover; 120 right Steve Speller; 121 (4) Mark Pinder (5) Steve Speller; 122 © The Noguchi Museum, New York; 122 right Ben Murphy; 123 (1 & 4) Olivier Mesnage (2, 3 & 5) Industrial Facility; 124 left Architects: Rolf

# acknowledgements

Gubtrod & Frei Otto, Engineer: Fritz Leonhardt; 124 right Daniel Kessler; 125 courtesy of Stefanie Hering; 126 left Corinna Dean; 126 right & 127 (2, 4, 5 & 6) SCP Ltd (3) Marcus Hilton (7) Handles & Fittings; 128 left Bettmann/Corbis; 128 centre courtesy of Geoff Hollington; 128 right SCP Ltd; 129 (2) Parker Pen Company (3) Je Joue (4) Herman Miller Inc. (5) Carol Sharp; 130 left Boris Braakhuis; 130 centre Rene Koster; 130 right & 131 Boris Braakhuis; 132 left Jeff Zaruba/Corbis; 132 right Mauro Davoli; 133 (1 & 3) Santi Caleca (2) Cinova Studio (4) Snaidero Studio (5) Studio Azzurro; 134 left Jonas Linell, 135 (2 & 3) Fabrizio Bergamo; 136 – 137 courtesy of Apple; 138 left Jam Design & Communications Ltd.; 139 (1 & 4) Rob Carter (2) Jason Tozer; 140 – 141 courtesy of Hella Jongerius; 142 left Selby Mcreery/Eye Ubiquitous/ Corbis (Architects: Richard Rogers & Renzo Piano); 142 centre & right & 143 (2 & 3) Thomas Duval (4 & 5) Tommaso Sartori; 144 left Andrew Lawson; 144 centre Yoshiyuki Ikuhara; 144 right Vincenzo Castella; 145 (3, 4, 5 & 6) Luigi Sciuccati, 146 left AFP/Getty Images; 146 right & centre & 147 courtesy of Harri Koskinen; 148 left Adina Tovy Arnsel/Lonely Planet Images; 148 right Out.Design; 149 (1, 3 & 5) Kozo Takayama (2 & 4) Nacása & Partners Inc.; 150 left Arik Levy; 150 right S Peetz; 151 (2) Else Puyo (3) Arik Levy (4) Niko Xanthopoulos; 152 left Peter Cook/View (Architect: Le Corbusier); 152 centre Tine Guth-Linse; 152 right 153 Johan Kalén, 154 left Giuseppe Pino/Contrasto/Katz Pictures; 154 right Helen Pe; 155 (2) Tommaso Sartori; 156 – 157 John Ross; 158 left Tate Gallery, London/ ARS,NY and DACS London 2004; 158 centre Laurent van Steenstel; 158 right MDF Italia; 159 (2 & 5) MDF Italia (3) Driade (4) Extremis (6) Benoit Deneufbourg;

160 left L'illustration; 160 centre Pierre Fantys; 160 right Ilvio Gallo; 161 (2) Christophe Marchand (3) Frank Tielemans (4) Felix Streuli (5) Ezio Prandini (6) Friederike Baetcke; 162 left Hulton Deutsch Collection/Corbis; 162 right courtesy of Enzo Mari; 163 (1) Aldo Ballo (2, 3 & 4) courtesy of Enzo Mari (5) Ramak Fazel; 164 left Bridgeman Art Library/Bonhams, London, UK; 164 centre Lara O'Hara; 165 (2) Sara Morris; 166 left United Artists/The Kobal Collection; 166 right Pijnata Monti; 167 (1) Olivier Cadouin (2) Leo Torri (3, 4, & 5) Studio Massaud; 168 – 169 Ingo Maurer GmbH; 170 left Kartell US, inc.; 170 right & 171 courtesy of Alberto Meda; 172 left Wolfgang Kaehler/ Corbis; 172 right Arnaud Barcelon; 173 (1 & 2) Peter Gabriel (3) Marre Moerel; 174 left Jasper Morrison; 174 right James Mortimer; 175 (2 & 6) Walter Gumiero (4) Stefan Kirchner (5) Christoph Kicherer; 176 left Mark Luscombe-White/ Conran Octopus; 176 centre Bernard Martinez; 176 right & 177 courtesy Pascal Mourgue; 178 left Grant Delin; 178 right & 179 Marc Newson Ltd; 180 above left Andreas Engesvik/Norway Says; 180 left below Ulf Rasmussen; 180 centre Colin Eick; 180 right ClassiCon; 181 (2 & 3) Mir Visuals (4) Globe Furniture (5) Hugo + Åshild (6 & 7) Iform (8) David Design; 182 left Marc Newson Ltd.; 182 right Cappellini; 183 (2) Tronconi (3) Renaud Callebaut (4) Studio Norguet (5) Artifort (6) De Vecchi; 184 left Cineriz/The Kobal Collection/ Michalke, Georgia; 184 right Settimio Benedusi; 185 (1) Livio Mancinelli (2) Settimio Benedusi (3 & 4) Alberto Ferrero; 186 left Bridgeman Art Library/Galleria dell Accademia, Venice, Italy; 187 (5) courtesy of Vertu Ltd; 188 left Josef Sudek © Anna Farova/Radoslav L. Sutnar's Archive; 188 centre & right Ondrej Kavan; 189 (1, 4 & 5) Filip Slapal (2) Jan Pohribny (3) Nikola Tacevski; 190 left

RIBA Library Photographs Collection (Architect: Terragni); 190 right Luca Fregosa; 191 (1 & 3) Tiziano Rossi (2) Marino Ramazzotti (4) Maurizio Marcato (5) Leo Torri; 192 left courtesy of John Pawson; 192 centre Cindy Palmano; 192 right & 193 (2, 3 & 5) Richard Davies (4) Fi McGhee; 194 left Tom Lloyd; 194 centre & centre right Sandra Lousada; 194 right Mario Carrieri; 195 (2) Andrew Peppard (3) Giovanni Pini (4) Thomas Koller (5 & 7) Peter Schumacher (6) Karl Hube; 196 left Carl Hansen & Søn A/S; 196 right Ed Carpenter; 197 (2) Robin Matthews; 198 left Joseph Sia/Getty Images; 200 – 201 courtesy of Philips Design; 202 left Mario Pignata-Monti; 204 left Naohiko Mitsui; 206 left Tate Gallery, London/ARS,NY and DACS, London 2004; 206 centre Lena Koller; 207 (2) Pelle Wahlgren (3 & 4) Roland Persson; 208 left John Minihan/Evening Standard/Getty Images; 208 centre Ilan Rubin; 210 left Adam Woolfitt/Corbis (Architect: Alvar Aalto); 210 centre & 211 courtesy of Sandell Sandberg; 212 left Keystone/Katz Pictures; 212 centre Bulent Durgun; 212 right & 213 (2, 4, 5 & 6) Firat Erez (3) 33 Multimedya Studio; 214 left Ron Case/Getty Images; 214 right Ummarino; 215 (2) Pietro Carrieri (3) Victor Mendini (4 & 6) Ummarino (5) Fabrizio Bergamo; 216 left Jerszy Seymour; 216 centre Karen Ann Donnachie; 216 right Carlo Lavatori; 217 (2) Marc Domage (3, 4 & 5) Carlo Lavatori; 218 left Reproduced by kind permission of the Dan Dare Corporation Ltd; 218 centre Jillien Edelstein; 220 left Doug McKinlay/Axiom Photographic Agency; 220 centre, right & 221 Michael Sodeau Studio; 222 left William Morris Gallery/London Borough of Waltham Forest; 222 right & 223 Ilvio Gallo; 224 left Jean-Baptiste Mondino; 224 right Tom Vack; 225 (2) Studio Deis (3) Studio Air (4) Kartell (5) Tom Vack (6) Stefan

Kirchner (7) Gal Busera (8) Piero Fasanatto; 226 Matt McKenzie; 227 (1 & 3) Mouse in the House (2) Drive Inc. (4) Andy Cameron (5) Bob Blackburn; 228 left courtesy of Studio Thun; 228 right Illy; 229 courtesy of Studio Thun; 230 left Honda R&D Co, Ltd; 230 right & 231 (1) Ian McKinnell (3) Alex Macdonald; 232 left © 2003, The Museum of Modern Art, New York/Scala, Florence; 232 centre Ruy Teixeira; 232 right Moroso; 233 (2) Leo Torri/De Vecchi (3 & 4) Moroso (5) Molteni & C.; 234 left Hans Werlemann/Office for Metropolitan Architecture; 234 right Bart van Leuven; 235 (1) Vitra (2, 3 & 4) Bart van Leuven; 236 left © Ernst Haeckel; 236 centre Katharina Behling; 236 right Hans Hansen; 237 (2) Agency 'E' (3) Carsten Eisfeld (4) Marcus Sauer; 238 left courtesy of Marcel Wanders Studio; 238 right Robbie Kavanagh; 239 (2) Occhiomagico, Miilan (3, 4 & 6) Maarten van Houten; 240 left Hulton Archive/Getty Images; 241 (1 & 3) Ventura Design on Time (2, 4 & 5) Molteni & C; 242 left Paul Chave/Fiell International Ltd; 242 centre Jason Bell; 242 right SCP Ltd.; 243 (2 & 5) James Merrell (4 & 5) SCP Ltd.; 244 Studio DSP/Patrick Despriet/courtesy of Extremis; 246 left Bridgeman Art Library © Detroit Institute of Arts, USA; 246 right & 247 (1, 2, 3 & 5) John McCarthy (4) Ed Reeve; 248 left Chris Moore; 248 right Tomoki Futaishi; 249 (2 & 3) Nacása & Partners Inc.; 250 left Arnaldur Halldorsson/ Nordic Photos; 250 right Pierre Fantys; 251 courtesy of Michael Young.

Every effort has been made to trace the copyright holders. We apologise in advance for any unintentional omissions and would be pleased to insert the appropriate acknowledgement in any subsequent publication.